LEFT SHIFT

RADICAL ART IN 1970s BRITAIN

JOHN A. WALKER

I.B.Tauris *Publishers*
LONDON • NEW YORK

Published in 2002 by I.B.Tauris & Co Ltd
6 Salem Road, London W2 4BU
175 Fifth Avenue, New York NY 10010
www.ibtauris.com

In the United States of America and in Canada distributed by
St Martin's Press, 175 Fifth Avenue, New York NY 10010

ISBN 1 86064 765 0 hardback
ISBN 1 86064 766 9 paperback

A full CIP record for this book is available from the British Library
A full CIP record for this book is available from the Library of Congress

Library of Congress catalog card: available

Project Management by Steve Tribe, London
Printed and bound in Great Britain by MPG Books Ltd

Contents

Illustrations

Acknowledgements

I am grateful to Philippa Brewster for her editorial skills and encouragement; and to Paul Overy for his useful comments on early drafts of this text.

Thanks are also due to all the artists, critics and others who granted interviews or provided information and photographs for the illustrations: Art & Language, Conrad and Terry Atkinson, Derek Boshier, Jenni Boswell-Jones of And Association, Guy Brett, Andrew Brighton of Tate Modern, Rosetta Brooks, Judy Clark, Brigit Collins of the TUC Library Collections at the University of North London, Emmanuel Cooper, Anneliese Davidsen of the Greenwich Mural Workshop, Terry Dennett of the Jo Spence Memorial Archive, Gen Doy, John Dugger of Banner Arts, Elizabeth Ellett of the Elizabeth Garrett Anderson Hospital Appeal Trust, William Furlong, The Gay Archive at Cat Hill, Middlesex University Library, Andrew Glew of the Tate Gallery Archive, Pamela Griffin of the Hayward Gallery, Janeen Haythanthwaite of the Whitechapel Art Gallery archive, Charles Harrison, Margaret Harrison, Michael Hazzledine, Susan Hiller, Breck Hostetter of Ronald Feldman Fine Arts, New York, Beth Houghton of the Tate Gallery's Library, Kay Fido Hunt, Dan Jones, Peter Kennard, Derek Manley, Denis Masi, Vanessa Marshall of the BFI stills library, Gustav Metzger, Jonathan Miles, Neil Mulholland, Frances Murray of the Whitworth Art Gallery, Manchester, Clive Phillpot, Richard Pitkin of the *Illustrated London News*, Nicholas Ross, Francis Routh, Maureen Scott, Barbara Steveni of O + I, John Stezaker, Brandon Taylor, Nicholas Wegner of CV Publications, Stephen Willats, Paul Wombell, Paul Wood; and finally, the staff of Greenwich Public Libraries and their Local History Collection.

While every effort has been made to trace the copyright holders of the illustrations, the author and publisher would be glad to hear from any we have not been able to reach.

Introduction

Is the art of the 1970s to suffer a fate similar to that of the 1930s, which has so often been presented as innovatively dull and empty, not worthy of much consideration?

Ian Burn[1]

Visual culture in Britain during the 1960s has been celebrated and documented in numerous books, articles and exhibitions, but that of the following decade – especially its fine arts – much less so. Did nothing happen in the 1970s aside from glam rock and punk, disco music and *Saturday Night Fever*, platform shoes and bell-bottomed pants, jogging, skateboarding, streaking, *Star Wars* and *Charlie's Angels*? Arguably, the 1970s is still a neglected decade despite the fact that there have been a number of general histories, nostalgic stylistic revivals, books and exhibitions about conceptual art and two books and several essays on the art of the 1970s in Britain and the United States. Indeed, such is the decade's invisibility that some writers have dubbed it: 'the undecade', 'the decade that style or taste forgot', and the critic Peter Fuller once wrote an essay that asked: 'Where was the art of the seventies?'[2]

According to Mel Gooding, many people regard the decade as an 'interim' period 'without excitement' or a 'spirit', while Jasia Reichardt remembers the 1970s as 'perplexing and paradoxical ... a period of contraction, diminution and lack of opulence'. Others consider that there was no fine art of note produced during the 1970s, or that there was no major movement/dominant style, simply a condition of fragmentation and pluralism. For example, Stuart Bradshaw, writing in 1981, discerned

1

... a loss of centre in contemporary art; a reflection, I think, of a deeper loss of centre in society as a whole ... In the seventies the optimism, faith in the future, and the belief in a mainstream largely disappeared. Art became fragmented into separate areas, none of which could hold the centre in the sense of supplying a dominant stylistic idiom or set of concerns or beliefs.[3]

It is certainly the case that there were various mini-movements and tendencies running in parallel. However, this book's argument is that what was new and significant about art in Britain during the 1970s was its repoliticization and feminization, its attempt to reconnect to society at large (even though this was not exclusive to Britain because similar developments occurred in Germany and the United States). This shift to the Left provides a unitary theme; consequently, the book claims to be *a* history of 1970s visual art (excluding architecture), not *the* history.

Conrad Atkinson, the artist, observed in 1979:

Contrary to the myth being spread by the media to the effect that the visual arts flourished magnificently in the 60s, and the 70s have produced little, the 70s and particularly the last four years have seen a strong and vital progressive movement which has begun to approach reality through a number of areas directly related to social and political questions.[4]

The critic Guy Brett concurred. In 1981, he wrote:

It is often said that the 1960s saw a wonderful flowering of the visual arts in Britain, but that in the '70s it all vanished. In fact, the '70s produced a different kind of movement, a remarkable growth of political and social consciousness among artists.[5]

In addition, in 1988, the artist John Hilliard recalled:

Squeezed between the carefree Swinging Sixties and the commodity-conscious Eighties, it was also a decade of austerely radical art, severely

ascetic in its uncompromising purity, the product of a cultural moment when a generation of young artists genuinely seized the time, exerting seminal influence in an international arena ... what remained consistent was a determined commitment to the present, an egalitarian spirit and an almost cavalier disinterest in money.[6]

Radical political artists of the time had three objectives: first, to change art; second, to use that new art to change society; and third, to challenge and transform their relations of production and art world institutions. Conformist artists and critics, of course, poured scorn on these ambitions and defended the status quo.

What this book will demonstrate is that many of the new developments were closely connected to the events and issues – economic, ideological, political and social – of the period. Art was subject to external and historical forces – it *reflected* society but it also *reflected upon* society and influenced people's ideas and behaviour, consequently, it was a minor social force in its own right. Of course, there were also many artists who ignored the public events of the 1970s, which therefore had no impact on their work.

As we shall discover, within the art world itself what occurred was an often-acrimonious struggle between various groups: traditionalists and formalists versus left-wingers and feminists, abstractionists versus figurative artists, blacks versus whites, practitioners versus theorists and critics. These groups argued about the character, social function and future direction of art and its institutions. Even those who shared a leftist political perspective indulged in factional disputes: there were anarchists, Labour party supporters, Maoists, Marxist-Leninists, Trotskyists and every shade in between. Within feminism too there were at least three strands: liberal, radical and socialist.[7]

Before proceeding, it should be made clear that, although this book concentrates on art made by left-wing artists, political art is not confined to the Left. A history of right-wing and fascist art and imagery during the 1970s could also have been provided. It would

3

have included flattering portraits of right-wing politicians and business leaders, paintings of groups of male establishment figures such as John Ward's *A meeting of the Society of Dilettanti at the St James's Club* in 1973, which includes a portrait of the art historian Lord Kenneth Clark, exhibited at the Royal Academy's 'Summer Exhibition' of 1976. The figurative painter John Bratby also began producing a series of portraits of individuals in 1975 precisely because he feared a 'collectivist state' was emerging that would result in 'the Herd man, the group being, the obedient constituent of a collectivist whole'.[8]

Examples of fascist imagery would encompass the vile racist representations, such as blacks depicted as gorillas, printed on flyers pushed through letterboxes in the 1970s. Ian Breakwell, an artist noted for his continuous diary of observations of daily life, preserved a photograph showing a demonstration in Smithfield Market of white women holding placards demanding 'Stop immigration, start repatriation' while infants in pushchairs waved Union Jack flags. Breakwell recorded that the mothers were chanting: 'Castrate black men! Castrate black men! Castrate black men!'[9] Certain observers suspected Gilbert & George of fascist tendencies because they depicted men from ethnic minorities plus derogatory appellatives and employed the swastika as a motif. Punks too used the swastika (as a fashion accessory) – not to signal an allegiance to Nazism but in order to confuse and shock liberals.

During the 1970s, some theorists argued that the label 'political art' to designate a subcategory of art was misleading because 'all art is (already) political'. This claim is surely too broad. A more reasonable assertion is that 'all art is ideological' and that 'all art has political implications'. The label 'political art' was also an embarrassment to left-wing artists because they suspected it was simply the name of the latest art movement, one that was destined to be replaced by a new 'ism' in a few years time. Nevertheless, the label will be retained here to signify artworks with political content/subjects that seek to contribute to social or political change. Similarly, the term 'feminist art' will be used to distinguish art made by women influenced by

feminism and seeking to further its cause from art made by women such as the abstract painter Bridget Riley who rejected feminism.[10]

The decade was particularly notable for its intellectual ferment and ideological struggles, its conferences and public meetings, and for significant developments in theory and criticism. Many radical artists wrote papers as often as they made images or objects. During the 1960s, the formalist ideas of the American critic Clement Greenberg (1909–94) and followers such as Michael Fried had dominated art theory in Britain and there were some British artists – mostly abstract painters and sculptors associated with St Martin's School of Art in Central London and the Stockwell Depot studios in South London – who continued to be influenced by the Greenbergians during the 1970s.[11] Greenberg also visited Britain several times during the 1970s to give talks in art schools and crits in studios. However, increasing numbers of British and American artists and critics began to question Greenberg's ideas and dissenting opinions appeared in British art periodicals. For example, the American art critic Barbara Reise (1940–78), who came to live in London (and to die there), wrote a critique of Greenberg and his group for *Studio International*, while the artist Victor Burgin sought an alternative tradition of formalism in the writings of the Russian Formalists.[12]

During the 1970s, American feminist art critics and historians such as Lucy Lippard and Linda Nochlin became more influential than Greenberg, as did European thinkers (especially those resident in Paris). The latter development paralleled Britain's entry into the European Economic Community. In the 1970s, texts by leading French intellectuals such as Louis Althusser, Roland Barthes, Pierre Bourdieu, Guy Debord, Michel Foucault and Christian Metz were translated into English. In London, in March 1973, the Institute of Contemporary Arts (ICA) mounted a series of events about French culture and theories such as semiotics and structuralism. Also influential were the prison notebooks of the Italian Marxist Antonio Gramsci, particularly his concepts hegemony and organic intellectuals, and the writings of the German 'critical theorists' – Theodor

Adorno, Walter Benjamin and others – associated with the Frankfurt School of Philosophy. While this book is not a theoretical work itself, it does describe the impact of theory on the thinking, writing and work of various artists and critics.

In some instances, theory was not simply a discourse developed by artists in parallel to making art objects but was itself imbricated in the processes of production and consumption. For example, films such as *Penthesilea* (1974) and *Riddles of the Sphinx* (1978) by Laura Mulvey and Peter Wollen, two independent filmmakers, writers and university lecturers, were described as 'theoretical films' because they extended the intellectual work the directors had previously undertaken in the realms of cinema, feminism and psychoanalysis. Furthermore, the directors often attended screenings in order to discuss with audiences the ideas addressed in their films.[13]

Even while the pop art and underground films of the American artist Andy Warhol were being celebrated in Britain via exhibitions, screenings and television programmes, the personality and work of his main European rival – the German artist Joseph Beuys – was intriguing British artists. The fame and reputation of Beuys, 'a prophet' who, according to Mel Gooding, 'exemplified the essential ethos of the 1970s, soon matched that of Warhol but the German provided a very different model of practice, one that involved active contributions to art education, ecology and politics. In 1974 and 1978, several important exhibitions of German art were mounted in London and radical British artists noted, in addition to the work of Beuys, the critical art of Klaus Staeck and Hans Haacke.

The 1970s was also a period of intense self-reflection regarding the concept and institutions of art, and the condition of British art: critiques were undertaken of art criticism, art magazines, art education, state funding and private patronage, galleries and museums and the art market. Dissatisfied with existing arts organizations, many artists founded their own. (The proliferation of 'alternative' organizations began in the late 1960s with such self-help bodies as AIR and SPACE.) Artists found and occupied new spaces in order to hold

meetings and mount exhibitions. Others decided to use the existing gallery network whenever possible. Those denied access to galleries resorted to other venues such as public libraries and the streets.

It was a period of expanded materials/media: instead of pigment and clay many artists began to employ banners, bodily waste, books, concepts/language, flags, film, mixed-media installations, mirrors, patchwork, performance, photocopies, photography, photomontage, posters, the postal system, sound and video. Of course, artists had adopted some of these materials and media in earlier decades but they took on a new importance during the 1970s because traditional art forms such as painting and sculpture experienced identity crises and were subject to critical analyses by both friends and enemies.

Arguably, there were crises in the visual arts that paralleled the ones afflicting Britain's economy and social order. The journalist Norman Shrapnel has observed: 'The Seventies, like the Thirties, saw crisis become a daily condition of life.'[14] In the 1930s, economic recession in Europe had been accompanied by the rise of fascism and by the politicization of art and by the aestheticization of politics. The same appeared to be true of the 1970s even though economic and political developments were not as extreme as in the 1930s.

Because of their desire to reconnect to society, certain artists rejected the purely formalist view of art and began to stress the importance of subject matter/content, social relevance and function. (For instance, feminist artists made works about housework and menstruation; homosexual artists made works about the struggle for gay rights.) However, it was not simply a question of *representing politics* because radical artists steeped in the history of avant-garde art also realized that they had to address *the politics of representation*, to perform work *on* representation. This was to result in two kinds of political art: the first depicted political events in a straightforward manner or performed an agit-prop function; the second was self-reflexive regarding representation and was, therefore, more complex and demanding. Thus, a conflict or tension emerged between the demand for accessibility and political utility on the one hand and the need for

reflexivity on the other. A few artists, most notably Jo Spence, managed to combine the two approaches.

A recurrent challenge facing radical artists was how to reach audiences beyond the narrow confines of the art world, how to convince political activists, local communities, campaigning groups, workers in factories or on strike, that art could be a valuable additional resource or weapon rather than merely an ornament or instrument of the Establishment. Art that was partisan – that sided with the exploited or foregrounded the experiences and needs of blacks, gays, the unemployed and women, for instance – challenged the conventional wisdom that art transcends such divisions and is universal in its appeal. Consequently, it was not simply a matter of increasing the *size* of the audience for art, but of developing new forms of art adapted to the needs of underprivileged groups, ethnic minorities, local communities, etc. Performance art, for instance, was one of the relatively new forms that appealed to radical artists especially because of its lack of historical baggage and its direct relation with live audiences in public places.

An account will be given of the various solutions that were tried by different artists and groups, and attention will be paid to efforts to involve ordinary people in the creative process, via behavioural art, community art, participation art, and to strategies designed to enable people to represent themselves.

Decade-based histories are problematical and somewhat arbitrary in terms of their periodization. (Of course, every period historians identify segments the continuum of time.) Despite the efforts of journalists, there is no single essence or *zeitgeist/stil* (spirit or style) for each decade. If spirits or styles of ages do exist then, surely, there must be several occurring simultaneously, just as there are different generations of artists alive and working concurrently. The mood and fashion at the beginning of a decade can be very different from those at the end of the decade. Furthermore, there are continuities that connect the 1970s with earlier and later decades. For this reason, a summary of the legacy of the 1960s will be provided in this introduction and, in

the conclusion, a brief account of what happened to radical culture after 1980. Despite the shortcomings of decade-histories, what happened in art between January 1970 and December 1979 deserves to be documented because firstly, it is intrinsically interesting and secondly, because so much recent work depends or builds upon what was achieved then. As Conrad Atkinson, one of the leading artists of the decade, has remarked: 'The British art of the '70s made the British art of the '90s possible.'[15]

It is also worth recalling an era when a Labour government was in office (1974–79) and trade unions were still powerful and recorded some memorable victories. Lucy Lippard, the American art critic, writing in 1980, noted that socio-political art was more visible and viable in Britain than in the United States precisely because there were left-wing movements and parties artists could join or collaborate with. Furthermore, some campaigns of the 1970s are still 'live' in the sense that they have not yet been resolved.

In addition, it is worth recalling a time when the paradigm shift from modernism to post-modernism took place. The death of Pablo Picasso in 1973 has been viewed as signifying the end of modernism and hence a point of 'cultural closure' but, of course, to critics of modernism it was a point of 'cultural opening'. Opinions were to be divided as to whether or not the loss of a centre or mainstream such as modernism, was a positive or negative development. What one can say with certainty is that major cultural shifts of this kind provide opportunities for both progressives and reactionaries.

Christopher Booker, in his history of the 1970s, argued that it was a profoundly important decade for three losses of faith: in the modern movement, the benefits of technology and the 'grand narrative' of progress.[16] Most of the artists discussed in this book had reservations about modernism but they also retained a belief in progress because they thought a different kind of art could help build a better society; hence, in this respect, they continued the utopian aspirations of 1960s radicals.

In order to give an impression of the unfolding of events during the

1970s, a chronological, year-by-year order has been adopted for the narrative, which is interspersed with accounts of a scattering of artworks exemplifying key events or issues. Also cited are the writings of such critics as John Berger, Guy Brett, Rosetta Brooks, Richard Cork, James Faure Walker, Peter Fuller, Clement Greenberg, Paul Overy and others. Key art magazines of the period are also featured because of the role they played in fostering discussion. Individual artists and groups of artists also founded their own magazines to promote their views or publish their work. Significant conferences, exhibitions and galleries have also merited attention.

British art possesses certain national characteristics and may take its subject matter from events, places and people in Britain but, of course, it is also open to influences from the wider world – Europe and North America especially. Certain kinds of art extend beyond national boundaries – conceptual and feminist art, for instance – and British artists live and work abroad, while foreign artists – particularly Americans – visit Britain, live and exhibit here. Americans such as Peter Gidal, John Dugger, Susan Hiller, Mary Kelly, R.B. Kitaj and Denis Masi made significant contributions to the British art scene during the 1970s, as did artists from Argentina, Brazil, the Caribbean, Europe, New Zealand, Pakistan, the Philippines and Romania. Artists of foreign origin – some of whom were exiles and political refugees – of course, were particularly concerned and knowledgeable about their homelands. Such artists often contributed to campaigns and organized festivals in Britain in the hope of influencing the course of events in their countries of origin. Exhibitions of foreign art, such as those featuring Chilean patchworks, Chinese peasant paintings and German photomontages also had an impact on radical British artists.

As transportation around the globe became cheaper, easier and faster, artists became more peripatetic. Conceptual artists, in particular, could travel light and artists employing photography could send whole exhibitions abroad by post or carry them in a folder on an aircraft.

Since national boundaries are permeable, the autonomy of British art is always relative. Nevertheless, this book contends that during the 1970s a significant number of British artists turned their attention to domestic issues and threw off foreign influences, particularly American ones. This was because they wanted to create art that was more relevant to the needs of Britons, indeed in some instances to communities living in small localities. For example, artists and local people painting a community mural in a working class district of Glasgow or Liverpool were not trying to reach and impress the art world habitués of New York or Paris. Since the mural's content and style had to be comprehensible to local people, an abstract style such as minimalism was inappropriate. However, this is not to say that the artists painting the murals were not interested in trans-national issues such as the threat from nuclear weapons or what contemporary muralists were painting in Los Angeles, or what the Mexican muralists of the twentieth century had achieved.

Given the above, it may seem to foreign observers that much radical British art of the 1970s was parochial in its concerns. However, while suffering and the struggle for justice and human rights may take different forms in different countries, they are crucial to all humanity (which is why the United Nation's declaration of human rights is a universal one). This means that politically-motivated art from different nations, originally designed for limited audiences and specific situations, can be appreciated by those who care about the fate of strangers, that is, those whose outlook is simultaneously local and global.

Normally, no sudden change in visual culture occurs just because one decade ends and another begins. Some historians think that the 1970s did not develop a distinct character until after 1973 when a war in the Middle East caused an oil crisis, which in turn resulted in an economic recession in the West. It follows that many styles and tendencies that developed in the late 1960s continued into the 1970s. (No doubt, this explains why Arthur Marwick's substantial history of the 1960s ends in 1974 rather than in December 1969 and why Robert Hewison's *Too Much*, a history of art and society in the 1960s,

concludes in 1975.)[17] The hippies, for example, continued to be influential until the punks reacted against them and declared 'Never trust a hippie'. (Flower Power withered in the harsher economic climate of the 1970s.) The fashion design company Biba was founded in the 1960s but failed in 1975. (Earlier, in 1971, the Angry Brigade – Britain's first urban guerrilla group – planted a bomb in Biba's Kensington High Street boutique because they thought such fashion shops were 'modern slave houses'.)[18] In the fine arts, conceptual art originated in the 1960s but reached an apogee in the next decade (witness the period – 1965–75 – covered by the exhibition 'Live in your Head' held in February 2000 at the Whitechapel Art Gallery).

The Vietnam War is indelibly associated with the 1960s but it continued well into the 1970s and prompted a number of critical responses from British artists. Revolution too was a recurrent feature of the 1960s and there were British art students and artists who became politically conscious and active because of events such as May '68 in Paris and the art school occupations at Birmingham, Croydon, Hornsey and Guildford. (Many of the artists discussed in this book trained at British art colleges during the 1960s and became known nationally and internationally in the 1970s.) Others, however, developed or modified their political views during the 1970s because of movements such as feminism and environmentalism, and some were persuaded by the films of directors like Jean-Luc Godard and Constantine Costa-Gavras that the combination of aesthetics and politics was an exciting and explosive one.

While the 1960s attracted the positive adjectives 'affluent', 'euphoric', 'liberated' and 'swinging', the 1970s have been judged 'bleak', 'cynical', 'difficult', 'dismal', 'down-at-heel', dreary', 'dysfunctional', 'miserablist', 'retrogressive', 'savage', 'seedy', 'shabby', 'tired', 'violent' and 'a decade of disillusionment ... of uncertainty, fragmentation and polarization'. Reviewing a 1981 Gilbert & George exhibition, the critic Waldemar Januszczak remarked: '... you sense a profound gloom and it is this gloom which makes them artists of the seventies rather than left-overs from the sixties.'[19]

Some accounts of the 1970s exaggerate its negative characteristics but the 1960s had been such a vibrant decade that the one that followed was bound to suffer by comparison and to seem an anti-climax. The change of mood from optimism to pessimism – in the mid-1970s, 'No future' was the theme of a Sex Pistols song – was prompted by the failure of so many of the hopes of the 1960s, plus the early deaths of so many of its leading figures. Of course, some of those who survived became rich and famous and moved abroad to avoid paying British taxes.

Worsening economic problems such as a sterling crisis, a high rate of inflation, escalating unemployment and industrial strife also caused gloom. There were also the injuries and killings resulting from the struggle for civil rights in Northern Ireland. Daily life in certain parts of Britain became more anxious and depressed because a bomb might explode in a street, pub or shop at any moment. A book by Richard Clutterbuck about industrial strife and political violence in Britain published in 1978 was entitled *Britain in Agony* and Trevor Sutton graphically distilled the perceived violence of the 1970s in a photomontage for the cover of the December 1979 issue of the *Illustrated London News*.

Crucial public services also became unreliable because of underfunding and strikes. Neither Conservative nor Labour politicians seemed able to find or impose solutions. For those who thought fascism had been defeated forever during the Second World War, it was dismaying to witness the increasing threat of racism from neo-Nazi organizations. Black and Asian artists who came from Britain's ex-colonies experienced racism at first hand in the nation's streets and institutions. However, on the positive side, Rock Against Racism and the Anti-Nazi League were founded to combat the resurgence of fascism.[20]

Interestingly, the decade was bracketed by two Conservative regimes, while Labour was in office during the middle years. Historians maintain that consensus politics – the similar political programmes of Conservative and Labour governments – broke down

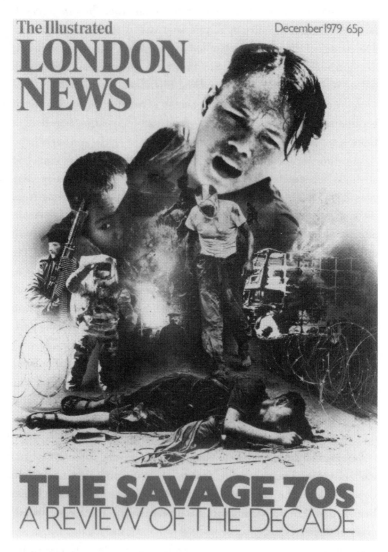

1. Trevor Sutton, *The Savage '70s*, photomontage for the cover of the *Illustrated London News*, Vol 267, No 6977 (December 1979). Photo courtesy of the *Illustrated London News*.

during the 1970s and that an intensification of the class struggle ensued. While the rich became richer, the poor and the unemployed faced a daily battle to survive and this is why so many workers felt compelled to strike to defend their living standards, even if this meant being vilified by right-wing politicians and journalists. (As we shall see, a number of socialist artists identified with the workers and trade unions and made efforts to assist them.) Eventually, the strikes of the winter months of 1978–79 – the so-called 'Winter of Discontent', when rubbish piled up in the streets, the dead were left unburied and the weather was harsh – turned the media and many voters against strikers and trade unions. The Labour government led by Jim Callaghan had failed to bring the workers to heel and so, in the election of 1979, the Conservatives under Margaret Thatcher reaped the benefit of public dissatisfaction. Consequently, while it seemed to many in the art world that there was a swing to the Left during the 1970s, towards the end of the decade the swing in the country at large was towards the Right.

Inflation and cuts in public expenditure affected higher education and placed in jeopardy the jobs and wages of both full-time and part-time tutors in art colleges. Student protests and occupations took place at colleges such as Maidstone, the Royal College of Art and the Slade. Nevertheless, the standard of living of the majority of the British people was higher at the end of the 1970s than at the beginning. Homeowners, to cite just one privileged group, benefited from a tenfold increase in house prices.

Pop art had been one of the main art movements of the 1960s and was celebrated late on in the decade when the Hayward Gallery in London mounted a large survey entitled: 'Pop Art Redefined' (1969). British pop artists continued to be productive during the 1970s but many of them emigrated to, or worked in, the United States, the nation that had supplied so much of pop's iconography. David Hockney, for instance, had taken up residence in California during the 1960s and was depicting affluent American lifestyles. In the 1970s, he also lived in Paris for a time. Was he still a *British* artist? In fact, he did maintain

a flat in London and contributed to several debates affecting British art; he also supported the Gay Liberation movement in Britain. The way male pop artists had depicted women as sex objects – as in the work of Peter Blake and Allen Jones – had caused little concern in the sexually 'liberated' 1960s (with the exception of Pauline Boty, who was concerned). However, such representations became contentious during the 1970s because of the critiques of feminists such as the artist Margaret Harrison, the filmmaker Laura Mulvey and the art historian Lisa Tickner. Attention will be paid to the work of Derek Boshier, a noted contributor to British pop art in the 1960s, because his art diversified and became more political during the 1970s and because he curated an important exhibition in 1979.

One characteristic of pop retained by many of the radical artists of the 1970s was the appropriation of images from the mass media. Artists such as Susan Hiller and John Stezaker assembled collections of popular culture images – postcards in particular – and became convinced that they embodied archetypes of a collective kind. Stezaker, Peter Kennard and others also employed mass media imagery in order to make political montages.

American artists dominated minimalism, another important movement of the 1960s. However, its severity appealed to only a handful of British artists, dealers and collectors. In the 1970s, the London dealer Nicholas Logsdail gave one-man shows to American minimalists such as Carl Andre and Donald Judd, even though his gallery – the Lisson – attracted only a trickle of visitors (as did most private galleries devoted to avant-garde tendencies). However, when works by Andre and Robert Morris appeared at the Tate Gallery, they did make an impact on the British media and public. Minimalism was a crucial precursor of conceptual art but, during the 1970s, many British artists reacted *against* minimalism because of its lack of content and popular appeal.

One 1969 exhibition, held at the ICA, London – 'When Attitudes become Form: Works – Concepts – Processes – Situations – Information' (plus the epigram: 'Live in your Head') – was significant for the

future because its contents represented a transition between minimalism and conceptualism. This was an international survey, initiated by Harald Szeemann, which first appeared in Berne, Switzerland. The critic Charles Harrison coordinated the British version. Three British artists were included: Victor Burgin, Barry Flanagan and Bruce McLean. Burgin (b. 1941) came from a working class family in Sheffield, Yorkshire. During the 1960s, he studied art at the Royal College of Art in London and at Yale University, New Haven, Connecticut. He was to become a key artist, lecturer and theorist of the 1970s. His contribution to the ICA show was a photo path of part of the wooden floor of the gallery laid over the same surface and was thus a succinct exercise in concealing and revealing. Two foreign artists who were also to be influential in Britain during the 1970s contributed information to the catalogue: Joseph Beuys and David Medalla.

Gilbert & George, the performance duo, were disappointed when Harrison failed to select them and they attended the private view dressed in their trademark suits with faces covered with multicoloured metalized make-up in an effort to steal the limelight.

Women's Liberation was also a phenomenon associated with the late 1960s (aside, of course, from the Suffragettes of the early twentieth century) particularly in the United States. However, British women artists and art historians were not slow to follow the initiatives of their American sisters. In their invaluable anthology *Framing Feminism* (1987), Rozsika Parker and Griselda Pollock assert: 'No political movement of the 1970s other than the Woman's Movement had a comparable effect on the visual arts.'[21] By the end of the decade, feminists had caused a significant transformation of the British art scene.

Gay Liberation followed a similar trajectory: events in New York in 1969 – to be described in Chapter 2 – soon had repercussions in London. The struggle of American blacks for civil rights during the 1960s was also an inspiration to their British counterparts. In the United States, throughout the 1970s, the American Indian Movement (AIM, established in 1968) mounted protests about discrimination,

racism, land rights, negative stereotyping and police brutality. Although few Britons were conscious of this struggle, it did become visible in London in 1976 in response to an exhibition of Native American Indian art held at the Hayward Gallery.

During the 1960s, British advertising and graphic design had flourished but in the 1970s visual communication in the service of commerce and politics reached new heights of creativity: in a list of the best British advertisements of the twentieth century complied by *Campaign* magazine in 1999, the top three dated from the 1970s. They were: 1) a 1974 Cadbury's Smash television commercial in which metallic Martians laugh at humans who continue to peel potatoes by hand; 2) a 1978 cinema commercial for Benson and Hedges cigarettes featuring a gold pack, a swimming pool and an iguana; and 3), a 1978–79 political poster devised for the Conservative party by Saatchi & Saatchi proclaiming 'Labour isn't Working'.

The fact that Edward Lucie-Smith's international survey of art in the 1970s[22] – a synchronic rather than a diachronic account – began with a reproduction of a poster from a Benson and Hedges cigarette campaign and the fact that Derek Boshier's *Lives* exhibition of 1979 included advertising photography by Duffy for Smirnoff Vodka, indicated that the fine artists of the decade who hoped to reach a wide public had to contend with extremely powerful rivals. The latter enjoyed much greater resources in terms of both the production and distribution of images. Critics such as Peter Fuller argued that fine art was experiencing a crisis because, compared to 'the mega-visual', it was a marginal and minor phenomenon. While a few exceptional artists, such as Peter Kennard, Jamie Reid and Jo Spence, were able to match the visual impact of advertising imagery, others resorted to a pictorial critique of it.

Youth subcultures such as the teddy boys, mods, rockers and hippies were familiar from the 1950s and '60s. The punks were the sub-cultural group that made the biggest social impact during the years 1976–77 and, as we shall see, there were parallels and affinities between them and some radical artists working at the same time.

However, since punk fashions, music and graphics have been docu-
mented in detail by writers such as David Laing and Jon Savage, this
book will not repeat the exercise, aside from a consideration of some
of Jamie Reid's work.

Subcultures were increasingly the subject of academic research
during the 1970s by such scholars as Stuart Hall, John Clarke, Tony
Jefferson, Paul Willis and Dick Hebdige of the Centre for Con-
temporary Cultural Studies at the University of Birmingham. (An
Art and Politics Group was also established at the Centre in 1974.)
Their books, stencilled papers and journal *Working Papers in Cultural
Studies* were read avidly. Theorists argued that 'a revolt into style', 'a
struggle for the control of meaning' was taking place; that what char-
acterized youth culture most was 'the search for excitement, autonomy
and identity – the freedom to create their own meanings for their exis-
tence and to symbolically express those, rather than simply accepting
the existing dominant meanings'.[23] In the case of Malcolm McLaren,
subversive and entrepreneur, awareness of teenage cults was not
merely after-the-fact academic analysis but a creative and business
opportunity: in the mid 1970s, he set out to invent a new style via the
Kings Road shop 'Sex' and the punk band the Sex Pistols.

Subcultures are mentioned here as one example of the 'fragmenta-
tion' and 'pluralism' that historians perceive characterized British
society in the 1970s. Divisions according to ethnicity, fashion, gender,
musical tastes, politics, race, religion and sexual orientation did
become more pronounced. Pluralism indicated a more diverse, multi-
cultural society but also a more complex and fractious one. (Plural-
ism does not necessarily mean harmonious coexistence.) Shrapnel
characterized the 1970s as the 'decade of the determined minority'
because so many minorities demanded recognition and rights.[24] The
craftsman Frank Nelson also recalled the 1970s as 'a tumult of strident
demands, basically Just Causes taken to ridiculous extremes'.[25]

A potential fragmentation of the British state was evident in
the campaigns waged by many Northern Irish, Scottish and Welsh
people for their nations to become independent of Westminster. This

prompted Tom Nairn to write a book, published in 1977, predicting 'the break-up of Britain'.[26] (However, Nairn was premature: it was not until the late 1990s that some devolution of power occurred.) Inspired by the devolution debate, the Welsh artist Glyn Jones and others formed the Association of Artists and Designers in Wales in 1974.

Having sketched in the preceding historical context, we are now equipped to examine the 1970s a year at a time. Each chapter will begin with a summary of key events in the world followed by a list of key events in the sphere of art (mainly the British art scene).

A final point: in writing this history, I have striven to be objective but I should acknowledge that I participated, to a minor extent, in the London art world of the 1970s as an artist, critic and polytechnic lecturer. For this reason, I refer to myself – in the third person – in several places. I was one of those who were politicized by the social and cultural ferment of the 1970s. (Before that, I had foolishly thought art and politics were unrelated.) I knew many of the artists cited in this book and witnessed at first hand many of the events described. My aim has been to demonstrate that the history of art is not simply an account of material objects displayed in galleries but a narrative involving creative human beings with passionate convictions, who co-operated, organized, competed and struggled. At stake was the future direction of art and society.

Chapter 1

1970

1970 was declared European Conservation Year and, in April, the first Earth Day was celebrated in America. President Nixon sent American troops into Cambodia and resumed bombing North Vietnam but also began withdrawing troops from Vietnam. The Kent State University shootings occurred in the USA and the American Indian Movement organized demonstrations. In Chile, Salvador Allende won the presidential election. Conservatives led by Edward Heath won an election in Britain and introduced an Industrial Relations Bill. Oil fields were discovered in the North Sea. The Gay Liberation Front was founded in London and disrupted a rally of the Festival of Light. A National Women's conference was held at Ruskin College, Oxford and the Miss World competition was disrupted by feminist protesters. An Equal Pay Act for women was passed in Parliament. *Shrew* and *Socialist Women* were established. Internment without trial was imposed in Northern Ireland. 'Expo '70' was held in Osaka, Japan. The movies *M*A*S*H* and *Woodstock* were released and Alan Arkin starred in Mike Nichols' *Catch 22*. Jean-Louis Trintignant appeared in the film *Le Conformiste* and Jack Nicholson starred in the movie *Five Easy Pieces*. Richard Neville's book *Play Power* was published, Mary Douglas' *Purity and Danger* appeared in paperback, Germaine Greer's *The Female Eunuch*, Eva Figes' *Patriarchal Attitudes: Women in Society*, Guy Debord's *Society of the Spectacle* and Walter Benjamin's *Illuminations* (including the essay 'The work of art in the age of mechanical reproduction'). Louis Althusser's and Etienne Balibar's *Reading Capital* was published in English. Simon and Garfunkel's ballad *Bridge over Troubled Waters* was popular, as were Kenneth Tynan's review *Oh Calcutta!* and the *Monty Python* TV comedy shows.

500,000 attended the Isle of Wight rock festival. The Beatles split up. The first jumbo jet landed at Heathrow. In Mexico, Brazil won the soccer world cup. The brothers Charles and Maurice Saatchi established their own advertising agency in London and Charles and his wife Doris began to collect art. Bertrand Russell, Charles de Gaulle, President Nasser, Janis Joplin and Jimi Hendrix died.

The police raided a London exhibition of John Lennon's erotic drawings. A kinetic art show and a Frank Stella retrospective were held at the Hayward Gallery, while Richard Hamilton had a show at the Tate and David Hockney at the Whitechapel Art Gallery. An exhibition '3 → : New Multiple Art' was held at the Whitechapel. 'Ten Sitting Rooms' – a series of installations – appeared at the ICA. John Hilliard and Ian Breakwell organized events at the New Arts Laboratory, London. The Arts Council opened the Serpentine Gallery and mounted a travelling exhibition of the photomontages of John Heartfield. The Museum of Modern Art in New York purchased John Latham's anti-Greenberg work *Art and Culture*. In London, in December, the Berwick Street Film Collective, which included the American artist Mary Kelly, began to make a film entitled *Nightcleaners* (screened in 1975). Gustav Metzger and others held a 'sit-in' at the Tate Gallery. The Women's Liberation Art Group was founded and held a show at the Woodstock Gallery. Monica Sjöö's 1968 painting *God giving Birth* plus five others were banned from an Arts Festival in St Ives. Sigi Krauss turned his frame shop in Covent Garden into a gallery for young artists and placed punk-style adverts in *Studio International*. An art and politics show ('Kunst und Politik') was mounted at the Kunstverein in Karlsruhe while 'Strategy: Get Arts' – artists from Düsseldorf, organized by the Richard Demarco Gallery, appeared in Edinburgh (Joseph Beuys gave a performance). 'Idea Structures' was held at the Camden Arts Centre and the Central Library, Swiss Cottage. John Latham presented the 'Least Event' show at the Lisson Gallery. The Artist Placement Group inserted a series of newspaper-style inserts in *Studio International* while the American Seth Siegelaub curated a special, 48-page 'exhibition' in the magazine's

July/August issue (works by Latham and some conceptualists were included). The 'Wall Show' was mounted by the Lisson Gallery (December 1970–January 1971). At the National Film Theatre, London, the first 'International Underground Film Festival' was held. The Other Cinema was founded in London. Another Coldstream Report on art education – following those issued in the 1960s – was published. The British sculptor Michael Sandle left Britain for Canada and the American artists Eva Hesse, Barnett Newman and Mark Rothko died.

Guy Brett, a critic and curator who consistently supported the experimental work of Afro-Asian and South American artists living or exhibiting in Britain during the 1960s, has recalled: 'The turn of the '60s to '70s was a time of extraordinary ferment in London. Looking back, one can see that the challenge to inherited cultural institutions had a remarkable number of facets.'[1] What these facets were will become clear as the narrative proceeds.

One challenge to an existing cultural institution, the Arts Council and its various panels of experts, during the late 1960s was the advent of new types of visual art – often non-object, non-commodity – that fell outside traditional categories such as painting and sculpture. An application for a grant from a performance artist, for example, might fall between the panels dealing with the theatre and the fine arts. It was for this reason that the Council established a New Activities Committee (NAC), which lasted one year: 1969–70. (It then became the Experimental Projects Committee, which existed for three years: 1970–73.) Michael Astor, who led the NAC, was allocated the modest annual sum of £15,000. (The total sum spent on the visual arts at that time was £95,500 from a budget of £8 million.) This sum had to cater for the needs of eight regions and so each one had less than £2,000 to distribute to artists and arts organizations.

Artists wanted more say over how public money was distributed and in London a few managed to form a panel to dispense the NAC grant. They advertised for applications and then interviewed artists who had submitted proposals. The panel of artists seemed to be

working more fairly and effectively than a panel of bureaucrats, but then it made a blunder: it agreed to give £10 to an artist who had been fined by a court for firing a cap pistol at the sculpture of an eagle adorning the façade of the American Embassy in London. Arts Council officials' trust in the judgement of artists was shaken. However, during the 1970s some artists were invited to serve on visual arts panels and, as we shall see, were commissioned to buy works of art for the Arts Council Collection and to curate travelling exhibitions and shows for the Hayward Gallery.

Such small sums were dispensed annually that most artists and arts organizations had their applications refused and so resentment towards the Arts Council increased. To cite just one example: John Latham (b. 1921, Rhodesia, Africa), an established if not Establishment British artist, was to conduct a bitter feud against the Council during the 1970s because he thought it had sabotaged the efforts of the Artist Placement Group (founded in 1966 by Latham and others) by withdrawing funding at a crucial stage of the Group's development.[2] Even in periods of prosperity, there is never enough money for the arts, and so the situation was exacerbated during the 1970s due to the economic recession that followed the 1973 oil crisis.

In 1974, an independent group called Artists Now issued a report entitled *Patronage of the Creative Artist*. Artists Now consisted of five individuals – Ian Bruce, who had served on the NAC, David Castillejo, Christopher Cornforth, Charles Gosford and Francis Routh – who were knowledgeable about different aspects of the arts. For instance, Routh was an expert on music, Castillejo on the theatre, while Cornforth was a Professor at the Royal College of Art (RCA) interested in art education and art's relation to society. Gosford (b. 1942) was an aristocrat and exhibiting artist. He had trained at the Byam Shaw and Royal Academy Schools and was later to contribute to arts administration (he was Chairman of the Artists' Union from 1976 to 1980 and served on the Visual Arts Panel of Greater London Arts during 1976–77).

Artists Now felt it was important to stress the needs of living

artists as against the support for the works of dead ones and to have separate mechanisms for aiding the two categories. They estimated that 850 fine artists were emerging from Britain's art schools every year and the majority were soon abandoning their calling because of a lack of support from either the private or public sectors. Artists Now also estimated that there were approximately 7000 painters who continued to practice as professionals. The report made some positive proposals for change – such as the setting up of a Council for Artists and large art markets in empty industrial warehouses (Vera Russell of the Artists' Market Association, which had a membership of 60, was to run an Artists' Market in Earlham St, London for a number of years beginning in 1973) – but, overall, it was gloomy reading. Artists Now believed that 'since the foundation of the Arts Council 27 years ago, something has been going wrong, and creative artists are today in serious trouble' and hoped their report would provoke a reaction.[3]

Presumably, the artist who had fired at the American embassy had been protesting against the Vietnam War during a late 1960s' demonstration. As mentioned in the introduction, this war continued into the 1970s. In fact, it did not end as far as the United States was concerned until 1973 when Nixon signed a cease-fire agreement and all American troops left South Vietnam. The war divided the American nation and caused friction and bloodshed at home. A notorious case in point was the shooting of students, who were protesting at the American and South Vietnamese invasion of Cambodia, at the campus of Kent State University, Ohio, by National Guardsmen in May 1970. Four students died and more were wounded. Most Britons, of course, only knew about the war and its atrocities at second hand via press reports, documentary photographs and television images. This was how Richard Hamilton (b. 1922, London), one of the founders of pop art in Britain during the 1950s, learnt about the Kent State incident. Hamilton is an artist who has always been conscious of the presence of the mass media and their mediating role. The print – based on a photograph taken off a television screen – that he produced in response to news of the Kent State shooting – which shows Dean

Kahler lying on the ground stained with blood – was itself taken from an amateur film. The blurred condition of Hamilton's still image made it hard to decipher and signified the huge distance it had travelled and the number of media transitions it had undergone.

Hamilton, a socialist and CND marcher who feels deeply about issues such as war, set aside personal disgust in order to produce a detached work of art accompanied by a dry, technical description that would comment both on the event itself and its mediated character. The print was issued in an edition of several thousand and sold at a low price so that it would be available to a wide public. Hamilton's partner, Rita Donagh, also produced a work about the Kent State shootings and so did Peter Kennard via a print entitled *Kent State*. Recently he has recalled:

> In 1970, I made 40 copies of a large print showing the image of a student lying in a pool of blood ... I took the photo from the front page of the *Evening Standard*, cropped it, painted out all the inessentials and the body and blood of the student became a cruciform. With a group of fellow students, I fly-posted it around London in solidarity with the American students. Because they were water-based, dyelines printed in red they bled in the rain and in the end the ones that weren't pulled down became blank sheets which could, and did, become notice-boards for people's slogans and messages.[4]

Kennard (b. 1949, London) trained as a painter at the Byam Shaw and Slade School of Art in the late 1960s but when he was radicalized by the student movement of 1968 and by media coverage of the Vietnam War, he sought an alternative to painting. Photomontage provided the solution and he worked throughout the 1970s in the tradition of John Heartfield. After leaving the Slade, he joined the *Workers' Press* newspaper for a time and then went freelance. For several years, he earned a living by operating telephones at night for the Post Office. Then, from 1976 to '79, he undertook postgraduate study at the RCA. His montages addressed a wide range of subjects including Northern

2. Peter Kennard, *Kent State* (1970), Dyeline print, edition of 40. London: artist's collection. Reproduced courtesy of Peter Kennard.

Ireland, South Africa and nuclear weapons. They were shown in galleries but since they were designed for reproduction, they also appeared in books, posters, postcards and placards carried in demonstrations and as illustrations to articles in many magazines and newspapers. Thus, his work was political in both content and function.

When, in April 1975, the North Vietnamese army triumphed over that of the South and entered Saigon, Rasheed Araeen (b. 1935, Pakistan; came to Britain in 1964) produced a tribute to their victory entitled *Fire!* A sequence of photographs depicted the formation of an American flag (shades of Jasper Johns' famous series of paintings on the same theme) – which had silhouettes of military aircraft instead of stars plus the words 'American Imperialism' – and then its defacement by graffiti and, finally, its destruction by burning. In the final frames, the American flag had disappeared and Viet Cong soldiers could be seen through a star-shaped opening in the surface plus the headline 'Long live the victory of the Indochinese people!' In the same year, Araeen also contributed a mixed-media installation to the 'Vietnam Victory Festival' held at the Artists for Democracy gallery, London. During the course of the decade, other British artists such as Terry Atkinson, Philip Hick and Michael Sandle also generated artworks prompted by America's involvement in the Vietnam War.

War, cold or hot, generally stimulates the development of new technology and, during the 1960s, the United States demonstrated its prowess in this realm by landing a man on the moon. The continuing ability of the British and French in the field of technology was indicated by the jointly designed supersonic aircraft Concorde that began service in 1977 (the design work for the aircraft had begun in the late 1960s). One sign of the impact of new technology on the fine arts during the 1960s was cybernetic or computer art, as evidenced by the 1968 'Cybernetic Serendipity' exhibition, held at the ICA, organized by the art critic Jasia Reichardt. However, despite the founding of the Computer Arts Society in 1969 and its contribution of an interactive simulation game to the 'Computer 70' trade exhibition at Olympia, and the development during the 1970s of the microprocessor and the

personal computer, the profound influence of computers on visual culture was not to be fully manifested until the 1980s and '90s.

Another sign of technology's influence was kinetic art, that is, electro-mechanical devices exploiting light, movement and transformations over time. According to one enthusiast, such art was characterized by 'energy and life'. In the autumn of 1970, at the Hayward Gallery, Theo Crosby organized a large-scale, international survey of kinetic art. To coincide with the show, the October issue of *Studio International* – then Britain's most influential and well-produced periodical covering modern and contemporary art – devoted six articles to the subject. This journal also featured a regular column about technology and art written by Jonathan Benthall who was to organize a lecture series on ecology for the ICA. In general, kinetic art depends upon and celebrates technology but technology, of course, often arouses concern about its negative effects on human life and the environment. The Ecological Movement started in the 1960s and this in turn gave rise to Green political parties and to ecological art; Gustav Metzger devised an early example of the latter.

Metzger (b. 1926, Nürnberg), a stateless person of Polish-Jewish parentage who came to Britain in 1939 as a child refugee from Nazi Germany, was notorious for his 1960s' Auto-Destructive art manifestoes and public demonstrations in which he 'painted' fabric with acid. Metzger was active in the anti-nuclear weapons movement and his use of destruction was designed to highlight the threat of such weaponry to humanity's survival. In 1970, he contributed to the Art & Technology Group of the British Society for Social Responsibility in Science. He studied computers, science and technology intensively and made a number of artworks calling attention to their potential and dangers. To mark the opening of the kinetics exhibition, Metzger parked a car – entitled *Mobbile* – on Waterloo Bridge, alongside the gallery. He had added a transparent plastic box to the vehicle's roof and connected the exhaust pipe to it. Inside were a number of plants. As a result of driving around London, the contents blackened and died. Thus, Metzger provided a vivid, visual illustration of urban pollution and a

3. Gustav Metzger, *Mobbile* (1970). Photo of car with roof structure, West End of London. Photo reproduced courtesy of the artist.

rebuke to the kineticists inside the Hayward. The next day the car was parked in the upmarket, Bond St area where many private art galleries are located. Here, his 'aesthetic of revulsion' and non-commodity work challenged the art on sale inside the galleries.

Readers will not be surprised to learn that in 1970 Metzger became the London organizer of the International Coalition for the Liquidation of Art. On 20 October, he, the Mexican sculptor Felipe Ehrenberg (b. 1943), the British artist Stuart Brisley, Sigi Krauss, John Plant and other, like-minded people descended on the Tate Gallery in order to engage staff and visitors in a debate. Similar demonstrations took place in Amsterdam and New York. In the latter city, a number of American radical groups occupied a space at the Metropolitan Museum. They had various complaints against museums: their complicity in racism, sexism, repression and war, and made a number of demands: equal representation for women, more opportunities for

ethnic minorities, a reduction in the elitism and power of major museums in order to decentralize culture and resources to local communities, and so on.[5]

At the Tate, Ehrenberg, who was then a student at the Slade, was refused entry by guards because he was wearing a white calico mask with one eyehole. Claiming that he was 'an artwork', he demanded entry but Tate officials refused because 'only the Trustees had the power to select works for the collection'. Another protestor was dressed in a white coat covered with slogans stating: 'Caution, art corrupts'. Two Tate curators, Ronald Alley and Michael Compton, eventually made a room available for the demonstrators to air their views.[6]

The London demonstration was motivated by ecological concerns: there was an over-production of art objects, an excess of auctions, galleries, museums, magazines, etc., hence a growing 'art pollution'. One suggested solution was that artists should confine themselves to producing miniatures. The increasing commercialization of art was another reason for the protest.

Metzger has been called 'the conscience of the art world'. Although a figure little known to the public, he was highly influential in terms of art's relationship to politics in London during the 1960s and '70s.[7]

In 1970, Charles Harrison, a critic, curator and art historian, was employed as assistant editor of *Studio International*. Besides contributing a number of substantial articles about new conceptual art, Harrison made the pages of the periodical available to the British members of Art & Language – a group that had been formally constituted in 1968 – and to the American conceptualist Joseph Kosuth. Harrison was soon to become a kind of critic/historian-in-residence for Art & Language. This gave rise to a question that was to trouble speakers at conferences about art criticism held in the 1970s: 'should the critic be objective or partial in respect of groups of artists and styles of art?' Certain female critics – Rosetta Brooks and Caroline Tisdall, for example – lived with the artists they praised in print. Exhibitions, of course, are a common means by which critics declare their support for particular kinds of art. In the summer of 1970, Harrison

organized the exhibition 'Idea Structures' at two venues in the North London borough of Camden. It featured work by Keith Arnatt, Victor Burgin, Ed Herring, Kosuth and the Art & Language members Terry Atkinson, David Bainbridge, Michael Baldwin and Harold Hurrell.

The catalogue conformed to a style that was typical of conceptual art: austere design, no colour, lots of white paper, pages of text and logical formulae, few images. (The contrast with 'underground' magazines such as *Oz* exemplifying the colourful, ornamental, psychedelic style fashionable in the late 1960s and early 1970s could not have been sharper.) No wonder painters became disturbed: the new breed of artists appeared to have abandoned visual imagery and optical pleasure. In their place, they substituted terse statements or long, densely written chunks of text influenced by linguistics and philosophy that required considerable effort and forbearance on the reader's part.

Arnatt (b. 1930) came from Oxford and studied art at Oxford School of Art and the RCA, London during the 1950s. In the 1960s, he taught at several art colleges in the provinces. One of his contributions to the exhibition was a two-page essay on the self-reflexive question: 'Is it possible for me to do nothing as my contribution to this exhibition?' Another was entitled *Self-Burial* (1969) and consisted of a set of nine photographs recording an event in a rural setting in which the vertical body of the artist gradually sank beneath the earth. Arnatt was perhaps making a droll comment on the 1960s vogue for earth or land art and 'the death of author' (a notion the French thinker Roland Barthes popularized via an essay written in the late 1960s).[8] This work could also be read in a critical way as indicating the unwillingness or inability of the artist to say anything about what was happening in the world: the artist does not merely bury his head in the sand, he buries his whole body. Was *Self-Burial* art's suicide note?

Burgin contributed a set of cross-referenced instructions each of which had to be held in the mind as the reader progressed around the gallery space. The instructions were couched in the abstract so that readers had to 'load' them with their own, particular experiences. In

short, the work was a mental rather than a sensory experience. Before ideas can be communicated, they have to take some material form; consequently, there was a medium of representation but it was the English language/print on paper not pigment or stone. Given the use of language, one might expect that Burgin's work belonged to the categories of poetry or literature but this was not the case. Despite the predominance of language in conceptual art, some visual images were generated, that is, drawings, diagrams, maps and photographs.

Conceptual art, such as that appearing in 'Idea Structures', aroused considerable antagonism and contempt in certain quarters, while simultaneously intriguing other observers because it was a new departure. Of course, Marcel Duchamp, the famous French dadaist and inventor of readymades, who had died in 1968, was its progenitor, hence John Stezaker's fondness for the term 'post-Duchampian art' to describe conceptual art. Stezaker (b. 1949, Worcester), who studied at Nottingham College of Art and the Slade in London, was a leading contributor to British conceptual art during the early 1970s. Yves Klein and Piero Manzoni, two European artists who had shows at the Tate during the 1970s, were also pioneers. Conceptual art was changing and expanding inherited definitions of art. It was also challenging traditional art forms and immediately preceding styles such as minimalism. Questioning, thinking and theory, for this generation of artists, had become essential. They were determined to alter the reputation visual artists had for being anti-intellectual and stupid. Painters and sculptors no doubt sensed that conceptualists considered themselves superior to artists who worked with their hands and who celebrated craft values.

Conceptual art also posed a challenge to the commodity nature of physical art objects – hence the alternative term 'post-object art' – because anyone who possessed a photocopy of Burgin's instructions or an issue of the small-circulation journals written and published by artists, such as *Art-Language, Analytical Art, Frameworks Journal* and *Statements*, owned the work. At the time, it was hard to see how conceptual artists could sell such art to make a living. While some

foreign dealers did emerge who were willing to buy texts or to pay artists retainers, the majority of conceptualists relied on their wages from art school teaching. This meant that there was no incentive to make art that was comprehensible to people outside the walls of colleges and galleries. It was also to lead to confrontations with more traditional artists teaching in art colleges and, when some students became 'infected' by theory and critique, to conflicts between them and the management of art schools and polytechnics.

One recurring characteristic of conceptual art was self-reference. An example by Stezaker appeared in the Lisson Gallery's influential 'Wall Show' (December 1970–January 1971): a photograph of the artist standing in a gallery pointing to a photograph on the wall which itself depicts him pointing ... Clearly, this was a visual instance of infinite regress. In an interview, Stezaker has explained that his intention at the time was to push self-reference to the point of paradox. He added: 'the self-enclosure of art seemed to reach its extreme with conceptual art, but to me what conceptual art represented above all else was a realization that the modernist programme had reached a dead end.'[9] Stezaker has also recalled that conceptual art 'opened up the use of non-specialist processes of everyday life in the production of work (for me, photography, collecting, captioning, etc.). It also sanctioned a much-expanded field of everyday imagery. (My collection of media images got underway during this period.)'[10]

Another example of self-reference, produced by John Hilliard (b. 1945, Lancaster) in 1971, consisted of a 35mm Praktica camera recording its own condition. He pointed the camera at a mirror and used seven aperture sizes and ten shutter speeds to generate a set of 70 photos, which he then presented in sequence. (There was a range from complete over-exposure [all white], through images of the camera, to complete under-exposure [all black].) A second, smaller mirror was used to re-reflect the camera's controls so that the viewer could understand the conditions of production governing many of the prints.

Hilliard had trained as a sculptor at St Martin's School of Art,

London during the 1960s but, like several other British artists of the period who became dissatisfied with heavy metal objects that few wanted to purchase, he developed an interest in photography and 16mm film. What he carried over from sculpture to photography was a 'truth to materials' aesthetic. Since cameras recorded what was in front of them, photographs were representational and had a direct, indexical relation to the real. Even so, Hilliard realized that the medium was not simply a window on the world, an inherently truthful means of representing reality, because photographers could stage what was placed in front of the camera (as Arnatt had demonstrated in *Self-Burial*). They could also manipulate photographs by altering camera settings, by taking creative decisions in the darkroom and in relation to prints (cropping, etc.). Furthermore, as Barthes and Burgin were to explain in analytical and theoretical essays, photographs were ideological constructs subject to the conventions of pictorial rhetoric.

Like Burgin, Hilliard taught in art schools and his 'forays launched against the medium [of photography] itself' throughout the decade can be regarded as visual illustrations to help students. His general aim was to pick away at 'received assumptions about its representative capability'.[11] Systematically, Hilliard explored photography's various dimensions: the consequences of changing viewpoint while moving round a static object; the effect of differential focus when recording a reproduction of a Velásquez protected by reflective glass; the impact of framing a scene he had arranged and cropping images in different ways; the inflection of meaning that resulted when different captions were applied to the same repeated image; and so on. However, Hilliard's goal was not abstraction because the content of his images remained important. What he was seeking was 'reciprocity', that is, a mutually informing relationship between procedure and picture content.[12]

Hilliard's findings reached a wider audience when they were displayed with exemplary clarity in exhibitions held in Britain, Canada and Germany. He also elucidated his work in statements that were

more perceptive and rational than some critics could manage. Further-
more, as Richard Cork explained in 1974, Hilliard's exposure of the
signifying codes of photography had a general educational value in a
society dominated by mass media imagery.[13]

It might be thought that self-reference or reflexivity was a self-indul-
gent phenomenon that continued the incestuous art-about-itself ten-
dency of the formalist tradition, but it can be regarded as a necessary
phase of self-examination, a clearing of the decks. By demonstrating
how a medium such as photography functioned and how meanings
were generated, artists such as Burgin, Hilliard and Stezaker, pre-
pared themselves and others for a new beginning.

John Latham mounted a show entitled 'Least Event' at the Lisson
Gallery, London that was important both in terms of his development
and as a contribution to conceptualism.[14] Latham's innovative, icono-
clastic art, executed in a variety of media but all based on a complex
theory of time and event, has influenced art students, younger
artists and critics for several decades. Latham came to prominence in
Britain and the United States during the 1960s as a result of his
book-burning rituals, relief sculptures made principally from books,
and his attack on Clement Greenberg – the work *Art & Culture*
(1966–67) – but he was to be particularly influential during the
1970s. This nearly did not happen, because in December he had a car
crash and ended up in hospital.

The year 1970 was also significant for the first appearance of the
major German artist Joseph Beuys (1921–86) in Britain. He visited
Scotland to participate in the show 'Strategy: Get Arts' organized by
the Richard Demarco Gallery and held at Edinburgh College of Art.
Demarco, one of the most enthusiastic and energetic of the arts impre-
sarios of the 1970s, invited a number of artists from Düsseldorf to
enliven the Edinburgh Festival. Besides Beuys, they included Klaus
Rinke, Dieter Rot and Stefan Wewerka. Edward Lucie-Smith, of the
Sunday Times, noted the German artists' 'shock tactics' and thought
their art made that of most English artists seem provincial. Letter
writers to the *Scotsman* complained that the contents of the exhibition

were 'anti-art', 'outrageously obscene' and 'psycho-pathological'. The police confiscated some films by the German artists before they reached the public because the British Board of Film Censors had not licensed them for screening.

With the assistance of Henning Christiansen, Beuys performed *Celtic (Kinloch Rannoch) The Scottish Symphony*, one of his famous 'actions'. Various media and objects were used including audiotapes, films, blackboards and ladders. A small audience included the *Art and Artists* critic Alistair Mackintosh who found the performance 'electrifying' despite the fact that he had to observe Beuys picking bits of gelatine off walls and placing them on a tray for over 90 minutes. When Beuys had finished, he emptied the tray over his head in a dramatic gesture. Mackintosh then records that Beuys stood still for a further 40 minutes. Nigel Gosling, of the *Observer*, thought that in this instance the act of creation had become the work of art and that the lack of material product to sell undermined the whole gallery system.[15]

Caroline Tisdall, who was then art critic of the *Guardian*, met Beuys at this time and became his collaborator and companion. She helped to select an exhibition of 400 drawings entitled 'The Secret Block for a Secret Person in Ireland' that toured Britain and Ireland during 1974. In the same year, she accompanied Beuys when he made his first trip to New York to perform, with the help of a live coyote, *I like America and America likes Me*. Beuys was to appear in galleries in such cities as Belfast, Edinburgh and London several times during the 1970s. Through public events that were part seminar and part performance, he contributed to the on-going debate about art's relation to society that was taking place in Britain and Germany.

Because fine artists generally produced single artefacts by hand, their works tended to be rare, expensive items only wealthy collectors could afford. Prints, of course, were cheaper than paintings but even their value was kept artificially high by limiting the size of editions. During the 1970s, exhibitions of multiples – that is art objects manufactured in bulk in factories – seemed to offer a solution to the problem of making art available to more people at affordable prices

because editions could be, theoretically, unlimited. One such show –
'3 → : New Multiple Art' – curated by Biddy Peppin and Hugh Shaw,
took place at the Whitechapel Art Gallery (November 1970–January
1971); art magazines also issued supplements about multiples: for
example, *Studio International* (September 1972). The fashion for mul-
tiples dated back to the 1950s and various artists and dealers pro-
duced and sold them in the 1960s. Beuys created over 500 multiples
between 1965 and 1986 in a variety of materials including one of his
favourites: felt. *Felt Suit*, a well-known example, was issued by
Galerie René Block, Berlin in 1970. However, since only 100 were pro-
duced, the edition was not an 'unlimited' one.

Not everyone thought multiples had democratic potential. Janet
Daley, a journalist who was both conservative and libertarian, was one
sceptic. She delivered a paper at a 'Multiples Symposium' organized by
the magazine *Art and Artists* and the Camden Arts Trust in Novem-
ber 1970, which attracted over 60 people. In her view, multiples were
not a solution to the radical artist's dilemma but rather 'a pernicious
red herring'. The idea that genuine political and social freedom could
be achieved by the general availability of all commercial products, she
argued, was the 'democracy as commercialization myth'. Furthermore,
historically it was a right-wing – Henry Ford's utopian capitalism –
rather than a left-wing vision. Daley's essay was an attack on mass pro-
duction, mass culture and consumerism and a defence of the indivi-
dual artist, art object and viewer. She concluded: 'The multiples
mythology is one front of an anti-art war being waged by neo-barbar-
ian "revolutionary forces" in the art world, others being conceptual
and "event" art. We must defend the revolutionary cause of art despite
them and even against them.'[16]

There are environmental and left-wing critics of capitalism who
would agree with some of Daley's criticisms of the society of the specta-
cle and consumerism, but designed goods, material prosperity and
access to culture can no longer be confined to the few. Daley seemed
to be nostalgic for the days when art was made for royalty and the aris-
tocracy.

Multiples did enjoy a degree of popularity and they challenged the existing, high-value structure of the gallery and auction house system. However, that system managed to absorb them: galleries marketed multiples along with prints, while at the same time continuing to sell expensive, unique artefacts. Multiples continued to be produced during the ensuing decades and, in the 1990s, objects with practical functions designed by several living British artists were offered for sale for a few pounds by the home improvement chain store Homebase; thus, as designed objects commissioned by big business for affluent, middle-class consumers, multiples have migrated beyond the fine art gallery.

Artists' books, or book art, were another way of making art available in editions. Titles were published by small presses and art galleries, or by their artist-authors. Most were printed in small batches and sold via galleries or specialist bookshops, consequently they did not reach a huge audience but they were certainly more affordable and portable than paintings or sculptures. The Arts Council, the British Council and the Nigel Greenwood Gallery and a British art librarian and writer – Clive Phillpot – organized exhibitions of artists' books during the 1970s. Phillpot, the art librarian of Chelsea School of Art and later the Museum of Modern Art in New York, became an expert on the subject. Tony Rickaby was one left-wing British artist who made extensive use of the book form. *16 Situations*, an example by Derek Boshier, will be discussed shortly.

One unusual method of distributing art was via the postal system: this gave rise to the minor genre known as 'correspondence, postal or mail art'. For obvious reasons, drawing, collage and photocopying were three techniques popular with mail artists. By using the post, such artists could easily establish networks, communicate internationally and engage in collaborative activity (chain letters, for instance). Robin Crozier (b. 1936, Newcastle-upon-Tyne) was one British artist whose specialization in mail art enabled him to overcome his comparative isolation in the provincial city of Sunderland. His *Portrait of Robin Crozier* (1973–75) was a collaborative enterprise that relied upon the

participation of *circa* 100 artists around the world, who were invited to devise a portrait of Crozier, even though most of them had never met or seen him. Genesis P. Orridge, an artist who enjoyed sending postcards with 'erotic' additions, was to be fined by a court for his actions.

Mail art was not exclusively male because feminist artists were also attracted to it; one reason being that it could be made quickly at home in spare moments between childcare and domestic duties. In 1974–75, for example, Kate Walker and Sally Gallop began their *Postal Event: Portrait of the Artist as a Housewife*, which involved the exchange of small artworks. Later, several other women artists joined them and an exhibition of their artefacts was circulated in Britain during 1976. Around 80 women eventually participated and Walker became the coordinator of the Feministo Postal Art Group.[17]

Of course, artists of any political persuasion can make use of such edition forms as multiples and books and of such means of distribution as the post to communicate their views, but these alternatives to painting and sculpture tended to appeal to artists on the Left and to feminists because they were cheaper and contributed to the democratization of art. However, in the case of mail art, democratization was restricted by the fact that so much of it was artist-to-artist communication. Paradoxically, anthologies and exhibitions were needed to inform members of the public what mail artists had achieved.

Caricaturists, cartoonists, graphic designers and illustrators produce images for reproduction via printing presses and distribution via books, magazines, newspapers and posters; consequently, their work generally reaches a wide audience. Jamie Reid (b. 1947), an artist and graphic designer who is best known for his contributions to the punk movement during 1976–77, grew up in the town of Croydon on the Southwest fringe of London. He was to develop a love-hate relationship with the suburbs in which he was raised. His father was Scottish and his mother was of English/Irish and French extraction; they met at a Labour party rally. Reid studied painting at Wimbledon and Croydon art schools during the 1960s and at the latter he encountered Malcolm McLaren, the future manager of the Sex Pistols. They soon

began to 'make trouble' by organizing student occupations in which dividing walls were torn down. (Individualism and specialization were physically embodied in the cubicles typical of art school studios.)

Much of Reid's early work consisted of caricatures, drawings, watercolours and illustrations about cats and monsters that were stylistically indebted to the British romantic tradition of artists-poets such as William Blake. After Art College, he and two friends established a printing press, entitled Suburban Press, that earned money by serving political organizations such as the Black Panthers, plus women's, prisoners' and anarchists' groups, and by printing fanzines for pop music fans. (Reid has claimed that their press was one of the first of the community presses to unionize, as a worker's collective.) They could then afford to publish their own community magazine *Suburban Press* (six issues, 1970–75), which eventually attained a circulation of 5000. It addressed education and housing issues, set out to expose corruption in local government and to attack the brash commercial architectural developments of central Croydon. Many of the social and political subjects that were first tackled in the magazine were later to resurface in the graphics that Reid produced for the Sex Pistols. By this time, Reid was making roughly executed collages consisting of newspaper headlines and images clipped from magazines, plus felt-tip and ink drawing and lettering. Again, this style prefigured that of punk graphics.

A key early influence on Reid's thinking was Christopher Gray's book about the Situationist movement, *Leaving the 20th Century*, published by Free Fall Press in 1974. Gray translated the Situationists' French texts into English and Reid executed the graphics. The Situationists were an international grouping of radical European thinkers and artists who had met sporadically since the late 1950s. Two British participants were the social historian of art T.J. Clark and the painter Ralph Rumney.

Reid has admitted that he did not understand many of the Situationists' complex, theoretical writings but he was energized by their slogans and distaste for the society of the spectacle and by their habit

4. Jamie Reid, *Supermarket Images and Sticker* (1974). The supermarket images were used in Reid's *Poster Book* and in Gray's *Leaving the 20th Century*. The sticker was placed in supermarkets to increase panic buying during the three-day week. Source: Jon Savage & Jamie Reid, *Up They Rise: The Incomplete Works of Jamie Reid*, (London: Faber & Faber, 1987), p 25. J. Reid.

of using the mass media against itself. He set out to simplify and visualize the political jargon of the Sits. Various posters he produced during the early 1970s were gathered together in a book published by Suburban Press in 1974. One poster took supermarkets as its subject at a time when a three-day working week (December 1973), caused by a rise in oil prices and a miners' overtime ban, was prompting panic buying. Reid's response to the national crisis was to aggravate it. A sticker he designed for placing on shop windows stated: 'Last Days, buy now while stocks last. This store will be closing soon owing to the pending collapse of monopoly capitalism...' A second sticker, intended for cars, improved on government advice to save fuel by urging: 'Save petrol: burn cars'. A third advised: 'Keep warm this winter: make trouble'. A fourth, which was later to become famous, informed shoppers: 'Special offer . . . this store welcomes shoplifters'.

Reid's activities during the first half of the 1970s can be considered

part of the community arts movement that was then gathering momentum having started in the 1960s. The Suburban Press was only one of many such small, alternative printing presses, photography and poster workshops. Community art, of course, was defined and limited by its local character. However, in Reid's case, the advent of punk enabled his experience of community publishing, printing, politics and agit-prop graphics to find a new lease of life in one of capitalism's most powerful cultural industries – the music business – consequently, his ideas, images and slogans were to reach a huge, transatlantic audience. Arguably, Reid was one of the most dynamic, original and effective political artists of the 1970s.[18]

Chapter 2

1971

India defeated Pakistan in a war and East Pakistan became the independent state Bangladesh. The USSR launched the first habitable space station. Apollo 14 and 15 missions to the moon were successful: Americans were landed. The microprocessor was invented and enabled radical developments in computers to take place. Britain's population reached 55 million and decimal currency was introduced. Bombings, shootings and riots occurred in Ulster following the reintroduction of internment – 12 died. The first British soldier was killed in Northern Ireland (by the end of the year 48 had died). The Angry Brigade planted bombs in London and the Post Office Tower was closed to the public after an explosion. British postal workers seeking a pay rise went on strike for seven weeks. The Industrial Relations Act became law but was resisted by the trade unions. A Women's Liberation demonstration took place in London. The editors of Oz magazine were imprisoned because of their 'School Kids' issue but were set free on appeal. Louis Althusser's book *Lenin and Philosophy and other essays* (including 'Ideology and Ideological State Apparatuses') was published in English. Stewart Brand edited *The Last Whole Earth Catalogue*. The pressure group Greenpeace was established in Canada. Friends of the Earth was founded. Stanley Kubrick's film *A Clockwork Orange* provoked controversy because of its violent content. Michael Caine starred in the British crime story *Get Carter*, Clint Eastwood in the American police thriller *Dirty Harry*, Jane Fonda in *Klute*, Gene Hackman in *The French Connection*, and Richard Roundtree in *Shaft*. Bruce Dern starred in the ecological space story *Silent Running*. Ken Russell's film *The Devils*, starring Oliver Reed and with sets designed by Derek Jarman, was released. The Other

Cinema at the Kings Cross Odeon screened *The Battle of Algiers*. John Lennon's song *Imagine* became popular. Louis Armstrong, Jim Morrison, lead singer of the Doors, and Nikita Khruschev died.

Caribbean artists resident in London exhibited at the Commonwealth Institute. 'Inno 70' was the title of a show mounted by the Artist Placement Group at the Hayward Gallery. Also at the Hayward was the exhibition 'Art in Revolution: Soviet Art and Design since 1917' and a Bridget Riley retrospective. 'The British Avant-Garde' was shown at the New York Cultural Center and Francis Bacon held a retrospective at the Grand Palais in Paris, which attracted huge crowds. Seven different 'Art Spectrum' exhibitions took place around Britain. Newton Harrison – an American artist – showed at the Hayward Gallery and caused a furore because of his plan to kill catfish. Margaret Harrison's exhibition at Motif Editions Gallery, London was closed after pressure from the police because of its sexual imagery, such as a drawing of Hugh Heffner as a bunny boy. Space Structure Workshop organized an event at the Ledbury Estate, Old Kent Road in July. David Hall's *7 TV Pieces* appeared on mainstream television in Scotland. In London, David Medalla and John Dugger founded the Artists Liberation Front while a group of militant worker-artists founded the League of Socialist Artists. In March, the Women's Liberation Art Group held their first show at the Woodstock Gallery, London. A large-scale Warhol show appeared at the Tate Gallery and Peter Gidal's book *Andy Warhol, Films & Paintings* was published. A Robert Morris show at the Tate had to be closed for a time because of danger to visitors playing with his exhibits. The Tory Government caused concern in the art world because of its plan to introduce entrance charges for public galleries and museums. An Islamic Festival was held at the ICA. The Photographers Gallery opened in London. The Crafts Council was established. Lord Goodman retired as Chairman of the Arts Council and was replaced by Lord Patrick Gibson. The Arts Council established an Experimental Projects Committee. The 'Rosc '71' exhibition of international art was held in Dublin and was reviewed by the American critic Clement

Greenberg. Jeff Sawtell founded the left-wing art magazine *Artery* with 100 duplicated copies at the Royal College of Art, London. Patrick Heron's article 'Murder of the art schools' appeared in the *Guardian* in October. David Curtis's book *Experimental Cinema: A Fifty-Year Evolution* was published. At Coventry College of Art, the Art Theory course was terminated and two members of Art & Language lost their teaching jobs.

As explained in the introduction, in the decades after the Second World War the British art scene was enriched by an influx of artists from abroad. One such artist is David Medalla who was born in the Philippines in 1942.[1] He came to Britain in 1960 and, during the early 1970s, he developed revolutionary ambitions. Medalla, an 'impractical visionary' according to the American critic Dore Ashton, came from a wealthy, aristocratic background and was well educated. He was such a child prodigy that in 1954 he was awarded a scholarship to study in the United States. At the age of 14, he was in New York attending Columbia University. He started to paint and met such luminaries as James Dean and Mark Rothko. Medalla, a charming, pleasure-loving homosexual proved to have a talent for making friends. On his arrival in London, he met Guy Brett, who was to become art critic for *The Times* newspaper (1964–75), and Gustav Metzger.

What Medalla and Metzger shared was an interest in auto-creative/ destructive processes. Medalla was attracted to kinetic art because of its internationalism and stress on flux, energy and movement. In 1967, he also became fascinated by performance art, via the dance and drama group The Exploding Galaxy, because it involved live and group activities. For a while, Buddhism influenced his thinking, but later Marxism and Maoism became more important. It was a logical development, therefore, when his interest shifted from natural to social systems. He and John Dugger (b. 1948, Los Angeles), an American who came to Britain in 1968, became close friends and artistic collaborators. Dugger had trained as an artist at the Gilmore Institute, Kalamazoo and the Art Institute of Chicago. He had supported the

American anti-Vietnam War movement and for seven years, he was a political refugee in Britain. Medalla was critical of the oppressive regime of Ferdinand and Imelda Marcos in his homeland.

During the late 1960s, the two artists travelled extensively in Asia and Africa studying and collecting national and popular art forms. By now both men were politically conscious artists who were keen to democratize art by breaking down the barriers between creators and audiences, between fine artists as specialists/professionals and ordinary people. This is why they laid such stress on participation (giving rise to the labels 'part art' and 'part artist'). Visitors to their events and exhibitions were encouraged to join in the making of artworks, thus the results could not be entirely credited to the individual artists who initiated them. It was for this reason that many artists chose to describe themselves as 'catalysts'.

In March, Medalla contributed to 'Toeval' or 'Random Festival', an arts festival held at the State University of Utrecht, Holland. One work, entitled *Down with the Slave Trade!* consisted of long polythene tubes filled with dried rice stalks from Asia that volunteers attached to their legs. After being linked together by ribbons hung with multi-coloured banners, the volunteers danced in the open air. This event was a reminder of the chains that had linked slaves together, but also of the social bonds that they shared. Another piece, called *A Stitch in Time* (four versions, 1968–72) was inspired by the Wall Newspapers found in China. Medalla suspended long cotton sheets, like hammocks, from a ceiling, provided needles and threads of different hues, and then invited people to embroider designs on the cloth. For most men, sewing has feminine connotations. Medalla challenged that gender assumption and so made possible the use of sewing by male landscape painters such as Michael Raedecker, a Dutch artist currently working in Britain.

Journalists covering the Festival reported that the events were popular and thoroughly enjoyed by participants. The message here was that ordinary people can make art and that major projects can be achieved via the small contributions of many individuals. *Down with*

the Slave Trade! was performed again in London in 1971 and in Utrecht in 1972, and *A Stitch in Time* at Gallery House, London in 1972.

'Popa at Moma' or 'Pioneers of Part Art' was the title of an exhibition mounted in the spring of 1971 at Oxford's Museum of Modern Art by Dugger and Medalla plus Li Yuan Chia (a Chinese artist resident in Britain), Lygia Clark and Helio Oiticica (two Brazilians) and Graham Stevens (an English artist who specialized in inflatables). The show was organized by Rupert Legge and Mark Powell-Jones and funded by an Arts Council grant. It epitomized the vogue for 'play power' that had emerged in the late 1960s: Richard Neville published a book with this title in 1970. Dugger constructed an environment – *Canalization of Psychic Energy* – made from 'body conductors', that is, plastic tubes hung from the ceiling, which visitors used to listen to the sounds of their own bodies. His declared intention was to provide a spatio-temporal atmosphere in which aesthetic sensations became meditative states.

At the time, it was extremely difficult for art critics to judge the quality of part art and it is even more difficult in retrospect, because when they visited an exhibit or event it was likely to be in progress/ unfinished and they would be expected to abandon their normal stance of detachment and join in. Furthermore, the contributions from so many different people made for an arbitrary and uneven result. In the case of events, the pleasure of play would be different for different participants and – no matter how genuine – transitory. The critic Edward Lucie-Smith suspected that play power in the visual arts was 'a new disguise for philistinism'. Doubtless, as far as the catalysts Dugger and Medalla were concerned, such aesthetic issues were less important than the artwork as a social model, as a demonstration of collective action that fostered a sense of community.

When artists such as Stevens provided 'inflatables' or 'blow-up' plastic structures in public parks, crowds were attracted and children and physically fit adults were soon enjoying themselves. This kind of art mobilized the body rather than the mind. Encouraging gallery

visitors to become physically active can and did have negative effects because a minority are likely to become over-excited and/or aggressive. For instance, the exhibition preview at Oxford was abandoned when Medalla protested about the destruction of Dugger's environment and Stevens withdrew his pneumatic structures because of broken glass on the floor. A similar situation occurred at the Tate Gallery in May 1971 when 'an assault course' provided by the American sculptor Robert Morris was closed for a time because of the danger of injury to visitors who were playing with the objects too vigorously and because several exhibits were being damaged.[2] Participation was to remain important throughout the 1970s, but, as we shall see shortly, found its fulfilment in community art rather than in gallery art.

During August 1971, seven exhibitions, designed to provide a survey or cross-section of contemporary British art, were held around the country. In the capital, 'Art Spectrum London' was funded by the Arts Council and the Greater London Arts Association (GLAA) and selected by a panel chaired by the critic Tim Hilton. The show was so huge that it filled the Great Hall of Alexandra Palace, a Victorian building in Muswell Hill. In addition to the display of art objects, musical and theatrical performances were provided and films screened. Around 100 male and 20 female artists participated. They included: Conrad Atkinson, Basil Beattie, Derek Boshier, Su Braden, Marc Chaimowicz, Rose Garrard, Rose Finn-Kelcey, Barry Flanagan, Vaughan Grylls, Tim Head, David Hockney, Kay Fido Hunt, Albert Irvin, Allen Jones, Bob Law, Bruce Lacey, John Latham, John Lennon and Yoko Ono, Gustav Metzger, Martin Naylor, Victor Pasmore, William Pye and John Stezaker.

Some works submitted were political and topical in character. For example, Atkinson contributed a film/performance piece about the Conservative government's Industrial Relations Bill that had prompted a protest march of 100,000 in London. One press reaction to art addressing such a subject was: 'How boring.'

Since the exhibition featured artists of different generations and

work in every conceivable medium and style, it exemplified the conditions of eclecticism and pluralism that have been identified as characterizing the 1970s and indeed the whole era of post-modernism that followed the expansion, diversification and experimentalism of the visual arts of the 1960s and the loss of 'a mainstream'. Depending on one's point of view, 'Art Spectrum London' illustrated the immense variety and talent of the London art scene or its condition of cultural confusion. According to the critic Andrew Forge, the exhibition was 'a glorious open-ended shambles'.[3] Ian Breakwell, one of the participating artists, was more sceptical and discerned a lack of quality: he judged the show's content to have been 'about 95 per cent rubbish'.[4]

Further evidence of the bewildering diversity of 1970s art can be found in Lucie-Smith's instant summary of the decade published in 1980.[5] In an attempt to impose order, the critic was driven to invent new labels of dubious value such as 'post pop', 'off stretcher', 'erotic heterosexual', 'kinky', 'mock archaeology', 'absurd machines', and so forth.

What is also relevant about 'Art Spectrum London' to this book is the fact that certain artists – Gerry Hunt was one – became dissatisfied with the selection procedure on the grounds that it was 'arbitrary and sloppy'.[6] He was also unhappy that only one artist had served on a selection panel dominated by critics, curators and dealers. Hunt proposed an alternative method that involved established artists nominating other, less established artists. Questions such as: 'Who selects the selectors? What criteria do the selectors employ? Should only artists be selectors or should there be a completely open entry with no selection at all?' troubled many British artists as they had troubled French ones in the nineteenth century. (In Paris, after protests from artists angry at having their works rejected by juries of the annual Salon shows, Salons de Refusées were introduced that had no selection process.)

Furthermore, the exhibition led – in the words of the feminist artist Margaret Harrison – 'to the discovery of shared problems concerning minimal survival and the inevitable competition for limited funds, with women artists in a particularly vulnerable position'.[7] The

upshot was that artists conducted inquests at the ICA during the course of which a decision was taken to form an artists' union (the latter will be discussed in more detail in Chapter 3).

Also in August, a group describing themselves as 'revolutionary worker-artists' founded the Union or League of Socialist Artists (LSA) in London. LSA's aim was to create a 'Marxist-Leninist proletarian art' that would serve the working class in their struggle for socialism. Over the next few years, LSA issued polemical manifestoes and pamphlets with titles such as *Theses on Art, Class War in the Arts!* and *Essays on Art and Imperialism.* Some of the ideas expressed reached postgraduate students at the RCA. Their *Theses on Art,* for instance, were reprinted – without LSA's permission – in the *Mewspaper,* the Students' Union magazine of the RCA. Despite their left-wing rhetoric, in certain respects the LSA artists were conservatives: they believed in representation not abstraction, employed traditional techniques such as painting and drawing, accepted art galleries as places to display work and the necessity for artists to make a living by selling their products as commodities.

In general, their manifestoes were written anonymously but the names of three LSA members were: Maureen Scott (b. 1940, Coventry), a painter, muralist, graphic artist, filmmaker and poet who trained at Plymouth College of Art, Goldsmiths' and St Martin's (she was the LSA's Provisional Secretary); Bernard Charnley (b. 1948), a graphic artist who studied at Leeds College of Art; and Mike Baker (1927–90). Baker, who was one of the principal theoreticians of the LSA, had been a member of the Communist party and was a life-long political activist.

They belonged to a left-wing organization called the Marxist-Leninist Organization of Britain (MLOB); it was founded in 1967 and published a journal entitled *Red Front* (later *Red Vanguard*). Initially, the MLOB pledged its support for the People's Republic of China under Chairman Mao.

LSA opened an exhibition space in Camberwell, South London called the Communard Gallery where they exhibited their own work,

delivered lectures, published the poetry of the Turkish Communist Nazim Hikmet with illustrations by Scott, sold posters of Marx, Lenin and Stalin and generally promoted the cause of socialist realism. Clearly, they did not share the German philosopher Theodor Adorno's opinion that 'no art at all is better than socialist realism'.[8] Given their preference for traditional visual media and figuration, it was not surprising that they detested all forms of experimental art. Scott claims to have been thrown out of Goldsmiths' because she refused to attend a lecture by Michael Craig-Martin about his glass of water on a shelf purporting to be an oak tree.[9]

In their theoretical writings, they were fond of citing Lenin and Stalin, and making ferocious attacks on Trotskyists, and members of the British Communist party associated with the magazine *Artery*. Another target was 'aridism', their name for 'anti-art, the latest nihilistic and disruptive exercise of the "New Left'" or 'bourgeois art at the end of its tether', in particular the 'aesthetically sterile' work of Conrad Atkinson, a supporter of the 'right-wing' Labour party, and the 'Women at Work' show held at the South London Art Gallery in 1975.

They also denounced the critic John Berger, the performance group COUM Transmissions, the artist Ken Sprague, the 'careerists and sinecure-hunters' who belonged to the Artists' Union, community art, Maoists associated with the Chicago Mural Movement, etc., etc. (It is unfortunately typical of many, small, ultra-left political groups that they expend more energy attacking potential allies than their principal opponents.) Nevertheless, LSA members contributed to the Art Workers' Subcommittee of the Artists' Union, to 'United We Stand: Exhibition in Solidarity with the Miners' (London, Congress House, 1974), to a conference on art education and to a conference on art/politics, theory/practice held at the RCA in 1974 (see Chapter 5). Their negative experience of the latter prompted a vitriolic critique of Peter de Francia, Head of Painting, and the RCA in general.

In their cheaply produced pamphlets, the cash-strapped LSA pleaded for donations and complained about the state funding received by other left-wing artists and by galleries such as the ICA

and Serpentine (their own applications to the Arts Council had been rejected). The only state funding received was a grant of £200 from the British Council so that Scott and Margaret Burlton could visit West Berlin in 1977 to attend the opening of a show of art about mining in which they were participating. (This payment prompted a question in the House of Commons from an irate Conservative MP.) In 1975, the LSA issued a challenge to the arts authorities to provide comparable financial support for 'an exhibition of progressive realist art' about 'the real life conditions, forms and methods of struggle . . . of working men and women'. Three years later the exhibition 'Art for Society', mounted by the Whitechapel, fulfilled some of these desiderata and one of the exhibits was Maureen Scott's painting *Life and Labour of the Miner* (1978). Aside from years spent studying, Scott earned a living by working in Fleet Street and as a secretary for the TUC. In 1985, she directed a film about the German poet Rainer Maria Rilke. Currently, her artistic output is poetry. She has not changed her political views.

Although American art and criticism became less important to British artists during the 1970s than they had been in the previous two decades, there were, of course, sporadic shows imported from the United States that enabled the British to learn more about the paintings of Barnett Newman, Agnes Martin, Frank Stella, Andy Warhol and others. Mostly the shows featured the artists of the New York School, but some revealed what was happening in California. At the Hayward Gallery in the autumn of 1971, for example, a mixed exhibition of Los Angeles' art was shown that was to generate much controversy and media coverage. The cause of the fuss was Newton Harrison's exhibit consisting of huge water tanks, machinery and fish – *Portable Fish Farm: Survival Piece 3* – because the artist planned several feasts – the killing, cooking and eating of catfish reared in the tanks – during the course of the show. Spike Milligan, the British comedian and animal lover, thought killing fish in the name of art was immoral and he smashed one of the Hayward's glass panels to demonstrate his disgust. The affair caused consternation in the

Arts Council, which called emergency meetings to resolve the crisis.[10]

What tended to be overlooked in the media outcry, were Harrison's rational motives for his apparent mindless cruelty to animals. Harrison was an ecological artist and his fish farm was intended as a model of future survival, of renewable resources, should the seas become polluted or over-fished. (Fish farms are now commonplace but unfortunately they also turn out to have ecological problems.)

One critic thought his exhibit was important and should not be closed because it was one of the first examples of 'installation art' to be seen in Britain. Nevertheless, it posed serious problems of critical evaluation: some observers wondered if it was art at all since it looked more like an agricultural exhibit than any previous species of art; it was also hard to see how it could be judged aesthetically. Harrison's literal use of animals was prescient given the fact that so many British artists – Damien Hirst being the prime example – were also to employ them in later decades.

In December, another significant exhibition was mounted at the Hayward Gallery by the Artist Placement Group (APG), which had been founded in 1966 by the British artists Barry Flanagan, John Latham, Barbara Steveni (Mrs Latham) and Jeffrey Shaw. Artists who joined later included: Ian Breakwell, Stuart Brisley, Roger Coward, Hugh Davies, Gareth Evans, David Hall and Ian MacDonald Munro. APG was an attempt to find an alternative to the commercial gallery system dependent upon the production and marketing of art commodities, to solve the problem of the avant-garde artist's alienation/isolation from society and the dearth of patronage. Although its members may have had selfish motives, they also felt that artists as creative and lateral thinkers were a vastly underused social resource compared to, say, scientists.

APG assumed that 'context was half the work' and its central idea was to insert artists for periods into the organizations and institutions, both private and public, which wielded so much power in contemporary society. It was considered important that artists should

run APG in order to avoid unnecessary layers of bureaucracy and mediation. Steveni handled most of the day-to-day tasks of negotiation with organizations on behalf of the other artists, while Latham was the group's principal theorist. Seed funding had been sought from the Arts Council in 1967 and was provided for a time.

During placements, the artists would function like independent consultants or researchers who would learn about the organization and its staff and then contribute observations, ideas and proposals. In other words, outcomes would not be prescribed in advance; they might take the form of a report, a film, or a sculpture. It was expected that both artists and the organizations would benefit and learn from the process of interaction. Clearly, APG's concept had affinities with artist-in-residence schemes in which artists were awarded fellowships for a limited period to live and work in an institution such as a university. However, most artists-in-residence simply continued with their usual work rather than making a fresh response to the new situation. Ultimately, APG's goal was, in Steveni's words, 'to introduce change in society through the medium of art relative to those structures with "elected" responsibility for shaping the future – governments, industries and academic institutions'.[11]

APG's Hayward show, entitled 'Inno 70': Art and Economics 1970–71', was intended as a progress report and an opportunity for further publicity. It was promoted as an 'exhibition in time' because it had commenced a year earlier with a teaser campaign consisting of a series of humorous, newspaper-style inserts in *Studio International* and because it was designed to reveal the negotiating process. Inside the Hayward, documentation was provided on placements that had been undertaken with British Steel, Hillie Furniture, Esso Petroleum and ICI. Naturally, APG hoped that more businesses would become interested and so live interviews and discussions – called 'the sculpture' – between artists and industry representatives took place and were relayed by video throughout the Hayward.

As mentioned earlier, Latham had been injured in a car accident in December 1970 and had spent time in Clare Hall Hospital recovering.

5. Artist Placement Group, '*The Sculpture*' (December 1971). An APG discussion at the Hayward Gallery, John Latham bottom left. Photos © Tony Sindon courtesy of Barbara Steveni.

He decided to treat his hospital stay as an unofficial placement and to illustrate this he put on display, in the Hayward, the wreck of his car plus X-rays of his chest. His hospital experience led him to propose a way of helping patients with blood clots by revolving their bodies on the long axis, but the medical profession did not pursue this suggestion. Later, Latham was to undertake official placements in the planning and development department of the Scottish Office, Edinburgh (1975–76) and in a traffic department in Düsseldorf, West Germany (1984). One positive consequence of the Hayward show was that the Civil Service committed itself to encouraging artist placements in government departments.

Not everyone in the British art world found APG's ideas persuasive. Three critical articles, written by Stuart Brisley, Peter Fuller and Gustav Metzger, were published after the Hayward show. Brisley, who was familiar with APG from the inside, complained that Latham and Steveni ran it as 'an autocratic family business, with a poor record of human relations'.[12] Metzger and Latham had cooperated in the mid-1960s to mount the Destruction in Art Symposium, but this did not

prevent Metzger from calling Latham 'a Holy Fool' and attacking his mystificatory use of language and his absurdly ambitious claims regarding the artist's ability to transform society. Metzger also characterized APG's politics as 'The Middle Way', which 'always leads to the Right'.[13]

Undaunted by these attacks, APG remained active throughout the 1970s and '80s. Conferences and seminars were held in Britain but also in Austria, Germany and Holland. In 1976, five artists involved in placements reported on their experiences in the 'Art and Social Purpose' issue of *Studio International*. At the time of writing, Steveni is still proselytising on behalf of APG, although since 1989 it has preferred the name O + I (Organization and Imagination).

While APG was a valiant and sustained attempt to transform the relation of contemporary artists to society and was not without success, it did encounter some fundamental contradictions and problems that in the long term limited its effectiveness. An artist inside an organization might well be caught between the different interests of the owners/managers and the workers. The former would be the artist's paymaster, but a left-wing artist might well side with the employees. (Latham argued that the artist represented *all* society not any one faction.) If the artists' proposals were too ambitious and expensive, as was the case of Latham's Scottish ones, then they might never come to fruition. If an artist was placed in a government institution such as a mental hospital or prison, then any negative findings might never see the light of day because of the Official Secrets Act. A private business would also want to protect commercially sensitive information. Another reason for APG's limited impact, paradoxically, was the increasing vogue for similar schemes – some sponsored by the Arts Council – that Latham felt imitated the concept but watered it down.

Latham had lost his part-time teaching post at St Martin's in 1967 because of an event he had organized – the partial destruction by chewing of Greenberg's book *Art and Culture* borrowed from the art school's library – the residue of which was later to be regarded, by curators at the Museum of Modern Art in New York, as a key example

of conceptual art. Younger conceptualists also came into conflict with art school authorities during the 1970s. For example, at Coventry College of Art three members of Art & Language – Terry Atkinson, David Bainbridge and Michael Baldwin – introduced, in 1969, an Art Theory course that was to prove problematic for managers and studio tutors. Initially, Art Theory courses were viewed as additions to existing courses teaching traditional art forms and newer ones such as performance and video. It was not envisaged that they might threaten the existence of visual kinds of art. When certain students began to emulate their mentors by producing written papers instead of paintings, there was nothing to hang on walls for the studio staff to evaluate aesthetically and to mark. The primacy of the visual was denied and the conventional division of labour between practice and theory was disturbed. Practice and theory were normally taught separately: practice occurred in studios and was supervised by professional artists while theory was the concern of Art History and Complementary or General Studies departments.

When Robin Plummer, a new Dean of the Faculty of Art and Design, was appointed at Coventry in 1971, he ordered that the Art Theory course be closed by 1973. As a result, Bainbridge and Baldwin's part-time teaching contracts were not renewed. (One reason for staffing cuts was a reduction in the College of Art's generous staff-student ratio following its incorporation into Lanchester Polytechnic.) Atkinson, a full-timer, was retained to ensure the existing cohort of students completed their studies; then, in 1973, he resigned. Previously, in January 1972, the students had been instructed by Plummer and Head of Department Colin Saxton to produce 'tangible, visual art objects' for assessment purposes.[14]

Among the students at Coventry who were attracted to theory were Graham Howard, Philip Pilkington and Dave Rushton. They produced a magazine entitled *Analytical Art* (2 issues, 1971–72) and later contributed to the Art & Language journal and project. At the end of the decade, Rushton was also to write (with Paul Wood and others) a coruscating study of the politics of British art education.[15]

Despite the demise of the Art Theory course at Coventry, Charles Harrison has claimed, in a history of Art & Language, that it had a wider influence because material from it subsequently surfaced, in 'travestied form', in a number of art schools as part of a modernizing process. (He did not specify what material.) During the 1960s, those responsible for reforming art education were keen for art students to study the history of art, to undertake research and to write dissertations because these activities served to raise the academic standing of the fine arts (making them worthy of degree status) and improved the students' literacy and communication skills. However, what the reformers did not anticipate was that reading and analysis might prompt students to cease making art objects and to become politically active. The art school occupations of 1968 are well known, but many also occurred during the 1970s because of fee increases, cuts and academic issues. In the 1970s, most art colleges lost their autonomy when they were absorbed into much larger institutions called polytechnics (which were renamed universities in 1992). This change had been planned during the 1960s and had been greeted with dismay and resistance by most art school staff and students. On 12 October 1971, the abstract painter Patrick Heron protested via an article in the *Guardian* newspaper melodramatically entitled 'Murder of the art schools'. Heron was convinced that huge, bureaucratic, academic institutions would destroy the informality and creative dynamism of the art schools. He called for the amalgamation process to be halted and reversed but his pleas were not heeded.

The incident at Coventry demonstrated that the liberality and tolerance that is generally thought to characterize the attitude of bureaucrats in higher education towards art teachers and students, and towards free speech, innovation and experiment in the arts, was a veneer. Other students discovered their assumption that they were free to say and do what they wanted was an illusion. Radical teachers encouraged them to be critical and to ask questions. However, if the students happened to scrutinize the education they were receiving and the institutions in which they were studying, and to criticize

managers via caricatures, posters and writings, then they would experience censorship, academic failure and expulsion. Stuart Semark, a student on the Environmental Media course at the RCA, who was expelled in 1975, was told by the Rector Lord Esher: 'You're not here to think, you're here to work.'[16]

British students brought up to believe that they live in a democracy are often disappointed to find that art colleges and universities are hierarchical organisations. Academics wield power over students and they in turn are subject to a line management structure in which power is concentrated at the top. The expansion of British higher education that occurred during the 1960s and the decade's general mood of liberation had resulted in high expectations that were to be disappointed during the 1970s because of the harsher economic climate. Higher education institutions in Britain were subject to spending cuts and experienced pressures from governments to serve business and industry, consequently staff and students frequently found that facilities and resources declined, part-time tutors and technicians were made redundant and disruptive restructuring exercises occurred. It is no wonder, then, that they became militant from time to time.

However, it should be acknowledged that during the 1970s certain tutors and students, motivated by the desire to exacerbate contradictions and to intensify the class struggle, deliberately set out to subvert the art education system precisely in order 'to sink the good ship liberalism'.[17]

Liberalism was also put to the test by homosexuality's increasing visibility. In New York, during 1971, the British artist Mario Dubsky (1939–85), in collaboration with John Button, executed a mural celebrating Gay Liberation and Pride in photographs and slogans.[18] A sense of dynamism was conveyed by tilting all the images to the left. The mural was produced for the Gay Activists Alliance building in SoHo and was entitled *Agit-Prop* (it has since been destroyed).

Dubsky was a student at the Slade during the 1950s and went to the United States in 1969 after being awarded a Harkness Scholarship. Emmanuel Cooper remarks that he was 'immediately caught up in the

6. Rich Wandel, *Photo of Agit-Prop photomontage mural*, designed by Mario Dubsky and John Button (1971). 2.4 x 10 m, Gay Activists Alliance Building, Wooster Street, SoHo, New York. Photo Rich Wandel and National Archive of Lesbian and Gay History, New York.

atmosphere of post-Stonewall euphoria'. Stonewall, of course, was the Inn where gays had first defied the New York police in June 1969. Later, Dubsky was to execute charcoal drawings of male figures fondling the enormous phallus of Pan, the Greek mythological God. Another set of drawings, produced during 1977–78, was prompted by the trial of *Gay News* for publishing a homoerotic poem about Christ by James Kirkup.[19] Mary Whitehouse, a self-appointed guardian of the nation's morals, initiated a prosecution because she thought the poem was obscene and a blasphemous libel. The jury concurred and the magazine was fined £1000; Denis Lemon, the editor, was fined £500 and given a suspended prison sentence.

Francis Bacon, perhaps Britain's finest post-1945 painter, was homosexual and the frankness of David Hockney's homoerotic etchings and paintings had contributed to a wider acceptance of homosexuality during the 1960s.[20] In 1968, Hockney returned to Britain for a time when his lover Peter Schlesinger enrolled as a student at the Slade. In

general, Hockney was indifferent to politics but he was willing to defend the rights of homosexuals. While in Los Angeles in 1970, he had taken part in a Gay Rights demonstration and in Britain he served as Vice-President for the Campaign for Homosexual Equality. When, in June 1976, the police raided the gay London bookshop Incognito, Hockney appeared and his complaints about oppression and censorship were reported in the press.

The Gay Liberation Front had been formed in Britain in 1970 and male homosexual artists such as Michael Leonard, Derek Jarman and Andrew Logan were emboldened by this event. Those generating lesbian imagery during the 1970s included Yve Lomax, June Redfern, Monica Sjöö and Susan Trangmar. While all these artists employed figuration, they had no common style and used various media – film, painting, performance and photography. A camp sensibility – often associated with gays – was also evident in the work of artists like Marc Chaimowicz and David Medalla. Early homosexual imagery was primarily a celebration of same-sex lovemaking and hence a sub-category of erotic art, but once the scourge of Aids began to decimate the gay community – during the 1980s – then the imagery took on a much fiercer political edge and the arts were mobilized to combat the disease and public prejudice against Aids sufferers.

One British artist who eventually died from Aids was Derek Jarman (1942–94).[21] He came from a middle-class background and was trained as a painter and stage designer at the Slade during the 1960s where he also studied the history of film. He proved to be extremely energetic and versatile: during the 1970s he designed interiors, and costumes/sets for the theatre and for Ken Russell's films *The Devils* and *Savage Messiah*, exhibited paintings and drawings in mixed and solo shows and became noted as an experimental, independent filmmaker using super-8 and 16mm film stock. He was also a prolific writer of diaries, notebooks, poems and scripts. Towards the end of his life, he created an exceptional garden at Dungeness, Kent. Paradoxically, Jarman was an individualist who also enjoyed collaborating with others on joint projects.

At the Slade, Jarman met Nicholas Logsdail and helped him to convert a house in Bell St into the Lisson Gallery (1967–); he was to exhibit there several times. He also befriended the British homosexual artists Dubsky, Duggie Fields, Hockney, Logan, Robert Medley, Keith Milow and Patrick Proctor and the notorious American photographer Robert Mapplethorpe. He attended Gay Liberation Front meetings and participated in Logan's hilarious Alternative Miss World annual events in which men 'bent genders' and subverted sexual stereotypes by cross-dressing. Logan (b. 1945) studied architecture at Oxford during the 1960s and later became noted as a sculptor, costume designer, decorator, jewellery maker and creator of kitsch interiors. He made huge flowers for the roof garden of Biba's art deco store in Kensington. The Miss World competition parodies began in Logan's Hackney studio in March 1972. In order to illustrate the fact that humans have both masculine and feminine sides, Logan dressed so that half his body was that of a man and the other half was that of a woman.[22] In 1975, Jarman won in the guise of Miss Crêpe Suzette. The following year he filmed the rock group the Sex Pistols when they played at one of Logan's parties (Valentine's Ball, 14 February 1976, Butler's Wharf) – the youthful energy, anger and anarchism of punk excited him.

Jarman visited the United States several times and the lofts he occupied in London's redundant industrial warehouses bordering the Thames emulated Warhol's Factory studio in New York by being centres for creative work, exhibitions, film screenings and parties that attracted a wide social mix. In effect, his studios were informal arts laboratories. Of course, Jarman was familiar with Warhol's 'underground' films (and those of Kenneth Anger) but he also admired the work of Italian directors such as Federico Fellini and Pier Paolo Pasolini. He visited Italy and filmed there during the 1970s and the Italian painter Caravaggio became the subject of a film he made in the 1980s.

Although many critics regard his paintings as dire, it is clear from the above that Jarman was exceptional in his ability to cross boundaries in order to contribute to several cultural realms. Since Jarman

had no formal training as a filmmaker, he learnt by doing and much of his output had an improvised quality that was valued because of its difference from the naturalistic illusionism and slick professionalism of Hollywood cinema. His films spanned the range from short home movies to lyrical, painterly experiments in slow motion to full-length art house films. Besides his own films, he made pop music promos for the singer Marianne Faithfull and others. Jarman liked to play with the form of the medium of film but not in the severe manner of structural-materialists such as Peter Gidal; he was still interested in content and was fond of using visual metaphors, personifications and allegory. Even though the dialogue of his 1976 film *Sebastiane* – about the Christian martyr and Roman soldier St Sebastian – was in Latin, its celebration of the male nude and homosexual desire ensured that it became a cult among gays. According to Jarman, it was the first film to depict 'homosexuality in a matter of fact way, such as another film might depict heterosexuality'. Brian Eno supplied the film's music. Jarman's 1977–78 film *Jubilee* will be considered in Chapter 8.

While opinions regarding the aesthetic merit of Jarman's oeuvre vary, his 'career' was to serve as a model to art students unwilling to surrender to market forces and mainstream media. He showed how to be a productive, independently minded artist on small sums of money culled from a variety of sources. By gradually establishing a record as a filmmaker, he was able to make more and more ambitious and expensive films. Even when he undertook commercial commissions, he usually managed to preserve his artistic integrity. Initially, his films appealed to only a small circle but later millions around the world saw them when they were screened at film festivals, in cinemas and on television. Peter Greenaway, born like Jarman in 1942, another experimental filmmaker who trained as a painter at a London art school in the 1960s, was to follow a similar path (although he was not gay and showed no interest in politics in his films of the 1970s).

Chapter 3

1972

Apollo 16 and 17 missions to the moon were a success. President Nixon won a second-term election for the Republicans and visited China and the Soviet Union. Burglars were caught inside the Watergate Building in Washington DC. Black September – Palestinian terrorists – killed Israeli athletes at the Olympic games in Germany. 40,000 Ugandan Asians fled to Britain after being expelled by the dictator Idi Amin. Martial law was imposed in the Philippines. Britain imposed direct rule on Northern Ireland. In Londonderry, the shootings of 13 Irish Catholics on 30 January by British paratroopers resulted in the day being called 'Bloody Sunday'. An IRA bomb killed seven in Aldershot and 22 bombs were planted in Belfast in one day. Unemployment in Britain reached one million. Britain agreed to join the European Economic Community. A national coal strike led to a state of emergency. The Industrial Relations Court imprisoned five dockers for contempt; a dock strike followed. During a strike in the building trade, two leaders of pickets were sent to prison for using intimidation. Four members of the Angry Brigade were tried and each received ten years. Clive Sinclair marketed pocket calculators. In the United States, the authorities blew up the award-winning housing estate Pruitt-Igoe, Missouri, and this was judged by Charles Jencks to mark the end of modernism and the beginning of post-modernism. The feminist magazine *Spare Rib*, *Gay News* and *Gay Marxist* were founded. In London, 2000 marched in the first Gay Pride demonstration. Roland Barthes' book *Mythologies* was published in English and Victor Papanek's *Design for the Real World*. A report for the Club of Rome – *The Limits to Growth* – was issued. Film of the year was Francis Ford Coppola's mafia family saga *The Godfather* starring

Marlon Brando. Lisa Minelli starred in the musical movie *Cabaret*. Werner Herzog directed *Aguirre, Wrath of God*, Luis Buñuel directed *The Discreet Charm of the Bourgeoisie* and Andriej Tarkowski directed the Russian film *Solaris*. Jon Voight and Burt Reynolds starred in John Boorman's *Deliverance*. There was a vogue for glam, or glitter, rock music. David Bowie's Ziggy Stardust album was issued and the first single by Roxy Music, a band which included two ex-art school students: Bryan Ferry and Brian Eno.

John Berger's *Ways of Seeing* arts series was shown on British television. 'Seven Exhibitions' was mounted at the Tate Gallery and Joseph Beuys made a personal appearance. Bruce McLean was 'King for A Day' there too. At the Victoria & Albert Museum, a show about the origins of photography was entitled: 'From Today Painting is Dead.' In Exhibition Road, London, Gallery House was opened and run by Sigi Krauss who put on shows of British and German avant-garde art. At the John Moores Liverpool exhibition, the prizewinners were Euan Uglow, Adrian Henri and Noel Foster. The 'Book as Artwork' show was held at the Nigel Greenwood Gallery, London and 'The New Art' at the Hayward Gallery. Bernard Cohen received a retrospective show at the Hayward. A sculpture by Barry Flanagan in Cambridge was vandalized. A section devoted to public art appeared in *Studio International* (July/August). The British artist Alan Gouk visited New York to show Greenberg one of his abstract paintings. A Barnett Newman exhibition was held at the Tate Gallery. The group show 'Systems' appeared at the Whitechapel and toured the country. At the Museum of Modern Art, Oxford an exhibition of fluxus art was shown entitled 'Fluxshoe'. Events entitled 'The Body as a Medium of Expression' were organized at the ICA, which also mounted a 'participation production' by David Medalla and John Dugger, plus Conrad Atkinson's 'Strike at Brannans' exhibition. A British sculpture exhibition was mounted at the Royal Academy (January-March). Michael Craig-Martin showed at the Rowan Gallery. The British artist Andrew Logan hosted the first Alternative Miss World competition. 'Documenta 5' was held in Kassel, Germany; its theme was 'Inquire into Reality – Images

of Today'. Robin Campbell was appointed art director of the Arts Council. In London, the Artists' Union, the Half Moon Gallery and the Women's Art History Collective were founded. Jack Wendler, an American living in London, opened a gallery devoted to conceptual art in North Gower St (it lasted until 1974). In December, the dealer John Kasmin closed his gallery in New Bond St.

A significant event occurred on British television in January 1972: John Berger's arts series *Ways of Seeing* was transmitted on BBC2.[1] Simultaneously, tie-in articles were published in the *Listener* and later the 30-minute programmes were made available to art colleges for hire as 16mm films. The BBC and Penguin Books also published a paperback that was to sell hundreds of thousands of copies. It is still in print and recommended reading on many lecturers' lists. Berger (b. 1926), a neo-Marxist art critic, poet, journalist and novelist who now lives in France, provided perhaps the first socialist analysis of art on television. To some extent, he was responding to Kenneth Clark's ambitious and much more expensive series *Civilisation* transmitted in 1969. Clark's patrician and patriarchal history of art was highly acclaimed on both sides of the Atlantic. The British Establishment regarded it as a lesson the student protesters of the 1960s should heed.

Ways of Seeing had four parts: the first considered the implications of the invention of photography and mechanical reproduction for the arts. Credit was given to the German critic Walter Benjamin whose 1936 essay on this subject had been published in English in 1970 and was to influence a host of artists and art students. R.B. Kitaj painted a homage to him entitled *The Autumn of Central Paris (after Walter Benjamin)* (1972–73).

The second programme raised the issues of patriarchy and the representation of women in Western art. This was one of the first 'images of women' analyses that were to engage feminists for years. To counter negative images of their sex, some feminist artists set out to produce positive images of women. (By 1980, women artists were organizing exhibitions of images that they had created of men.)

The third examined the traditional genres of Western European oil

painting – landscape, still life and portraiture – and their connections to class and power, to the private property enjoyed by the aristocracy and middle class.

The fourth provided a critique of advertising imagery because Berger believed it continued the kind of representation that oil painting had provided in earlier centuries. Publicity was also 'a political phenomenon of great importance' because it substituted consumption for genuine democracy (shopping choices rather than political choices).

Modern and contemporary art were barely mentioned in the series and Berger did not address the question: 'Assuming living artists agree with this critique, what should they do?' However, an answer was implied in his stated intention of using the existing bank of images to construct new montages and meanings. The making of the four films was self-reflexive and the first included a clip from Dziga Vertov's dazzling documentary *The Man with the Movie Camera* (1929) to illustrate the various ways film can be edited. In addition, the paperback contained a number of 'chapters' consisting entirely of pictures.

The impact of *Ways of Seeing* can hardly be overestimated. It aroused adverse reactions from the Right and enthusiasm from the Left. (But later it was to be attacked by both Art & Language and Peter Fuller for being simplistic and misguided.) Not only did it stimulate further research and discussion of the topics Berger had addressed and contribute to the founding of 'The New Art History', but it also inspired many artists to undertake critiques of mass culture and then to generate critical photomontages, paintings and slide-tape works using images appropriated from the media. Some examples will be cited in later chapters.

At the Tate Gallery, during February and March, 'Seven Exhibitions' was mounted at short notice to fill a gap in the Tate's programme. The title indicated that it was not a group show, but seven individual displays. Tate curators took the opportunity to catch up on recent trends such as conceptualism. On show were works by Keith Arnatt, Michael Craig-Martin, Hamish Fulton, Bob Law, Bruce McLean and David Tremlett, plus videos and films by Joseph Beuys.

Arnatt also made a photographic documentation of all the workers employed by the Tate to reveal the number of people whose labour was needed to mount shows. However, the staff objected to a display and it was excluded.[2] In February, Beuys appeared in person in the octagon of the Sculpture Galleries to hold one of his public seminars in which he explained his ideas for social and political change. (He was to host further seminars at the ICA in 1974.) *Information Action* lasted over six hours and among those that crowded around him were the artists Gustav Metzger and Richard Hamilton. Part shaman, part showman, Beuys was a charismatic figure. (Peter Fuller disagreed and dubbed him 'a low charlatan'.) Initially, British artists and critics listened to him attentively but some found his proposals vague, implausible and impractical, and so they posed questions and counter arguments.

Metzger was one of the sceptics. At the Tate event, he challenged Beuys and complained about his mystificatory language. Metzger also asked Beuys to make clear the precise steps needed to realize his

7. Joseph Beuys, *Information Action* (February 1972). Action at the Tate Gallery. On the far right are Richard Hamilton and Gustav Metzger. Photo © Simon Wilson courtesy of the Tate Gallery Archive © DACS, 2002.

ideas. Some of the discussion focused upon education as a means of change and the issues of science and technology. Metzger raised the threats of the latter to the ecology of the planet and the negative impact of advanced Western technologies on the nations of the Third World. Beuys' interest in ecological matters was to surface at the end of the decade.[3]

Some observers of Beuys' events in London thought that he was not prepared to listen and change his mind because he was so convinced by his own ideas and rhetoric. Hence, the impression of dialogue and mutuality was largely a sham. Beuys' mantra 'everyone is an artist' was banal when interpreted as 'everyone is capable of creativity' and patently untrue when interpreted as 'everyone is a professional artist'. The latter was contradicted by his own exceptional status as a super-star of the international art circuit. Metzger, who lost members of his family in the Holocaust, once asked him: 'Was Himmler too an artist?'

Nevertheless, Beuys' ability to attract supporters and to cause uproar in West Germany's art colleges, his campaign to establish Free Universities throughout Europe, his commitment to animal rights and to transform politics, via an organization for direct democracy and a Green party, meant that by the end of the 1970s he was a far more influential figure internationally than any British artist.

Throughout 1972, exhibitions held in London provided opportunities to discover what was happening in contemporary art in Britain. The year before, Sigi Krauss, a German resident in London, had turned his framing shop in Covent Garden into an art gallery for showing the work of young unknowns and placed crude, punk-style advertisements in *Studio International*. Then, in 1972, he obtained the use of a town mansion while it was standing empty awaiting renovation as an extension to the German Institute in Princes Gate, Exhibition Road. He called this new exhibition space 'Gallery House', appointed himself Director and secured some Arts Council Funding. His Assistant Director and exhibitions organizer was Rosetta Brooks, a highly intelligent critic who, during the 1970s, was the partner of the artist John Stezaker. Krauss and Brooks set out to present a range

of shows, events, lectures and film screenings devoted to the newest trends.

Gallery House and later the ICA were responsible for introducing new German art to the British public, particularly radical, left-wing art. Travel between the two countries also increased: German artists such as Beuys and Immendorff visited Britain, while British artists such as Stuart Brisley, John Latham and Michael Sandle worked in Germany. Women artists such as Margaret Harrison and Maureen Scott also exhibited in Germany during the 1970s. The massive, international exhibition 'Documenta' held every few years at Kassel in West Germany began to rival the Venice Biennale and helped to raise Europe's art profile *vis-à-vis* that of the United States. 'Documenta' became an essential platform for ambitious British artists.

Historical exhibitions of German art, such as that by the communists and dadaists George Grosz and John Heartfield, were also circulated in Britain during the 1970s. The Heartfield show stimulated an interest in the technique of photomontage. Victor Burgin has recalled that when he was a student during the 1960s, he was never taught anything about Heartfield. This example highlights the fact that the history of modernism as taught in most art schools and presented in many museums was a highly selective one. Political and public art tended to be omitted.

Krauss' and Brooks' inaugural show, 'Three life Situations', was held in March and April and featured Stuart Brisley, Marc Chaimowicz and Gustav Metzger. (Because certain artists undertook long-term projects in Gallery House, they became virtually artists-in-residence and one advantage of this was that visitors could meet and talk to them. There were opportunities, therefore, for art and artists to be demystified.)[4] Brisley (b. 1933) had studied painting at the RCA in the late 1950s and then spent time in Germany and the United States. Witnessing racial segregation at first hand in Florida raised his political consciousness. He earned a living by teaching at the Slade and other art colleges, and specialized in body, performance and installation art, that is, in the creation of extreme situations that demanded

physical discomfort and endurance on his part and that were designed to attract and repel the audience simultaneously. He was one of the few British performers whose time-based rituals rivalled those of Beuys and the Austrian Aktionismus artists (Gunter Brus, Hermann Nitsch, et al) who had shocked audiences throughout Europe during the 1960s.

At Gallery House, Brisley converted a large room into a kind of filthy prison cell by splashing the walls and windows with black and grey paint and covering the floor with debris, dirt and slop water. He occupied the room for two weeks while living on a restricted diet and with no amusements or external communications. The only furniture was a battered table and an ancient wheelchair. Brisley himself, dressed in dark clothes and glasses, with grey face and hair, crawled across the floor or sat swaying in the wheelchair making repetitive thumping noises. The person could have been a senile old age pensioner or a political prisoner. Visitors viewed this sinister scene through a peephole and read an information sheet headed 'REPORT: Subject ZL 656395 C', plus dictionary definitions of the words 'exist' and 'survive'.

Clearly, the performance was a metaphor for the existentialist predicament of man, an isolated, nameless individual reduced to a National Insurance number and imprisoned in squalor, with no history and a future limited to survival. Brisley's performance was a cross between theatre (the character he 'acted' was similar to those found in Samuel Beckett's plays) and fine art (action painting). Viewers may have rejected the bleakness of Brisley's social analysis, but there was no denying the power of its visual/physical embodiment.

Even more disturbing and repellent was another performance at Gallery House entitled *And for Today – Nothing* (September 1972) in which Brisley transformed a bathroom on an upper floor into a messy slaughterhouse or murder scene (thus inverting normal expectations of hygiene and cleanliness) and then lay like a corpse in the bath filled with dirty water and rotting ox lungs. As visitors climbed the stairs,

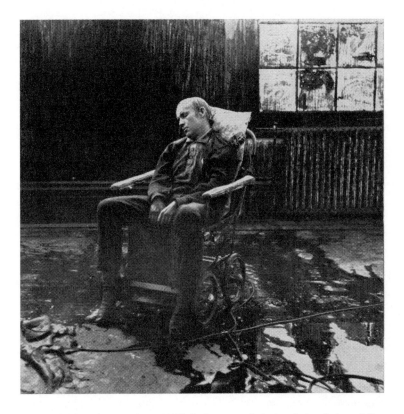

8. Stuart Brisley, *ZL 656395 C* (April 1972). Performance and mixed media installation at Gallery House, London. Photo D.R.E.A.M.S., reproduced courtesy of the artist.

the meat's nauseous smell grew stronger and stronger. Once inside the bathroom, they faced a tense situation: if they stayed too long then the man under the water might drown. They also wondered if any communication between performer and viewers was expected.

Brisley's performances were re-enactments of the state of alienation caused by capitalism, of the struggle against social structures restricting the freedom of the individual, but in the case of these two performances the political meanings were implicit rather than explicit. Nevertheless, he was keen to widen the audience for his art and so, in addition to art galleries, he appeared in theatres, parks, car showrooms

and on television. He also contributed to the Artists' Union and undertook an Artist Placement Group project.

Krauss' and Brooks' most ambitious venture, 'A Survey of the Avant-Garde in Britain', was presented in several parts from August to October. Among the artists they selected, besides Brisley, were: Ian Breakwell, Victor Burgin, Gerard Hemsworth, John Latham, David Medalla, Graham Stevens, John Stezaker and Stephen Willats. Included among the film- and video-makers were: Steve Dworkin, Peter Gidal, David Hall, John Latham, Bill Lundberg, Denis Masi and William Raban. Those invited to deliver lectures included: Victor Burgin, Colston Sanger (the editor of *Frameworks Journal*), Charles Harrison, Tim Hilton and John Stezaker.

Caroline Tisdall, art critic of the *Guardian*, noted two absences from Gallery House exhibitions: colour and women artists.[5] Margaret Harrison has claimed that in two years of operation only one woman artist – Hannah Stills – appeared at Gallery House as against around 100 male artists, although just before it closed in 1973 three women artists – Susan Hiller, Carla Liss and Barbara Schwartz – did share a show. Hiller displayed slides and a large construction made from tissue paper entitled *Transformer*, while Liss and Schwartz projected their films.[6]

None of the male artists in the avant-garde survey were conventional painters or sculptors; instead they used a variety of media to generate art that ranged from the behavioural, through installations, performances, participatory projects and sound artworks, to the theoretical. The latter – which took the form of writing – was more appropriate to the pages of the catalogue or to the lecture programme. In fact, there was such a dearth of art objects on view that the critic Hilary Spurling complained about 'a succession of large, spotlit rooms occupied with so little confidence that most of them seemed empty.' Furthermore, the exhibition was judged 'totally devoid of humour, inventiveness and energy'.[7]

A number of the artists who exhibited had ambitions to redefine art and reform society. Unfortunately, few visitors were attracted to

Gallery House – it was a new addition to the London scene – and so its public impact was limited. The critic Paul Overy noticed that while the private views were well attended, the rest of the time Gallery House was 'deserted'. Overy thought the public's general lack of interest in the visual arts was due in part to the English education system, because it stressed the literary rather than the visual arts. Gallery House, therefore, could be judged to have been a failure. However, in terms of the history of British art, its exhibitions and publications were important and a few – such as Brisley's installations/performances – were unforgettable.

In July 1973, when the lease of Gallery House was about to expire, a meeting was convened to protest at its imminent closure. The artists believed the German Institute had reneged on a promise to provide another space and they were worried by the loss of 'a free gallery, for artists run by artists, a place for "difficult" artists to show without commercial or status considerations'. David Medalla and the German Jorg Immendorff accused the Institute of suppressing political statements they had wanted to make. Demands were then made for art to serve the working class. The confused and raucous character of the meeting prompted the performance artist Shirley Cameron to remark: 'Art should be life-giving and life-enhancing ... you could die in here, in this meeting.'[8]

Although Brooks had employed the term 'avant-garde', she was not sure it was still valid. In a catalogue introduction, she argued that 'avant-garde' was now a historical notion, one that the artists exhibiting at Gallery House might ultimately reject because they were attempting to alter the concept of art, plus its social purpose. Robert Hughes, the Australian-born critic, also thought the avant-garde had run its course: witness the article he wrote for a British newspaper at the end of the 1970s entitled '10 years that buried the avant-garde'.[9]

Stezaker too was unhappy with the concept avant-garde because it implied a minority culture that was opposed to official and mass culture. This, he believed, was an outmoded situation, and the fact that state organizations such as the Arts Council were willing to

subsidize shows of conceptual art and purchase examples, indicated that official culture was only too happy to embrace the remnants of the avant-garde; hence, it was no longer adversarial. Indeed, 'The avant-garde artist has simply become a business man, wheeling and dealing in a restricted cultural circle and to a specialist clientele'.[10] This led Stezaker to conclude that society's authentic culture was mass culture and that fine artists had somehow to come to terms with it.[11]

In response to the 'end of the avant-garde' problem, other writers began to use the terms 'neo-avant-garde' and 'post-avant-gardism'. However, coining such uninformative new labels did not solve the actual problems artists faced in respect of their relations with official-dom and mass culture.

A major exhibition held at the Hayward Gallery in the summer of 1972, avoided the difficulties associated with the term 'avant-garde' by using a more neutral, but quickly dating, title: 'The New Art'. [12] This show was funded by the Arts Council and selected by Anne Seymour, an Assistant Keeper at the Tate Gallery. It featured work by 14 artists and groups who included: Keith Arnatt, Art & Language, Victor Burgin, Michael Craig-Martin, Barry Flanagan, Hamish Fulton, Gilbert & George, John Hilliard, Richard Long and John Stezaker. These artists used various materials and media – light and sound, mirrors, photographs, performances and words – and the catalogue printed statements and essays by the artists. Works ranged from the straightforward and entertaining – Gilbert & George – to the highly complex and forbidding – Art & Language. Although the show was not without humour, the general impression was clinical and serious; there was a shortage of colour and the visual/tactile aesthetic pleasures normally associated with art exhibitions. The attendance figure – 16,768 – was low. (For the purpose of comparison, over 188,000 attended a Dada and surrealism show held later in the decade.)

At the time and in retrospect, 'The New Art' was/is judged to mark the official recognition of the dominance of conceptual art (even though more than this tendency was represented), consequently it

baffled many visitors and infuriated many painters and sculptors. The show's defenders explained that the artists were like philosophers or researchers probing the very nature of art.

Sceptics accused the artists of using 'private languages' even when they wrote in English. According to Seymour, what the exhibitors shared was 'an ability to look reality in the eye', but while that perceived reality included landscape – the land art/photography of Fulton and Long – it excluded the social and political fabric of contemporary urban life. (However, within a few years, several of the Hayward exhibitors would have remedied this situation.) Thus, Seymour's selection can be criticized for having omitted new art with a political edge, for instance, that by Brisley, Dugger, Medalla and Willats, which Brooks did select for Gallery House.

Brooks' exhibitions were also more inclusive because they featured artists of an older generation such as John Latham. When Brooks reviewed 'The New Art', she identified an interest in time as a recurrent element in the British avant-garde and maintained that Latham's emphasis on time rather than space was a formative influence.[13] Both selectors were women but showed little interest in the work of female artists. Seymour also ignored Afro-Caribbean and Asian artists living and working in Britain.

Writing in retrospect, Margaret Harrison's verdict on 'The New Art' was:

> To some of us conceptualism ended with the show . . . conceptual art was a mirror image of the art world it criticized. In other words, it was still in the cul-de-sac of art about art. What myself and many artists of that period were making was art . . . about the issues we had become involved in . . . The focus on subject matter led me (and others) into finding different forms and aesthetics . . . throwing up different ways of looking rather than fitting into a style of art production.[14]

Gilbert & George, who contributed two gigantic charcoal drawings showing them standing among shrubbery to 'The New Art', were

probably the most commercially successful artists included because they had become nationally and internationally famous during the early 1970s. Abroad they were considered the epitome of English eccentricity even though Gilbert was of Italian origin. He was born in the Dolomites, South Tyrol in 1943 and George was born in Devon in 1942. After meeting in 1967, while students at St Martin's, London, they decided to live together and to join forces as artists. They renounced their surnames and collapsed the distinction between art and life by becoming a pair of 'living sculptures'. (Posing as statues was something they borrowed from Piero Manzoni and shared with Bruce McLean and the Nice Style pose band.) Their rapid success was due to their total commitment to Art with a capital 'A', their productivity and versatility: they gave performances, made postal sculptures, artists' books, drawings, paintings, photographs, films and videos. Everything they made was executed with meticulous artisanship and immaculately presented.

They soon removed any signs of handwork because it was redolent of individual expression and specialized in the production of photopieces made from multiple images, which eventually became huge, colourful photomurals with an emblematic quality resembling stainedglass windows and billboard advertising. Photography and montage were thus two characteristics they had in common with certain leftwing artists of the period. However, G & G's politics were puzzling because of their invented personae – which caused doubt as to who was speaking – and because their art was a blend of radical and reactionary elements. (A more detailed analysis of their controversial 1978 work *Paki* appears in Chapter 8.) For example, in the late 1960s, their rigid body language and gentlemanly appearance was at odds with the long hair and loose clothing of hippie fashion and so was both conservative and non-conformist.

Their art world success was also due to assiduous self-promotion and clever marketing. They devised an instantly recognisable brand image: traditional suits, faces and hands covered with metallic paint, which was especially effective when communicated by the robot-style

musical performance *Underneath the Arches* (1969–73) given in galleries throughout Europe, in New York and in Australia.

Furthermore, unlike other 'conceptualists', their art was entertaining and as direct and simple as Warhol's. Most of their imagery was descriptive rather than analytical. It had accessible subject matter and meanings: narcissistically, they created a world in which they were the principal actors; but their art also developed strong formal qualities, such as symmetrical patterns and vivid, non-naturalistic colouring.

Commercial success enabled them to indulge in a period of yobbish behaviour – drunken binges and fighting that led to arrests by the police. As artists, they thought of themselves as social outsiders just like the alcoholic tramps they encountered near their house in Fournier St, Spitalfields. For a time, G & G made their drinking habits the theme of their art. A videotape they recorded in the summer of 1972 showing them drinking Gordon's gin at home – *Gordon's makes us Drunk* – was entertaining enough to function as a television commercial except for the fact that it was too frank about the intoxicating effect of alcohol. (The video was issued in an edition of 25 and the Tate Gallery acquired one.) However, their iconography also encompassed the English landscape, both rural and urban, and various types of Londoners. Most of their pictures included portraits of themselves gazing voyeuristically at their human subjects, who were invariably male because G & G thought women had been 'used up in art'. Observers surmised that G & G were homosexuals but the artists did not openly support the burgeoning Gay Liberation Movement. (George was also married with a child in the early 1970s.) In a 1997 interview, they declared that they did not believe in gay or straight, male or female![15] This was because they felt such categories did not do justice to the complexity of human beings. They also wanted to preserve a sense of mystery as to their sexual habits. Although G & G were to be included in histories of homoerotic art and once organized an exhibition/sale to benefit Aids' charities, they told the writer Daniel Farson: 'We never did gay art, we *never* did, *ever*.'[16]

It was no wonder then that G & G intrigued curators, dealers, gallery-goers and the mass media and soon became celebrities akin to those in the realm of pop music. According to the critic Brian Sewell, one of the reasons for their cult status was 'a pathetically weak and puerile art establishment'.[17] In their published statements – written in an absurd, precious style – they also espoused a philosophy of 'Art for All' that can be regarded as a parody of the democratic agenda of the Arts Council and the popular ambition of British and German socialist artists active in the 1970s.

Later in the decade, in an effort to give their work a more radical edge, G & G flirted with 'shocking' subjects and motifs, such as dirty words, obscene graffiti and swastikas. They defended their use of the swastika by pointing out it had once been a good luck symbol. In the 1990s, their subjects included their own blood, urine, excrement and sperm, and they appeared naked baring their genitals and anuses to the camera. Even so, their art was never shocking enough to preclude official recognition, sales and shows in major public galleries.

Left-wing artists and critics paid heed to G & G during the 1970s because they were so visible, because their technical achievements were impressive, because a harsh social reality of life on the streets of London was depicted in certain photo-series and because their pronouncements and politics were so peculiar: in a fit of nationalism, G & G once described Picasso as a 'foreign dago wanker'. Insulting remarks and perverse opinions aired in interviews were almost certainly calculated to cause confusion and to provoke controversy and media coverage.

By the 1980s, G & G were supporting the British Royal family and expressing admiration for the Tory Prime Minister Margaret Thatcher. In the same decade, the critic Peter Fuller dismissed them as 'tedious poseurs' and their work as 'empty drivel'. Roger Scruton, a right-wing philosopher, thought their art was easy to understand because it contained nothing to understand, since it was 'empty rhetoric'. Other writers accused them of fascism, misogyny and racism. The artists, for their part, complained about 'witch-hunting lefties' and

told one journalist: 'We are sick and tired of artists wanting to be Marxists.'[18]

Barry Flanagan (b. 1941), who had trained at St Martin's in the mid-1960s, was probably the nearest to an orthodox sculptor appearing in 'The New Art', even though he then preferred materials such as canvas, fibreglass, rope, sandbags and sticks to bronze, clay and marble. Something quirky about his seemingly casual abstract assemblages provoked a physical response from audiences and his works were vandalized both inside and outside galleries.

One way in which contemporary art could reach a public broader than the art world, was via the genre of public or civic sculpture. In 1972, a foundation established by the international tobacco company Peter Stuyvesant funded a nationwide project involving the placing of sculptures by 16 contemporary artists in eight cities across Britain. The sculptures were to remain for six months so that local people could become familiar with them and the contextual information that was also to be provided. By these means, the organizers hoped to persuade the public to appreciate contemporary art. At the end of the six months, the sculptures were offered for sale to local councils at bargain prices but the majority of cities refused to buy them.

In Cambridge, Flanagan's sculpture *Vertical Judicial Grouping* was attacked and gradually dismantled by, it turned out when police arrested them, members of the nation's elite – undergraduate students – egged on by a local vicar.[19] Such incidents led to numerous discussions in the art press about what the critic Lawrence Alloway dubbed 'the public sculpture problem'. Some writers believed the problem lay with those sculptors who were incapable of communicating in 'a language' comprehensible to ordinary people, but at least one British artist – William Turnbull – blamed the ignorance of the public. During the 1970s, a significant number of contemporary artists tried to solve the problem and to devise new forms of art that would be accessible to those outside the art world. Flanagan's personal solution was to revert to representational sculptures (of animals such as hares) made from sculpture's traditional materials (such as clay and bronze).

The fact that a private, industrial company funded the 'City Sculpture Project '72' was a sign of things to come. To foster the relationship between art and business, an organization – the Association for Business Sponsorship of the Arts (ABSA) – was founded in London in 1976, and during the 1980s this kind of patronage became commonplace.

As far as many businesses were concerned, trade unions – which loomed large in the 1970s – were a nuisance. On the one hand, the power of organized labour proved capable of bringing down British governments (the miners and the Tory government of Edward Heath in 1974), while, on the other hand, some employers were able to prevent their employees from forming or joining unions. Both Labour and Conservative governments attempted to restrict trade union power and workers' claims for wage increases. Because of the infamous 'Winter of Discontent' (1978–79), many voters concluded that trade unions had become too powerful and elected a Conservative government that would reduce their influence via new legislation and the privatisation of nationalized industries.

Most left-wing artists were sympathetic to the struggles of trade unionists and some assisted them during strikes and by designing banners. Indeed, Conrad Atkinson has claimed that his exhibition 'Strike at Brannans' (ICA, May 1972), a documentation of a year-long strike about hazardous working conditions at Brannan's thermometer factory in Cumbria, persuaded workers at another Brannan factory in South London to unionize. However, despite the media attention the ICA show generated, the strikers in the North West – two of whom came to talk at the ICA – experienced a bitter defeat.

Artists themselves were not exempt from the appeal of belonging to a union. British actors, musicians and designers belonged to unions, so why not the nation's visual artists? However, as critics pointed out at the time, there were formidable obstacles in the way and many questions needed answering. For instance: Who counted as an artist? What training and qualifications, if any, should they possess? Should anyone claiming to be an artist, even amateurs, be able to join? (Not

just anyone can legitimately claim to be a surgeon or a pilot.) Should artists form their own, independent union or should they become a branch of an existing union?

Most artists did not have any employer with whom to negotiate, against whom to strike. If they earned a living from teaching rather than from art, then they might already belong to a lecturer's union such as NATFHE. Financially successful artists, who were already selling their work to collectors and under contract to dealers, had little incentive to join a union.

In certain respects, artists were more like small manufacturers of luxury goods, or self-employed/freelance specialists whose income derived from various sources, some public and some private, than they were like blue-collar employees in a factory. Performance artists did not have a physical product to sell; they received fees and expenses for each event; consequently, they resembled actors and musicians more than object-makers. Furthermore, artists were geographically dispersed and frequently competed against one another for puny resources. Attending union meetings, fund-raising, keeping records, recruiting and organizing were deterrents because artists had less time to devote to their art. If full-time union officials were to be appointed, then they would need a wage but paying union dues would burden artists on low incomes.

Some critics thought that a professional association to act as a pressure group and to uphold standards – such as the Association of Art Historians formed by British art historians in 1974 – was a more appropriate type of organization for artists than a trade union. (One was formed later in 1988: the National Artists Association.)

Despite these difficulties, a core of artists persisted and in spring 1972, the Artists' Union (AU) was formed in Camden Studios, London. Its constitution was ratified in May and monthly meetings were held at the ICA, which also provided office facilities. AU's members included: Conrad Atkinson and Margaret Harrison (husband and wife), Barry Barker, Stuart Brisley, Marc Chaimowicz, Stuart Edwards, Gareth Evans, Gerry Hunt and Kay Fido Hunt

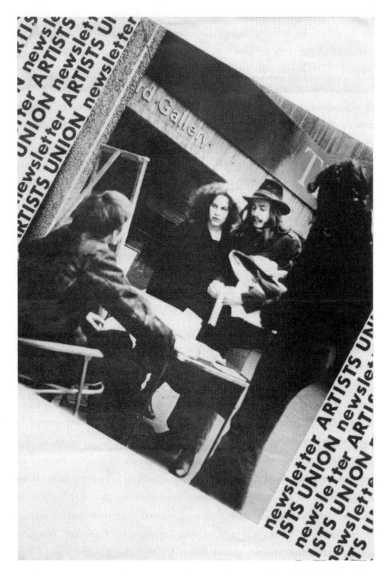

9. Cover of the Artists' Union *Newsletter*, No 1 (1972). Photo shows Mary Kelly (on right) and two others recruiting outside the Hayward Gallery at the time of 'The New Art' show. 120 new members were recruited.

(husband and wife), Carol Kenna, Robin Klassnik, Don Mason, Gustav Metzger, Jeff Sawtell, Colin Sheffield and Peter Sylveire. For a time Mary Kelly was its Chairman (sic). Regional branches were established and membership reached 400.

The main aims of the AU were: to promote and protect the economic and cultural interests of members and artists in general; to regulate relations between members and patrons; to campaign for democratic reform of national bodies concerned with art patronage and for greatly increased national expenditure on art; to promote participation by artists in local government and regional bodies; to campaign for legislation for the benefit of artists; to seek affiliation to the Trades Union Congress (TUC) and to support the Labour Movement in general.

A legal document was drawn up in order to give artists *droit de suite* (resale rights). Artists on the continent of Europe enjoyed these rights for many years but it was not until 2000 that they began to apply to British artists.

Since the art market in Britain was weak in the early 1970s, the main source of patronage for many artists was the state: the Arts Council and local government arts organizations. It was for this reason the AU stressed how important it was that the needs and rights of artists were represented and their views made clear to state bodies. Ideally, the AU should also have representatives on committees so that they could influence policy-making.

The AU was a worthwhile attempt to overcome the endemic individualism and isolation of artistic practice and to raise the consciousness of artists in respect of their social relations of production. Perhaps the most productive and educational activities were those of the various subcommittees/workshops that were set up: Women's Group, Exhibition, Government Policy for the Arts, Trade Union Workshop, Artists in Education, and so on.

Passionate debates occurred in many of these workshops because different political ideologies and strategies vied for dominance. From the perspective of revolutionaries, trade unions are of limited value

because they are primarily defensive/reformist organizations. This is why certain members wanted the AU to become a revolutionary organization. However, representatives from the League of Socialist Artists – who infiltrated the Art-Workers' Subcommittee and who characterized artists as 'petty-bourgeois individuals haunted by the fear of proletarianisation' – argued against the 'ultra-left, pseudo-revolutionaries, Trotskyists' on the grounds that artists had first to learn the basics of class struggle. They thought the AU should not become a political organization because such organizations already existed. Eventually, LSA members withdrew in the face of 'the confirmed reactionary role being fulfilled by the organization'. As the LSA pointed out, the AU had almost no wage-earning, employed art-workers among its membership and, in their view, this fundamental absence made a trade union in the traditional sense a virtual impossibility.

Nevertheless, by the end of the decade, the AU's Chairman – Charles Gosford – was claiming that it had a national structure and network of branches, that it held an annual conference, had subcommittees concerned with contracts, social security and taxes, and was represented on bodies concerned with copyright and censorship. It is clear therefore that as a pressure group for artists the AU was active across a broad range of fronts.[20]

On May Day 1971, Dugger and Medalla founded 'a movement for people's culture', which they named the Artists Liberation Front (ALF) and then designed a banner. In 1972, they were photographed holding it while sitting on top of a pavilion at the international art show 'Documenta 5'. The banner, which was stolen during the show, featured the slogan 'socialist art through socialist revolution' beneath a horizontal row of images of the famous male revolutionaries Marx, Engels, Lenin, Stalin and Mao. The inclusion of the dictator and mass-murderer Stalin, rather than Trotsky or Rosa Luxemburg, indicated a lack of discrimination on the part of the two artists. Their banner was also deadly dull in terms of design. This was something Dugger remedied a few years later when he began to specialize in making banners.

Dugger's and Medalla's 'People's Participation Pavilion' was built by a team of local workers and located in a corner of the garden of Kassel's Museum Fredericianum. The 22-metre-long, wooden structure resembled a communal house of the East. Naturally, it was painted a lurid red. In front were two soap bubble machines and scrolls with calligraphic poems by Lu Xun, while on the roof was one of Graham Stevens' inflatables. To enter the Pavilion, visitors had to take their shoes off in order to wade through a water tank, which was intended to deter arts bureaucrats. Inside there were grass mats and installations that included Medalla's *A Stitch in Time* and Dugger's *Snake Pit and Gold Bars*, which featured a live snake! There were also posters concerning liberation struggles.

Dugger and Medalla were keenly aware of conditions in Third World nations – neo-colonialism, poverty, exploitation, repressive regimes, police and military brutality and torture – and for a time they looked to communist China because it was supporting liberation struggles. (As indicated in Chapter 7, Maoism influenced a number of other artists in London during the 1970s.) Dugger visited China in the summer of 1972 (at a time when it was illegal for Americans to do so) as co-leader of a delegation from the Society for Anglo-Chinese Understanding, in order to learn what role artists were playing in the building of a new socialist society.[21] He found that professional artists were paid wages by the state and given free materials and travelling expenses. In return, they were expected to serve the people rather than themselves and to revise their work in response to group criticism. Exhilarated by what he saw and heard, Dugger read Chairman Mao's writings on art with renewed interest and returned to Britain determined to adapt Maoist principles to the very different context of the West.

In China there was not a succession of avant-garde movements based on formal innovations, but an attempt to achieve a unity of the past and present – following Mao's precept 'Heed the old to bring forth the new'. Dugger communicated this idea via the project 'People Weave a House!' organized at the ICA during November–December 1972.

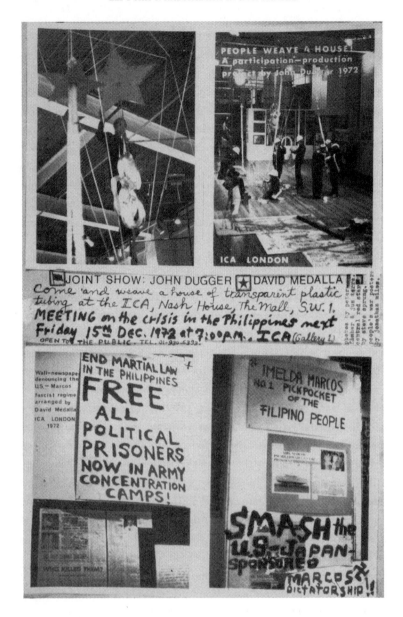

10. John Dugger and David Medalla, *People Weave a House*, four photos showing events and wall newspapers at the ICA in December 1972, plus captions. Documentation supplied by Medalla to *Time Out*, (15–21 December 1972), p 15. Reproduced courtesy of Dugger and Medalla.

Weaving was an ancient craft but the material of construction Dugger chose was modern, that is, transparent plastic tubing (five and half miles of it, donated by the collector and industrialist Alistair McAlpine). A 'production brigade' of voluntary labour was formed with Dugger as Head. Spells of labour were interspersed by political discussions led by Medalla in his role as Head of Cultural Propaganda. In addition, music and puppet shows were provided by Jun Terra, another Filipino artist, and traditional Chinese dance exercises by Helen Lai. Brett organized documentation about woven houses and participation.

Again, the aims of the ICA show were to raise artistic and political consciousness and to demonstrate the value of communal labour. The ALF's idealistic desire to 'involve the masses' was somewhat vitiated by the fact that the ICA – a private organization which required membership fees – did not attract that many visitors and the majority were artists and art students rather than industrial or office workers. Nevertheless, it was refreshing for visitors to art galleries to be able to meet and converse with artists in addition to contemplating what they had made. The political value of such shows was more metaphorical than actual, although when Medalla launched what he called 'investigation art' with his work *The International Dust Market*, at the Ikon Gallery, Birmingham in February 1972 at the time of a miners' strike for higher wages, some miners did participate.

During the course of the ICA exhibition, Medalla and Jonathan Miles pasted up agit-prop posters and newspaper reports about the imposition of martial law in the Philippines by Marcos's 'fascist' regime. Slogans included: 'End martial law ... Free all political prisoners now in army concentration camps!' 'Imelda Marcos, No. 1 pickpocket of the Filipino people', 'Smash the US-Japan-sponsored Marcos dictatorship!' However, Medalla had to wait a long time for his wishes to become reality: it was not until 1986 that the Marcos couple were deposed and fled into exile.

Towards the end of the 1970s, Medalla became disillusioned with life in Britain. He told one interviewer it was the most philistine

society he had encountered. Furthermore, while in Lambeth, South London, in 1979, he was assaulted by a gang of racist youths. Therefore, in 1980, Medalla resumed his nomadic existence and concentrated on painting and performance. (Although, he did return to England and currently lives in Bracknell, Berkshire.) He is more an international rather than a Filipino-British artist because he has lived and worked in so many countries. Since he came from 'the margins' and has been marginalized in many national histories of art, the French critic Pierre Restany dubbed him 'the marginal artist *par excellence*'. Bryan Robertson, once Director of the Whitechapel Art Gallery, who knew Medalla in the 1960s, described him as 'a sexy young character, but ... monumentally ungifted'.[22] However, because Medalla has worked in so many media and places, there are few observers qualified to judge his entire *oeuvre*. While he has generated a stream of artefacts – paintings, collages, drawings, poems and sculptures – much of his activity has been spontaneous and transitory and so has not lent itself to preservation in museums.

Medalla's art has struck certain critics as lightweight. Nevertheless, he does have British admirers: the critic and curator Guy Brett, for example. Rosetta Brooks has also praised him precisely because of his light touch: 'The magic of Medalla's work is the way in which he invariably manages to touch ever so lightly on issues of a cosmic and political magnitude. His art always seeks a lightness . . . ' She then characterized him as an 'international flaneur'.[23] 'Flaneur' suggests a detached observer but Medalla was surely an effective catalyst and tireless organizer.

Regarding Medalla's cultural identity, Brett has argued that he is equally at home in East and West, that he is truly avant-garde but simultaneously Third World and that he 'epitomizes the artist in a period of the accelerating mix-up of cultures, without exclusivity. . .'[24] Thus, it would seem that Medalla was/is a benign symptom of globalization.

Chapter 4

1973

The 'Yom Kippur' war between Egypt and Israel took place, because of which the OPEC nations imposed an oil embargo that triggered an economic recession in the West. The Vietnam War ended as far as the United States was concerned when a ceasefire was agreed in Paris and American prisoners were released. Nixon and Brezhnev signed the SALT, arms limitation, agreement. The Watergate scandal in America damaged Nixon. An army coup in Chile resulted in the killing of President Allende, leader of a democratically elected Marxist government, who was replaced by General Pinochet. Britain, Ireland and Denmark joined the European Economic Community. IRA bomb attacks occurred in Northern Ireland. A Royal wedding took place: Princess Anne married Captain Mark Phillips. The first graduates of the Open University received their awards. The actress Vanessa Redgrave joined the Workers' Revolutionary Party. Elvis Presley gave a concert in Hawaii that was transmitted by satellite television. Al Pacino starred in the police drama *Serpico* and Fred Zinnerman's movie *Day of the Jackal* proved popular. Marlon Brando starred in and Bernardo Bertolucci directed *Last Tango in Paris*. Clint Eastwood directed and starred in the Western *High Plains Drifter* and Yul Brynner appeared in *Westworld*, a film about a future, simulated environment. Peter Wollen's book *Signs and Meaning in the Cinema* and Karl Marx's *Grundrisse* were published. The *Ecologist* magazine published 'Blueprint for Survival', which led to the founding of the British Ecology Party (later renamed the Green Party). E.F. Schumacher's book *Small is Beautiful* also appeared.

Andy Warhol visited China and subsequently produced a series of

huge portraits of Chairman Mao. At the Edinburgh Festival, works by Austrian artists were exhibited and Beuys gave a 12-hour lecture on creativity. The Arts Council and the Videogalerie Schum mounted the first British exhibition of video art entitled 'Identifications' at two venues in London. At the Swiss Cottage Library, London an exhibition of feminist art called 'Womanpower' proved controversial. The Women's Fine Art Alliance was founded and *Art and Artists* published a special issue on women's art edited by Carla Liss. *Spare Rib* published a feminist critique of Allen Jones' 'erotic' pop art by Laura Mulvey. Gallery House closed. The Palais des Beaux Arts, Brussels, mounted the exhibition of British art 'From Henry Moore to Gilbert & George'. An exhibition of American photo-realist paintings was held at the Serpentine Gallery. William Turnbull and Robyn Denny were given retrospective shows at the Tate Gallery. The British sculptor Michael Sandle returned from Canada but then moved to Germany. A huge art deco store in Kensington was taken over by the fashion company Biba but it was not a commercial success. The Walker Art Gallery in Liverpool mounted a group show of British art entitled 'Magic and Strong Medicine'. At the ICA, the show 'Illusion in Art and Nature' took place and a month of events devoted to French Culture. At the Whitechapel, Derek Boshier had a retrospective and John Gorman curated a display of trade union banners entitled 'Banner Bright'. Theo Crosby organized 'The Environment Game', about the built environment, at the Hayward Gallery. Judy Clark exhibited at Garage, in London. Terry Atkinson resigned from his teaching post at Lanchester Polytechnic when the Art Theory course ended. Artist William Furlong founded the audiocassette magazine *Audio Arts*. In December, *Studio International* published an 'Art Theory & Practice' supplement. An alternative exhibition space called 'The Gallery' was opened in Lisson St, London by the artist Nicholas Wegner. In June, a National Conference on Art Education was organized by the Artists' Union. T.J. Clark's books *Image of the People* and *The Absolute Bourgeois*, John Stezaker's booklet *Beyond 'Art for Art's Sake'*, *a propos Mundus* and Lucy Lippard's book *Six Years: The*

Dematerialization of the Art Object, were published. Picasso died, leaving an estate worth £650 million and the American artist Robert Smithson was killed in a plane crash.

A number of 'alternative' art galleries were established during the 1970s, which provided spaces for artists to meet, organize, perform and exhibit works by artists ignored by existing dealers. One of the most curious and exciting was The Gallery, two first-floor rooms in Lisson St, Marylebone just round the corner from Nicholas Logsdail's upmarket Lisson Gallery. Nicholas Wegner and some friends founded it in the autumn of 1972. Wegner was born in Bromley, Kent in 1948 and studied painting at the Slade from 1966 to 1970. He turned his studio into a gallery space by painting it white and by assuming the title of Director. He then began to collaborate with other artists, in particular the 'pun' sculptor Vaughan Grylls (their partnership lasted from 1973 to 1975). They also attempted to collaborate with several commercial companies. The space's name emulated that of Warhol's New York studio – The Factory – and indeed Warhol was an inspiration for both Wegner and Grylls. Their enterprise was an artists' venture more than a conventional gallery.

The Gallery passed through several phases. At first, the shows – which often only lasted a few days – were humorous and ridiculed recent fashions in art: an invented land artist called Robert Lang took walks along Oxford Street taking photographs at intervals. (A dart directed at Richard Long and his rural excursions.) A book – by the 'Walsall Art Language Group' – parodied the habit of chaining conceptual art texts to tables to prevent theft: it had a stake driven through it so that it could not be opened. Fake Jackson Pollocks were painted in seconds. Openings attracted amused art students and young artists. Gilbert & George visited and even purchased a work for their personal collection of bad art.

The Gallery's jokes at the expense of contemporary art reached a climax when Peter Cook, Director of the ICA, invited Wegner to curate the conceptual art section of the 'Summerstudio Exhibition' of 1973. Works by 12 artists – all fictional – were displayed, including a

tea chest that served as a wishing well (to wish for a work of art). Only a few coins were deposited. A naïve young woman, employed by the ICA as a guide, escorted a critic around the show, but it was evident from her comments that she had no idea it was all a prank. This incident demonstrated how narrow the line was between authentic and fake conceptual art.

Then, in the autumn of 1973, The Gallery became more serious and photography was adopted as a primary medium because it enabled disparate source material to be adapted to a common format. Display units and photo panels/murals were generated and a graphic house style dependent upon a black/white contrast emerged. Wegner later introduced the expression 'standard art'. Shows were mounted about such offbeat subjects as bungalows, coalmines, drug abuse in Maine and floods in Egypt.

Grylls was born in Newark in 1943 and studied at Goldsmiths' and the Slade during the late 1960s. Initially, he combined quirky sculptures with verbal jokes but later he devised panoramas made from multiple photographs. In 1973, he made a trip to the United States where he saw the Kodak galleries in Manhattan and was impressed by their display style. His first show in The Gallery, held in October 1973, consisted of floor-to-ceiling enlargements of press photographs of the signing of the Vietnam peace treaty – between North and South Vietnam and the United States – in Paris, in January of that year. As in the case of Warhol's paintings, 'hot' subjects were dealt with in a 'cool' manner.

Grylls also visited Belfast to take colour photographs of life in the streets. His intention was to counter sensational mass media representations of 'the troubles' by depicting banal, everyday scenes. Nevertheless, his images included patrolling soldiers and army vehicles. For his show 'Belfast in Art' (1974), he selected the six 'least interesting' snapshots. (At times, Wegner and Grylls' ironic detachment was inhuman.) An Irish Art Group visited and asked: 'Did you have permission from the army to stage this exhibition?' They also commented that a café appearing in one photo no longer existed

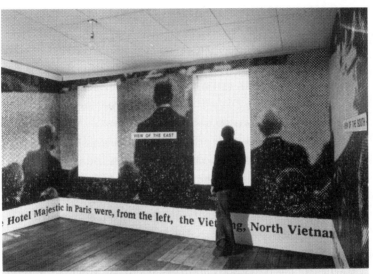

11. Vaughan Grylls, *An Indo-Chinese Punsculpture*, (October 1973). Photomural installation at The Gallery, London, plus the *New York Times* newspaper source material. Photos courtesy of Nicholas Wegner, CV/Visual Arts Research Archive, London.

because a bomb had recently exploded there and blown a man's head off.

For one show, business sponsorship was sought and for another homage was paid to the famous American art magazine *Artforum*. The most controversial work of 1974 proved to be *Contemporary Art*, a photo panel consisting of details 'appropriated' from the works of eight internationally known artists who included the Italian Mario Merz. He attended the private view in the company of the dealer Jack Wendler (an American), who was furious because The Gallery had not sought permission to reproduce the artist's work. Wendler took a photograph of the offending panel, threatened legal action and then stormed out. The Gallery accommodated even art history and theory; witness the slide-tape presentation 'Art Diagrams' (1975) by the critic John A. Walker who had reviewed several earlier exhibitions for *Studio International*.

Gradually, The Gallery's impersonation of an avant-garde venue became more convincing as shows were organized in association with recognized figures such as Rita Donagh, John Latham, Gerald Newman and Stephen Willats.

Latham had begun the decade with an exhibition at the Lisson Gallery. Subsequently, he had three shows at The Gallery: 'Offer for Sale' (1974), 'THE' (1976) [a time-based roller of 1975], and 'Government of the First and Thirteenth Chair/Erth' (1978). Wegner was also heavily involved in the preparation of Latham's 1976 retrospective exhibition 'State of Mind' held in Düsseldorf and at the Tate Gallery, London, and in the design of its catalogue. (Rosetta Brooks and John Stezaker, both fans of Latham, wrote the text for the catalogue.) Thus, The Gallery was instrumental in enhancing Latham's reputation during the 1970s both at home and abroad.

Eventually, even explicitly political displays were mounted such as Jonathan Miles' photomontage exhibit entitled 'Global Route' (1976). Wegner then made a trip to New York where he visited Warhol and showed him a photo-documentation of The Gallery's evolution. While viewing the black and white images of the black and white displays, Warhol kept asking what colours had been employed.

In 1977, Wegner decided to turn The Gallery back into a private studio in order to concentrate on his own work, which at that time monitored the news as depicted on television and in tabloid newspapers. Wegner closed The Gallery in 1978 having achieved what he had set out to accomplish. He had never thought of it as a business and had subsidized it with income from part-time teaching and by sharing costs with exhibiting artists. Financially, it had not made a profit, but no loss either. It was not without influence: dealers noted who was shown there and later took on some of the artists.[1]

British art schools trained far more fine artists than the art market could sustain; consequently, many budding artists felt excluded. This was one reason why a demand for change gathered impetus. In any case, for radical artists such as Metzger, commercial galleries were problematic because they reinforced the artwork as a commodity sold to a small elite of affluent, middle-class buyers. Publicly funded galleries were more acceptable because they reached a wider audience and were less dominated by mercantile considerations; even so, they were not ideal. The relationship between radical artists and the gallery system thus became a much-debated issue during the 1970s.

In order to canvas opinion and to reach some conclusions, the British artist Tony Rickaby issued a questionnaire to *circa* 150 artists, critics, curators and dealers in Europe and North America and then exhibited the replies in the London gallery called Art Net ('Radical Attitudes to the Gallery', June–July, 1977). Art Net was then directed by Peter Cook and subsided by Alistair McAlpine, an industrialist who was also Treasurer of the Conservative party. Three years later, the texts were reprinted in a thematic issue of *Studio International*.[2]

As one might expect, there were various views about what radical artists should do but three options recurred. One was to avoid galleries altogether – the artist Peter Dunn baldly stated: 'A socialist cultural practice cannot be gallery-orientated' – and to seek new audiences by employing different means of communication and patronage. (For example, poster collectives, public art, book art, mail art, community murals or videos, artist-in-residence schemes, exhibiting

in non-gallery spaces, etc., etc). A second was to make use of existing galleries but to reform or subvert them; a third was for artists to establish and operate their own 'alternative' spaces as Wegner and Grylls had done. Since none of these options was completely satisfactory – each had advantages and disadvantages – what actually happened is that all three were tried. In addition, there were pragmatic artists – such as Stephen Willats – who moved back and forth between the gallery system and the wider world.

Willats was born in London in 1943 and studied at Ealing College of Art in the early 1960s. Roy Ascott, a tutor and maker of 'change paintings' was an important influence as was the scientist Gordon Pask. In 1965, Willats founded an art magazine entitled *Control* to act as a platform for what he called 'behavioural art'. (Ascott had once remarked: 'Art is now a form of behaviour.') Willats edited and published the magazine – which only appeared about once a year – and contributed many descriptive and theoretical articles about his own projects but he also opened its pages to others working in a similar manner. The magazine was not addressed to the layperson but to other specialists; consequently, it resembled small circulation science journals.

Throughout the second half of the 1960s, Willats contributed devices to exhibitions of kinetic and light art but, as in the case of Medalla, his interest gradually shifted from physical to social systems, from machines to people. In fact, from the outset, Willats had wanted to involve the audience directly and to allow them to take decisions. His ideas were strongly influenced by the behavioural social sciences and especially by cybernetics, a relatively recent science that stressed the use of feedback information to enable a system to regulate itself.

Willats developed an almost unique methodology for involving individuals, families and groups of people outside the art world, for example members of tennis clubs in Nottingham or members of different social classes resident in districts of West London and Edinburgh. He used market research and social science-type techniques,

1973

such as interdisciplinary teams of 'project operators' and interviews/
questionnaires, to elicit information from participants about their
habits and desires and then fed it back to them via 'Public Register
Boards' located in public buildings and places.

In the case of the *Edinburgh Social Model Construction Project*
(August 1973), for example, operators recruited 32 people from four
districts and the project lasted five days. Participants were given
window posters using images of the local environment and a project
file in which to keep personal records. They were also handed 'problem
sheets' to complete and asked to describe their annual holidays and
typical meals; they were then asked to imagine their ideal holidays
and meals. (A shift from description to prescription, from actuality to
the ideal.) To reveal commonalities, differences and aspirations, the
completed problem sheets were posted up on boards in each project
area. Typically, the displays resembled bulletin boards covered with
text documents, photographs and diagrams. In addition, Willats

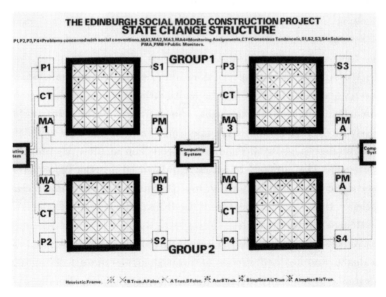

12. Stephen Willats, *The Edinburgh Social Model Construction Project, State Change Structure*
(May 1973). Diagram, 51 x 76 cm. Photo courtesy of the artist.

99

designed posters and diagrammatic/photographic panels that were more aesthetically refined and could be sold to collectors and museums.

According to Willats, the Edinburgh Project was a 'self-organising interactive system' and 'homeostatic learning system', one that constantly adapted to the information fed into it in order to restore a state of equilibrium.

In order to report back to his peer group, Willats wrote articles for *Control* magazine and *Art & Artists* and represented the various social relationships and behaviour patterns involved via abstract diagrams resembling those found in computer textbooks.[3]

Willats' intention was to alter the self-perception and social behaviour of the participants by raising their awareness of their social situations and their physical environments. 'Remodelling' was one of his favourite words. His aim, therefore, was a laudable one – knowledge and empowerment – but whether or not he succeeded only those who took part in his projects can tell.

For non-participants such as art critics, Willats' projects were hard to fathom because all the critics had to rely on was second-hand information. As James Faure Walker remarked, 'social art happens elsewhere [if it] succeeded in merging completely into the social environment it would become invisible'.[4] (What he really meant was: invisible to those in the art world – it would not be invisible to the participants.) An exception was a machine entitled *Meta Filter* (1973) that Willats installed in The Gallery in 1975. It was designed for the interaction of two people at a time and therefore enabled those in the art world to gain an insight into the actual workings of Willats' projects.

Willats did have his critical champions: Richard Cork, for example, was a keen supporter throughout the 1970s. Even those critics who found Willats' work difficult to appreciate and understand, had to admit that he was one of the few artists who really did operate outside art institutions and involve ordinary people. He was bold and brave enough to enter decaying housing estates and tower blocks and to engage with

isolated, elderly pensioners. Whereas painters worked with pigment and canvas, Willats worked with human beings, their minds and interpersonal relationships. His emphasis on interaction and participation clearly had affinities with Dugger and Medalla's part art.

At the same time, Willats was an assiduous self-publicist and networker. His tenacity in pursuit of his goals had few equals. He regularly mounted shows in art galleries and appeared in mixed exhibitions such as 'A Survey of the Avant-Garde in Britain' (Gallery House, 1972) and 'Art for Whom?' (Serpentine Gallery, 1976). In addition, he was written about and wrote articles for contemporary art magazines such as *Studio International*; he issued a blizzard of pamphlets, reports and books.[5] In short, Willats oscillated between the two realms. To be effective as a 'social artist' he had to engage with everyday life but to be recognized as an artist and to benefit from grants and teaching posts in art schools, he needed the legitimation of art world institutions. Arguably, this was another instance of feedback: he fed back to the art world information about what he and his collaborators had been doing in society so that – in exhibitions like 'Art for Whom?' – it could serve as a model of practice for other artists.

Faure Walker attacked Willats and 'social art' in general at the time of the 'Art for Whom?' exhibition. He complained about 'leaden visuals' and 'verbiage' and condemned Willats' projects as 'condescending and manipulative, experimenting on the subjects through mazelike either/or recognition tests as if they were rats learning to press Pavlovian stimulus-leavers'.[6] Willats' art did lack glamour and there was something cold and scientistic about it, perhaps manipulative – witness the rather sinister title of his magazine: *Control*. But who really exercised the control? To Faure Walker it seemed as though Willats treated human beings like rats in a maze, while others thought he abdicated the artist's responsibility by allowing his subjects to express their own opinions and to reach their own conclusions.

Willats wanted to influence society, to empower people, but the political origins and ramifications of his art-as-social-process

remained obscure. (The way people change is not always in a progressive direction – they can become fascists as well as socialists.) According to David Mellor, curator of a show of 1960s art, Willats' politics derived from anarchism: he disrupted people's routines so that they could reach a more flexible self-organization, a new order: 'For Willats this process reverberated with his own political beliefs of anarchist mutuality, an optimistic hope that human potential might still possibly re-pattern the environment.'[7] However, in Willats' writings dating from the 1960s and '70s, there are no direct references to any leading anarchist philosophers, only to experts on advertising, artificial intelligence, cybernetics, information theory, language, marketing and perception. Persistence is one of Willats' virtues: at the time of writing, he is still as active as ever.

One of the contributors to *Control* was John Stezaker even though as artists he and Willats did not have that much in common apart from an interest in social codes. Stezaker's articles continued to explore the prospects for art after Duchamp. Like Willats, Stezaker constructed an interactive machine in 1973. It was an electronic apparatus, entitled *Mundus* (World or System), which invited the viewer to play a symbolic game using a push-button control device. Panels were illuminated in sequence to display a diagram with signs representing four concepts: action, custom, learning and law. By answering questions and following alternative pathways – one subjective that held the end in view and one objective that emphasized meaning – the player eventually reached a goal – a point of synthesis – at the bottom of the machine. *Mundus* was designed as an ideal type or model of the integration of artistic theory and practice. It was functional in the sense that it simultaneously exemplified and prescribed a form of art that was intentional, logical and end-driven rather than medium-driven. Its context and operations were further discussed in an accompanying booklet written by the artist entitled *Beyond 'Art for Art's Sake', a propos Mundus*, published by Nigel Greenwood Inc.[8]

After *Mundus*, Stezaker's art underwent a drastic change. He turned towards everyday experience, specifically the reality of the

media-saturated environment, and began to make photo-collages employing imagery taken from such mass media sources as the cinema, advertising, tourist postcards and Italian photo-novels. At first, this involved the use of captions but then he dropped them because he felt they restricted the meaning and ambiguity of visual images. Collage has obsessed Stezaker ever since.

During the early 1970s, Stezaker generally exhibited at the Nigel Greenwood Gallery in South Kensington. Only initiates knew this gallery because there was no gallery frontage or sign outside. (It was really a conversion of Greenwood's private flat.) Nevertheless, along with the Lisson, it was an influential gallery. (It has since closed, but the Lisson continues to thrive.) Besides mounting shows by Bill Jacklin, Keith Milow and the abstract painter John Walker, Greenwood distributed and sold artists' books – including one by Gilbert & George – and related publications. Lynda Morris, a critic and curator, had established the gallery's bookshop.

Feminist artists were one of the groups who, with good reason, felt excluded from the existing gallery and patronage systems. Some fought to gain entry to those systems, while others were driven to adopt the separatist strategy of establishing their own galleries, art magazines and support organizations. One group, called 'Woman-power', whose approaches to Central London arts organizations and public galleries had been rejected because their art was considered aesthetically feeble, sought the help of local government. They persuaded Peter Carey, the visual arts manager of Camden Council, to allow them to show in the Swiss Cottage Library, a 1964 building that had been designed by Sir Basil Spence. During the 1960s and '70s, Camden was one of the richest and most progressive of the London boroughs. 'Exhibition on Womanpower: Women's Art' was organized by five artists – Anne Berg, Elizabeth Moore, Monica Sjöö, Beverly Skinner and Rosalind Smythe – and held in April.

The fact that the venue was a busy public building meant that the 90 paintings, drawings and posters on display were seen by a much wider cross-section of the populace than is normal for art shows.

The militant feminism of the images – some of which had stencilled lettering demanding 'wages for housework', 'abortion, a woman's right to choose' – and the artists' manifestos attacking male domination printed as a cheaply produced leaflet aroused intense interest and extreme reactions both for and against. A comments book rapidly filled with praise and insults. Some viewers found the pictures 'fantastic' and 'profoundly moving', while others thought them 'aggressive' and 'ugly'.

Following complaints about obscenity, the police's porn squad investigated but no prosecution ensued. There were also accusations of sacrilege and some parents feared that their children would be corrupted. In addition, anonymous telephone threats to deface the pictures were received. Carey vowed to defend the show with his life if necessary. A public meeting called to discuss the exhibition degenerated into screaming and uproar. A flurry of reports and reviews appeared in the national and the local press – it was dubbed a 'Women's Lib' art show – but, aside from a review in the *Guardian*, the London art world virtually ignored the event.

Eleven works were sold and Monica Sjöö's painting *God giving Birth* (1968) became famous and was later acquired by a museum in Sweden. (Sjöö lived in Bristol but had been born in Sweden in 1938. She was a mother and a self-taught artist.)

In recent years, it has also been widely reproduced in general histories of art and in books about feminist art. As a result, it has become an icon of early feminist art. This painting proved controversial because it showed a nude woman of indeterminate race in the middle of childbirth and asserted that God was female rather than male. Mara R. Witzling has described Sjöö as 'a leading figure in the international Goddess movement'.[9]

In sum, the exhibition had a bigger public impact than it would have done if it had appeared in the Serpentine or Whitechapel galleries.[10]

A few young female artists were taken up by the private gallery system. Judy Clark, for instance, was given a solo show – entitled

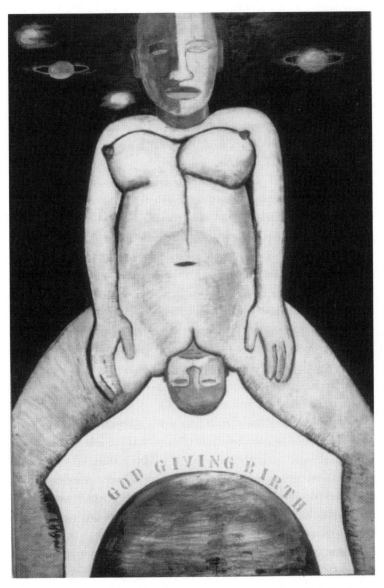

13. Monica Sjöö, *God giving Birth* (1968). Oil on hardboard, 183 x 122 cm. Skelleftea, Sweden: Museum Anna Nordlander Collection. Photo Nina Monastra, courtesy of the artist and Museum Anna Nordlander.

'Issues' – at a new Covent Garden gallery called Garage in November–December 1973, shortly after she emerged from art school. Martin Attwood and Tony Stokes managed Garage and its directors included Terence Conran and John Kasmin. Clark was born in 1949 and trained at Portsmouth Polytechnic (1967–71) and then at the Slade, London (1971–73). During the early 1970s, she also spent time in Germany where she was impressed by the work of Beuys' students and influenced by such German artists as Diter Rot and Klaus Rinke and by the Swiss sculptor Daniel Spoerri.

Much of her early work was a contribution to body art, an international tendency that had been fashionable since the 1960s at least. In Clark's case, the body was literally present in the work because she employed its waste products as her raw materials. For instance, when the critic John A. Walker commissioned a portrait in 1973, she gave him plastic bags and instructed him to collect samples of his blood, hair, nail clippings, sperm, urine, etc. These unpromising residues she then sealed and mounted (under glass) aesthetically and systematically in a minimalist-type grid at the centre of which she placed a small mirror, so that when Walker stood in front of it, the portrait was completed by the reflection of his face. Clark claimed at the time that most men were repelled by her work, especially when such materials as menstrual blood and semen were employed.

Other works involved stained first aid plasters, soiled cotton wools and 'body maps', that is, imprints of human skin created by rubbing graphite powder into the flesh and then lifting them off with sticky Fablon. Another work was made from dust collected from her flat in Hackney. In Clark's case, domestic chores such as cleaning and intimate bodily rituals such as grooming took on a new dimension. Like a forensic scientist, Clark collected evidence of human behaviour and existence; of the traces we all involuntarily leave behind, and then organized them into new patterns. Her interest in dirt and bodily residues, which most people ignore or find disgusting, was partly prompted by reading Mary Douglas' influential book *Purity and Danger: An Analysis of the Concepts of Pollution and Taboo* (first

edition 1966; Pelican paperback 1970). Douglas, a social anthropologist, defined dirt as 'matter out of place' and discussed the many social boundaries and taboos associated with it. Abjection – a psycho-analytic concept referring to what is rejected by the body – was subse-quently to become a recurring motif of much new art. Years later, Gilbert & George were also to become fascinated by their own wastes – faeces, urine and sperm – and photographed them via microscopes and then blew up the images to make huge photomurals.

Clark's art invoked primal emotions and had multiple resonances – such as witchcraft. It touched upon many issues pertaining to fem-inism without being explicitly feminist art. Female critics writing for the *Guardian* and the *Financial Times* reviewed Clark's exhibi-tion favourably and Rozsika Parker interviewed her for *Spare Rib*.[11] The Arts Council and the Tate Gallery also purchased works. In 1974, five of her drawings – charts recording where items such as hairs had been found – were selected by Michael Compton for the Arts Council's touring group show *Art as Thought Process*. However, this early attention did not result in a high-profile art world career. This was because Clark spent years living in India and Italy and became a parent. When she returned to England in the early 1980s, she found it hard to re-establish herself as an artist. At the time of writing, she earns a living by teaching at the Surrey Institute of Art and Design, Farnham but she has also resumed making and exhibit-ing art.

During the 1960s, Derek Boshier (b. 1937, Portsmouth) had achieved fame as one of a generation of pop artists who had trained at the RCA. Like so many British pop artists, he was attracted to Amer-ican iconography but there was a critical edge to his use of it in his paintings because the process of Americanization that was changing British society disturbed him. Nevertheless, he was eventually to live and work in the United States (his home is now in California). After his pop phase, he altered direction several times: for a while he made completely abstract paintings with brash colours and shaped formats; he then gave up painting for more than a decade and turned to

drawing, collage, photography and filmmaking and he also introduced more explicit political comment.

During the 1960s, Boshier spent a year in India where he mixed mainly with writers who were left wing and they influenced his thinking. He claims always to have been more interested in life than in art and was concerned that a gulf had opened between formalist avant-garde art and the tastes of ordinary people. His ambition was to make art with content that was accessible to non-specialists. He also saw no reason – other than the financial one – why he should have to remain wedded to one medium – painting – and one style – pop; hence his willingness to alter direction, to experiment with different media and to borrow from the new art movements that followed pop. (He welcomed conceptual art because he considered art was primarily about ideas rather than the medium used to communicate those ideas.) However, although he continued to exhibit in galleries and to teach in art schools, the refusal of 'consistency' did hinder his career.

In 1971, Boshier produced an artists' book entitled *16 Situations* (published by Idea Books, London), which consisted of 16 disparate photographs that had in common an abstract object or module, consisting of an oblong column and an open cube that had been inserted into the picture spaces. When *16 Situations* was presented in galleries, the physical object – which had been fabricated from Perspex and was only a few inches high – was displayed on a plinth near the photographs. The object resembled a minimal sculpture and Boshier was certainly referencing that recently fashionable art movement. In each photograph, the object appeared to be a different size: in one smaller than an insect, while in another larger than a factory. Boshier's aim was to foreground the context in which art appears, to illustrate 'the way in which an object changes a situation and the way in which the situation changes [the scale and meaning of] an object'.[12]

In the autumn of 1973, Boshier held a retrospective exhibition at the Whitechapel Art Gallery entitled 'Derek Boshier – Documentation and Work, 1959–72' (a version of which had previously toured

the country). It featured some early pop paintings and abstract shaped canvases but also presented examples of his most recent work. For instance, a series of short 16mm colour films he had made between 1968 and 1973 about the way unrelated subjects often share similar forms and about such themes as change, circularity and duality. *Reel* (1973) was the most political because it contrasted the privileged and underprivileged in British society.

However, the principal new exhibit was a sequence of over 200 photographs, collages, diagrams and drawings forming a single line placed at eye level along the gallery's walls. Context was again relevant because no one image was intended to be 'read' except in the context of its neighbours. Entitled *Change* (1972–73), it was, according to its creator, an exploration of 'change of pace, face, alteration, variation, transformation, modulation, permutation, shift, merging or difference at different times' – some of which were humorous. For example, white blobs invaded a photograph of Chinese soldiers until it became an image of trees laden with snow. In one drawing, a foreign language script divided into two parts was repeatedly abstracted until it resembled a Barnett Newman 'zip' painting.

Others concerned serious issues such as political unrest in South Africa. The starting-point for one sequence of drawings was a photograph of a Scottish terrier. Boshier isolated the terrier and made it into a black silhouette; then, frame-by-frame, he changed it into the shape of a map of South Africa; this in turn was changed into the shape of a leaping Alsatian. Another photograph at the end, clipped from a newspaper, revealed that the Alsatian was a police dog in the act of attacking a university student in Cape Town.[13] Today, of course, we are familiar with rapid metamorphoses of one thing into another on cinema and television screens via the special effect known as 'morphing'. Boshier must wish this technique had been available to him at the time.

Boshier has explained that in *Change* he wanted to evoke the cinematic even though he was employing still images. He also desired to make links to popular, time- and screen-based media because they

were familiar to the majority of the populace and he hoped this would aid their appreciation of his work.[14]

As we have seen, some of the imagery in *Change* referred to the art world and was thus likely to be understood only by insiders. As part of his research into public attitudes to art and artists, Boshier had been collecting images of artists found in the mass media, such as Kirk Douglas playing van Gogh in the 1956 movie *Lust for Life*. (An interest in mass culture is something that has persisted throughout Boshier's life.) He had been planning a volume entitled *Art Book – or How to Understand Left Wing Jewellery*, but it was never published. However, in December 1973, a collage made from his archive of pictures of artists did appear on a cover he designed for *Studio International*.

As we shall discover in Chapters 8 and 10, Boshier's concern with politics, the role of the mass media, especially newspapers, and with making art more accessible to the public was to persist throughout the decade.

Chapter 5

1974

President Nixon resigned because of the Watergate affair and was replaced by Gerald Ford. Following the death of Georges Pompidou, Giscard d'Estaing became President of France. A change of regime in Portugal ended dictatorship. Turkey invaded Cyprus. In California, the Symbionese Liberation Army kidnapped Patty Hearst. The Russian novelist Aleksandr Solzhenitsyn was expelled from the Soviet Union. In Britain, in January, there was a three-day working week due to the oil crisis and power industry disputes. Edward Heath called an election and the Labour party led by Harold Wilson won the most seats but had no overall majority. A new Ulster Executive was established in Northern Ireland but was later suspended after Protestants held a general strike against power sharing. The IRA exploded bombs in Guildford, Woolwich and Birmingham; the latter killed 21 people. The British government introduced an anti-terrorism bill to outlaw the IRA and to give the police more powers. Nurses and miners organized strikes. Five dockers were imprisoned in Pentonville Prison. Police in Red Lion Square, London allegedly killed Kevin Gately, a Warwick student, during an anti-Nazi demonstration. The Earl of Lucan vanished after murdering his children's nanny. Streaking became a fad at sports events. West Germany won the world soccer cup in Germany. Paul Newman and Robert Redford starred in *The Sting*; William Friedkin's horror movie *The Exorcist*, John Guillermin's fire disaster movie *The Towering Inferno*, Roman Polanski's *Chinatown* and Michael Winner's vigilante film *Death Wish* were popular. Dirk Bogarde played a Nazi in *The Night Porter*. Gene Hackman starred in Francis Ford Coppola's surveillance movie *The Conversation*. Mike Oldfield had a hit album with *Tubular Bells*.

Ferdinand de Saussure's *Course in General Linguistics* was published in English, Daniel Bell's *The Coming of Post-Industrial Society* and Raymond Williams' *Television – Technology and Cultural Form* appeared. Christopher Gray edited a book about the Situationists – *Leaving the 20th Century* – with illustrations by Jamie Reid. Duke Ellington and Charles Lindbergh died.

In Moscow, the authorities broke up an open-air exhibition of unofficial art with bulldozers and water cannon; visitors were beaten and five participants arrested. The international art exhibition 'Contemporanea' was held in Rome. An exhibition of drawings by Joseph Beuys called 'The Secret Block for a Secret Person in Ireland' toured Britain and Ireland. At the ICA, the show of new German art – 'Art into Society – Society into Art' – and Conrad Atkinson's exhibition 'Work, Wages and Prices' took place. 'Six from Germany' was held at the Serpentine Gallery. An *Art and Politics* conference was held at the RCA and scholars at the Centre for Contemporary Cultural Studies at Birmingham founded an 'Art and Politics Group'. John Latham presented his work *Offer for Sale* at The Gallery. In London, 'C.7500', a show of 26 American, female conceptualists organized by the critic Lucy Lippard was mounted at Warehouse, Covent Garden. The South London Women's Art Group organized a project entitled 'A Woman's Place'. The Art Meeting Place – a gallery run by artists – was opened in London and the Women's Workshop of the Artists' Union held meetings and exhibitions there. At the Tate Gallery, large-scale shows of Yves Klein and Piero Manzoni took place. Richard Cork bought artworks for the Arts Council, which then became a touring show entitled 'Beyond Painting and Sculpture'. 'British Painting 74' was held at the Hayward and featured works by 106 men and 16 women. Three long articles by Patrick Heron attacking American cultural imperialism were published in the *Guardian*. David Medalla, John Dugger, Guy Brett and Cecilia Vicuña organized an arts festival for democracy in Chile at the RCA. Medalla then squatted premises in Whitfield St, London which the group Artists for Democracy turned into a gallery. Michael Craig-Martin's controversial

work *An Oak Tree* (1973) was installed at the Rowan Gallery. Art & Language and Victor Burgin exhibited at the Lisson Gallery. Burgin's book *Work and Commentary*, *The Language of Sculpture* by William Tucker and Adrian Henri's *Environments and Happenings* were published. Nice Style, the world's first 'pose band', performed *High Up on a Baroque Palazzo* at Garage in London. The Whitechapel Art Gallery mounted a retrospective of Euan Uglow's figurative paintings. At Congress House, the TUC's Headquarters, members of the Artists' Union and the LSA organized the show 'United We Stand: Exhibition in Solidarity with the Miners'. The Arts Council produced a report entitled *Community Arts* and the Association of Community Artists was founded. Artists Now issued the report *Patronage of the Creative Artist*. The Calouste Gulbenkian Foundation began to fund a two-year programme of artists-in-residence in schools. The annual show of student art 'The Young Contemporaries' – which had ceased functioning in 1970 – was revived as 'New Contemporaries' at the Camden Arts Centre, London. Jack Hazan's frank documentary about David Hockney, *A Bigger Splash*, and Laura Mulvey and Peter Wollen's first film *Penthesilea* were released. The Independent Filmmakers Association (IFA) was founded in Britain.

In the early 1970s, it seemed evident to many observers that painting and sculpture were experiencing identity crises. Some traced painting's problems back to 1848 when the invention of photography prompted one rattled French artist – Paul Delaroche – to declare: 'From today painting is dead.' (This remark was adopted as the title of an exhibition about the origins of photography held at the Victoria & Albert Museum in 1972.) He did not anticipate a time when it would become commonplace for fine artists to use photography as their primary medium. The proliferation of new media during the nineteenth and twentieth centuries and the dominating presence of the mass media in general were two reasons for the decline in the status and influence of painting and sculpture – there was now so much more competition.

Another was the tendency of certain avant-garde artists to mix

media – in assemblages, collages, happenings and installations – so that the 'purity' of painting or sculpture was compromised. (The abstract painters and sculptors who followed Greenberg's advice to restrict themselves to the 'essential' properties of their chosen medium, were making a last-ditch effort to preserve painting and sculpture in the face of the mass media but it soon resulted in a terminal situation – no further development along the same lines was possible.)

A third reason was the vogue for conceptual art dating from the mid-1960s, which apparently took art 'beyond painting and sculpture' – the title of an exhibition organized by Richard Cork for the Arts Council that toured Britain in 1974. Cork's selection included works by Keith Arnatt, Victor Burgin, Hamish Fulton, Gilbert & George, John Hilliard and John Stezaker. In his catalogue essay, Cork claimed that the artists' decision to defy the hegemony of painting and sculpture did not necessarily indicate an attitude of rejection or hostility but rather 'a willingness to experiment with alternatives'.[1] (Cork was to curate a section of the *Arte Ingelese Oggi 1960–76* show [Milan, 1976] and to write an essay with the title 'Alternative Developments' for the catalogue, and this label gained some currency. In British art schools, such developments were categorized as 'Third Area', 'Environmental Media' and 'Time-Based Arts'.) However, at least one of the artists Cork featured was contemptuous of the older art forms: witness Burgin's dismissive descriptions of painting and sculpture as 'the anachronistic daubing of woven fabrics with coloured mud, the chipping apart of rocks and the sticking together of pipes – all in the name of timeless aesthetic values'.[2] Burgin preferred to use the English language and photography because more people understood them.

During the 1960s, artists such as Latham and Metzger had publicly demonstrated a destructive attitude towards painting and sculpture, and the American-born Susan Hiller (b. 1942), who trained as an anthropologist and came to London in 1970, had produced, with the help of others, a series of paintings of handprints, which she later

burnt. The ashes were then sealed in glass jars and placed in a bowl to become a three-dimensional work entitled *Hand Grenades* (1969–72). Her intention had been to transform works in one format into another on an annual basis, to produce relics like burial urns, traces that simultaneously pointed backwards and forwards in time.

In February 1970, John Hilliard, a recent student of St Martin's, the London art school with a reputation for sculptural innovation under the leadership of Anthony Caro, organized a public event at the New Arts Laboratory in which he and Ian Breakwell smashed three, large, abstract sculptures Hilliard had built from wood.[3] Before they did so, the constructions were wrapped in paper covered with the word 'unsculpt'; they were also offered for sale. The fact that no one wanted to buy them confirmed Hilliard's view that there was no social need or market demand for such work. He later explained his motivation for the event: 'I had become disturbed by the physical intrusion of the art object into the world, seeing it almost as a kind of pollution.'[4] Afterwards, Hilliard ceased making sculptures and concentrated on photography.

Bruce McLean (b. 1944, Glasgow), an energetic and versatile Scot resident in Barnes, London, can be cited as another artist trained at St Martin's who developed an aversion towards sculpture. In 1970 he concluded a critical review of the ICA show 'British Sculpture out of the Sixties' by remarking: 'I think they ought to sling the lot out of the window ... It's time for a re-think, or a think.'[5] A year later, he entertained audiences by performing poses on plinths that parodied Henry Moore's famous reclining figures.

A fourth reason was a decline in traditional skills such as life drawing and clay modelling: in many art schools, they were no longer taught. (If a student was making a sculpture from plastic sheet or shooting a 16mm film, then learning about vacuum forming or film editing was more useful.) Furthermore, since Duchamp's readymades had been accepted as art by major museums (against his intentions), considerable numbers of artists had decided it was sufficient to *present* found or bought objects rather than to *represent* them via a medium.

For example, at the Rowan Gallery during April and May, Michael Craig-Martin (b. 1941, Dublin) mounted an exhibition that consisted of a glass shelf and a glass of water placed high on a wall, plus a leaflet containing a philosophical self-interview. The piece was called *An Oak Tree* because, according to Craig-Martin, he had magically trans-formed the shop-acquired items into a tree merely by saying so. This work became notorious as a prime example of the 'con' in conceptual art even though it can be interpreted as a sly attack on the faith of Catholics who accept wine and wafers as the blood and body of Christ.

Yet another reason for the crises in painting and sculpture, was the tendency of younger generations of artists to subvert existing concep-tions of the two art forms by redefining them, often by broadening them to such an extent that the very terms 'painting' and 'sculpture' became virtually meaningless. For example, Gilbert & George called them-selves, their drawings, performances, photo-works and videos 'sculp-ture' and Beuys described his efforts to reform society 'social sculpture'.

A final reason was a general feeling that so much new painting and sculpture was of low quality, that too many painters and sculptors had nothing significant to say about contemporary events, and that their art forms had no social function left. (In 1979, the *London Magazine*, April/May issue, was to publish a series of articles by both artists and critics in response to a questionnaire which had asked: 'Painting 1979: A Crisis of Function?') Paintings that were empty grey monochromes and sculptures consisting of stacks of firebricks did nothing to reassure those worried about the state of the two vener-able art forms.

In 1970, the British painter Bob Law (b. 1934, London) generated huge canvases in a landscape format that were unprimed and blank apart from a black line close to the edges of the support and a date in one corner. These were statements of the minimum condition for a picture: a rectangle enclosing a void. In a statement dated 1972, Law explained that they were 'the last of complete unit picture making in Western culture easel painting ... one is forced to be aware of an idea of a painting idea, at this point one has entered into conceptual art

and my work is the transition from pictures on the wall to conceptual art in the head'. It seems even some painters recognized the terminal condition of the art form.

During 1974 and 1975, the crises were made explicit via a number of exhibitions and discussions: 'British Painting '74', selected for the Hayward Gallery by Andrew Forge with the help of some artists, held in September and October; 'Sculpture Now: Dissolution or Redefinition?' organized by Richard Cork at the RCA in November. Reviewing the painting show for *Time Out*, Sarah Kent said she had felt angry and then depressed by the morass of exhibits and their general dreariness and mediocrity.[6] Peter Fuller criticized Forge's reductive, physicalist conception of painting as 'coloured flat surfaces' and then remarked: 'Predictably, many of the paintings by new artists exhibited ... were just that: coloured, flat surfaces. They deserved all the inattention they got.'[7]

The RCA sculpture exhibition Cork curated included works by the British artists Boshier, Flanagan, Fulton, Gilbert & George and Long. Cork had been invited to deliver the Lethaby Lectures at the RCA by the then Head of Sculpture Bernard Meadows. In his final lecture, Cork predicted that sculpture would not disintegrate completely but he was convinced it had to be 'redefined' in order to play a role in society again 'rather than within a fragmented battlefield full of petty rivals pretending that their enemies simply do not exist'.[8]

Even practicing sculptors and writers on sculpture, such as William Tucker, author of the 1974 book *The Language of Sculpture*, seemed nervous about its health and prospects: witness his defensive series of essays 'What sculpture is' published in *Studio International*, (1974–75) and his exhibition 'The Condition of Sculpture: A Selection of Recent Sculpture by Younger British and Foreign Artists' (Hayward Gallery, May–July 1975). In his essays, Tucker admitted that 'the evolutionary concept of modern art' was now dead and that painting and sculpture were 'mined out, depleted'. Nevertheless, sculptures in a variety of styles continued to be made. However, on the evidence of Tucker's selection, he favoured only one kind: abstract constructions

made from metal or wood. (Thus, he ignored figurative sculptors such as John Davies, Elisabeth Frink, Raymond Mason, Nicholas Monro and Malcolm Poynter who were active during the 1970s.) The exhibition too was a stoical defence of sculpture – defined, according to formal and material criteria, as 'the language of the physical . . . free standing *things* in the world . . . subject to gravity and revealed by light . . . available to perception' – in the face of the then fashionable 'alternative developments' that Tucker despised. His definition was theoretically inadequate because it failed to distinguish between sculpture and other non-art objects found in the urban environment such as diversion road signs. What Tucker and his fellow exhibitors seemed to be after was sculpture for sculpture's sake. This meant that their constructions were primarily of interest and value to other sculptors and art students rather than to the lay public. Fuller described Tucker's exhibition as 'a tedious spectacle: room after room was filled with placements of welded I-beam, expanses of steel plate, with in effect "things".[9] Only 10,643 visitors were attracted to the exhibition, which was several thousand less than had attended 'The New Art', the conceptualism show of 1972.

Analysis of the gender of those contributing to the Hayward shows revealed the dominance of men. More male than female painters and sculptors seemed to be practicing in Britain, despite the roughly equal number of women emerging from the art schools. Did the imbalance in exhibitions merely reflect reality or was it due to the dominance of men on selection panels? Feminist artists concluded that discrimination was taking place. The action they took in response will be considered in the next chapter.

Furthermore, the rise of feminism prompted accusations that painting was a patriarchal, phallic practice, while sculpture, because of the heavy labour it required, was a macho, virile one. In reaction, some feminist artists resorted to feminine skills associated with the crafts such as sewing while others opted to use combinations of words and images (so-called 'scripto-visual' work). Kate Walker was an example of the former, while Mary Kelly was an example of the latter.

Of course, there were certain women artists who managed to achieve recognition and sales. Elisabeth Frink (1930–93), for instance, was a noted, physically strong sculptor who countered the fashion for abstract constructions by representing human figures and animals in clay, plaster and bronze.

It should be acknowledged that painting and sculpture did not expire because of the identity crises and hostility they experienced during the 1970s. In fact, in the following decade they made an emphatic return to favour among artists, collectors, dealers and curators. Even during the 1970s, the two art forms continued and towards the end of the decade, some artists – Art & Language, for instance – who had abandoned them took them up again, albeit with sardonic intent. It should also be remembered that many community artists also painted, but, of course, their street murals were not intended for sale or for display in private and public art galleries.

1974 was a year in which art's relation to politics came under intense scrutiny because of several conferences and exhibitions. The latter included: Conrad Atkinson's 'Work, Wages and Prices', a factographic display exposing inequalities in British society by juxtaposing stock exchange prices, press cuttings about the rich, photographs of people at work plus wage slips indicating their low pay. It took place in April at the ICA as part of a programme of events with the overall title of 'Alienation'. Public meetings were also arranged at the ICA to discuss art and politics.

A second exhibition – 'United We Stand' – held in April and May was organized by members of the League of Socialist Artists and the Artists' Union at Congress House, London, the headquarters of the trade unions. It was more conventional in character: expressionist/realist paintings, graphics and prints on the theme of mining by Mary Coulouris, Anthony Dorrell, Joseph Herman, Dan Jones, Maureen Scott and Ken Sprague were hung alongside paintings by the Ashington Group of miners. The show was intended as a sign of solidarity with the striking miners who played a leading role in the defeat of an Industrial Relations Act. However, members of the LSA felt no

solidarity with Atkinson because they scorned an artist who, in their opinion, merely pinned documents to walls, and then received extensive press coverage for so doing while their show was ignored. In interviews, Atkinson defended his practice and argued that even the arrangement of printed matter on the walls of the ICA necessitated aesthetic decisions.

As Burgin emerged from his conceptual art phase, he became interested in photographs again, although at first they were appropriated from the mass media rather than ones he took himself. In addition, the images were presented with text alongside. A key transitional work of this period was *Lei Feng* (1973–74), exhibited at the Lisson Gallery (May–June 1974).

It comprised nine copies of the same photograph, taken from an advertisement for Harvey's Bristol Cream, depicting a middle-class English family drinking sherry to celebrate the appearance of their daughter on the cover of *Vogue*. Subtitling the photographs was a text derived from a Chinese comic book recounting the story of a Vietnamese worker whose heroism, or personal success, was achieved through service to the community rather than in pursuit of selfish goals. Accompanying the image/caption sequence was a meta-commentary written by Burgin himself about semiotics, the science for analyzing how linguistic and pictorial signs function, with quotations from such European theorists as Umberto Eco and Christian Metz.

Lei Feng's theme was success and how it differed in two cultures. The juxtaposition of photograph and subtitle generated a series of antitheses: West/East, capitalism/communism, conspicuous consumption/frugality, individualism/collectivism and family/community. However, a question arose: 'Which side was Burgin on?' The presence of the semiotic analysis implied that his stance was that of an objective scientist who dissects the signs of East and West without committing himself to either side. Apparently, Burgin realized this was an evasive position because shortly afterwards his work became more direct and manifested a more open commitment to socialism.

Although Burgin exhibited in art galleries, sold some works to

In the Service of the People was written by Mao in
memory of the soldier Zhang Si-de. Lei-Feng knows
the essay perfectly and does not understand why he
must return to it now.

14. Victor Burgin, *Lei Feng* (1973/4). One of a series of nine photos with text and subtext, 41 x 51
cm. Photo courtesy of the artist.

public museums and earned money from writing articles and books,
his art practice was primarily subsidized from his earnings as a lec-
turer at the Polytechnic of Central London. (At the time of writing,
he still teaches.) His lectures on modernism, photography and semio-
tics were noted for their clarity and perception and proved highly influ-
ential – one of his best known students was Jo Spence – and so were
his published theoretical writings. This may explain the didactic, edu-
cational character of much of his art. However, Burgin had to endure
the sneers of the Art & Language group regarding 'semio-political'
artists and Peter Fuller's jibe that he was really an academic artist:
'The abysmal Burgin is, in fact, a salon artist, a ubiquitous Bouguer-
eau of our time.'[10]

At the RCA, in May, a well-attended conference entitled 'Art/Politics:
Theory/Practice' was held. It was an Anglo-Dutch venture prompted,
according to Su Braden, by a 'doctrinaire' group of Marxist-Leninist

students who had been meeting at the RCA for three years under the title 'Alternative Directions'. Delegates encompassed academics, artworkers, political activists and trade unionists. The Chair was Stuart Hood and the speakers and topics included: Peter de Francia, painter and RCA professor, on Marxism and art; Roger Taylor, philosopher, on art theory and practice; Toni del Renzio on art and ideology; the artist John Stezaker and theorist Peter Smith on the avant-garde; and Peter Fink, the sculptor, on Europe's New Left tendencies.

In addition, the conference considered such issues as: the relation of left-wing intellectuals to the proletariat, the production of meaning versus the production of commodities, the problem of form and content, the relation of individual artists and artists' collectives to capitalism and the relation of artists' unions to other trade unions.

Representatives of the BBK, the Dutch Artists' Union, were bemused to find that many of the papers delivered by the British speakers were excessively long and over theoretical. Reporting on the conference for *Studio International*, Braden also complained the conference was 'entirely academic' – even though groups such as Red Ladder Theatre and the Artists Liberation Front did describe their experiences of trying to put theory into practice – and therefore lacked 'active goals, plans for protests or future meetings'.[11] As explained earlier, members of the League of Socialist Artists were also extremely critical of the proceedings; indeed, they withdrew in disgust. As with most interdisciplinary gatherings, the experts in the different fields made little attempt to reach agreements – it was left to the audience to seek a synthesis. Despite its frustrations, the RCA conference was worth holding and provided many delegates with intellectual stimulus. The issues raised continued to be debated for the rest of the decade.

In September, a mass rally in support of the Chilean resistance, organized by the British Joint Labour Movement and the Chile Solidarity Campaign, was held in Trafalgar Square. Mrs Allende, widow of the President, addressed the crowd. Behind her at the base of Nelson's column was an impressive banner entitled *Chile Vencera* (1974), designed, appliquéd and embroidered by John Dugger. Its vivid expanses of red and

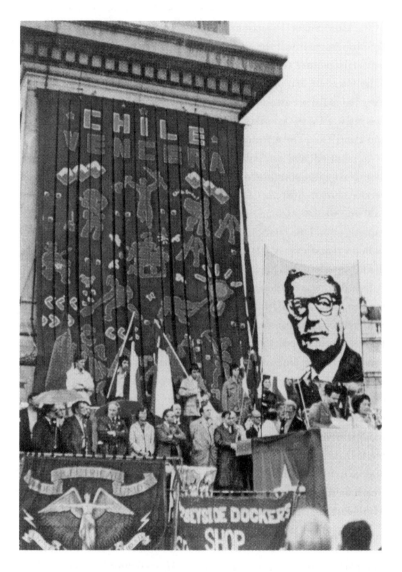

15. John Dugger, *Chile Vencera* (1974), 20 unit strip-banner, appliquéd and embroidered, 6.6 x 4.5 m, on display in Trafalgar Square, Rally for Democracy in Chile, 15 September 1974. San Francisco: artist's collection. Photo courtesy the artist.

blue and its highly simplified figures appeared modern in comparison
to the more Victorian style of the British trade union banners among
the crowd and it was the first designed according to Dugger's innova-
tive,'strip' method (described in more detail in Chapter 8).

In October, David Medalla, John Dugger, Guy Brett and Cecilia
Vicuña organized an arts festival at the RCA to assist the struggle of
democratic forces against the fascist junta that had seized power in
Chile in 1973. (The atrocities committed in Chile after the army coup
demonstrated how paper-thin is the civilization of the bourgeoisie.
This class will use military force and be ruthless if its power and prop-
erty are really threatened.) Documentation about Chile's popular
culture, poetry readings, murals, music, inflatables and a temporary
'shanty town' enlivened a hall. 600 artworks were donated to be auc-
tioned to raise money for the cause and the Chilean surrealist painter
Matta travelled from Paris to make a work *in situ*.

One consequence of the RCA festival was the organization Artists
for Democracy (AFD) that lasted from 1974 to '77. Rasheed Araeen
and Jonathan Miles were also members for a time. The following
year, AFD squatted in premises in Whitfield St and then opened a
space called the Fitzrovia Cultural Centre. Medalla was the Director
and Nick Payne was the Manager. AFD's purpose was to provide cul-
tural and material support to liberation struggles in foreign coun-
tries, but particularly those in the Third World. Artists of many
nationalities organized discussions, exhibitions, performances,
poetry readings, film and slide shows. Araeen, Tina Keane, the Fili-
pino artist Virgil Calaguian and the Irish artist Sonia Knox gave per-
formances, which, Brett has claimed, were early explorations of
autobiography and identity. One of Araeen's performances is con-
sidered in Chapter 8.

However, according to Araeen, a weakness of AFD was its failure to
address the ideological issue of cultural imperialism – the cultural rela-
tionship between the Third World and the West. Later, Medalla was
also to pinpoint another problem that AFD experienced: some artists
had little understanding of politics while some political activists

were indifferent to art.[12] This is frequently a problem when art and politics meet.

AFD lasted for three years and had, Brett has recalled, 'a turbulent history'. One of its best known achievements was a 1976 exhibit by the American Indian Movement documenting their continuing political and legal struggles at a time when the Hayward Gallery was celebrating historic North American Indian art in the exhibition 'Sacred Circles'.[13]

At the ICA, during October and November, a show of new, radical German art – 'Art into Society – Society into Art' – took place as part of a German Month of events that included lectures on the ideas of the neo-Marxist critical theorists of the Frankfurt School of Philosophy. Christos M. Joachimides, a Berlin art critic, and Norman Rosenthal, Head of Programmes at the ICA, organized the exhibition and selected seven artists – all men – who included Joseph Beuys, Hans Haacke and Klaus Staeck. This show demonstrated that the politicization of art was not confined to Britain and therefore it encouraged British, left-wing artists. However, the artist and writer Michael Daley was distinctly unimpressed. He wrote: 'The New Political Art (on this showing) turns out to be the very dampest of squibs' and concluded his review by remarking: 'This generation of political artists has contrived to give us the worst of all possible worlds – they have subverted (or perverted) art while failing to alter the art establishment by one iota and they have rendered suspect any genuine attempt to introduce political and social content back into art.'[14]

Gustav Metzger had also been invited to take part. He, of course, spanned the two nations and was then living in London. At first, he was reluctant to participate but finally he contributed a statement to the catalogue and a bibliography about art dealers to further understanding of the capitalist art system. (Daley was scornful of Metzger's ability to be both in and out of the exhibition, to have his cake and eat it too.) His reluctance stemmed from a conviction that:

The use of art for social change is bedevilled by the close integration of art

and society. The state supports art, it needs art as a cosmetic cloak to its hor-
rifying reality, and uses art to confuse, divert and entertain large numbers
of people. Even when deployed against the interests of the state, art cannot
cut loose from the umbilical cord of the state . . . Despite these problems,
artists will go on using art to change society.[15]

Metzger's argument – which Herbert Marcuse called 'repressive tol-
erance' – was confirmed by the show's sponsors: the Bowater Corpora-
tion, the Goethe Institute and the British government. The latter
allocated funds that had been earmarked by Edward Heath, when he
was Prime Minister, for promoting European culture during Britain's
run-up to joining the European Economic Community.

Metzger also called upon artists to strike for three years – 1977–80
– in order to 'bring down the art system'. The French writer Alain Jouf-
froy first proposed this idea in 1968 and, two years later, a coalition of
American artists and museum workers entitled 'The New York Art
Strike Against War, Repression and Racism' did down tools for a day
of protest. Nevertheless, Metzger's proposal was hopelessly idealistic.
The idea that successful and wealthy painters such as Francis Bacon,
David Hockney and R.B. Kitaj would strike was absurd. Virtually the
only person who later followed Metzger's example was the British
writer Stewart Home.[16]

The ICA exhibition was not simply a display of static images and
objects because discussions also took place. A symposium was held
with a panel of speakers that included the exhibition's organizers, the
German exhibitors plus the *Guardian*'s art critic Caroline Tisdall. One
of those who attended – Rasheed Araeen – found the discussion of
Germany's contribution to the international avant-garde too compla-
cent. He pointed out that the concept 'international' was being used
unproblematically so that the existence of black and Third World
artists was being ignored. Finding that his intervention was not taken
seriously, Araeen later wrote a letter to Rosenthal and Tisdall and,
when it was not answered or published, he accused them of 'a con-
spiracy of silence'.[17]

Beuys engaged visitors to the ICA in a dialogue regarding his scheme for a direct democracy via referendums. Wearing his trademark felt hat and green fishing vest, he spoke for hours while writing and drawing in chalk on a blackboard. Daley's comment was: 'While his views represent an unimpeachable affirmation of human dignity, the value of personal creativity and so on, his programme of *action* remains obscure to the point of unintelligibility.'

As mentioned earlier, Beuys employed the term 'social sculpture' to encompass the wide range of activities he pursued, thereby contributing to the expansion (or dissolution?) of the concept 'sculpture'. In Britain, only Latham – who was born in the same year as Beuys and who, like the German, had fought in the Second World War – had a comparable stylistic range, interest in science and a utopian programme rooted in the transformatory potential of avant-garde art.

In November and December Latham held a solo show called 'Offer for Sale' at The Gallery. Two documents, both entitled *Offer for Sale* and both issued by organizations with the initials APG, were photographically reproduced on a freestanding display unit. One document was a 1971 offer from the Artist Placement Group to the Arts Council and the other was an offer of shares in the Allied Polymer Group. Latham was comparing and contrasting what art and business had to offer society but adopting the language and graphic style of presentation used by the City because he had been advised that business people would only understand APG's ideas if they were couched in an idiom familiar to them. Naturally, Latham thought art had much more to offer humanity than business.[18] Since the display appeared in an art gallery, its audience was the art world rather than the business world; it may be viewed as an invitation to the former to rethink the relationship between art and economics. Visually speaking – black text on white paper with triangular symbols superimposed – and in terms of the reading/thinking required of viewers, the work *Offer for Sale* resembled conceptual art. It was typical of Latham that he would borrow from a currently fashionable movement in order to serve his own purposes.

The conflict in Northern Ireland between the nationalists and the loyalists and the British state, which spilled over onto the mainland of Britain during the 1970s, prompted responses from a number of artists in both locations. Those based in England included Conrad and Terry Atkinson, Rita Donagh, Vaughan Grylls and Susan Swale; while those based in Northern Ireland included Pat Coogan, Brian Ferran, Rowel Friers, John Kindness, Joe McWilliams and Joe Paken-ham. Two sculptors who responded to 'the troubles' were Bob Sloan and F.E. McWilliam.[19]

In the towns of Northern Ireland, loyalists painted propaganda murals on exterior walls in their ghettos; many depicted 'King Billy' on horseback. Nationalist signs included giant green shamrocks and statements such as 'You are now entering free Derry'. In both cases, there was no doubt as to which side the signs in question supported. For other artists, taking sides was more of a problem, especially if they were 'outsiders' from England with little knowledge of the history of Ireland and who were exhibiting in Belfast and Dublin. Never-theless, most left-wing artists supported the nationalist cause and agreed with the IRA's 'troops out' demand.

Rita Donagh was born in Staffordshire in 1939 but her mother was of Irish origin. Donagh studied fine art in Newcastle-upon-Tyne during the late 1950s where she was taught by Richard Hamilton (they were later to marry). Her slow, painstaking methods and precise, linear style with thin, pale washes of greys, whites and other colours were indebted to Hamilton's example. Donagh produced a whole series of paintings, drawings and collages commenting on events in Ireland during the 1970s and '80s; Hamilton followed suit in the 1980s. Both artists, therefore, remained convinced that the ancient art of painting was still of value in the contemporary world.

Donagh's *Evening Newspapers* (1974), a canvas executed in oil, newsprint and Letraset, was one example. In this instance, the subject concerns the male victim of a car bomb explosion in Talbot St, Dublin on 17 May 1974 whose body lying on the pavement was covered by newspapers. Donagh's starting point, like Hamilton's

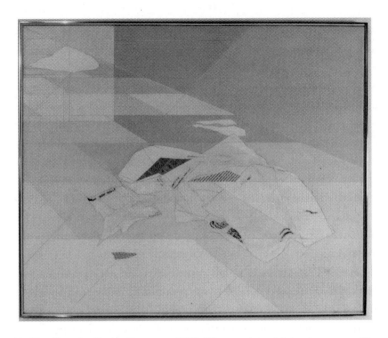

16. Rita Donagh, *Evening Newspapers* (1974). Oil, newsprint and Letraset on canvas, 62 x 77.5 cm. London, Nigel Greenwood Collection. Photo © John Mills, reproduced courtesy of the artist.

pop art, was mass media imagery and the painting's content also featured one type of mass media: the press. Newspapers cover the body and hide it from view. Newspapers also 'cover' stories, often in a brutal or sensational manner that hides the personal tragedy of the individuals involved.

While Donagh was moved by the deaths reported in the press, her pictorial response was remarkably restrained – no blood or guts, no vehement brushstrokes, no angry denunciations or partisan demands for political action. 'Hot' subjects were treated in a 'cool' but humane manner, with delicacy and subtlety. This prompted Edward Lucie-Smith to observe: 'the refinement of the design, the almost metaphysical concern with measurements and proportions' tended to remove what she did from the political arena . . . all that remained was 'a generalized, elusive melancholy'.[20] However, the writer Sarat

Maharaj has eloquently defended her work by arguing that it is an 'ethical cartography':

> ... representation about representation ... she draws us into examining the pros and cons of representation, of mulling over the choices and dilemmas involved in mapping the world ... a search for new perspectives on 'Ireland', beyond worn-out fixed ways of understanding it ... her emphasis falls on the search for critical awareness, on how meanings are made, rubbed out, revised. She avoids the forthright, full-voice address associated with art in the programmatic, committed mode.[21]

Conrad Atkinson's very different response to the situation in Ireland will be considered in Chapters 6 and 8.

During 1974, the Arts Council issued a report entitled *Community Arts*. A working party headed by Professor H.C. Baldry had been commissioned the year before to investigate the subject because of the increase in applications for grants to sustain community initiatives. The latter dated back to the 1960s and were associated with alternative bookshops, theatre groups and the so-called Arts Laboratories that had succeeded in attracting new, younger audiences.

Defining 'community' proved to be a challenge. The working party decided it often meant people living in a limited geographical area or neighbourhood but not always. (Tenants associations, new towns, hospitals, schools, youth clubs and so forth supplied ready-made communities.) In reality, the segment of the population approached was generally at the lower end of the social scale living in deprived inner city zones because residents in wealthy areas were not considered to be communities or to be in need of additional culture and skills. Since economic forces and mass media forms of culture were weakening the traditional communal values and spirit of the British working class, community art can perhaps be viewed as a last-ditch attempt to nurture and preserve those values.

Community artists, the working party thought, were better described by the French term 'animateurs'. Such individuals – more often

groups – took their work into the environment – 'streets, pubs and the like' – and tried to 'widen and deepen the sensibilities of the community . . . and so to enrich its existence'. Most community artists had a base or 'resource centre' for their operations (sometimes a mobile one) and employed a variety of facilities, media and techniques – dance, drama and writing classes, festivals, inflatables, murals, performance, photography, printing presses, play structures, video – which they used to foster public participation and to teach skills.

Since the measure of success was the extent of community involvement and creativity, process was valued more than product and 'the achievement of standards acceptable to specialists in the various art forms'. Furthermore, community art cut 'across the distinction between particular art forms' and 'the distinction between professional and amateur'. (It is important to distinguish public art – that is, paintings and sculptures made by professional artists for public places – from community art that was the result of collaboration between artists and non-professionals.) The working party could find no simple answer to the question: 'Is it art?' but did recognize that art was an open-ended concept rather than a fixed one inherited from the past.

In its conclusion, the working party recommended that the Arts Council should support community arts initiatives and that a Community Arts Panel should be established to review applications. The Council agreed, and in its first year the Panel distributed £176,000 to 57 projects.

Another organization deeply interested in community matters was/ is the Calouste Gulbenkian Foundation, a private charity established in 1956. It was named after a British oil magnate of Armenian origin – Calouste Sarkis Gulbenkian (1869–1955) – who was also a wealthy art collector. He had settled in Portugal and so the headquarters of the charity is in Lisbon; there is also a branch in London. The Gulbenkian Foundation gives grants and prizes for arts activities, education, research and social welfare programmes. In the 1970s, it commissioned Su Braden to make a study of the artists-in-residence in schools

scheme it had instituted between 1974 and '76. Braden (b. 1943, Hert-
fordshire) had trained as a sculptor at Goldsmiths' in the 1960s and
worked as a critic for the listings magazine *Time Out*; she became an
advocate of community art during the 1970s. Her research extended
beyond the Gulbenkian scheme and was eventually published in 1978
as the paperback *Artists and People*.[22] The 1970s witnessed a sig-
nificant expansion of community arts activities, which were inevitably
of variable effectiveness and quality. They reflected a strong desire on
the part of many artists to escape from the isolation of the studio, the
existing gallery system and its middle-class audience, in order to reach
out to new audiences who either had no experience of the fine arts or
were hostile to them. Naturally, dealers and collectors were indifferent
to such developments because they could not profit from them.
However, what was somewhat more surprising were the criticisms that
came from those in the art world who one might have thought would
have been sympathetic. The Art & Language Group and the League of
Socialist Artists were particularly contemptuous. A & L, in its 1975
poster *Des Warren is a Political Prisoner*, remarked: 'The art rip-off
hit its highspot in "community arts" – you know, earnest arty bores,
embarrassing people with their unfunny mime, community theatre,
inflatable sculpture.' The LSA identified a 'bourgeois cult of commu-
nity' and condemned it as: 'superficial social tinkering with the inher-
ent evils of capitalism and designed to satisfy the innate need of the
petty bourgeois servants of monopoly capital to find a suitably reward-
ing framework for their otherwise starved idealism.' Even the *Guar-
dian* published an editorial (20 December 1977) that asked
rhetorically: 'What indeed is community art but the coinage of tired
minds prepared to argue that the man who hands over his cash at the
box office is discreetly bourgeois, while the man in the pub or the
street corner is the worker whom all artists truly desire to reach?'

Among the complaints made and doubts expressed were: the word
'community' was dishonest and elided differences of class, race,
gender, etc.; community art was poor art for poor people; it was social
work masquerading as art; community artists were middle-class

do-gooders who were patronising the working class; certain community artists had political motives and were trying to convert people to their point of view, to use public monies for subversive ends; wall decorations were often a blight on the environment rather than an embellishment.

Some of the supposed beneficiaries also resisted community art. For example, local residents objected to some murals because they were inappropriate and ugly. Certainly, a number of murals were unsuited to their architectural sites and were poorly executed. Furthermore, surfaces covered with cheap paint soon became eyesores due to graffiti and weathering. However, the best community art did consult and involve local people and, surely, it was their experience and judgements that mattered rather than the opinions of outsiders. The fiercest defenders of community art were, of course, the artists who had direct experience of collaborating with ordinary people.

One mural workshop active in South East London during the 1970s was the Greenwich Mural Workshop led by the fine artists Carol Kenna and Stephen Lobb. (At the time of writing, it is still functioning.) During the hot summer of 1976, they and 30 local people designed and painted a mural on the side of a house in the working-class Floyd Road, Charlton. Sponsorship was obtained from the Arts Council, Greater London Arts, the London Borough of Greenwich and Crown Paints. Members of the Tenants Association had managed to prevent the local council from demolishing their homes and this provided the mural's subject matter. By depicting figures holding back digging machines while others painted and repaired property, the mural recommended renovation rather than wholesale redevelopment. The mural's colours were cheerful and its composition was crowded with people acting collectively, taking control of their lives and environment.[23]

In 1974, the Greater London Arts Association proposed to spend a grant of £10,000 from Thames Television on a 'let's take art to the people' scheme entitled *Eyesites*, that is, posters designed by artists for hoardings in the East End district of Tower Hamlets. Local people

who thought the scheme irrelevant to their cultural needs held protest meetings. Consequently, the Tower Hamlets Arts Project (THAP) was founded and it redirected the £10,000 to community arts initiatives. In November 1976, THAP took over the Whitechapel Art Gallery, then directed by Nicholas Serota, in order to celebrate its borough-wide activities and multifarious achievements. Maggie Pinhorn, an ex-art director, filmmaker and founder of the multimedia group Alternative Arts, used a fairground theme when designing the exhibition, which was accompanied by a grand procession, a tea party, a fireworks and water show, poetry readings and musical performances.[24]

When Sarah Kent reviewed the show, she praised the energy and variety of culture manifested but found much of it amateurish. She also doubted community art's political effectiveness and criticized its appearance in a major art gallery. She remarked:

> Community art and gallery exhibitions seem to me to be ideologically opposed: community art is justified by the quality of involvement of participants and not the end product. To present them for exhibition, therefore, seems absurd and suggests delusions of grandeur inappropriate to the purpose, function and political stance of community arts.[25]

THAP's programme of events included an Asian Arts evening and an African/West Indian concert plus performances by the British Czech Dancers and Celtic Folk Culture. The presence within British society of numerous minorities that had been formed because of waves of immigration, mostly from Britain's ex-colonies, prompted funding bodies such as the Arts Council to consider such questions as: Are black Africans and West Indians, Asians, the Irish, Greek and Turkish Cypriots, and so forth, to be regarded as communities or ethnic minorities? And should they be funded separately?

To provide answers, Naseem Kahn was commissioned by the Arts Council, the Gulbenkian Foundation and the Community Relations Commission to write a report that was published in 1976 entitled *The*

Arts Britain Ignores. Immigrants brought their own arts, crafts, customs, dress styles, languages, music and rituals with them. Was it the task of British authorities to encourage assimilation to the dominant, white European culture or to preserve the minorities' own traditional cultures? Kahn was in favour of the latter. London's Notting Hill Gate annual street carnival can be cited as a vibrant example of an organic cultural phenomenon – imported from the Caribbean – that became increasingly popular with whites (aside from the police) as well as blacks during the 1970s. It was to receive some funding from the Arts Council.

Kahn's report identified chronic under-funding and lack of recognition of Britain's ethnic arts and led to the establishment of the Minorities Arts Advisory Service (MAAS), an organization designed to implement Kahn's recommendations. Her report was not welcomed by Rasheed Araeen because he considered it ignored the situation of artists like himself: he was an immigrant from Pakistan but he was not an 'ethnic artist' because he had identified with Western modernism even before coming to Britain. As a radical black artist seeking to contribute to avant-garde art and to challenge white racism, he considered the designation 'ethnic' demeaning and a limit to his creative potential. In response to Kahn, he wrote a polemical article entitled: 'The art Britain *really* ignores' (1976), in which he accused her of 'ignorance and misrepresentation' and described her report as 'a recipe for cultural separatism'.[26] Similar criticisms were levelled against community art – it was an art of the ghetto and its scattered, local character restricted its socio-political impact.

A central issue here was the relationship between such minority arts and the dominant or mainstream culture of Britain. Even if they co-existed as separate categories, there was surely still a hierarchical structure in place because although the Arts Council proved willing to assist communities and minorities, high culture institutions such as opera houses received the bulk of its cash. Su Braden estimated that the Arts Council spent 99 per cent of its budget on the 'high' arts and only one per cent on community arts.

Concern for the cultural needs of communities and minorities was to continue well into the 1980s, especially in London when a Labour administration took control of the Greater London Council in 1981. The strength of the GLC's commitment to helping such groups was a testimony to the initiatives taken by artists, local people, the Arts Council and the Gulbenkian Foundation during the 1970s.[27]

Chapter 6

1975

The United Nations declared 1975 to be International Women's Year and shows of women's art were organized to mark the occasion. South Vietnam surrendered to North Vietnamese forces and the Americans evacuated their embassy in Saigon. The Khmer Rouge won power in Cambodia and began mass extermination. Civil wars started in Lebanon and Angola (after it gained independence from Portugal). Because of a constitutional crisis in Australia, the Governor-General sacked premier Gough Whitlam. In Britain, unemployment increased to 1 million; an Equal Pay Act for men and women became law and the Sex Discrimination Act was introduced. In a referendum, a majority of the British people voted to remain members of the EEC. North Sea oil began to flow and to benefit Britain's economy. More IRA bombs were exploded in Ireland and England. Over 40 people were killed in an underground train crash at Moorgate, London. In November, the fashion business Biba failed and its Kensington store was closed. Margaret Thatcher was elected leader of the Conservative party. The Sony Corporation marketed videocassette recorders. Popular films included: Robert Altman's *Nashville*, the erotic movie *Emmanuelle* and Steven Spielberg's shark thriller *Jaws*. Joe Dallesandro appeared in Andy Warhol's film *Trash*. Tim Curry starred in *The Rocky Horror Picture Show* and Jack Nicholson starred in *One Flew Over the Cuckoo's Nest*. *The Nightcleaners* by The Berwick Street Film Collective was screened at the Edinburgh Festival of Independent British Cinema where the event 'Brecht and Cinema/Film and Politics' was also held. Queen's pop music record *Bohemian Rhapsody*, plus the promotional video that accompanied it, was a hit. The Sex Pistols performed their first gigs in London art

schools while in Scotland the Bay City Rollers were popular. *Gay Left* was founded. Stuart Hall and Tony Jefferson edited the book *Resistance through Rituals: Youth Subcultures in Post-war Britain* and Juliet Mitchell's *Psychoanalysis and Feminism* was published. The writer John Berger and the photographer Jean Mohr collaborated to produce a book about immigrants in Europe entitled *A Seventh Man*. A rent boy in Ostia murdered the Italian film director Pier Paolo Pasolini. King Faisal of Saudi Arabia was assassinated and General Franco died.

Joanna Drew was appointed art director of the Arts Council, which established a Community Arts Committee. A John Latham retrospective 'State of Mind' was held at the Stadtische Kunsthalle, Düsseldorf. An APG seminar was held at Garage, London. A large-scale festival of video art was presented at the Serpentine Gallery and the Arnolfini Gallery, Bristol, organized the 'First Festival of Independent British Cinema'. The Tate Gallery presented a film series entitled 'Avant-garde British Landscape films'. A show of Art & Language 1966–75 took place at the Museum of Modern Art, Oxford; Terry Atkinson left the group. At the Hayward Gallery, the show 'Condition of Sculpture' prompted protests by feminists because so few women artists had been selected. In February, the exhibition 'Sweet Sixteen and Never been Shown', organized by the Women's Free Arts Alliance, was held in Camden and, in May, a 'Women and Work' exhibition was mounted at the South London Art Gallery and in Brighton. The Women Artists Collective and the radical photography group Hackney Flashers were formed. Stephen Willats' *Meta Filter* was installed at The Gallery. In New York, the radical art magazine *The Fox* was published by the Art & Language Foundation. *Artforum* published a special issue on painting. Hilton Kramer attacked this magazine for its 'muddled Marxism'. The Palestinian artist Mona Hatoum moved to London. Richard Cork took over the editorship of *Studio International* from Peter Townsend and published a thematic issue: 'Art and Photography'. Four seminars about support structures; art theory/criticism; art education; and the artist's position were organized by Richard

Cork, Robert Self and William Furlong at the P.M.J. Self Gallery, Earlham St, London. The Artists Information Registry – an artists' cooperative – opened the AIR Gallery in Shaftsbury Ave, London. Laura Mulvey's important essay 'Visual Pleasure and Narrative Cinema' appeared in *Screen* magazine. Secker and Warburg published *The Erotic Arts* by Peter Webb and Thames and Hudson published John A. Walker's *Art since Pop*. Barbara Hepworth died.

Earlier, it was claimed that the influence of American art and criticism on the British declined during the 1970s. The history of Art & Language can serve as an example. During the late 1960s, several members of the group visited New York because they considered it the world's art capital. They went to see minimal artists and to make useful contacts with younger artists who were working in a similar way. (Victor Burgin also studied in the United States at this time.) Because of these visits, collaborations began to take place between A & L and American minimalists such as Sol Lewitt and conceptualists such as Joseph Kosuth. For a while, A & L became a transatlantic organization. (There was also 'a branch' in Australia.) Its membership expanded rapidly and began to include people the group's founders considered 'hangers on'. However, collaborations proved hard to maintain because of the different centres of operation and the tensions between the group and certain artists who were unwilling to submit their work to collective scrutiny and to renounce their careers as individuals. There was also rivalry and ideological disagreements between the Americans and the British.

During the early and mid-1970s, in New York, a politicization of art and theory took place comparable to that which occurred in London at the same time. One consequence was the magazine called *The Fox* (three issues 1975–76) published by the Art & Language Foundation of New York. Although British members of A & L contributed articles to *The Fox*, some of them viewed it, according to Charles Harrison, with 'derision and dismay'. The sudden conversion of so many Americans to 'Marxism' was regarded as shallow opportunism. Efforts were made to sabotage the group and splits occurred. Several key

figures left voluntarily or were 'expelled'. (A & L increasingly resembled a religious cult or a political party.) Mel Ramsden, who had been born in England in 1944, and a few Americans then left New York and joined A & L in Oxfordshire.

By 1976, the collaboration between the British and the New Yorkers had ceased. According to the ex-members Terry Atkinson and Joseph Kosuth, all parties agreed not to use the group name 'Art & Language' again but in Britain Michael Baldwin, Ramsden and Harrison continued to do so. By the middle of the decade, therefore, it was clear to A & L (UK) that they could function perfectly well without America.[1]

Outsiders may regard the internal squabbles of art world groups such as A & L as petty and of little public interest, but they do illustrate the difficulties and challenges associated with all communal human endeavours.[2]

In September 1975, A & L (UK) held a retrospective exhibition at Oxford's Museum of Modern Art. The word 'retrospective' was treated by the artists with scepticism – in one of the catalogue's many essays they stated: 'Retrospective art shows are invariably silly and pointless' – because they doubted that their body of work would exemplify the logical historical development and coherence the word normally implied. According to Charles Harrison and Fred Orton, certain new works displayed 'took "Dialectical Materialism" (ironically) as a thematic basis for the graphic display of relations between items of discourse. These works remain difficult . . .'[3]

However, a small text poster accompanying the show was reasonably straightforward in its use of English and perhaps the most overtly political document the group had ever issued. It was addressed to visiting school children and art students and stated in bold: 'Des Warren is a political prisoner; school prepares us to connive at the survival of the ruling class. History classes are capitalist history classes . . .' By now, the name Desmond Warren has probably been forgotten. He was a communist trade unionist employed in the building trade who, in 1972, was one of the leaders of 250 strikers who intimidated lump workers who refused to join a national strike. In 1973, he

YOU'VE GOT OUT OF SCHOOL FOR A WHILE —THAT'S POSSIBLY THE ONLY GOOD ASPECT OF YOUR VISIT.

The survival of 'social life' partially but importantly depends upon a system of education; to point to the world of working/buying/selling (economics) alone as the basis of 'social life' is inaccurate. The main thing for the ruling class (do you know who they are?) is to re-produce people whose private aims will not seriously challenge the prevailing production system.

Education (not just being in school) is directed towards the reproduction of more than skills: we are forced to swallow (and do swallow) values, and we are supposed to deploy them as our own. (These values are obvious in school: consider the success of success in the classroom – however pious a few teachers may be, your success in the classroom is somebody else's failure. Can you think of any other examples?)

Now the social relations demanded by the ruling class are not just reproduced 'like nature' (i.e., because there is no alternative), they are learned. The picture of the world as consisting of objects to be consumed is forced on us as the limit to our own aims.

Remember that the wonderful-young-people-doing-ever-so-'Christian'-or-diverting-things-for-people is a social relation laid down by the ruling class.

'Cultural revolution' is not a funny exotic thing; it can be a positive educational activity in the wide framework of producing history. Cultural revolution is not associated with the mindless 'counter-culture' of pop/rock festivals. Cultural revolution is definitely not a 'modification' of the political character of institutions as they stand.

There's an ideological crisis here and now: aesthetic (e.g., wonderful thing, wonderful feeling or 'I like it') art is as stale as last week's R.I. lesson. Ideological education against official ideological 'education' is what's necessary.

Most of the stuff that's displayed on the walls here is very unexciting. It consists of a) 'slogans' of varying lengths, or b) material arranged in such a way that it might imply (suggest) ways that the ideology that's forced upon us might be replaced by a socialist alterna-tive. 'Slogans' are not all alike; they are often associated with overt moronic sales promotion of work 'propaganda' – and the latter is, of course, something that moderates don't engage in.

Obviously, we are subjected to liberal-capitalist propaganda; perhaps the differences between slogans reflect the possible types of ideo-logical propaganda.

In sneaky ways, artists are trapped as instruments of domination by the ruling class. The majority of the ruling class is, of course, absurdly philistine, but a minority is 'cultured' ... and it even wants to share its culture.

The artist is expected to hold the posh mysteries of 'talent', 'genius', 'imagination', 'creativity', etc. very close. These categories are mostly dependent on the artist's ability to persuade some mindless institution or plutocrat that the surface public-relations of his apparent preoccupations are terribly important.

DES WARREN IS A POLITICAL PRISONER
school prepares us to connive at the survival of the ruling class
HISTORY CLASSES ARE CAPITALIST HISTORY CLASSES
Substitute 'geography', 'maths', etc., where necessary.

EDUCATIONAL REFORM IS AN ASSAULT ON THE WORKING CLASS

Try these out loud in various classes (e.g., history, complementary studies). Would it hurt the teacher to be unable to avoid listening to you? Think of your own 'slogans' together.

The art rip-off has hit its highspot in 'community arts' – you know, earnest arty bores, embarrassing people with their unfunny mime, community theatre, inflatable sculpture. The rip-off is the more poignant for those students who, because of the raising of the school leaving age, are stuck in various harmless corners, of which the 'art room' is usually the saddest. These students are being trained to be hopeless; their teachers have let-down the system in failing to produce the tidy individuals it requires, so then they are obliged to plug the resulting hole in the system by letting-down the students.

This show has little to do with art, and nothing whatever to do with art as it is taught in schools and, for that matter, art schools. You might be able to shut-up an old bore with dandruff, tweeds and bad breath – or a trendy young bore – by attending to the problems (not 'his' problems) of English, History, etc., but not by making roll pots or doing posters for the school play.

The 'masses' are not the economic weaklings they (once) were. The problem of change is importantly an ideological one. Consumerism and its relatives have made people think of themselves as powerless, fit only to hope for work and the odd hobby. Art has got to be an ideological instrument; its transitional function can't be thought of as a mere increase in the availability of products and consumption. A silly example would be everybody's getting the chance to be a leisure abstract-artist, reflecting, or failing to reflect the reality of snobs and aesthetes.

1) Is 'Free Des Warren' a slogan? Is 'Free Des O'Connor'?
2) The work in the show is labelled 'A', 'B', 'C', etc.; this is to help you identify what?
3) Can you correct any of the 'slogans'? How?
4) Do you think they need any additions? Which ones? What would you add?
5) Is the work in the show realistic? How would you defend the claim that it is more realistic than, say, portraits – like those in the Town Hall?
6) What if someone (we) say that the slogans (or art) are made by you? (We've just put sheets of paper on the walls.)
7) If you did have some alternatives, would we have a conflict situation?
8) Most people 'go back to the painting' so as to settle, or inform, arguments about 'art'. Why shouldn't the art(ist) go to you – in the sense that it asks the question whether your practice is itself a change (or supersession) of its meaning? (The consumer approach is different: all you: add you take away is the possibility of a conflict of 'opinion' among approximations to an 'authentic experience'; consider the crap that's written on L.P. covers, or whispered by BBC2 music industry front-men.)

17. Art & Language, *Des Warren ...* (1975). Poster, 41.5 x 30 cm. Reproduced courtesy of Art & Language.

was tried in a criminal court under a conspiracy law for picketing offences, found guilty and jailed for three years. The rest of the poster's text provided a more detailed critique of conventional education and community arts. There were also comments about A & L's exhibition and readers were asked to reflect upon the group's use of slogans.

A & L's historians have remarked that the group's shows in Britain attracted few sales and little critical attention. This, they thought, was

because of its 'determination to speak for itself, and for its tendency to seize the initiative in debate'.[4] The fact is that even curious readers/viewers became increasingly alienated by the obscurity, difficulty and ugly language of the group's seemingly endless discourse, by the absence of visual pleasure, and its gang-like bullying attacks on other British artists such as Victor Burgin and John Stezaker.

During the early 1970s, Paul Wombell, a student of Stezaker's at St Martin's, produced a number of photomontages, photographs and a film addressing social issues. One participant observation project he undertook was of young, Tottenham Hotspur football supporters; for a time he dressed like one to obtain their trust so that he could photograph them. The photos were then printed in a book he compiled and published himself. Another subject that concerned him was the plight of Britain's poorly paid workers who had come from Asia, Africa and the West Indies, many of whom performed menial labour whites were no longer willing to do. *Air India* (1975) consisted of two photographs placed side by side to form a basic montage. One was an advertisement that appeared regularly in art magazines such as *Art & Artists*.

18. Paul Wombell, *Immigrant Labour* (1975). Photograph and advertisement, plus captions. Photo courtesy of the artist.

It promoted the pleasures of air travel and featured an alluring Indian air hostess. The other, taken by Wombell, depicted a female cleaner coping with squalor at London's Heathrow airport. Wombell parodied the advert's slogan – 'A glimpse of India on your way to New York' – by substituting the word 'exploitation' for 'India'.

Since the two images had some similarities and some differences, they invited a compare and contrast exercise. One telling contrast was between the opulent traditional costume worn by the air hostess and the plain white overalls worn by the cleaner. The two images could be interpreted as a simple opposition of fantasy and reality, but because each image is read in terms of the other, the antithesis is called into question. For example, the air hostess can also be seen as a victim of exploitation and lower grade work (most pilots are men, women perform service roles); her elaborate costume is really a uniform worn for work.

Similarly, the juxtaposition of two common photographic genres – advertising and documentary – calls attention to the fact that neither contains the whole truth about capitalism since they are two facets of the same system, that the conventional distinction between fact and fiction is an ideological one. Earlier, in *Ways of Seeing*, John Berger had highlighted the contradictions revealed by the differences of content between the utopian adverts and the dystopian news photos found side by side in Sunday newspaper colour magazines and remarked that their amicable coexistence indicated a schizophrenic culture.

Wombell's awareness of the issue of pictorial representation distinguished his work from simpler forms of political photography and agit-prop imagery, and made it more sophisticated. Nevertheless, *Air India* was printed as a poster and used in campaigns to assist immigrant workers. At the time of writing, Wombell is the director of the Photographers' Gallery in London.

A year later, one of Victor Burgin's enlarged black and white photographs tackled the subject of immigrant women workers and contrasted two photographic genres. He photographed an Asian

machinist toiling in a dress factory and, in order to extend the photograph's meaning beyond the merely documentary, he added a quote from the kind of effusive copy that accompanies images in fashion magazines. Clearly, the ironic contrast Burgin was seeking to highlight was that between the glamour of fashion magazines marketing expensive clothes and the mundane reality of the factories in which they were actually manufactured by low-paid women workers. Despite the introduction of a minimum pay act by the present Labour government (elected in 1997), wages lower than the minimum and sweatshop conditions persist in Britain to this day.

Female labour was also the theme of a show entitled 'Women and Work: A Document of the Division of Labour in Industry' held at the South London Art Gallery in May 1975. It was the result of a lengthy investigation conducted by Kay Fido Hunt, Margaret Harrison and Mary Kelly, three artists who had decided to collaborate. Issues debated within the Women's Movement concerned them all and, since they were members of the recently formed Artists' Union, they were conscious of the need for artists to unionize like industrial workers. Between 1973 and '75, funding of £1500 was made available by the Greater London Arts Association and the Thames Television Artists' Fund to record the experience of women factory workers in the Southwark works of the Metal Box Company. (Traditionally, the tin box trade had been predominantly women's work since the time of the First World War.)[5] None of the artists had any training in the research methods sociologists might have employed and so they learnt by doing.

Hunt was born in South London in 1933 into a working-class family. She studied sculpture at Camberwell College of Art and taught at Guildford at the time of the 1968 student occupation; she was one of 40 staff sacked at that time for supporting the students' cause. Hunt had a strong personal motivation for the project: it was a way of honouring living workers' experience and the lives of her own mother and aunts who had all laboured in South London factories.

Harrison (b. 1940) came from Wakefield, Yorkshire and had studied at Carlisle College of Art from 1957–61 and the Royal Academy

Schools in London from 1961 to 1964. She has recalled that her motiva-
tion for undertaking research in Companies House and in archives of
the Trade Unions' headquarters was political activism.[6] Mary Kelly (b.
1941), an American, came to London to undertake postgraduate study
at St Martin's from 1968 to '70 and was to remain in Britain for two
decades.

The three artists visited the factory, gained the cooperation of a
Public Relations officer, filmed and took photographs and inter-
viewed employees. The exhibition that followed was overwhelmingly
factual in character: there were images and sounds of the noisy assem-
bly lines, portraits of the women workers, photographs of their hands
engaged in fiddly, repetitive tasks plus timetables of their daily rou-
tines before, during and after work. Two colour films were projected
side by side so that male and female labour could be compared.
Another section displayed folders of documents and sound record-
ings supplying information about the company and industrial inju-
ries suffered. A further display recorded the numbers of men and
women (and their grades) who performed the various tasks in the
factory.

In terms of its style of presentation, the exhibition reflected the
influence of minimal and conceptual art – the use of grids for the
arrangement of photographs, for example. Harrison has also argued
that Conrad Atkinson's exhibition 'Strike at Brannans' (ICA, 1972)
had established a precedent for documentary-type displays as art.

What the three artists discovered was that men were more mobile
within the factory, had the more interesting jobs and enjoyed higher
wages, and that many women experienced problems when expected to
work a shift system because of their additional responsibility of
caring for children. At the time, British employers were applying the
Equal Pay Act passed in 1970. Jane Kelly has summed up what hap-
pened in the case of Metal Box:

> ... the management were restructuring the work force to keep profits
> intact. The female work force was not simply downgraded; a much more

complicated reshuffling process was introduced, including token female representation in the top grades, automatic machinery and therefore redundancies in the second, and eventually the phasing out of all part-time work (traditionally a married woman's province) and the introduction of a double-day shift with the concomitant anti-social hours ... the exhibition documented a labour force on its way out, showing the way in which industry copes with problematic, liberal legislation by either restructuring or ignoring its stipulations.[7]

As already explained, Hunt's primary motivation had been her own personal, family history; nevertheless, a feminist credo of the time was: 'the personal is political'. Mary Kelly married the English artist Ray Barrie and became pregnant during the course of the enquiry into Metal Box and so became acutely aware of the subjective dimension and the unequal division of labour between men and women in the home as well as in factories. (Women's domestic labour enabled husbands and sons to 'reproduce' themselves day after day so that they could be productive outside the home and women's ability to bear and rear children enabled society to reproduce itself.) Kelly's long-term project *Post-Partum Document* (1973–79) was also to be about reproduction and the labour of mothers, that is, it concerned the development of her own son Kelly Barrie born in 1973.

Metal Box's employees were invited to the opening of the exhibition and were pleased and flattered to find their portraits on the walls of the local art gallery – a place most of them did not normally visit. The critical information in the show, on the other hand, displeased the all-male management and the artists were banned from visiting the factory again.

A sympathetic review appeared in *Spare Rib*. Rosalind Delmar found the presentation low-key but lucid and concluded that the exhibition was 'a stimulating and thought-provoking experiment'.[8] It was indeed a worthy attempt by three artist-intellectuals to address a real life issue and to connect with working women outside the world of art.

Predictably, the socialist realists of the LSA were hostile to a doc-
umentary-type exhibition and they distributed a critical pamphlet to
coincide with it.[9] They objected to the 'generous handouts' given to
three members of the Artists' Union and doubted that 'mere report-
ing' counted as 'real art'. They found the display marked by 'barren-
ness and monotonous paucity of material' and sarcastically dismissed
its 'facile reformist message'. The critics seemed oblivious to the long
and honourable documentary tradition in British photography and
filmmaking, especially that produced during the 1930s.

However, the critical works of Wombell, Burgin, Hunt, et al, did
prompt some viewers to wonder: 'Having called public attention to
the problem of exploitation, what can or should be done? Can art also
propose a solution?' Hunt has claimed 'Women and Work' had one
positive effect, that is, it persuaded some female employees of Metal
Box to join a union. However, it seems that many of them subse-
quently lost their jobs because part-time employment was phased
out.[10]

Northern Ireland's so-called 'troubles' are so complex, historically
compounded and fraught with danger that many British artists –
even those who are politically aware, even those who live there –
prefer to ignore them.[11] During the 1970s, Conrad Atkinson was more
courageous. He is an artist acutely conscious of social context and
even though he makes use of art galleries, he ensures that the sur-
rounding context is drawn in. Another of his strengths is that he
deals directly with particulars not abstractions; for example, when
dealing with issues such as industrial injuries, he names individual
victims and the companies responsible.

In May 1975, he organized an exhibition in the Belfast gallery of
the Arts Council of Northern Ireland that concerned the political situa-
tion there. The previous year he had been commissioned by the Arts
Council and the Irish Congress of Trade Unions to produce work for
the May Day celebrations in Belfast. Atkinson (b. 1940) was an Eng-
lishman from Cumbria but he was descended from Irish immigrants.
He spent several months in Northern Ireland gathering information,

making drawings and diagrams, recording the urban environment with a camera and videotaping interviews with individuals and groups. Among those interviewed were internees of the British who had been abused in prisons in Northern Ireland. In this instance, therefore, the artist's role was that of compiler and editor rather than creator.

The title of his installation – 'A Shade of Green, An Orange Edge' – ironically evoked a two-colour abstract painting but Atkinson's actual use of colour revealed the difference between him and formalist artists: he acknowledged that colours have socio-political meanings in specific cultures. A second version of the show was held in 1976 at Art Net, London and in Nottingham with the title: 'Northern Ireland 1968–May Day 1975'. Atkinson employed his by now familiar factographic approach: the display consisted of official and unofficial public relations handouts, newspaper clippings, videos and 200 colour photographs showing street scenes, slogans, wall graffiti, etc. As Atkinson has pointed out, visual information in the streets of Belfast and Derry defined 'tribal areas' and could be 'a matter of life or death'. In addition, there were 150 sheets of typed paper some white, some tinted orange (the colour of the loyalists), some tinted green (the colour of the nationalists), with quotations representing the variety of views expressed by local people, historians, poets and British soldiers.

Atkinson felt that the two main political parties in mainland Britain had imposed an embargo on debate about the civil war in Northern Ireland. He was also concerned that the Labour party did not have a separate policy. His intention was to stimulate discussion by bringing together the views of the grassroots and by depicting the popular culture present on the streets. As far as possible, he left out his own opinions although it is evident from contextual statements that he approached the situation from a socialist perspective – 'the only solution is a united socialist Ireland' – favoured the withdrawal of British troops from the province and supported a Bill of Rights rather than terrorist methods. Some reviewers of the exhibition discerned a bias towards the republican cause.

While preparing for the show, Atkinson was invited to a council house in Derry in order to photograph a Civil Rights banner that had been used to cover the dead bodies of unarmed Catholics shot by British paratroopers on Bloody Sunday in 1972. The banner was still stained by the blood of the victims. At first, he wanted to include the banner in the exhibition but then decided against it for security reasons. Nevertheless, photographs of it did appear.

The time that Atkinson spent researching the history of the Civil Rights Movement since 1968 and recording Ireland in 1974 was a learning experience for him. It would have been arrogant for an Englishman to propose a glib solution to Northern Ireland's agony and so his exhibition did not attempt this. Rather, it performed a feedback function for the populace. As Atkinson has explained: 'The fight to reveal to people their own powers of representation is an aspect of my work that is rarely detected or understood.'[12] Providing paper and pens for visitors to add comments facilitated further feedback. One visitor complained that the beauty of the countryside and the existence of peaceful inhabitants had been ignored and added: 'We are not all murderers and bigots'; another accused the artist of being a communist and told him: 'Get out of Ulster'; a third declared: 'This is not art but journalism.'

It is, of course, always difficult to judge the impact of an exhibition with a political purpose, but Atkinson's did attract considerable interest and press comment. Predictably, reactions to it tended to reflect the sectarian divide already present in Northern Ireland. He was interviewed for radio – though this was not broadcast – and television programmes were made about it. When the exhibition was shown in England, public meetings were held in the gallery – with speakers from Northern Ireland – to discuss the need for a Bill of Civil Rights.

Subsequently, Atkinson produced other works about Northern Ireland, for example, the painting/collage *Silver Liberties* (1978) – to be discussed in Chapter 8 – and several pieces for a show held in Dublin in 1980. When, in 1979, examples of Atkinson's work about Northern Ireland were selected for an exhibition of English art to be

held in Paris, Sir Nicholas Henderson, the British Ambassador there, wrote to the British Council (who were funding the exhibition) objecting that they gave a 'highly one-sided and critical interpretation of British action in Northern Ireland'. He also remarked: 'these exhibits may qualify as interesting social and political statements. I do not see by what conceivable criterion they can be called art.' The British Council rejected this attempt at censorship by arguing that Britain's reputation as a free and tolerant nation depended on allowing its artists freedom of expression. In the same year, however, Atkinson was to experience censorship in London at the hands of the Arts Council.[13] This incident will be described in Chapter 10.

Because of the large number of Irish-Americans living in the United States, whenever Atkinson's works about Northern Ireland appeared in mixed exhibitions of British art held there, they attracted much attention and discussion. At times, his exhibits embarrassed British officials worried about Britain's image abroad.

There was little demand from British collectors for political art and so, during the 1970s, Atkinson tended to rely upon income from teaching, fellowships, grants and the odd commission. However, when he exhibited in an American private gallery – the Ronald Feldman Gallery, New York – there were sales. Furthermore, Atkinson's solo show at Feldman's in 1979, entitled 'Material – Six Works', inspired several American left-wing and feminist artists to form a group and to name it 'Group Material'. The interest and encouragement Atkinson received in the United States prompted him to move there during the 1980s and to take up a university teaching post. At the time of writing, he divides his time between California and Cumbria.

Sony Portapaks – portable video cameras and recorders using half-inch tape – had become commercially available in the United States in the mid-1960s and were one example of the technological progress from which adventurous fine artists could benefit. Of course, as the special issue of *Studio International* (November/December 1975) devoted to 'Avant-Garde Film in England and Europe' reminded readers, many artists had previously used or were currently using

film. However, video was a significantly different medium; for example, it involved magnetic tape with an invisible stream of signals distributed along it instead of a filmstrip divided into separate frames, thus editing procedures differed. Furthermore, video images appeared on television monitors rather than being projected onto huge screens in darkened cinemas. Compared to video, filmmaking was complicated and slow. A video camera linked to a monitor could display a real-time image; a news report could be recorded on tape in a particular neighbourhood and shown to local people in the street or via the new cable networks within hours; consequently, it was a relatively low-cost and quick means by which social and political issues could be addressed.

The advent of video challenged the monopoly of existing broadcasting institutions and, by enabling children and laypeople to use video equipment, the medium and technology of television were demystified. Thus, the passive consumption of television was replaced or supplemented by the active production of images.

By the middle of the 1970s, a significant number of artists and groups were employing video as their primary medium and art colleges had acquired video equipment for training students. This was made clear in Britain by the large scale of 'The Video Show: Festival of Independent Video' funded by the Arts Council and held at the Serpentine Gallery in May 1975.[14] Philips, the television manufacturing company, supplied most of the equipment needed for the Festival. In 1975, after three years of production, the output of videocassette recorders at the Philips factory in Vienna reached 100,000. The word 'independent' in the Festival's title indicated, first, its difference from commercial and mass-media/broadcasting applications; and second, that video usage extended beyond fine art to community groups and politically motivated organizations such as Action Space, Inter-Action and Bolton's Women's Liberation Group.

While the Festival's scope was international, priority was given to British work, especially in the 20 live performances and the ten CCTV (closed circuit television) installations. Video's ability to supply

immediate, real-time images or short, time-delay playback meant that viewers could watch themselves on video monitors mounted inside galleries. Now that such visual surveillance is commonplace in shops and streets, it is hard to recall how innovative and unusual this mirror-like experience seemed. A library of tapes was also provided for visitors as well as seminars and a conference, which was held at the RCA.

The Serpentine's curator was Sue Grayson and the Festival's organizing committee included the outside consultant Peter Bloch, the critic William Feaver, the artist David Hall and Professor Stuart Hood, of the RCA's Film and Television school. Among the British artists who participated were: Derek Boshier, Su Braden, Ian Breakwell, David Hall, Mike Leggett, Stuart Marshall, Stephen Partridge and Paul Wombell.

Hall was born in Leicester in 1937 and studied art at Leicester College of Art and sculpture at the RCA from 1954 to 1964. Influenced by conceptualism, his attention shifted to photography, film and video. He also established, in 1972, a Time-Based Arts department at Maidstone College of Art, Kent. During the early 1970s, Hall was one of the pioneers of British video art. At the Serpentine, he showed three tapes made during 1974–75 including one entitled *This is a Video Monitor*.

As in the case of so much photomontage art of the 1970s, radical film and video often had a love/hate relationship with mainstream media because they were the dominant forms of communication and because they provided – if access could be obtained without compromising artistic integrity – the opportunity to reach a much wider, non-art world audience. Earlier, in 1971, Hall went beyond the art gallery by making ten, short *TV Pieces* – shot on film – that interrupted (without any advance warning) programmes being transmitted on Scottish Television. *TV Pieces* was designed to call attention to 'the box in the corner' and succeeded in doing so.[15]

At the Serpentine, Hall and Tony Sindon also mounted an installation of multiple monitors entitled *101 TV Sets*. The sets were arranged

in rows around the four walls of a gallery so that they formed a total environment and were tuned to mainstream broadcasting channels but without sound. According to Hall, the aim was to provide 'an antithesis of the broadcaster's intent. The media and the message were objectified, re-forming as a new and autonomous experience.'[16]

In 1976, when Hall received a commission from the BBC, he reprised *This is a Video Monitor* by making an eight-minute colour video entitled *This is a Television Receiver*. It was then transmitted on the arts programme *Arena* (March 1976). This was an example of self-reflexive, 'deconstructive' art in that it showed Richard Baker, a well-known newsreader, talking about the monitor screen viewers were watching and the loudspeaker they were listening to while gradually the image and sound were progressively distorted. (Hall had repeatedly regenerated the image optically off the monitor's screen.) Hall's aim was to undermine the reality effect of television by reminding viewers that the television image was an illusion but also one with an electronic, mechanical base. Two stills from the tape were reproduced on the cover of *Studio International* (May/June 1976) when the magazine published a thematic issue about video art. Hall himself contributed an article on the short history of British video art.

One thing the Festival clarified was the sharp difference in the way video was used by fine artists and by community agencies. Inter-Action, a London-based, 50-strong Community Arts Trust headed by the American Ed Berman, possessed a mobile media van, which it hired out to local government departments. The van travelled to eight cities throughout the country; it was present at the Serpentine plus three compilations edited from tapes shot by local groups. Inter-Action had a 'non-directive' policy that encouraged local people, youth clubs and voluntary agencies to experiment with the medium and use it for their own purposes. For Inter-Action, the process or experience of production was more important than professionalism and a polished finished product. Making a video about a problem of common concern brought people together and then, after they had viewed and discussed it, they might well decide to take further action.

19. Inter-Action, *Community Video Project, Lissom Green Adventure Playground* (1974?). Photo Inter-Action, reproduced in *Film Video Extra, A Supplement to Greater London Arts*, No. 2 (June 1974).

It gave people more power and control over their lives and fostered grass-roots creativity, self-expression and self-representation. The role of Inter-Action was that of catalyst and facilitator; video was simply one of their repertoire of 'organizing tools'.

Graft On! another London community agency, directed by Sue Hall, saw its role as assisting political campaigns such as the demand for more affordable housing. One of its tapes, which critics praised and found dramatic, depicted squatters being evicted from a house in

Chalk Farm, London. A year earlier, the tape had been used as evidence in a court case in defence of squatters charged with assaulting the police. (This was the first time a videotape recording had been used by the British legal system in this way.) Of course, since the 1970s it has become commonplace for both the police and protesters to videotape scenes of conflict.

Journalists reviewing the Festival complained that some of the TV monitors could hardly be seen. (The Serpentine Gallery let in too much light because it had many windows and was located in the middle of a London park.) Critics also noted examples of amateurism and poor technical quality. As in all exhibitions involving machines, maintenance was expensive, time-consuming and required technicians to be constantly available. By 1975, video had already acquired a reputation for tedium and since over 100 hours of recorded material was available, it was hard for any visitor to assimilate everything. Some critics thought an art gallery was not suitable for the display of video at all. (Since videotape cassettes could be duplicated, in future they could be issued in editions and bought by members of the public and, once video recorders/players became commonplace in British households, they could be viewed at home.)

Nevertheless, critics did enjoy the live events in which roving bands of performers dressed in costumes encouraged visitors to video their own behaviour. Overall, the Festival was judged to have been an overdue, worthwhile venture. In terms of content, genre, style and intended social functions, the videos displayed at the Serpentine were bewilderingly diverse. The Festival revealed that, in 1975, video was still a wide-open field of creativity and experimentation. However, as was noted with regret at the time, mainstream television channels greeted the Festival with 'a deafening silence'.

As the annual festivals of video art held in cities such as Liverpool and the international recognition now afforded to figures such as Nam June Paik and Bill Viola by major museums demonstrates, artists' video has become accepted as one of the many types of contemporary art. Today, millions of ordinary people have access to a wide range of

television entertainment and information channels, and watch bought or hired videocassettes at home. Many also make home videos using their privately owned camcorders. However, the medium of television is still dominated by the major companies, networks and institutions. Empowering the people in a political sense, the goal of the community and political groups of the 1970s, was only partially and temporarily achieved.

Chapter 7

1976

In China, Chairman Mao Zedong and Chou En-Lai died; and the so-called 'Gang of Four' was arrested. Jimmy Carter, a democrat, was elected President of the United States in the year that his nation celebrated its bicentennial. The Americans landed a spacecraft on Mars. In California, the company Apple invented and marketed the first personal computers. In Britain, Jim Callaghan became Prime Minister after Harold Wilson resigned. A sterling crisis forced the British government to seek a loan from the International Monetary Fund and cuts in public expenditure followed. Riots between blacks and the police occurred in South Africa and at London's Notting Hill Carnival. Israel mounted the Entebbe raid to rescue hostages. Asian workers at Grunwick's in London were dismissed and they then picketed the factory. Unemployed people organized the first 'Right to work March' from Manchester to London. The hottest summer for 500 years caused water shortages in Britain. A 'cod war' erupted between Iceland and Britain over fishing rights in the North Sea. There were Peace Movement demonstrations in Ireland and England. In Northern Ireland, the first IRA prisoners were sent to the 'H'-Block prisons and the European Commission on Human Rights found Britain guilty of torturing internees. In the summer, 130 colleges, polytechnics and universities had occupations protesting about the closure of teacher training colleges. Bob Marley was shot in Jamaica and the Sex Pistols' punk record *Anarchy in the UK* was released. Rock Against Racism was founded. Martin Scorsese's film *Taxi Driver* starred Robert de Niro and Jodie Foster. Dustin Hoffman and Robert Redford played reporters in *All the President's Men*, a movie about Watergate. Sylvester Stallone played a boxer in the film *Rocky*. Derek Jarman filmed

the Sex Pistols using super-8 and directed *Sebastiane*, a cult gay movie. Nicolas Roeg directed and David Bowie starred in *The Man who fell to Earth*. Clint Eastwood directed and starred in the Western *The Outlaw Josey Wales*. Nagisa Oshima directed *In the Realm of the Senses*. The Other Cinema opened its own cinema in Tottenham Street, London. Umberto Eco's book *A Theory of Semiotics* was published in English, as was Solzhenitsyn's *Gulag Archipelago*. The French writer and politician André Malraux died.

'Arte Ingelese Oggi 1960–76', a British Council exhibition was held at the Palazzo Reale, Milan; the catalogue included Richard Cork's essay 'Alternative Developments'. The first issues of *Artscribe*, *Art Monthly* and *Camerawork* were published. 'Art Magazines' and 'Art and Social Purpose' issues of *Studio International* appeared. The 'Art Press' exhibition was held at the Victoria & Albert Museum plus a conference at Sussex University, Brighton. An 'Artists' Books' travelling exhibition was organized by the Arts Council but a work by Suzanne Santoro was withdrawn because it included images of the female genitals. The Redcliffe-Maud report *Support for the Arts in England and Wales* was issued. Naseem Kahn's report *The Arts Britain Ignores* was published and the Minorities Arts Advisory Service (MAAS) established. The Association for Business Sponsorship of the Arts (ABSA) was founded. The Acme Gallery was opened in London. A conference on Marxism and Art Practice was held at the RCA with speakers Laura Mulvey, Conrad Atkinson and Mark Karlin. At the Hayward Gallery a 'Festival of Islam' took place and 'Sacred Circles' a celebration of North American Indian art; R.B. Kitaj also organized the show 'The Human Clay'. The abstract painter John Walker won the first prize at the John Moores Liverpool Exhibition. Sir Kenneth Robinson was appointed Chairman of the Arts Council. T.J. Clark became Professor of the fine art department at Leeds University. An exhibition of Terry Atkinson's history drawings took place at the Midland Group Gallery, Nottingham. A John Latham retrospective appeared at the Tate Gallery and his paper *Time-Base and Determination in Events* was published. The Arts Council organized a large-scale show of

Jean Frañcois Millet's peasant paintings for the Hayward Gallery. Carl Andre's 'bricks' at the Tate Gallery, Ddart's pole-carrying performance, Mary Kelly's 'Post-Partum Document' and COUM Transmission's 'Prostitution' at the ICA provoked public contempt and press headlines. 'Peasant paintings from China' was shown at the Warehouse Gallery, London. Victor Burgin showed at the ICA and John Stezaker at the Nigel Greenwood Gallery. A 'Festival of Expanded Cinema' was organized by the ICA. The performance *Academic Board*, devised by William Furlong and Bruce McLean, took place at the Battersea Arts Centre. The Women Artists Slide Library was established in London. Maureen Scott painted a mural in support of Chile for the Peckham headquarters of the Amalgamated Union of Engineering Workers. A Performance Art Festival was held at the Serpentine Gallery and the Tower Hamlets Arts Project mounted a 'Big Show' of community arts at the Whitechapel. *Afterimage* magazine published a special issue on 'Perspectives on English Independent Cinema' and Stephen Willats' book *Art and Social Function: Three Projects* appeared. Dawn Ades' history of photomontage was published. The deaths occurred of Sir Basil Spence, Man Ray and L.S. Lowry.

During the scorching summer of 1976, a long and bitter industrial dispute began at the Grunwick photographic and printing processing laboratories in North London. Many Asian women on low wages were dismissed by their employer George Ward. They then joined the trade union APEX and picketed the factory. The dispute lasted until 1978 and became a national focus for the battle between employers and unions, the Left and the Right. On 17 July 1977, at the height of the conflict, 18,000 secondary pickets and sympathizers joined women pickets led by Mrs Jayaben Desai outside the factory gates. Violence then broke out between the police and the demonstrators. Norris McWhirter's right-wing organization the National Association for Freedom (NAFF) helped the employer, who managed, in the end, to defeat the dismissed workers. After a secret ballot, 80 per cent of the workforce voted against unionization. Subsequently, British

governments increasingly passed laws to reduce trade union rights and to curb their power.

To assist those on the Grunwick picket line, a small group of artists who constituted the Poster/Film Collective, which occupied a squat in Tolmer Square, London, designed and produced posters for use on placards in the street.

Another campaign, launched in 1978, for which it designed posters was that trying to save the Elizabeth Garrett Anderson Hospital in London from closure due to cuts in the National Health Service. The EGA was one of two hospitals in England, run by women for women. Fortunately, that campaign did succeed.[1] A group called the Newsreel Collective made films about both the Grunwick and EGA struggles that were screened at The Other Cinema.

Members of the Poster/Film Collective included Jonathan Miles, Sylvia Stevens and Steve Sprung. Miles was a photomontagist who had trained at the Slade School of Art.[2] Unlike most industrial and office workers, Miles and his comrades owned their means of production: photographic and silkscreen printing equipment purchased second-hand at auctions. Not only did they seek to assist the political struggles of external groups, but also aimed to transform their own social and economic relations as artworkers, as proposed by Walter Benjamin in his famous essay 'The author as producer' (1934). Another major influence was Benjamin's essay 'The work of art in the age of mechanical reproduction' (1936), which advocated that new radical art should be based on the mass replication/democratic potential of photography and printing.

The aim of the Collective was to make films and to design and print posters that would be of direct use to trade unionists, left-wing groups, particular causes, etc. Consultations with users were considered essential to the design process. Generally, the posters were more complicated in their layout than advertisements because the messages to be communicated were more complex than those selling consumer goods and services. The posters were also smaller and if pasted-up in the street were 'illegal' because, unlike advertising

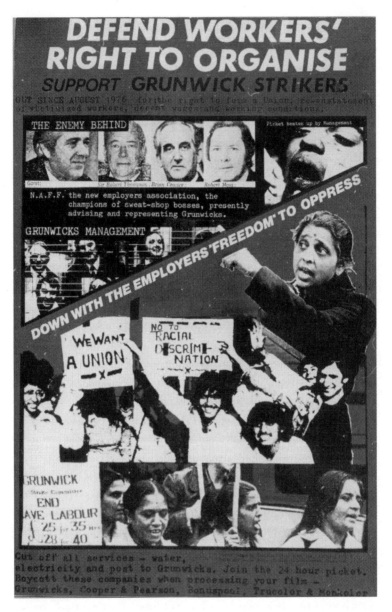

20. Poster/Film Collective, *Grunwick Strike Poster* (1976 or '77). Photo courtesy of Jonathan Miles and Brandon Taylor.

agencies, the Collective could not afford to rent huge billboards. Sets of posters were also exhibited at other cultural events, such as a Chinese film season at The Other Cinema. They were displayed in primary schools to raise racial awareness and offered for sale at low prices to anyone interested. Sometimes, they appeared in art galleries; for example, in 1978 they were included in the 'Art for Society' exhibition held at the Whitechapel.

Miles contributed to other groups and devised image/text montages that addressed issues that are more general and which were designed for alternative spaces such as The Gallery, Lisson St. He mounted a display there during April and May 1976 entitled 'Global Route'. Most of the images on the freestanding panels were clipped from American magazines and selected in collaboration with Nicholas Wegner, The Gallery's artist-director. The show's theme was the way in which the business and military interests of the developed Western nations planned and organized their struggle for global domination of world trade and power, and the dire consequences for the peoples of the Third World.[3]

Right-wing critics would no doubt argue that the functional posters of the Collective were not art in the high culture sense, even though aesthetic decisions were taken during their design. Some of the Collective's posters were in fact colourful and decorative but, of course, as far as members of the Collective were concerned, 'art' was a bourgeois concept to be abolished or transcended.

One of the other groups whose meetings Miles attended was the still little-known St Martin's Group (SMG). This name derives from the art school where most meetings were held during 1976. Other names considered by the group itself were: 'Into', from 'Into Production', Ossip Brik's manifesto in favour of photography and photomontage published in *Lef* in 1923; artWORK Group, Intervention and P R [Pictorial Rhetoric] Group. Actually, participants preferred the word 'association' to 'group' because meetings were informal. SMG was not highly structured or organized. It emerged because of seminars given in the autumn of 1975 by two St Martin's lecturers: the artist

John Stezaker and the left-wing art historian and theorist John Tagg. Students from St Martin's and staff and students from other London colleges, such as the RCA, also attended SMG's gatherings; they included: Paul Barbour, Rosetta Brooks, Peter Challis, Francis Fuchs, Yve Lomax, Sarah McCarthy, Ieuan Morris, Richard Shepherd, Dave Trayner, John A. Walker (of Middlesex Polytechnic), John Wilkins and Paul Wombell.

One of SMG's aims was to overcome the division between staff and students, and so both contributed on an equal level. Another was to overcome the external, distanced relation of criticism to art: in meetings, critical evaluation was considered part of the production process. A third aim was to close the gap between artistic practice and theory, to pursue both but to develop a theory *for* future art rather than a theory *of* past art. In terms of written theory, important concerns were the relation between ideology and systems of visual representation such as perspective (vantage and vanishing points), the common mechanisms of pictorial rhetoric (visual metaphors, similes, hyperbole, personification, etc.) and the vexed relation of the avant-garde to official and mass culture.

SMG differentiated itself from conceptual art and Art & Language by being more interested in pictures than words. News photographs and advertising images were intensively analyzed as a means of understanding dominant ideology. An expression current at the time was: 'work on ideology'. (Thus, SMG anticipated the more systematic analyses provided by Judith Williamson in her 1978 book *Decoding Advertisements*.) Roland Barthes' brilliant analyses of French ideology and mass culture, published in English as *Mythologies*, were a key influence, as was John Berger's dissection of publicity in part four of *Ways of Seeing*. Semiotics was fashionable in the early 1970s and this was a methodological interest SMG shared with Burgin and film theorists such as Peter Wollen. Chairman Mao's writings on art and class, and the tactics of guerrilla warfare, were also read. Mao's sensible advice to weak guerrilla forces was: 'rely on the weapons of the enemy'.

Photographs were taken and adverts appropriated for use in the

production of artworks that took the form of films, photo-text juxtapositions, books of photographs, magazine layouts, slide projection and sound tapes. The overall aim was 'to use the ideological tools of bourgeois mass culture for its own subversion'. Collective work was an ideal and a number of collaborative projects went some way towards overcoming the individualism typical of most art practice.

To some extent, SMG meetings recalled those the Independent Group had held at the ICA during the 1950s to discuss mass culture, and SMG's art had affinities with pop art. The main difference was that SMG's members were engaged in a critique of popular culture not a celebration of it. Although contributors shared a left-wing political perspective there was a reluctance to define this precisely, or to align with any existing political party, and the one manifesto issued, in April, was itself a protest against the concept of political art as simply meaning a new style or art movement. What SMG proposed instead was 'art that is consciously political and politically conscious'.[4]

SMG's economic base comprised staff wages and student grants plus the premises and facilities of art schools, consequently it could not really flourish outside the institutions of higher education. Members tried to make a virtue of necessity by addressing other staff and students in the hope of mobilizing them. ('For whom are we producing? What audience are we addressing?' became crucial questions.) The nature of the art produced virtually precluded support from the commercial gallery system even though SMG was not averse to using galleries because otherwise rivals would occupy them. (Stezaker did exhibit in galleries in Britain and Europe.) The critiques of representation and dominant ideology also meant that external support, say from the Labour Movement was unlikely, and simple agit-prop imagery for the street was not favoured even though SMG was aware of this mode of practice via its contacts with Jonathan Miles of the Poster/Film Collective.

Perhaps SMG is best characterized as a research project. Its principal value for participants was self-education (plus the experience of mutuality), although lecturers who continued to teach in art schools

were to make use of SMG's findings to educate future generations of students. It also fed into the art that artists such as Lomax, Stezaker and Wilkins later produced and in books that art historians such as Walker wrote.[5]

Some members of SMG mounted an exhibition in Newcastle-upon-Tyne in February and in April two members contributed a slide work to a conference on art and society held in Belgrade, Yugoslavia. A presentation of theoretical work was also given at the ICA in September. Artworks were reproduced in *Studio International* and in the RCA's student magazine but the only articles about the group, published at the time, were by Brooks in *Studio* (see below) and Brandon Taylor in *Artscribe*.[6] After a sympathetic account of the 'impecunious' group's activities, Taylor complained that SMG's counter-rhetoric failed to match the glamour of advertising, that it was limiting itself by appearing in art magazines and galleries, and that SMG needed to rethink its tactics. In Taylor's opinion, the prospects for a new, politically radical avant-garde in England were poor because of serious flaws in the British art education system.

Eventually, the energy and commitment of SMG's members waned and by the end of 1976 they had ceased to meet. Lack of resources, reluctance to organize and failure to overcome the problem of distribution and to resolve the contradictions with which SMG struggled, also contributed to its demise. By 1983, a disillusioned Stezaker was telling critics: 'I feel my work is apolitical. I can't imagine art changing a thing. I think art is more about a resignation to certain things.'[7] Today, despite a long exhibiting career, Stezaker still relies on teaching for a living: he is currently employed by the RCA.

Not all artists who claimed to be socialists produced art directly related to the political events of the 1970s. R.B. Kitaj (b. 1932), the American painter who had been living in England since 1959, did not, for example, even though he felt that much contemporary art appealed to only a tiny minority and he was in favour of 'social art', by which he meant 'art that was accessible to more people'. During the 1970s, his drawings and paintings increasingly focused upon his Jewish identity

and the Holocaust. *If Not, Not* (1975–76), a highly allusive and complex picture referenced such diverse historical material as T.S. Eliot's poem *The Waste Land*, paintings by Bassano and Giorgione and photographs of a Nazi extermination camp. According to Peter Fuller, who saw this canvas in a 'Narrative Painting' show in Bristol, this was 'one of the very best British paintings of the decade'.[8]

At this time, Kitaj also produced portraits of friends and erotic scenes (one 1975 pastel of a naked man and woman making love on a bed was strangely entitled *Communist and Socialist*). Writing in 1977, the critic Richard Cork complained about the obscurity of Kitaj's iconography, his historicism and innate conservatism, and urged him to 'demonstrate a more urgent contemporary relevance'.[9] However, via a summer exhibition Kitaj curated at the Hayward Gallery, which also toured, entitled 'The Human Clay', he did attempt to intervene in the British art scene. This show consisted of drawings he had purchased for the Arts Council Collection by such artists as Michael Andrews, Frank Auerbach, Lucien Freud, David Hockney and Henry Moore, and was intended as a celebration of figurative art and the skill of drawing from life that Kitaj feared was being lost because of its neglect in British art schools. During the 1970s, Kitaj honed his own drawing skills and many of his drawings looked quite nineteenth-century in appearance; that is, they seemed a retreat from the quotational/intertextual, modernist methodology he had employed during the 1960s. Some commentators felt that his 'return to drawing' philosophy was reactionary and anti-abstraction. However, Hockney agreed with Kitaj's arguments and the pair – who constituted a mutual admiration society – boldly demonstrated their commitment to the human figure by posing stark naked for a photograph that graced the cover of the *New Review* (January/February 1977).

Kitaj claimed that he was not against all abstract art but, during the early 1970s, some feminist artists rejected abstraction and insisted on figuration. Monica Sjöö, for instance, dismissed abstraction as 'playful gimmicks characteristic of contented and successful male artists ... playing games with surface reality' and argued that

figuration was such 'a powerful means of communication' that 'an oppressed group – half the human race', could not afford to ignore it.[10] However, there were some successful female abstractionists, the op painter Bridget Riley for instance. Not surprisingly, she was not a feminist.

Another way in which Kitaj tried to influence the art world was through his use of the promotional label 'School of London'.[11] He was convinced that living in London were ten or more 'world class' artists (they included Andrews, Auerbach, Bacon, Freud and Kossoff) – most of whom were friends of his – who constituted a 'school' comparable in quality to those of Paris and New York. Although several critics soon disputed the validity of this label, it became quite influential and in later decades other curators and writers used it for book and exhibition titles.

An interest in what French intellectuals called 'popular memory' was a characteristic of American and European cultures during the 1970s. This was evident in such films as *The Sorrow and the Pity* by Marcel Ophüls (1971), Bernardo Bertolucci's *1900* (1976), Liliana Cavani's *Night Porter* (1974), Michael Cimino's *Deer Hunter* (1978), in such television series as *Roots, Holocaust, Days of Hope* and *When the Boat Comes In* and in books such as *The Great War and Modern Memory* by Paul Fussel (1977). Some visual artists, in addition to Kitaj, also began to take an interest in the past even though history painting had long been out of vogue. One such artist was Terry Atkinson (b. 1939). He had been a member of Art & Language for eight years but left in 1975 because, in the words of the critic John Roberts:

> . . . he wanted to develop a more direct and interventionist relationship between art and politics. Whatever the political virtue of Art & Language, they did not look upon their art as being organically connected to any existing socialist culture or public, in fact on the whole they saw themselves as antagonistic of much of the sentimentality and earnestness of those who were constantly wishing one into existence.[12]

After Atkinson left A & L, he resumed drawing and painting, and in the following year he held a one-man show of history drawings, which included some in pencil and pastel, plus some etchings and lithographs at the Midland Group Gallery, Nottingham. (This show, which was curated by the critic Lynda Morris, also appeared at the Robert Self Gallery in London in February 1977.) Their subject matter was the First World War and the sources of the images were documentary photographs taken at the time. As a student at the Slade in the early 1960s, Atkinson had produced a large painting entitled *Postcard from Ypres* (since lost) and constructed a full-scale replica of a camouflaged First World War tank, hence he was reprising an earlier concern.

Atkinson contended that a return to a traditional medium was not necessarily reactionary and that drawing could be used to explore the past as well as writing. However, writing was not excluded because the artist provided copious notes in a publication that accompanied the exhibition. His intention was not simply to copy the source photographs meticulously – as the photo-realist painters fashionable during the 1970s did – but to *interpret* them in such a way as to take the viewpoint of the working-class men who had been decimated by the war, a vicious struggle between rival, imperialist, capitalist powers. Atkinson came from the working-class, coal-mining villages of South Yorkshire, all of which had war memorials inscribed with the names of those who had sacrificed themselves for their comrades and nation.

Atkinson interpreted photographs through his use of hand-drawn marks, by making certain alterations and deepening shadows, and by adding colour and titles. Frequently, the latter were bitterly sarcastic: *Privates Shrapnel-Face and Shrapnel-Face, 15th Durham Light Infantry, 64th Brigade, 21st Division, VII Corps. Near Heninel, 9th April 1917.* This title accompanied a depiction of two dead, mutilated soldiers. Normally, artists add titles after completing works but Atkinson claimed that in his case the situation was reversed.

As time passed, Atkinson's titles became longer and longer as more creative effort was expended on them. In this respect, Atkinson set a precedent for Damien Hirst.

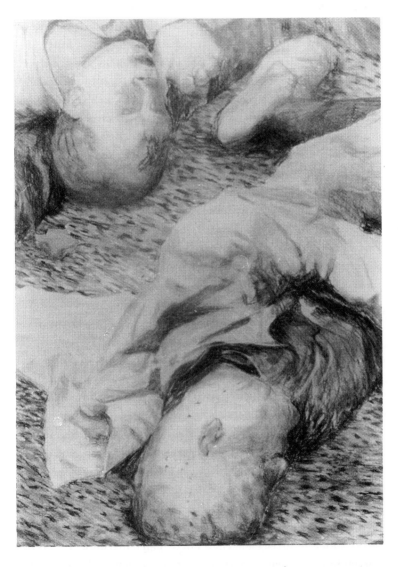

21. Terry Atkinson, *Privates Shrapnel-Face and Shrapnel-Face, 15th Durham Light Infantry, 64th Brigade, 21st Division, VII Corps. Near Heninel, 9th April 1917* (1976). Drawing, conté crayon on paper, 61.2 x 97.25 cm. Leamington Spa: artist's collection. Reproduced courtesy of the artist.

Atkinson's representations of Tommies in trenches were curiously impressive and, to anyone who had lost relatives on the battlefields of the Western Front, moving without being sentimental. Clearly, they were imbricated in debates concerning realism in art that took place during the 1970s – especially in the books that the social historian of art T.J. Clark published about Gustave Courbet and politics in nineteenth-century France and in response to exhibitions of paintings by Jean François Millet held at the Hayward Gallery in 1976 and by Courbet held at the Royal Academy in 1978. Clark was instrumental in the appointment of Atkinson as a lecturer at Leeds University fine art department in 1977, a department that became noted for giving equal importance to theory and practice, and for the teaching of the feminist art historian Griselda Pollock. Atkinson was to continue exploring the First World War theme until the early 1980s while at the same time broadening his subject matter to include the Vietnam War, Nazism in Germany during the 1930s, Stalinism, the media and newscasters, Northern Ireland and apartheid in South Africa.

At first glance, Atkinson's mid-1970s' work seemed highly traditional and some viewers may have thought that his resumption of drawing and painting was a retreat from the advanced position he had achieved with Art & Language, but this was no simple return because the new work was inflected by Atkinson's experience of conceptualism – it was post-conceptual drawing and painting. This was evident from the parodic appropriation and interpretation of past imagery, from the emphasis placed on titles and the continuing practice of writing and theoretical reflection alongside the production of visual artefacts. As John Roberts has pointed out, Atkinson's aim was not to duplicate a nineteenth-century type of realism but to challenge and problematize received conceptions of realism, to 'make strange' conventional readings of historic photographs and to disrupt the normal relationship between images and their captions. (Most captions simply anchor – confirm or repeat – what can be seen in the visual image rather than relaying or extending it). Furthermore, the subject matter was itself a means to a broader end:

Atkinson's work on the First World War is not realist because it is *creating* historical knowledge but in terms of how, through image and text, it uncovers and addresses the First World War as a set of historical events and relations, which reveal how political power in the world actually works.[13]

In Britain, during annual anniversaries, the mass slaughter of the Great War is usually remembered as a melancholy but mysterious human tragedy, rather than the result of 'the objective dynamics of capitalist development'.

Atkinson's departure from Art & Language left a legacy of mutual antagonism but it is interesting to note that, in the late 1970s, the remaining members of Art & Language were also to construct images based on historical images – such as Courbet's *Studio* – and their approach to them was similar to the critical work *on* representation which Atkinson had performed in respect of images of the First World War.

During 1976, certain exhibitions of contemporary art in London aroused unprecedented negative responses from the British public and the mass media. Carl Andre's *Equivalent VIII*, owned by the Tate Gallery, Ddart's pole-carrying performance/sculpture in rural England, Mary Kelly's 'Post-Partum Document' and COUM Transmission's 'Prostitution' exhibitions, both held at the ICA, prompted controversy and outrage.[14]

Andre (b. 1935), an American sculptor working in the tradition of Constantin Brancusi, was a leading minimalist. The work that aroused so much fuss and press headlines such as 'What a load of rubbish' dated, in fact, from 1966. It was a ground-hugging, oblong arrangement of 120 firebricks, hence the word 'bricks' became better known than its actual title and the subject of many jokes and cartoons. The sheer simplicity of the piece, the fact that Andre appeared to have undertaken little work – no hand labour, no skilled craftsmanship or creative effort – just the selection and arrangement of an everyday building material, affronted many journalists and gallery-goers.

One of the latter vandalized the work by throwing blue vegetable dye on it.

A repeated charge against modern art is that it is 'a waste of public money'. In this case, the state funds – generally believed to have been a few thousand pounds – were spent by the Tate Gallery. Tabloid newspapers were only too pleased to make the waste of taxpayers' money accusation because it was a time of economic difficulties and this was a way for the populist press to embarrass the then Labour government.

Tate deputy keeper Richard Morphet mounted a defence of Andre's sculpture in the pages of the *Burlington Magazine*, but his justifications lacked conviction and, in any case, reached only a small, specialist audience. Within the art world itself, radical British artists and critics had for some while been undertaking a critique of minimalism because of its reductive 'less is more' rationale, paucity of aesthetic pleasure, absence of content and social/political utility, consequently they were reluctant to defend it. This meant that they were in danger of finding themselves in the same camp as philistines who objected to all types of avant-garde art. The principal value of Andre's sculpture was the philosophical questions it raised, namely: 'What is art? Are the materials from which it is made crucial to its identity?' and 'Who in our society has the power to define it?' Reflection on these questions was bound to reveal the crucial role of art institutions and the power exercised by art world professionals.

Ddart, a performance group whose name was redolent of 'dada', 'art' and 'darts', consisted of three artists who had studied at Leeds Polytechnic. They created a 'sculpture' called *Circular Walk* by walking in a 150-mile circle in East Anglia while connected by a ten-foot yellow pole worn on their heads. It took them a week to accomplish this bizarre task. Each day they stopped and performed a short ritual for the amusement of local people in pubs. While this work resembled Morris dances, many journalists found it ludicrous and trivial. Giles Auty, the author of a sustained attack on avant-garde art entitled *The Art of Self-Deception* (1977), compared *Circular Walk* to the paintings

of Velásquez and found the British artists' performance wanting. The Member of Parliament for Ipswich wrote to Hugh Jenkins, Minister for the Arts, querying the use of public money. This was because the Arts Council had granted Ddart the small sum of £395 towards the cost of costumes and photographic documentation.

Mary Kelly's October exhibition at the ICA, entitled 'Post-Partum Document', offended certain newspapers because it included nappy-liners with faecal stains by her infant son. The work was in fact an interim report about a long-term project, a complex investigation and record of her child's socialization and acquisition of language. Kelly had been reading theoretical articles in *Screen* – a film journal that was extremely influential during the 1970s – and Juliet Mitchell's book *Psychoanalysis and Feminism* (1974). In addition, she had been studying the psychoanalytic theories of Jacques Lacan, the French Freudian, and had used several of his ideas and diagrams. The sheer difficulty of the content and a perceived shortage of visual pleasure, made even some feminist visitors, who were otherwise sympathetic to Kelly's endeavour, express doubts about its value to the feminist cause. Another detractor was Peter Fuller who dismissed Kelly's work as 'forensic ramblings'. However, Kelly did have supporters and these included Jane Kelly, Laura Mulvey, Griselda Pollock and Lisa Tickner. Critical opinion concerning 'Post-Partum Document' continues to be divided, but what is not in doubt is the radical challenge it made to traditional pictorial and sculptural representations of the mother-child relationship and the fact that it became a canonical work in the history of feminist art.

COUM Transmissions managed to provoke the most extreme reactions with an exhibition that immediately followed Kelly's. 'Prostitution', the exhibition's title, was intended as a metaphor for the way in which so many artists have to 'prostitute' themselves for their art. COUM was a performance group founded in 1969 by Genesis P-Orridge, Cosey Fanni Tutti and Peter Christopherson. None of them had attended art school and they were contemptuous of most fine artists working in traditional and conventional ways. COUM preferred

direct contact with live audiences and aspired to the reality of rituals typical of tribal cultures, that is, when body mortification occurred, it was genuine rather than simulated. However, some of Tutti's solo performances were balletic, gentle and mesmeric. As mentioned previously, in April 1976, P-Orridge had been taken to court by the General Post Office for sending 'indecent' postcards through the mail. He had amended various popular, mass produced cards by adding sexual imagery. Despite testimonials given by several famous individuals, P-Orridge was found guilty and fined £100 plus £20 costs.

COUM's exhibits at the ICA were a mixture of props used in their performances and photographic/press documentation. The former included anal syringes, chains, Vaseline, meat cleavers and used sanitary towels, while the latter included pornographic magazines featuring Tutti. There was a challenge here to the conventional division between art and pornography. Could Tutti's activities as a porn actress and model be regarded as an example of performance art, indeed an artistic subversion of pornography? Could pornographic imagery attain the status of art by being framed and displayed in an art gallery? Earlier, the relationship between erotic art and pornography had been discussed in Peter Webb's substantial volume *The Erotic Arts* (1975). The blurring of art and pornography in 'Prostitution' anticipated the 1989 *Made in Heaven* series of works by the American artist Jeff Koons featuring himself and his future wife, the Hungarian-Italian porn actress Ilona Staller or La Cicciolina, engaged in sexual acts.

Predictably, the exhibits at the ICA were found disgusting and provoked denunciations from the Conservative MP Nicholas Fairbairn and others. Fairbairn declared the artists to be 'Wreckers of Civilization' and newspaper editors thought the show evidence of Britain's industrial and moral decline. COUM's view was that there was no civilization to be wrecked, because it was already a barbaric 'death factory'. Given the history of the twentieth century, with its two world wars and genocides, one can only agree with COUM that humanity has not yet achieved a state of civilization. However, the contents of the show

were deliberately distasteful and designed to shock. The aggressive attitude of COUM towards mainstream society was comparable to that of punk rock groups like the Sex Pistols who were provoking similar moral panics because of their nihilism.

Numerous cartoons and angry headlines appeared in the tabloid press and the Arts Council came under attack because of the annual funding it was giving to the ICA and the small travel grants it had previously given to COUM for performing in Europe. So extreme was the vilification that even the members of COUM were taken aback and decided to abandon the realm of art for the more open-minded and lucrative field of rock music. The affair undoubtedly embarrassed the ICA's management and damaged the art centre's reputation. Arts bureaucrats also became more cautious and censorious. Eventually, P-Orridge felt compelled to leave Britain for the United States in order to escape the attentions of the British authorities and the persecutions of a Christian sect.[15] As we shall discover in Chapter 8, the attacks on avant-garde art were to recur during 1977 when a popular television journalist joined in the sport.

During 1976, *Studio International* published six substantial issues about such topics as contemporary Italian art, art magazines, performance art, video art, experimental music and 'Art & Social Purpose' (ASP).

The last named issue (March/April) is particularly relevant to this book. In his editorial, Richard Cork argued that 'the most important challenge facing art in the latter half of the seventies [was] to restore a sense of social purpose, to accept that artists cannot afford for a moment longer to operate in a vacuum of specialized discourse without considering their function in wider and more utilitarian terms'. Given that the principal intention of the issue was to document the efforts of various living artists to reconnect art to society, no single model of practice was prescribed.

Among the critics and artists Cork commissioned were Terry Atkinson, Rosetta Brooks, Victor Burgin, Gustav Metzger, John Stezaker, Caroline Tisdall, John A. Walker and Stephen Willats. Cork himself

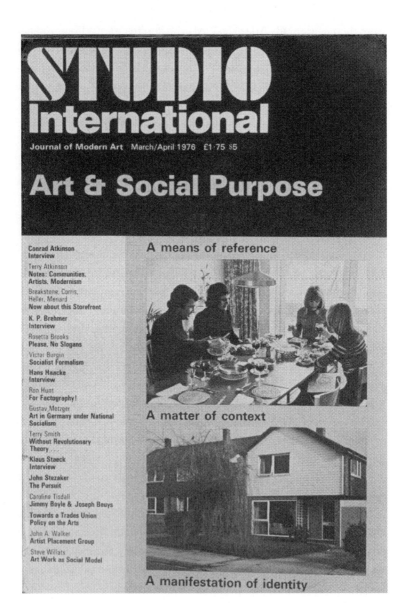

22. 'Art & Social Purpose' issue of *Studio International*, Vol 191, No 980 (March/April 1976). Photos on cover are by Stephen Willats, *From a Manifestation of Context and Identity* (1974).

interviewed Conrad Atkinson. Also featured were three radical German artists: Joseph Beuys, Klaus Staeck and Hans Haacke. In addition, members of the Artist Placement Group provided reports regarding the progress of placements that they were undertaking. Terry Smith, an Australian member of Art & Language, wrote an essay on the need for revolutionary theory while Margaret Harrison interviewed a trade union official regarding union policy on the arts.

Brooks' article, 'Please, no slogans', contextualised montages and posters by members of SMG – Challis, Lomax, Miles, Stezaker and Wombell – and was supplemented by comments written by Miles, Stezaker and Tagg. In a magazine work entitled *The Pursuit*, Stezaker added titles, quotes from J.S. Mill and commentaries to a sequence of advertising images (which, unfortunately, lost much of their visual impact because they were reproduced in monochrome, not colour). *The Pursuit* utilized automobile and tourist imagery depicting individuals dwarfed by huge spaces. Stezaker used a 'build-up' technique to explore the idea of freedom, more specifically, the desire for escape so common in Western society, which he then linked to the modern artist's cult of freedom and independence. Burgin contributed a historical and theoretical article entitled 'Socialist Formalism' plus a photo-text, double-page spread that used images of Auguste Rodin's *Thinker* and a woman to raise the issue of class-consciousness.

While many readers found the ASP issue informative and useful, there were negative reactions too. One art school principal cancelled his subscription because, in his opinion, the magazine no longer seemed to think painting was part of contemporary art. Even some left-wing critics were dissatisfied: in the course of a harsh profile of Cork published three years later, Peter Fuller and John Tagg accused him of being an opportunist, because he had only recently converted to socialism, and of avoiding class politics; they called the contents of the ASP issue 'a spineless mélange'.[16] Right-wingers were equally displeased: one Conservative MP informed a national newspaper that Cork was 'a communist' critic who was 'attempting to undermine the entire British art world'. Even Cork realized that there was a problem

in publishing a partisan issue as a one-off. How were subsequent issues tackling different subjects to sustain the social purpose requirement?[17]

Two new art magazines – *Artscribe* and *Art Monthly* – were established in 1976 and art magazines in general were scrutinized in detail via a thematic issue of *Studio International* (September/October) and via 'The Art Press' exhibition and conference held at the Victoria & Albert Museum and Sussex University respectively.[18] The latter were the result of an initiative taken by British art librarians belonging to The Art Libraries Society (ARLIS) founded in 1969. Much of the attention given to art magazines was because artists using language and photography were disseminating their work directly to readers. Some groups of artists were even editing and publishing their own journals. Furthermore, as awareness of the importance of art's infrastructure grew, the power of art criticism and the art magazine to make and break reputations, and to make art history, became more apparent.

Art Monthly (first issue October), a modest magazine printed on cheap paper whose priority was text rather than illustration, set out to report the art news in Britain, to review current exhibitions and to provide a forum for debate. It succeeded in these aims and, at the time of writing, is still being published. Its first editor was Peter Townsend, the ex-editor of *Studio International*, and its financial backer was Jack Wendler, an American resident in London who had earlier run an avant-garde gallery in North Gower St.

Artscribe (first issue January/February) was also cheaply produced but it was a different animal because it was founded by a group of painters and critics – Ben Jones, Caryn and James Faure Walker and Brandon Taylor – who were discontented with existing journals that concentrated on conceptualism, socialist art, new media and academic theory. In his first editorial, Jones explained that *Artscribe* would expose the poverty of so much that passed as art criticism and refuse to endorse 'the rationale of an art to illustrate a social or psychological thesis'. Instead, it would support 'the primacy of the aesthetic element

in human experience', of feeling and the formal structures of art, and 'the precedence of the art object'. Most of the artist-contributors were unpaid; there were few adverts and no colour illustrations; funding derived from sales and a public source: the Greater London Arts Association. Thus, *Artscribe* was an example of self-help by a body of artists who felt disenfranchised by recent trends in art. In short, it was an alternative to 'Alternative Developments'! Paradoxically, the visual artists who despised those who produced nothing but theory and writing were compelled to take them up in order to fight a battle of ideas.

Artscribe became a platform for the artists to promote their own work and that of their friends and allies. The kind of painting favoured was lyrical abstraction and the kind of sculpture abstract constructions made from metal or wood. The artists' commitment to abstraction meant that they opposed any return to figuration advocated by 'disillusioned modernists' (doubtless a reference to R.B. Kitaj). Although the art of the Artscribers was sincere and worthy, it was also dull and samey. Too much was being produced for the art market to absorb and it held little interest for those outside studios and art schools.

Many of the articles and interviews were tedious and of inordinate length. Overall, the magazine was amateurishly produced; its graphic design showed little sign of the aesthetic sense they claimed mattered so much to them. At the same time, it did contribute some new voices and opinions to the ferment of ideas and the debates of the decade about the nature of art, the role of art criticism, the future of art education and so forth.[19]

Academic Board: A New Procedure was the title of a collaborative work with a cast of seven performed at the Battersea Arts Centre, South London, in December. William Furlong and Bruce McLean devised it. Furlong (b. 1944, Woking, Surrey) was an artist, publisher and lecturer who had studied at the Royal Academy Schools and who taught at Wimbledon School of Art. He is best known as the founder of *Audio Arts* (1973–). From 1972 to '75, McLean had participated in

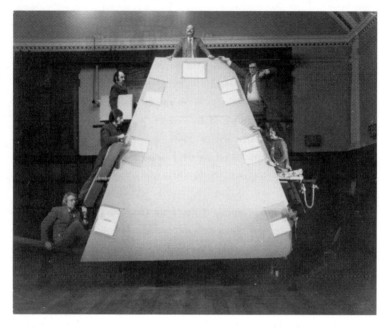

23. William Furlong, Bruce McLean and others, *Academic Board* (1976). Performance, Battersea Arts Centre, London. Photo courtesy of W. Furlong.

Nice Style, a highly entertaining 'pose band' whose performers executed violent and acrobatic movements 'with style' and then froze into 'nice', 'sharp' poses.

Since so many British artists earned a living by teaching in art schools, they inevitably endured the tedium of long staff meetings and experienced the problems of administration and bureaucracy typical of most organizations. Furlong has recalled that in the mid 1970s 'A developing tendency in such institutions was for senior practitioners to be replaced by spurious quasi-managers who pursued personal ambition.' *Academic Board* was a humorous, defensive response to such experiences. Furlong added:

This scripted work explored manipulation and control according to hierarchy expressed by relative positions around a vertical table. [Tipped up to

face the audience like a tabletop in a Cubist painting. The chairman at the top of the table was actually standing on a ladder.] The agenda for the meeting comprised opaque and trivial matters, such as the redecoration of a caretaker's flat, which involved the projection of 20 shades of mid grey from the Munsel scale, from which the board was invited to make a selection.[20]

According to one reviewer – Marc Chaimowicz (himself a performance artist) – the piece was 'visually stunning' and hilarious:

> The script kept up a steady laughter from the audience with many, no doubt, recognising their own experiences of meeting procedures. Certainly, the sense of boredom and frustration, building up to near hysteria over the minutiae of irrelevant detail, produced from the audience the very English reaction of laughing at one's own foolishness. The end was predictably the point at which all committee members began to speak simultaneously, thus producing a chaotic barrage of noise.[21]

Chaimowicz concluded: 'although Furlong/McLean focussed on issues of public concern, they identified problems but did not offer solutions. Rather did they operate within the domain of British comedy or quintessential farce'. Nevertheless, it would appear that acting in and witnessing *Academic Board* provided a much-needed cathartic release from stress. What those present did not foresee was the exponential increase in bureaucracy, administrative duties and student numbers that was to occur in British higher education during the 1980s and '90s, as the result of an under-funded expansion programme imposed by successive Conservative governments.

Chapter 8

1977

General Zia ousted Prime Minister Bhutto of Pakistan. The South African police murdered Steve Biko. President Sadat of Egypt visited Israel for a peace accord and President Carter visited the North East of England. 1977 was the year of Queen Elizabeth's Silver Jubilee (1952–77). In Northern Ireland, a general strike by loyalists lasted 12 days. A bitter strike at the Grunwick film processing laboratories in London, which began in 1976, prompted mass picketing. British fire fighters also went on strike. The National Front marched in Lewisham, South London and violent clashes then took place between the police and anti-Nazi demonstrators. Clashes too occurred between young blacks and the police at the Notting Hill Carnival. The Socialist Workers Party started the Anti-Nazi League and Rock Against Racism began publication of *Temporary Hoardings*. Mary Whitehouse successfully prosecuted *Gay News* for publishing 'an obscene and blasphemous' poem. The British/French supersonic aircraft Concorde came into service. Virginia Wade was the first Englishwoman to win the Wimbledon women's tennis final for years. Alex Haley's series *Roots* appeared on American television. Successful films included: Bernardo Bertolucci's *1900*, Wim Wenders' *The American Friend*, John Badham's disco film *Saturday Night Fever*, Steven Speilberg's *Close Encounters of the Third Kind*, George Lucas's *Star Wars* and Woody Allen's *Annie Hall*. In December, The Other Cinema was forced to close because of financial problems. The punk band the Sex Pistols issued *God Save the Queen* as a single and sold two million copies. Books and magazines on the theme of post-modern architecture were published. Walter Benjamin's book *Understanding Brecht* appeared with the essay 'The author as producer'. Roland Barthes'

Image – Music – Text, with the essays 'Death of the Author' and 'Rhetoric of the Image', Jacques Lacan's *Four Fundamental Concepts of Psychoanalysis* and Michel Foucault's *Discipline and Punish* were published in English. Tom Nairn's book *The Break-up of Britain: Crisis and Neo-Nationalism* and Susan Sontag's *On Photography* appeared. The entertainers Marc Bolan, Charlie Chaplin, Bing Crosby, and Elvis Presley died.

David Hockney and R.B. Kitaj appeared naked on the cover of the *New Review* (January/February issue) in order to promote figurative art. In Paris, the Pompidou Centre was opened. In Berlin, the exhibition 'Kunstlerinnen International (1877–1977)' of contemporary and historic art by women took place; Margaret Harrison contributed the work *Anonymous was a Woman*. At the ICA, the Feministo Postal Event *Portrait of the Artist as a Housewife* was held. The 'Documenta 6' exhibition was mounted in Kassel, Germany at which an APG seminar occurred in which John Latham and Joseph Beuys shared a platform; another APG event was held at the RCA. Occupations occurred in various art colleges, including the Slade in London, protesting about fee increases and lack of democracy. History Workshop organized a conference on the theme of 'Art and Society'. A 'Painting now' issue of *Artscribe* and a 'Women's art' issue of *Studio International* were published. The American critic Clement Greenberg wrote the catalogue introduction for the show 'Four Abstract Painters', held in Edinburgh; he also visited Edinburgh to see the show and give a talk. Laura Mulvey and Peter Wollen's film *Riddles of the Sphinx* was released and Derek Jarman started work on his film *Jubilee*. Terry Atkinson exhibited 'History drawings' at the Robert Self Gallery in London and began to teach at Leeds University. An exhibition of posters, books, photographs and magazines entitled 'The Revolution Paris, May 1968' was held at House Gallery, London; 'Shared Meanings and Critical Views' at the Cockpit Theatre, London; and 'Photomontage Now' at the Half Moon Gallery, East London. A show of John Heartfield's photomontages was held at the ICA. Brandon Taylor organized a London conference on the theme of 'Art and Politics'.

Peter Fuller wrote 'Troubles with British art now' for *Artforum* and later delivered a paper at the conference 'The Crisis in British Art' held at the Arnolfini Gallery, Bristol, which attracted 250 people. The first 'Hayward Annual' exhibition was mounted at the Hayward Gallery in London. In addition, at the Hayward, the Arts Council presented 'Perspectives on British Avant-Garde Film'. Fyfe Robertson attacked contemporary art on British television, as did Giles Auty in his book *The Art of Self-Deception*. 'Towards Another Picture', an exhibition (plus a publication) was organized by Andrew Brighton and Lynda Morris in Nottingham. In Newcastle-upon-Tyne, Colin and Anne Painter founded the art magazine *Aspects* and the group show '1977 – Current British Art', initiated by John Hilliard, was held. The Birmingham Women Artists' Collective issued the booklet *MaMa – Women Artists Together*. Malcolm Le Grice's book *Abstract Film and Beyond* was published. Richard Cork resigned as art critic of the *Evening Standard* because he was unwilling to write gallery round-ups.

1977 was a year in which industrial unrest and racial strife intensified and attacks on contemporary British art continued both from within the art world and from without.

An issue of *Studio International* was devoted to the theme of 'Women's Art'. It featured articles by the American critic Lucy Lippard and the American art historian Linda Nochlin, author of the famous 1971 essay 'Why have there been no great women artists?'[1] British contributors included Rosetta Brooks and Sarah Kent, while the artist Margaret Harrison provided a chronology entitled 'Notes on Feminist art 1970–77' and gave special help to the magazine's editor Richard Cork. The issue's drab appearance and lack of colour illustrations indicated that *Studio International* was experiencing financial problems. In fact, even when Cork was appointed, the magazine was losing thousands of pounds per annum. Cork claimed that more and more copies were being sold and that the magazine had an international appeal: the print run was 9500 and 75 per cent of copies were sold abroad. However, advertising revenue decreased because of the recession and because powerful dealers disapproved of Cork's editorial policy.

In an effort to protect the future of the magazine – which had started life in 1893 – a non-profit-making trust was established (The Studio Trust) by publisher Michael Spens but, unfortunately, it was not able to rescue it. In 1977, only three issues instead of the scheduled six appeared and the title ceased regular publication in 1978 (it was to be resuscitated by Spens for a time during the 1980s).

In April, Peter Fuller published a highly critical and pessimistic article entitled 'Troubles with British art now' in the American journal *Artforum*.[2] His premise was that something had 'gone wrong' with the visual arts and he predicted that 'the 1970s will be seen in retrospect as a time when the visual arts came to represent only a handful of anachronistic and decadent residual forms'. 'Today,' he wrote, 'the visual arts in Britain have become a sterile, lifeless tradition, lacking in creative contradictions and imaginative oppositions, with no real audience except the contracting "art world" itself.' Only David Hockney's work, he thought, was capable of appealing to non-specialists.

Fuller's attack extended across a range of British art movements from Euston Road School realism to pop, but was especially directed at painters of empty monochromes (Alan Charlton, Bob Law and others), performance artists, such as Genesis P-Orridge and Cosey Fanni Tutti, and the conceptualists featured in the 'The New Art' show of 1972. According to the critic, creative energy had effectively vanished and 'the British bourgeoisie had no use for its contemporary artists'. The latter statement was dubious given the official support the exhibition he cited had received. One reason for this parlous state of affairs, Fuller considered, was the shift of power that had taken place from the fine arts to the mass media of advertising, cinema, television, etc., all of which he subsumed under the label 'mega-visual tradition'.

Fuller's negative critique must have been music to the ears of Americans seeking confirmation of the superiority of their own art. A decade later Fuller was to declare, in an editorial in his own journal *Modern Painters*, that American art was 'aesthetically bankrupt'.

One wonders if *Artforum* would have been happy to publish this opinion.

Given Fuller's low opinion of new British art of the 1970s, it is not surprising that he began to espouse the virtues of traditional art forms such as painting and sculpture and those artists who imaginatively transformed their materials and sources to produce a sensuous synthesis of form and content. Stephen Buckley was one painter Fuller considered was moving in the 'right' direction. Buckley (b. 1944) was an abstract painter who, Fuller contended, was reacting against the modular units of minimalism by employing violent, non-painting techniques, such as tearing, scorching and bricolage, in an effort to revitalize painting, to make it expressive again.[3]

Although Fuller was a journalist rather than an academic historian and theorist, he did make use of certain theories. For example, his thinking was informed by Herbert Marcuse's writings on aesthetics (Marcuse was the German-American associated with the Frankfurt School of Philosophy who had influenced the counter-culture of the 1960s) and by the Italian Marxist Sebastian Timpanaro's writings on materialism.

While some of Fuller's complaints about British art were justified, his analyses of the works of individual artists were so brief they did not do them justice. In many cases, dismissals occurred without supporting argument or evidence. Nor did he entertain the possibility that one useful task that fine artists might perform in respect of the mega-visual was to undertake pictorial critiques. Furthermore, his almost total negativity and pessimism was undialectical and he had nothing to say about recent work by black, community or feminist artists.

Fuller died in a car crash in April 1990. He had many admirers who regretted his abrupt departure from the art scene. Certainly, he was a combative and provocative critic who could be relied upon to enliven any debate, but he struck many observers as untrustworthy because he changed his views so often and dramatically: beginning as a neo-Marxist, he became a kind of conservative.[4] *Modern Painters* (1988–),

was named after a book by the nineteenth-century critic John Ruskin. At one time Fuller praised John Berger's *Ways of Seeing* but later on he changed his mind and attacked it.[5]

In June, the Queen's Silver Jubilee – 25 years of her rule – was celebrated in Britain and throughout the Commonwealth as a mark of respect for her 'life of dedicated service', as an expression of the 'gratitude and love of your people'. In London, large crowds cheered a royal procession, which travelled from Buckingham Palace to St Paul's, while millions more watched on television. At night, a chain of bonfires was lit and a torchlight parade took place in Windsor. An orgy of visual kitsch accompanied the event: costumes, uniforms, flags, heraldry and pageantry; plus a flood of affirmative images – such as sugary picture postcards of the Queen and Prince Philip. In her televised talk to the nation at Christmas, the Queen claimed that the success of the Jubilee proved that the British people were united. This was at a time when, in fact, class, gender, politics, race, religion and sexual orientation divided the nation. Evidently, the political function of the Jubilee celebrations was to reinforce the monarchy as a symbol of a spurious unity.

There were some dissenters. Artists and others, who were republicans rather than monarchists, objected to the existence in Britain of a Royal Family and resented the expense, nostalgia and sycophancy associated with it. Consequently, the Jubilee prompted virulent criticism from the far Left. For example, the Socialist Workers Party (SWP) mounted a 'Stuff the Jubilee' campaign with badges, stickers and a special issue of their newspaper *Socialist Worker*. On the latter's cover the red flag of revolution was held aloft, not the Union Jack.

The Sex Pistols, the leading punk group who had become infamous in 1976, also responded with their subversive rendering of the National Anthem *God Save the Queen* and their designer Jamie Reid devised the famous portrait of the Queen with a safety pin through her lips plus the insult: 'She ain't no human being'. The designer was to pay a price for his effrontery: he spent two months recovering from a broken nose and leg caused by a beating he was given outside a

rockabilly pub by patriots offended by the 'God Save the Queen' artwork printed on his T-shirt.

Aggression was a key ingredient of punk performance and iconography. Clearly, pent-up anger at the state of Britain was being released. In terms of punk's politics, there was little in the way of a positive programme, simply a passion for 'anarchy' and a desire to destroy the capitalist, consumer, corporate society. Even so, young people were set a creative example, that is, a do-it-yourself-with-whatever-you-can-scavenge-from-the-ruins ethos.

In their ability to generate 'cash from chaos' (payments from several record companies in quick succession), media frenzy and moral outrage in general, Malcolm McLaren and the Sex Pistols were far more successful than the fine artists who were working in parallel. In part, this was due to the presence of a youth subculture of fans and to the greater economic importance and visibility of graphic design and the popular music and fashion businesses. Both McLaren and Jamie Reid were products of the art schools of the 1960s and had learned lessons from radical art movements, such as Dada and surrealism, and from the Situationists, but perhaps they were simply more creative and effective, and more adept at media manipulation, than the visual fine artists of the period.

Punk design, with its ransom-note lettering, acidic pinks and yellows, swastikas and torn national-flag motifs, had a directness, rawness and energy that most left-wing fine art lacked. Nevertheless, a collage aesthetic, an aesthetic of revulsion and shock-value were also elements punk and avant-garde art movements such as Dada and surrealism shared. Many punks were well informed about the history of modern art and would cite the use of rubbish in the work of Kurt Schwitters to justify their use of it. A drawing in a punk fanzine quoted a painting by Gustave Courbet and the band Siouxsie and the Banshees based one of their songs – *Mittageisen (Metal Postcard)*, (Polydor, 1979) – on a 1935 photomontage, *Hurrah, the butter is all gone!* by John Heartfield and reproduced part of it on the record's cover. A Heartfield exhibition was held at the ICA in 1977. Punk rock

was destined to self-destruct or to be destroyed, but then most new trends in music and fashion have a brief life. At least the punks caused mayhem while they lasted.

Some in the art world – such as Stephen Willats – appreciated punk design and collected it. Robert Fraser, the 1960s dealer in pop art, later persuaded the Victoria & Albert Museum to buy a collection of punk material. In 1979, Boshier was to feature punk in the exhibition *Lives*, which he curated, and to illustrate a songbook for the punk band the Clash; so there were examples of an overlap between the two realms.[6]

During the summer of 1977, Derek Jarman directed a film entitled *Jubilee* (released February 1978) that was prompted by the parlous condition of Britain and by contact with punk. Jarman was responsive to the present and future but the past fascinated him too: historic art and literature and ancient subjects such as alchemy. *Jubilee* referenced all three and combined documentary-type footage with fabricated, fictional scenes. Jarman has explained that it was inspired by fanzines and by Frances Yates' book *The Art of Memory*, which led him to Renaissance texts by Agrippa and Giordano Bruno.[7] In the film, the angel Ariel magically transports Queen Elizabeth I to a Britain of the near future characterized by chaos, decay, destruction, sex and violence, the latter perpetuated by bored female street gangs and corrupt police. The film was shot in London's docklands at a time when property developers were active – they were thought to be burning warehouses to gain access to land.

Jubilee starred Jordan (Pamela Rooke, b. 1955) – a shop assistant to McLaren and Vivienne Westwood who was a living embodiment of the punk style – as Miss Amyl Nitrate (historian of the void), the pop music singer Toyah Willcox as Mad (a revolutionary pyromaniac) and Adam Ant as Kid (a musical simpleton). In one of the most memorable scenes, a semi-naked Jordan gives a parodic rendering of *Rule Britannia* inside a recording studio that was once Buckingham Palace.

She auditions for Borgia Ginz (played by Orlando/Jack Birkett), a

24. Jordan as Britannia in Derek Jarman's *Jubilee* (1978). Photo courtesy of the British Film Institute. © Jean-Marc Prouveur.

blind, evil media impresario, who claims he is entering the song for the Eurovision Song Contest. Musicians who contributed to the film's soundtrack included: Adam & the Ants, Chelsea, Brian Eno, Siouxsie & The Banshees and Wayne County.

Perhaps Jarman's most overtly critical statement about Britain, *Jubilee* was an apocalyptic and brutal picture of a society in crisis. Despite moments of black humour, the film was relentlessly pessimistic and its punk characters tiresomely nihilistic – they had nothing constructive to offer. Indeed, the plot implies that rebellious youth will soon sell out and Jarman later argued that this did happen in the case of Adam Ant.[8] Nevertheless, the film was praised by reviewer Scott Meek because it contained a 'wealth of imaginative incident ... a textual and thematic richness quite extraordinary in the field of British production'.[9]

As far as 'straight society' was concerned, Jarman was an outsider because of his sexual orientation. Naturally, he rebelled against authority, artistic conventions and social rules. Committed as he was to creativity, the freedom of the individual and sexual pleasure, Jarman was sceptical of groups and organizations, even those on the Left, which acted puritanically or repressively. For example, *Jubilee* was dedicated 'to all those who secretly work against the tyranny of Marxists fascists trade unionists Maoists capitalists socialists etc ... who have conspired to destroy the diversity and holiness of each life in the name of materialism'.[10] When *Jubilee* was released, Jarman noticed that it upset some viewers. This was due in part, he thought, to his unwillingness to make films in a social realist manner:

> In England at that time there was a political purity in artworks – woe betide if you didn't come from Barnsley – you were already lost. Provincial, parochial and still alive in universities like Oxford. Even Tolstoy was second rate. Some aristo on a fallen estate, that's how I consoled myself in the face of so-called social realism, that was never real.[11]

Because Jarman made films on tiny budgets, he often did not seek

permission to shoot in public locations and could not afford to pay union rates to his actors and technicians. He was against trade unionists because they preferred working on Hollywood-type films rather than the experimental kind he favoured. Jarman knew Vanessa Redgrave, a famous actress who was also an active trade unionist and a member of the Workers' Revolutionary Party (WRP), which she had joined in 1973. Sometimes he went with her to political meetings but did not join the party. Apparently, he agreed with the WRP's analysis of the problems of British society, but not with its proposed solutions. For a time (1973–74), Peter Kennard assisted the WRP by devising photomontages for its newspaper *Workers Press*.

According to biographer Tony Peake, the pleasure-loving Jarman mistrusted the 'dour left'. Nevertheless, he voted for Labour when Michael Foot was leader and denounced homophobes and racists, and, during the 1980s, he became a fierce critic of Thatcherism and the Tory government's anti-gay legislation Clause 28. As Peake notes, towards the end of his life, Jarman became an internationally known 'cultural icon' and spokesperson for gay or queer politics.

One powerful visual response to the Jubilee celebrations of 1977 by a fine artist was a large, four-panel painting/collage sarcastically entitled *Silver Liberties, A Souvenir of a Wonderful Anniversary Year* that Conrad Atkinson made in 1978 especially for the 'Art for Society' exhibition held at the Whitechapel. The work's title, a pun on 'civil liberties', and its content were prompted by Atkinson's conviction that civil liberties in Britain were being eroded by the implementation of the Prevention of Terrorism Act and by growing police violence. The overall format of the work was borrowed from the Irish flag. (The flag motif was also an implied reference to Jasper Johns' American flag paintings of the 1950s that had been shown at the Whitechapel.) Since three panels featured vertical strips of photographs and texts, the design also echoed the abstract 'zip' paintings of Barnett Newman. What photos and texts linked were injustices in several places: the murder of Steve Biko by South African police; the killing of Liddle Towers (a drunken young man who was kicked to death by local

25. Conrad Atkinson, *Silver Liberties: A Souvenir of a Wonderful Anniversary Year* (1978). Paint on canvas with collaged additions, 2.74 x 5.84 m. New York: Ronald Feldman Collection. Photo courtesy the artist and the Ronald Feldman Gallery.

police) in Newcastle-upon-Tyne; the physical abuse of suspects by the RUC in Castlereagh Police Station, Northern Ireland; and the 13 Catholic victims of Bloody Sunday. Atkinson included a quotation from the poet Percy Bysshe Shelley who had supported the Irish struggle for Home Rule in 1812. One panel reproduced a caricature of a British soldier with a pig's head dressed in protective clothing and holding a club. This figure, based on wall graffiti Atkinson had photographed in Northern Ireland, was outlined in orange spray paint to identify the army with the loyalist cause. As a final touch, Atkinson added a strand of barbed wire.

Silver Liberties offended some in authority and there were attempts to censor it when it was due to appear in a show of English art in Paris and when the 'Art for Society' exhibition was about to be hung in the Ulster Museum, Belfast. The Museum's guards and trustees banned the painting along with works by Alexis Hunter, Margaret Harrison and others and so the Arts Council of Northern Ireland transferred the works to its gallery. Loyalist students then demonstrated outside with signs demanding: 'Atkinson out! *Silver Liberties* out!' Later, when the painting was shown in 'Directions 1981' held at the Hirshhorn Museum, Washington DC, Bernadette Devlin, the Irish Republican activist, held a press conference in front of it. A furore ensued in which British officials and American politicians became

embroiled. Clearly, *Silver Liberties* was a potent political painting.[12] In 1984, Atkinson recalled that his painting had 'unleashed a fury of horrified reaction, a sequence of innuendos, black listing and sheer venom that took me by shocked surprise. I had become an un-person, a non-artist in Britain'.[13]

At the Hayward Gallery during the summer of 1977, the first of a series of annual exhibitions devoted to current British art was mounted. The show was presented in two parts, the first of which was selected by Michael Compton, a Tate curator, assisted by two artists: the painter Howard Hodgkin and the painter and sculptor William Turnbull. The artists they chose included: Frank Auerbach, Anthony Caro, Patrick Caulfield, Bernard Cohen, Nigel Hall, John Hoyland, Allen Jones, John Latham and Peter Phillips. Apart from one woman, Kim Lim, they were all men and most of them had made their reputations during the 1960s. As in the case of 'Art Spectrum London', selection was a contentious issue: the show was criticized for being 'an old-boys' venture by art-establishment figures. Art critics associated with the 'social art' tendency – Richard Cork, Paul Overy and Caroline Tisdall – were particularly vocal and some artists retaliated by accusing them of political bias.

Part two of the '1977 Hayward Annual' featured works by Peter Blake, Stuart Brisley, Victor Burgin, Michael Craig-Martin, Robyn Denny, Barry Flanagan, John Hilliard, David Hockney, R.B. Kitaj, Bob Law, Eduardo Paolozzi and the performance group The Theatre of Mistakes. (Only the latter included women.) Blake took the unusual step of displaying a letter attacking the three critics who had complained about part one. An acrimonious exchange between Blake and Cork followed in the letter pages of the *Guardian*. Blake had joined the backward-looking Brotherhood of Ruralists – a group of figurative painters formed in 1975 to celebrate 'the spirit of the countryside' – and showed some half-finished paintings that included a full-length, naked portrait of the fairy queen Titania. Such escapist subjects and the finicky way they were painted provoked the scorn of Peter Fuller who felt living artists should address the reality of the world around

them. Blake defended himself by saying that he believed in fairies. The dispute between painter and critic lasted for years and was made public in several issues of the magazine *Aspects*.

While part one of the '1977 Hayward Annual' was subject to a critique from inside the art world, part two was subjected to a more damaging assault from outside in the person of the popular Scottish journalist and television presenter 'Robbie' (Fyfe Robertson). During the course of a half-hour television programme, he lambasted mystificatory art criticism, the work of Brisley, Craig-Martin, Law and Carl Andre's 'bricks' (filmed at the Tate). Conceptual art, minimalism and performance art were his prime targets and Robbie's contempt exemplified the populist antagonism towards recent trends in art that had surfaced in the tabloid press the year before. One artist and writer he interviewed who shared his opinions was Giles Auty, the author of a book entitled *The Art of Self Deception* that was published in 1977.

Arts Council officials organized a public meeting at the Hayward in an attempt to repair the damage but, although well attended, it failed in its purpose. In truth, it was extremely difficult for the arts establishment to find reasons for much contemporary art that would convince sceptics outside the art world. This is why so many artists who shared the public's concern resorted to alternatives such as community art.

As an Asian immigrant, Rasheed Araeen had endured racist taunts in the streets of London and encountered institutional racism in the British art world. At the Artists for Democracy gallery, London, in July, he gave a 25-minute performance with sounds and projected slide images, entitled *Paki Bastard (Portrait of the Artist as a Black Person)*, which used the story of his own life to make more general points: '[it] reflects upon the predicament of black people in Britain; showing also how a black artist, uprooted from his original environment in the Third World and rejected by white society in the West, eventually comes to terms and identifies with the reality of his people.'[14] During the event, Araeen referred to the Grunwick strike –

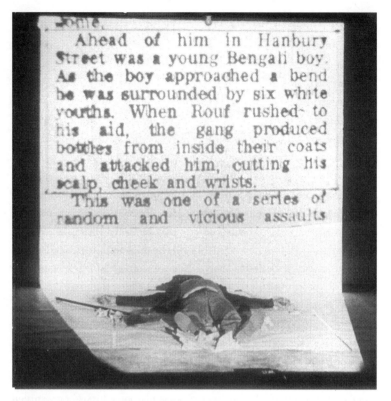

26. Rasheed Araeen, *Paki Bastard* (31 July 1977). Live event with slides and sound, Artists for Democracy, London. Photo courtesy of R. Araeen.

the insult 'Paki bastard' had been used by a police officer about one of the pickets – and to the violent assaults that Asians had experienced at the hands of the police and white gangs. The event was an angry and powerful indictment of racism, which Araeen presented again in 1978 at the Whitechapel Gallery and Sussex University.

A year later Gilbert & George produced a three-panel, photo-piece entitled *Paki*, which shows the two artists standing on either side of an Asian man. They are tinted red while the Asian is black and white. The artists, who are better dressed, gaze down towards the smaller Asian in a cool, somewhat supercilious manner. For some time G & G had been documenting everyday life and local people in Spitalfields

where they lived. They had a voyeuristic relationship to those less for-
tunate than themselves: alcoholic vagrants, young working-class
males and members of ethnic minorities. Naturally, images such as
Paki gave rise to suspicions of racism.[15] In a televised interview, the
artists denied any racist connotations; indeed, they claimed to be
'super liberals' and that their use of the term 'Paki' had been affec-
tionate rather than contemptuous. Wolf Jahn, the author of a book
about G & G, wrote in justification:

> Clearly, in *Paki* Gilbert & George are presenting another person without
> making any explicit statement about him. This pictorial isolation makes
> the title seem more, but also ... less significant. In English usage, 'Paki' is
> a very derogatory name ... It is precisely this aspect of the word that is
> called into question in this picture. By presenting the man's image in a
> deliberately neutral way, Gilbert & George nullify the generally under-
> stood semantic content of the title.[16]

Two artworks, two perspectives: Araeen identified with the view-
point of the victims of racism, while G & G identified with the view-
point of whites whose 'neutrality' masked a complacency regarding
racial discrimination. According to Rosetta Brooks, G & G personified
'the aesthetic attitude, the cruelty of aesthetic distance' and she main-
tained:

> It is not the subject matter that is provocative ... it is the pair's personifica-
> tion of the aesthetic attitude in the extolling of a lost social norm (of a
> white British middle-class majority) brought into relation with the urban
> realities of oppressed minorities ... The double gaze of the Gilbert &
> George becomes the representation of power. To represent the position of
> the power of the gaze in such an obvious relationship with the powerless is
> shocking; but it is our own position as watchers ... that is ultimately put
> into question. We are forced into complicity in a crime.[17]

In Araeen's struggle against institutional racism in the art world,

he undertook theoretical critiques of colonialism, ethnic arts, Euro-centrism, imperialism and the multinational style modernism and battled tirelessly for the rights of Afro-Asian artists in Britain. He did this via conference papers, exhibitions, performances, letters of protest, manifestoes, magazines (*Black Phoenix, Third Text*), a pub-lishing house (Kala Press), a book (*Making myself Visible*) and by contributing to groups such as Artists for Democracy and by serving on the visual arts panels of funding bodies. Eventually, after years of striving, he achieved a degree of success in terms of grants from the Arts Council towards the cost of publications and in mounting exhibi-tions such as 'The Other Story: Afro-Asian Artists in Post-War Britain' (1989) at the Hayward Gallery. However, he had much less success in gaining recognition for his art. While there are many mono-graphs and glossy catalogues about Gilbert & George written by critics, there is only one book about Araeen's work and he had to compile it himself!

In August 1977, the National Front attempted to march through Lewisham, a district of South East London with a large black population. A huge counter-demonstration succeeded in halting the racists but then violence broke out between the police and the anti-fas-cists. According to newspaper reports, some demonstrators used weapons against the police and injured 50. Representatives of the demonstrators, on the other hand, blamed the police for provoking the violence. Dramatic, black-and-white documentary photographs of the street battles, by such photographers as Mike Abrahams, Peter Marlow and Paul Trevor, were published by the Camerawork Collec-tive in a special issue of its magazine *Camerawork*.[18]

Two fine artists of different generations – Derek Boshier and John Stezaker who became friends during the 1970s – also reacted to the so-called 'Battle of Lewisham' but their focus was the representations that followed in right-wing newspapers supporting the police. A *Daily Mail* front cover featured a photograph of a lone 'London Bobby' holding weapons taken from demonstrators and asked: 'Now who will defend him?' (Disregarding the fact that the police usually appear at

demos in force, armed with truncheons and riot shields, some with dogs and some on horses, which they use to charge crowds.) Both artists used the newspaper's front cover as their starting points with the intention of 'turning the mass media upon itself'. Boshier juxtaposed a real front page against a drawing he had made of it which highlighted loaded words and phrases. *Daily Mail, August 15 1977* was a succinct example of critical reading or aberrant decoding and Situationist *détournement*.

Stezaker altered the same page by substituting images of a camera and tripod for the weaponry. Alongside he added a collage with a camera in place of a police officer's head spewing forth a perspectival sequence of photos depicting factory labour and police making arrests. Stezaker's points were that the camera automating the European system of perspective and the medium of photography routinely served authority in all spheres of life. He went on to produce a set of five newspaper collages that were also published as silkscreen posters on newsprint by Spectro Arts Print Workshop located in Newcastle-upon-Tyne. The posters were then folded to make a simulated newspaper entitled *Daily Old*.

Boshier and Stezaker showed that the police *did* have their defenders, namely, the newspapers themselves. (The press employed emotive language, layout and typographic skills and photographs to support the police and to reinforce dominant ideology.) Both artists also demonstrated that fine artists could provide immediate, perceptive critiques of recent journalism. Of course, what they lacked were the huge printing and distribution facilities that enabled the national press to reach and influence millions of readers. The following year, *Camerawork*'s photo spreads, Boshier's drawing and Stezaker's collage were all displayed in the Whitechapel's 'Art for Society' exhibition.

There are three substantial cities – Gateshead, Newcastle-upon-Tyne and Sunderland – in the North East of England and this was a lively region for the visual arts during the 1970s. Galleries, arts centres and silkscreen workshops flourished and, in Newcastle, Colin Painter and his wife Anne established, in 1977, a thoughtful new art

magazine called *Aspects*. (It lasted until 1987. Colin Painter later became Principal of Wimbledon School of Art.) Socialist artists such as Conrad Atkinson had spent time there (1974–76) when Northern Arts appointed him Visual Arts Fellow. John Hilliard, another Fellow, initiated the group show '1977 – Current British Art' that was held at several venues, both galleries and public spaces, in Newcastle during October and November; an associated publication was entitled *Newcastle Writings*. Hilliard's intention was to introduce examples of new art that was post-painting/sculpture and socio-political to the North East and so Art & Language, Conrad and Terry Atkinson, Victor Burgin and John Stezaker were featured.

Conrad Atkinson held a one-man show at the Northern Arts Gallery and this included his banner painting for the Northern Region of the General and Municipal Workers' Union. Stezaker too had a one-man show of his recent collages at Spectro Arts.

A year earlier, in June 1976, 500 copies of a poster designed by Burgin had been fly-posted in the streets of Newcastle at the time he held an exhibition of photoworks at the Robert Self Gallery (Self had premises in Newcastle and London). Given that this was an example of 'art beyond the gallery', it was paradoxical that Burgin's dealer Robert Self met the cost: £772.

The poster reproduced a colour photograph – a stock image acquired from a picture agency – which showed a glamorous young couple embracing. Burgin's use of colour was unusual because he generally preferred black and white. He added a headline question: 'What does possession mean to you?' and a subtitle: '7 per cent of our population own 84 per cent of our wealth', which was, in fact, a quote from the *Economist*. Clearly, Burgin was employing the conventional pictorial rhetoric of advertising while simultaneously undermining it by adding statistical information about the unequal division of wealth in Britain. He had three aims: to problematize the concept of 'possession', to prompt thought about the issue of wealth/poverty, and the way advertisements function. He wanted viewers to work harder, to become more productive in their reading of images.

Public reaction became known via reports in the local press and a radio programme that had recorded interviews with people in the street.[19] Some viewers seemed confused by the poster and its ambiguities and misread the headline thinking that it asked: 'What does *passion* mean to you?' Others claimed the statistic was a lie or stated they did not care about the unfair distribution of wealth. The one person who was angered by the information was unemployed. Someone thought the imagery was 'sexist' – one sticker asserted: 'sexism invalidates socialist art.'

Comment within the art world was generally negative and so Burgin decided not to pursue the street art strategy. Influenced by Louis Althusser's seminal essay on 'Ideological State Apparatuses' arguing that ideological, superstructural institutions such as universities and art galleries had a relative autonomy from the economic base, he concluded that future interventions should be made via lecture halls and galleries. In this way, he would reach a more specific and sophisticated audience. (This prompted Art & Language to invent the dismissive term 'university art'.) Burgin also decided that 'psychic space' was as important as physical space and this is one reason why he became interested in psychoanalytic theory.

In Newcastle in 1977, Art & Language did not present their usual texts; instead, they designed 'a visual', that is, a huge poster depicting two columns of workers walking towards a factory and the vanishing point. It was pasted up in a passageway in the Eldon Square Shopping Precinct. Curiously, the poster had a French title: *Ils donnent leur Sang: donnez votre Travail* ('They give their blood: give your labour') emblazoned in large letters beneath the image. This was because the image was partly copied from a Nazi propaganda image of 1942 for recruiting industrial labour in Vichy France. A & L's poster was also based on a large painting that had been exhibited at Robert Self's London gallery in June 1977.

The group's aim was to demonstrate that idealizations of the working class were not the prerogative of the Left in Britain or Soviet socialist realists. Although seen by many passers-by in Newcastle,

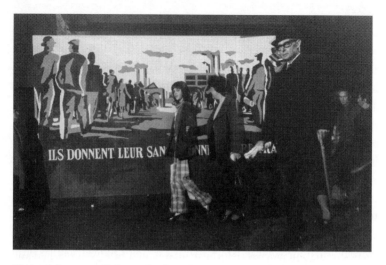

27. Art & Language, *Ils donnent leur Sang: donnez votre Travail* (1977). Photo shows poster with passers by, Eldon Square Shopping Centre, Newcastle upon Tyne. Photo courtesy of Art & Language.

who must have been puzzled by the foreign title, arguably the real targets were those British, art-and-social-purpose artists A & L regarded as being guilty of comparable idealizations. In short, the poster was a spoiling tactic.

The decision to design a poster and place it in the street was also a riposte in kind to Burgin whose posters they regarded as offensive to the working class and primarily career moves on the part of a bourgeois artist. (For his part, Burgin thought A & L's work was 'satire'.) A & L stated that their poster 'would not contribute positively to the development of culture or the advancement of the visual arts,' instead, it would function 'in contradiction'.[20] Although ostensibly a straightforward representation and 'public' work, A & L's poster really concerned an internal art world dispute; consequently, it was accessible at one level but inaccessible at another. Using a public space for such a purpose could be regarded as just as condescending to the people of Newcastle as Burgin's 1976 poster.

The presence of the art critic and historian Charles Harrison inside A & L and the group's general consciousness of the importance of the

history of art, meant that much of their late-1970s art reworked imagery from the past: fascist posters, paintings by Gustave Courbet and Jackson Pollock, socialist realism and so forth. In 1977, Harrison began working for the Open University, one of Britain's positive achievements of the 1970s. (The plans for this distance-learning institution dated back to the 1960s but the first students only enrolled in 1971.) He wrote texts and presented television programmes for the 'Modern Art and Modernism: Manet to Pollock' (1983) course. Naturally, other members of the group assisted his research and Michael Baldwin scripted a critical programme about the Pompidou Centre in Paris written from a Jean Baudrillard/neo-Marxist perspective. Arguably, it was through such means rather than via their exhibitions and small-circulation journal that the mental labour of A & L reached and influenced a wider public – if not the working class, then the middle class (many OU students were teachers).

In 1976, John Dugger had founded the Banner Arts Project in London with financial help from the Greater London Arts Association and the Gulbenkian Foundation. Two years later, he was to receive a grant from the Arts Council to establish a Banner Arts Studio. These initiatives were to result in huge, brightly coloured and decorative banners, influenced by Oriental art and the late paper cut-outs of Henri Matisse, made for both political rallies and non-political events. The kind of participatory exhibitions Dugger and Medalla had mounted in the early 1970s deliberately eschewed the art object as a saleable commodity; consequently, their art activities were subsidized by small grants from galleries and by teaching in art schools (Medalla taught at the Slade and St Martin's for a time). The economics of a socialist art practice and the challenge of reaching communities outside the gallery and the narrow confines of the art world remained unresolved. It was not until Dugger hit upon the idea of making banners that a solution to both problems was found. He identified four fields of practice: public events, architecture, art and commercial clients. By designing banners for businessmen (such as Terence Conran), commercial organizations (such as British Petroleum) and

sports centres, Dugger could earn money to subsidize banners as art and banners for cash-strapped community groups, political campaigners and trade unionists. The causes and groups Dugger assisted included: the Chilean opposition to the Pinochet regime; the Port of London Dockers; the London Borough of Tower Hamlets; the revolution in Angola; and the African National Congress's struggle for freedom in Southern Africa.

Of course, Dugger was criticized by artistic and political purists for engaging in 'textile craft' and serving commerce, but he was convinced that a 'contextual art' with a use-value was needed, one capable of intervening in 'the society of the spectacle' indicted by the Situationists. Furthermore, he considered that his work 'challenged community artists due to its recognition of the mobility and interpenetration of human participation over a wide range of social activities in a contemporary urban setting not dependent on locale'.[21]

The Maoist old/new synthesis was again applied: banners were an ancient form but Dugger employed new fabrics such as Purapak and the woven nylon cordura (for outdoor display, banners had to be durable, fireproof, flexible and strong) instead of painters' canvas. Oriental art continued to be a source of inspiration: Dugger decided to slice his banners into narrow, vertical strips after seeing a Chinese scroll painting that had been cut into sections to assist transportation. Stripping enabled banners to cope with flows of air, to be manufactured by machines, packed and stored in small boxes and made installation easier. From 1983 to 1985, Dugger was employed as a banner maker for the Greater London Council and then, in 1988, he returned to live permanently in California where he continues to design banners for a variety of clients.

In Britain, before the 1970s, banners were primarily associated with the trade unions of the Victorian era and most of their designs were influenced by allegorical paintings of the past rather than by modern art. (The Whitechapel had earlier mounted a show of trade union banners organized by John Gorman.) However, due to the increasing politicization of art during the 1970s, banners became

fashionable again and contemporary artists such as Conrad Atkinson, John Dugger, Dan Jones, Ken Sprague and Andrew Turner began to create new, more exciting designs. This type of political art had a popular appeal and a practical function. When carried aloft during May Day processions and mass demonstrations, banners moved and responded to the wind, thereby taking on a live quality missing from static objects found in galleries. Banners were not normally contemplated in the same manner as artworks displayed in a gallery, but Dugger has pointed out that when hung behind speakers on a platform inside a hall or square, audiences would view a banner over a long period.[22]

Conrad Atkinson was commissioned in 1976 by the Northern Region of the General and Municipal Workers' Union (GMWU) to produce five banners. One was a large general banner made of sailcloth with images and lettering on both sides; the other four were smaller, representing different areas of the region. Atkinson discussed the content and form of the banners with union members for several months and researched the history and iconography of earlier trade union banners. Some of the images and slogans of previous banners he considered reactionary and he felt exposed because there was 'no sense of a visual radical tradition, no Cézanne of the Labour Movement' to follow. He divided the front side of the main banner into a series of horizontal zones and then into rectangles in order to depict a cross section of workers – women and men, both black and white – engaged in diverse types employment from cleaning to mining.

The miners he depicted were not coal miners but iron ore miners from West Cumbria. Atkinson was particularly concerned about this group of workers because he knew some of them personally and had visited iron ore mines. He was aware that many of the miners suffered from work-related illnesses and were not able to benefit from the compensation schemes available to those in the coal industry. Atkinson became an active campaigner for the disabled iron ore miners of his home county.

In addition to the images of workers, ancient symbols such as a

beehive and a bundle of sticks were featured plus a chain to exemplify visually the union's motto 'unity is strength'. (In another banner designed by Andrew Turner for the Manchester branch of the same union, chains were again used but this time to symbolize oppression: Turner depicted a giant male worker breaking free from his chains.) On the banner's reverse side, Atkinson listed the principal aims and ideals of the Union, which had been formed by an amalgamation of several previous unions including the Federation of Women Workers which had joined in 1919.

In May 1977, the main banner was carried on a multi-union march protesting about job redundancies in the North East. The British Prime Minister Jim Callaghan and the American President Jimmy Carter saw the marchers. Another mass demonstration in which it appeared during the summer of 1977 was one in support of the Grunwick strikers in London. Film footage of demonstrations on television news and arts programmes also meant that Atkinson's banners were seen by millions of viewers. When not on parade, the banners were displayed in the union's headquarters in Newcastle-upon-Tyne and in branch offices. They were also reproduced on Christmas cards sold to union members.

Artscriber James Faure Walker saw the main banner when it was hung in the 1978 'Art for Whom?' exhibition. Rather unfairly he noted it was not 'functioning' and then added: 'as a painting its colour is turgid and space-less, and as a banner it is partially illegible, yet by straddling the two domains it remains intrusive to both.'[23] Since the banner was designed for the use of a particular group of people, their opinion surely mattered more than the art critic's. Therefore, evaluating banners aesthetically as if they were simply paintings intended for a gallery was inappropriate.

However, banners designed by fine artists did pose a problem to the arts establishment because they bridged two, normally separate categories: art and craft. The view that banners are a form of applied art was one held by the Arts Council who once refused a request for a grant to restore historic banners on this basis. Historic banners are

not preserved in national art galleries such as the National Gallery and Tate Britain, but in the National Museum of Labour History, established in London but now in Manchester. (However, the Tate did acquire one of Dugger's sports banners – *The Gymnast* – in 1980.)

One banner in the collection of the Manchester museum, designed in the 1970s for the Grunwick Strike Committee, is unusual because it was created by a young Indian and Grunwick worker called Jayandi rather than by a professional artist. He and Vipin Magdani, a member of the Strike Committee, painted it. Jayandi must have had some knowledge of modern, revolutionary art because the banner's dynamic abstract design echoed that of El Lissitzky's famous Soviet poster *Beat the Whites with the Red Wedge* (1920). The banner's colours were black, red and white and it featured the slogan 'Defend the right to strike'; this banner was carried around Willesden when 1400 marched in support of the Grunwick strikers.[24]

Chapter 9

1978

Demonstrations occurred in Iran against the repressive regime of the Shah. The *Amoco Cadiz*, an oil super tanker, spilled its cargo in the English Channel. The Red Brigade caused terror in Italy and murdered Aldo Moro. Argentina played against Holland at home and won the world soccer cup final. Louise Brown, Britain's first test tube baby was born. In Guyana, 913 followers of the 'Reverend' Jones committed suicide on his orders. In July, the Grunwick strike was finally abandoned. Workers at Ford car factories won a 17 per cent wage increase after a seven-week strike. Industrial action by various groups of British workers was dubbed the 'Winter of Discontent' (1978–79); it caused much disruption and antagonism towards trade unions. Saatchi & Saatchi designed the famous 'Labour isn't working' poster for the Conservatives. The IRA planted bombs in Britain's provincial cities and IRA prisoners began a 'dirty' or blanket protest. Gatwick Airport was opened. Sony of Japan launched their Walkman portable cassette player. In the United States the new soap opera *Dallas*, starring Larry Hagman as JR, became popular. Johnny Rotten left the Sex Pistols at the end of an American tour. *The Deer Hunter* – a movie about the Vietnam War by Michael Cimino starring Robert de Niro and Christopher Walken – was critically acclaimed. John Carpenter's horror film *Halloween*, Alan Parker's *Midnight Express* and Richard Donner's *Superman* were also successful at the box office. E.P. Thompson's book *The Poverty of Theory*, Edward Said's *Orientalism*, Judith Williamson's *Decoding Advertisements* and *The Boy Looked at Johnny: The Obituary of Rock 'n' Roll* by Julie Burchill and Tony Parsons were published. In May, Rock Against Racism held its first carnival in Victoria Park, Hackney, London. Derek Jarman's

film *Jubilee* was released. F.R. Leavis, the literary critic and Keith Moon, of the pop group The Who, died.

Jo Spence appeared in *Spare Rib*. An exhibition of Carl Andre's sculpture 1959–76 was held at the Whitechapel Art Gallery (March–April). At Art Net, there was a show entitled 'Radical Attitudes towards the Gallery'. The exhibition 'Art for Whom?' was mounted by the Serpentine Gallery and 'Art for Society' by the Whitechapel. Peter Fuller's article 'On social functionalism' appeared in the August issue of *Artscribe* and he delivered a conference paper entitled 'Fine art after modernism'. A large 'Dada and Surrealism' show was held at the Hayward Gallery. Five women artists selected the second 'Hayward Annual' exhibition. In March, Margaret Harrison mounted a show entitled 'Woman's Work' at the Battersea Arts Centre. John Mapondera founded the Drum Arts Centre organization to promote black art and culture in Britain. David Binnington began to design a public mural *The Battle of Cable St*, which was completed by other artists in 1983, about a historic confrontation in London's East End. Sir Hugh Willatt retired as secretary general of the Arts Council and was replaced by Sir Roy Shaw. An APG event was held at the Whitechapel Art Gallery. The *State of British Art* conference was held at the ICA, which also mounted an Allen Jones' exhibition – feminists were offended by his sculptures of women as furniture. A large-scale Gustave Courbet exhibition was organized by the Arts Council and held at the Royal Academy. At the AIR Gallery in London, a display of Chilean patchworks was held and the Half Moon organized a travelling show of photomontages entitled 'A Document on Chile'. At the University of East Anglia, Norwich a new art museum – the Sainsbury Centre – was opened in a high-tech building designed by Norman Foster. Several shows of German art appeared in London: at the Whitechapel 'Eleven Artists Working in Berlin' featured Wolf Vostell, Gunter Brus and several neo-expressionist painters; at the ICA 'Berlin – A Critical View: Ugly Realism '20s–'70s; and at the Hayward, 'Neue Sachlichkeit and German Realism of the 1920s'. Paul Overy, the art critic, was dismissed by *The Times* newspaper.

Nicos Hadjinicolaou's book *Art History and Class Struggle* and Roger Taylor's *Art: An Enemy of the People* were published. Lisa Tickner's article 'The body politic: female sexuality and women artists since 1970' appeared in *Art History*. Peter Gidal's *Structural Film Anthology* was published by the BFI. Liberation Films released *Morgan's Wall* about a community mural. The Italian metaphysical painter Giorgio de Chirico died, as did the American critic Harold Rosenberg.

In February, the ICA hosted a three-day conference entitled 'The State of British Art', which attracted capacity audiences. It was organized by four writers on art – Andrew Brighton, Richard Cork, Peter Fuller and John Tagg – who believed that exhibitions of British art during 1977 had revealed a state of crisis due to the exhaustion of modernism, the marginality of the fine arts compared to the mass media, and avant-garde art's lack of social and political roles. Platform speakers included artists, art school staff, art historians, critics, a dealer, a museum director and magazine editors, who represented a wide cross section of opinion in the art world. For instance, among the artists were: the figurative painter Josef Herman, the abstract painters Robyn Denny and Patrick Heron, the pop painters David Hockney and Allen Jones, the sculptor Reg Butler and the artist-theorists Terry Atkinson and Mary Kelly. Some members of the audience – Conrad Atkinson, John Dugger, Barry Martin, Paul Overy and others – also contributed to the sometimes heated debates. The length of the proceedings was such that when Richard Cork of *Studio International* published an edited transcript – against, incidentally, the wishes of the other organizers – it ran to over 60 pages.[1]

The subject of the first session was the crisis in professional practice. Antagonism and differences of views between certain artists – Denny and Jones – and certain critics – Cork and Fuller – soon emerged. The artists were convinced there was no crisis, merely a lull after the glitz of the 1960s; or that if a crisis did exist, it was in the parlous state of art criticism not art. (Later, James Faure Walker accused left-wing critics of inventing a crisis because they were

cynical and disillusioned with art.) The artists' complacency presaged that of Prime Minister James Callaghan when he returned from a foreign trip in January 1979 to be greeted by reports of chaos at home and his attitude was interpreted as 'Crisis? What crisis?'

Andrew Brighton demurred: 'I think the crisis *is* upon us. Suddenly a lot of that work doesn't convince us very much.' The intense interest aroused by the debate was also a sign that the conference had touched a nerve. Ken Turner from Action Space agreed there was a crisis but argued that it was due to the public's inability to appreciate experimental art. Later, the art historian Ray Watkinson maintained that 'the crisis in the arts is a crisis in the structure of our society'. ('Crisis' was also the name adopted by a politically motivated punk rock band.)

René Gimpel, an art dealer, added a note of realism by reminding the audience of the power of the art market, of the fact that only a tiny number of those who wanted to be artists actually succeeded in becoming full-time professionals because of the shortage of British collectors of contemporary art. (Later, Conrad Atkinson pointed out that visual artists were 'invisible' as far as the authorities were concerned in the sense that the profession was not even recognized as a job category by labour exchanges and benefits agencies.) These observations prompted consideration of alternatives such as funding from public sources for non-gallery art such as community murals.

Consideration of the profession of artist naturally led to the second session about art education. Again, the talk was of a crisis in the training of artists. Hockney wanted a return to the past: he thought art schools should teach life drawing and craft techniques again and that academic entrance requirements should be dropped. Peter de Francia argued for more knowledge and professionalism – fewer students and a longer period of study. From the floor, a filmmaker reminded listeners of the existence of other, newer media and Peter Freeth maintained that confusion in the art schools reflected confusion about art in the wider society and then added: 'as artists, we have absolutely no social function. We are unemployed.' Desmond Rochfort, a public muralist, wanted craft skills taught to facilitate 'social communication'

rather than self-expression. The implication was that art education could not be reformed without a clear notion of its goal and social purpose. Therefore, it was odd that none of the speakers discussed the Labour government's policies on art education.

Session three, in which Rasheed Araeen, Alan Bowness, Patrick Heron and John Tagg spoke, discussed the question of nationalism, the relation of British art to wider international events and styles. A paper by the critic Caroline Tisdall, read out in her absence, argued for more artists' cooperatives and collectives to resist the globalization associated with multinational companies. Heron rehearsed the reasons why he had complained in print about American cultural imperialism in the post-1945 era and Bowness urged British artists to assert their national identity. Araeen, of course, reiterated his critique of Western imperialism and racism and discussed the relation of artists from the Third World to the 'international' style, which was in fact Euro-American. Cork concluded the session by confessing: 'We are guilty of appalling British imperialist provincialism with regard to the Third World.'

Mary Kelly summed up the conference thus far by arguing that it could never have taken place but for the radical movements associated with blacks, students and women. However, she thought the debate had largely been a battle of 'the sons against the fathers' – crudely, the social artists and critics against the defenders of the modernist mainstream, and this had made it difficult for women and non-whites to contribute.

Session four concerned the question 'For Whom?' that is, the audience for contemporary art, and what was meant by 'popular' and 'the people'. Andrew Brighton, a critic and painter now employed in the Education Department of Tate Modern, delivered a paper. A year earlier, he and Lynda Morris had organized an intriguing exhibition in Nottingham entitled 'Towards Another Picture' that juxtaposed modernist work against academic paintings and prints of steam engines and animals. The latter were 'popular', in the sense of being widely appreciated and easy to understand, but most art historians

and museum curators ignored their existence because they despised them. Brighton thought there were two kinds of art favoured by the Establishment: modernism (enjoyed by the intelligentsia and supported by wealthy collectors and state bodies such as the Tate Gallery and the Arts Council) and 'consensus painting' (by which he meant the kind of figurative canvases shown in Royal Academy's summer exhibitions). Neither, in his view, met the needs of the vast majority at the lower end of the social scale. To democratize existing art was not enough. What was needed was a new kind of 'democratic art', which he defined as 'an art that enables people to recognize themselves and to create themselves in the world'. Unfortunately, Brighton did not cite any examples.

Faure Walker, the painter and editor of *Artscribe*, responded to Brighton's paper by complaining that social critics repeatedly called for new art that fulfilled their political agendas, instead of responding to what artists had actually created. (Apparently, critics should never express opinions about the future direction of art.) Such critics evaded responsibility for aesthetic judgement 'while maintaining power through the rhetoric of dominance. The slogans may be radical ... but they are defended by authoritarian tactics'. As a supporter of modernism, he disliked the 'sour tone' used to discuss it and he detected 'venomous negativity' and 'parochialism': 'talking only about a *British* context, and about *British* art, never looking over the horizons – it's so claustrophobic.' Since the title of the conference was 'The State of *British* Art', it seems Faure Walker was out of sympathy with its basic premise.

Naseem Kahn, the author of the 1976 report on the arts of Britain's ethnic minorities, described ethnic art as 'the survival kit of communities; it's the talismans that they've brought with them from home'. This type of culture was popular within the groups that produced and consumed it, but Kahn's research had shown that it received almost no financial support from state bodies such as the Arts Council.

'Images of People' was the subject of the final session. Terry Atkinson delivered one of his incredibly long and convoluted papers,

which nevertheless had a surprising twist and thesis. The 'people' he discussed were not the working class but artists and their self-representation in pictures such as Courbet's *Studio* (1855). He then outlined the theory of possessive individualism, devised by bourgeois philosophers such as John Locke, and demonstrated its links to the free market system and the ideology of freedom espoused and reproduced by artists and tutors in art colleges. Atkinson's intellectually ambitious paper was difficult to assimilate and so other artist-members of the panel – Reg Butler and Josef Herman – were left floundering.

Next, the feminist art historian Lisa Tickner and the photographer-theorist Victor Burgin delivered lucid papers in which the role of the nude in art was reviewed and the ways 'deconstructive' artists were responding to the reality that most images of people were to be found in the mass media.

An interesting clash of opinion occurred between Tickner and Butler. The sculptor believed most female art students failed to make careers as artists because having babies was their form of creativity and because marriage and maternity diminished their energy and will to continue. Tickner reminded him of the example of Barbara Hepworth who had managed to achieve both career and children. Tickner could also have cited Mary Kelly's economical and ingenious solution: have a baby boy and then make art about his development.

An extraordinarily wide range of political issues and theoretical problems were raised at the ICA. Inevitably, they – and the opposing views that emerged – could not be resolved in verbal debates. As the conference ended, Geoffrey Wickham described it as 'successful, remarkable and historic' and Cork added: 'We have only just begun to get to grips with the problems which have been debated here in an inevitably diffuse way.'[2] Later in the year, several exhibitions extended aspects of the debate.

In March 1978, Margaret Harrison held an exhibition of drawings, documents and paintings entitled 'Woman's Work' – subtitled 'Home-workers: Rosa Luxemburg: Rape' – at the Battersea Arts Centre

(BAC), in the London Borough of Wandsworth. Local government – the London Borough Councils and the Greater London Council – supported such art centres situated in unfashionable districts of the capital. Bill Hutchison, BAC's Director, maintained that such multipurpose, inter-disciplinary centres could overcome the specialization associated with commercial, fine art galleries, integrate the arts and sciences and reconnect them to the public. During the 1970s, such centres were sometimes more significant in encouraging radical art than upmarket galleries in London's West End.

One section of 'Woman's Work' was a continuation of the earlier Metal Box factory project in which Harrison had been involved because it concerned the lives of women who worked at home, because they could not care for children and work factory shift systems. In gathering information – which involved researching the law, unions, advertising, the power of the state and big business – Harrison was assisted by Helen Eddy, the organizer of the London Homeworkers' Campaign. Although homeworkers were one of the most exploited groups, most of them did not belong to a trade union. Harrison's work about them was both objective and subjective: she felt a personal affinity with their plight because she too was struggling to raise children, to organize nurseries and to practice as an artist. Her aim was 'consciousness-raising within the trade union movement, for a broadly non-art audience in regional towns and finally within the gallery network.'[3]

Harrison had trained as a painter during the 1960s but had then abandoned the medium for a factographic method, as this seemed more appropriate to the needs of the Women's Movement. However, in 1978 she returned to painting in order to produce a major canvas about rape, a crime that concerned Harrison personally and women in general.

In fact, painting was combined with documentation in the form of press cuttings and adverts glued to the surface. There were also sections of hand-lettered text. (This meant that the medium's purity was disrupted and that viewers had to stand quite close to the painting to

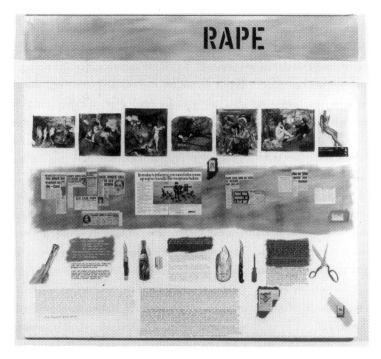

28. Margaret Harrison, *Rape* (1978). Painting, acrylic and collage on canvas, 1.7 x 2.4 m. London: Arts Council Collection, photo © John Webb, courtesy of the Arts Council of England.

read it.) The canvas was divided into four horizontal bands containing the title, images of women from the history of art (from Rubens to Manet) and from advertising, news reports about the attitude of the courts towards rape, plus recruiting adverts for the British army and accounts of violent acts of rape illustrated by pictures of various weapons used by male rapists. The copies of famous paintings from the past were designed to indicate the long history of representations of women as sexual objects for the delectation of male voyeurs, a tradition continued by the advertising industry.

Rozsika Parker and Griselda Pollock have commented:

The painting tried to address the complex of prejudices and stereotypes, which pervade current popular, police and legal attitudes to the offence.

The painting proposes to disrupt the smooth functioning of ideologies, which assume that 'women ask for it'... [the work establishes] an unexpected relationship between usually separated areas such as high culture, advertising and judicial report in order to show that representations of women circulate across and are sustained by these different sites of meaning. This indexes art and advertising to daily social life, and to politics.[4]

Harrison's work was too fragmentary in composition and disturbing in content to be pleasurable. (Arguably, it refused visual pleasure for the political reasons given by Laura Mulvey in her highly influential essay 'Visual pleasure and narrative cinema' published in *Screen* three years earlier.) Its function was didactic rather than decorative. The artist has explained how:

While being shown at the BAC, it was used in a directly educational context by teachers from local schools as a teaching aid, and visiting groups of adolescents were introduced to some of these ideas about visualization, ideology and a specific issue ... At another level, the Rape Crisis Centre was able to utilize *Rape*'s political dimension through the reinforcement of the sociological problems raised by the issue.[5]

Shortly afterwards *Rape* reached a different audience when displayed in the Whitechapel's 'Art for Society' show. *Rape* was later banned from the Ulster Museum because Harrison's use of army recruiting advertisements was regarded as a slur on the British army. In 1979, the work was shown in the Hayward Gallery during the 'Lives' exhibition, organized by Derek Boshier who purchased it on behalf of the Arts Council. A decision had been taken to change the venue of 'Lives' from the Serpentine Gallery to the Hayward. One reason given by the authorities for the switch was that *Rape* might upset casual visitors – mothers with children – to the Serpentine.[6]

Women were also in evidence at the AIR Gallery, London, in March when a display of Chilean Arpilleras (patchworks) was mounted with

the help of Oxfam. In Chile, following the army coup of 1973, which had the backing of the United States, there was a period of terror and extreme hardship for the poor, especially women living in the shanty-towns around Santiago. Many of them had no news of their husbands and children who had 'disappeared' after being arrested by the military or the DINA (secret police). Groups of such women began to organize workshops and to construct small pictures by sewing scraps of fabric and wool – waste discarded by factories – together using old flour sacks as supports. The women were not trained artists but they did possess traditional craft skills such as embroidery.

These humble artefacts attracted the interest and stirred the emotions of those on the Left in the British art community who were concerned about the fate of Chilean people under the dictator General Pinochet. Because women made them, they were also of interest to feminists and to socialists because they were an example of genuinely popular or people's art (in the sense of art made by the people for the people). The critic Guy Brett was a keen supporter and wrote several essays praising the Arpilleras.[7]

Two years earlier, Maureen Scott of the LSA had painted a mural in support of the opponents of fascism in Chile for the Peckham headquarters of the Amalgamated Union of Engineering Workers (AUEW). The picture space was crammed with figures and in the centre was a grim portrait of Pinochet with his henchmen and their victims floating in a river of blood. A bleeding Allende was also shown. Above the dictator, a giant male figure flanked by red flags carried by trade unionists strained mightily to break the chains that bound his wrists, while below the people marched forward holding aloft a flame of resistance. While there was no doubt about the artist's emotional sincerity, the mural's pictorial rhetoric was antiquated and its style was heavily indebted to that of the Mexican muralists. One of its aims was to foster solidarity among trade unionists around the world in the hope that they would use their power to mount an international blockade of Chile's commerce. Hugh Scanlon, the AUEW's President, unveiled the mural in July 1976 in

the presence of Alvaro Bunster, President of the Chilean Anti-Fascist Committee.

Chile was also the theme of a travelling exhibition – 'A Document on Chile' (first shown in June–July 1978) – organized by the Half Moon Photography Workshop, in East London, of photomontages by Peter Kennard with text by the journalist Ric Sissons. At the time, six Chileans were on hunger strike in St Aloysius Church, Euston as part of global protest against the 'disappearance' of those arrested in Chile. Thirty montages were laminated on to panels to facilitate transportation and hanging and, for two years, the show visited community centres and universities across the country. Chile Solidarity Groups also viewed it.

When Kennard made work about Chile in Britain, he did not have to pull any punches because of fear of arrest and so he was able to attack the barbarity of the military junta head on. One of his montages merged three images: at the top, ranks of soldiers, in the centre, a slaughterhouse with suspended animal corpses, at the bottom, a dead man with a rope around him. The slaughterhouse metaphor, of course, was not new; it had previously been used by political film-directors such as Sergei Eisenstein in *Strike* (1924) and Fernando Solonas and Octavio Getino in *The Hour of the Furnaces* (1968).

Another powerful image showed a steel-helmeted soldier armed with a rifle and a brush engaged in painting out the portraits of Allende supporters (he was making them 'disappear'). Other montages were designed to portray the period before Allende was elected, the three years of the Popular Unity government and the Pinochet period of repression that followed. Kennard's montages were also intended to explain the economic, political and social structures that lay behind the coup including the involvement of the Americans, their monetarist economists and the CIA. Clearly, Kennard's aims were agitational and educational: to inform the public about the true character of the regime in Chile and to arouse anger.[8]

Kennard did not expect to encounter censorship in Britain but, in 1985, when two of his Chilean montages were displayed at the

Barbican Centre, London one was removed and the other covered with a blanket because a high-ranking official from Chile was due to visit in order to address British bankers.

Although some contemporary critics believe Kennard's images (and photomontage in general) have lost their potency, others regard him as one of the most important artists of the late twentieth century. Today, Kennard continues to work as a political photomontagist but he also mounts gallery exhibitions (some of which experiment with other materials such as industrial wooden pallets and feature live appearances by the left-wing politician Ken Livingstone). In addition, he teaches photography at the RCA.

The questions: 'For whom is art currently produced?' and 'For whom *should* it be produced?' had concerned left-wing artists for some years. An exhibition held during April and May at the Serpentine Gallery, selected by the critic Richard Cork, who described himself as 'a democratic socialist', set out to supply answers. 'Art for Whom?' documented five projects representing different solutions to the problem of widening the public for art beyond the art world audience. The artists were: Conrad Atkinson, Peter Dunn and Loraine Leeson, David Cashman, Roger Fagin and others/Islington Schools Environmental Project, David Binnington and Desmond Rochfort/ Public Art Workshop and Stephen Willats.

Atkinson provided information about an exhibition addressing the divisions in Northern Ireland that he had organized at Art Net, Belfast in 1976; hence, this was a show that had been designed with a particular political problem and public in mind. Dunn and Leeson reported on their poster and video contributions to a campaign to save the Bethnal Green Hospital from closure. The exhibition's catalogue also recorded their work with local people in Ruislip in the South of England and Peterlee in the North, and their interest in the history of the two areas. Cashman and Fagin described their experience of collaborating with children and teachers in an Islington, inner city school to generate murals and play structures. In this instance, the 'audience' was very specific and participated in the design process.

Binnington and Rochfort provided documentation about the huge murals on the subjects of capitalism and labour (both manual and white collar), which they had painted on the concrete buttresses of a motorway flyover near Royal Oak underground station, Paddington, in London. Local residents and commuters, most of whom would not be gallery-goers, thus encountered their images. Willats reported on a project in Perivale that had required the active involvement of local residents. The findings of the project had then been communicated to the same people via displays in local buildings.

Unusually, the catalogue included a ten-point manifesto, agreed by all contributors, stating their objections to existing art and explaining the changes in art and society they were striving to achieve.

These types of art posed difficulties for critics and visitors to the Serpentine because judgements about aesthetics and social efficacy could really only be given by those who had been addressed and who had participated in their creation. Consequently, it would appear that the show's purpose was to reveal to the London art world the existence of five 'alternative' models of artistic practice.

The exhibition provoked a tirade of abuse and sarcasm from the right-wing journalist Bernard Levin.[9] His review, published in *The Times*, was headed: 'This poisoning of the wells of art' and he declared the show's contents were 'not art' but 'rubbish' and that the ideals stated in the manifesto were 'intolerant idiocies'. The intention to use art to create a more egalitarian society infuriated him because he thought nothing could be 'less egalitarian, by its nature, than art'. According to Levin, art is always 'the outer expression of the inner vision, the inner growth of the artist'.

One could not find a clearer summary of the Western European, bourgeois concept of art as the subjective creation of a few, exceptional, autonomous individuals. Levin did not think that art could be made 'to fit pre-arranged purposes' – so much for the art commissioned by the Christian church over the centuries or the architecture, monuments and statues ordered by Royalty, governments, etc. Levin was apparently ignorant of the history of art and of recent challenges

to the bourgeois concept of art, and indeed to the very notion of 'author-ship'.

Since the public murals at Royal Oak had been executed by two, serious, professional artists using a special, weather-resistant paint, and had been reasonably funded (£11,000, about £8,000 of which came from the Arts Council), they were of a higher standard than many other street murals. However, this did not save them from scath-ing judgements. Sarah Kent, *Time Out*'s critic, thought their 'heavy-handed propaganda' reeked 'insultingly of middle-class paternalism'.[10] James Faure Walker commented:

> its heavy-handed symbolism must remain obscure to most (one half is visually incoherent quite apart from its oppressive iconography). Dwarfed by its environment ... its principal merits are formal, the ingenious way the perspective diagonals capitalize on the fly-over's overhang. It is impress-

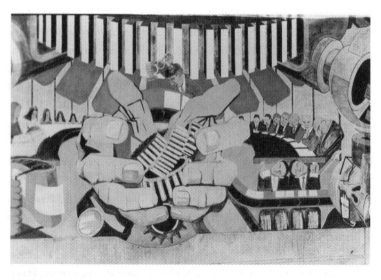

29. David Binnington, *Public Mural at Royal Oak* (1976–77). Executed in Keim Kunstfarben. Detail of mural on the East Wall of a flyover at Royal Oak, London, concerning the labour of white-collar workers. Photo © J.A. Walker.

ive on account of the work and dedication that went into it, and not because of the social impact it makes, which is marginal.[11]

Binnington and Rochfort's imagination, skill and vigour were praised, as one might expect, by writers associated with the left-wing magazine *Artery*.[12] Jeff Sawtell, *Artery*'s editor, remarked: 'their response [to the crisis in Britain] has been a *socialist realist* intervention, coupled with a commitment to revolutionary politics – communism.'[13]

Another London show that might well have angered Levin, was 'Art for Society: Contemporary British Art with a Social or Political Purpose' held at the Whitechapel from May to June. The idea for the show was Margaret Richards'. Nicholas Serota and Martin Rewcastle of the Whitechapel, with the help of a committee that included Richards, Toni del Renzio, Richard Cork and Caroline Tisdall, organized it. A selection was made from submissions made by 300 artists. Among the artists featured were: Rasheed Araeen, Conrad Atkinson, Derek Boshier, Ian Breakwell, Victor Burgin, Rita Donagh, John Dugger, Peter de Francia, Margaret Harrison, Josef Herman, Dan Jones, Mary Kelly, Peter Kennard, R.B. Kitaj, Martin Parr, Ken Sprague, John Stezaker and Stephen Willats. The works displayed, most of which dated from the 1970s, were in various styles and media: banners, drawings, paintings, photographs, photomontages, posters, prints and slide/tape. (The politics of the participants varied almost as much as their styles.) Sculptures were in short supply, but one striking example, by the ceramic potter Alison Williams, was a representation of the right-wing politician Enoch Powell as a massive spider. Powell, of course, was notorious for a speech against immigration predicting 'rivers of blood'. The fact that London dockers had marched in support of Powell was a warning to left-wingers against uncritical workerism.

Essays by Cork, John Gorman, Charles Gosford, Ian Jeffrey, David Logan, del Renzio, Richards and Sprague appeared in the catalogue. Public meetings were held and a programme of films accompanied the

exhibition. Since 'Art for Society' attracted 14,272 visitors, it was more popular than the previous exhibition of Carl Andre's minimalist sculptures held in March and April – only 10,353 attended the latter.

Some visitors found the sheer diversity of the exhibits refreshing after the sterile appearance of the minimalist show, but others thought there was a lack of unity. The presence of left-wing art with a social purpose inside an art gallery was regarded by some critics as a contradiction but, as Serota pointed out, the location of the Whitechapel in a poor district of the East End (but near the City of London) meant that up to 50 per cent of visitors lived or worked locally.

'Art for Society' was scheduled to appear at the Ulster Museum in Northern Ireland but, as mentioned earlier, it ran into censorship problems when the Museum's Board of Trustees discovered that the show included art critical of British rule in the province.

Writing in *Artscribe*, Faure Walker attacked both 'Art for Whom?' and 'Art for Society' because the art and the politics on display were 'mediocre' and because the shows were a pretext for a new fashion, which he labelled 'social art'. In his view, 'The disappearance of the mainstream has been profoundly disorientating', hence social art 'provides identity, purpose and destiny, and, most important, it promises redemption after the fall of modernism'. The idea that artists could intervene in world events was 'a collective fantasy engendered by the art community's fear of impotence'. (If Faure Walker is right, then surely art has no social role or ideological influence on human thought and behaviour.) In fact, he thought 'all art is ultimately for society by virtue of its being art. Its social purpose does not increase simply because artists pin-point specific audiences or incorporate "social" subject-matter, underlining their social responsibility ... advertising political allegiances betrays a lack of confidence in the inherent capacities of art to embrace social experience'.

According to Faure Walker, a common characteristic of late 1970s art – other than social art – was 'a rejection of doctrines in general'. Since art had become 'less centralized', artists had been thrown back

on their own resources and now had to search for 'their own ethic of truthfulness regardless of overall absolutes'.[14] In other words, pluralism had resulted in individualism of an extreme kind. 'Back to square one', social artists and critics might have retorted.

Attacks on socialist-inspired art from abstract painters and from the Right were only to be expected but more surprising were the negative critiques that emanated from those on the Left too. Art & Language appeared at a meeting held at the Whitechapel to deliver a blistering paper accusing the British art world of 'feebleness, corruptness and ersatz thinking'.[15] Exhibitions such as 'Art for Society' — organized by 'opportunist monsters and fools' — were 'an affront to working-class self-activity and a boost to bourgeois democratic domination'. Furthermore, for the most part, the art was dreary and lacking in festiveness and spontaneity.

A & L's principal objection was that the workers were already engaged in class struggle and earnest missionaries from the realm of art did not assist their daily reality. Left-wing artists were idealizing the workers, playing at politics or merely illustrating political subjects. What A & L looked for from artists was self-reflection/criticism regarding their own position within the existing social structure, the transformation of the artists' own practice via group/collective activity which A & L, of course, had been attempting since the 1960s.[16] Despite A & L's critiques of art and its institutions, it had never really escaped from their orbit.

Peter Fuller, in a September conference speech, also attacked what he disparagingly labelled 'social functionalism', characterizing it as 'a false solution' to the demise of modernism and the crisis in British art.[17] He chastised Richard Cork for organizing exhibitions of art for society's sake and favouring 'the most deadening, dull, derivative work carried out in a quasi-"socialist realist" style or the sort of modernist, non-visual art practice which packages bad sociology and even more dreadful Lacanian structuralism and presents them as art...' Fuller believed such artists were donning factory overalls but never leaving the cosy confines of the art world. (But, surely, this was

untrue in the case of members of APG, community and public mural-
ists and Willats' projects?) Despite his reservations about 'the profes-
sional fine art tradition', Fuller remained convinced it was worth
preserving because authentic art could not be reduced to ideology,
and within that tradition 'imaginative, truthful depictions of experi-
ence' were still possible.

Whether the works featured in the exhibitions at the Serpentine
and the Whitechapel were aesthetically and politically satisfactory
or not can be debated on a case-by-case basis, but what was not in
doubt was the validity of the questions posed by the artists and
curators.

During the 1970s, women artists noticed that their representation
in mixed exhibitions of British art held at prestigious public galleries
was very low and they took action to rectify the situation. For
example, a protest demonstration was held in 1975 outside the
Hayward when the 'Condition of Sculpture' exhibition was on because
it featured 36 men but only four women. Balloons, stickers and
banners carried the slogan 'Combat Male Artocracy'. The year before,
members of the Artists' Union had met Hugh Jenkins of the Arts
Council and asked for parity for women in exhibitions and on the
Council's visual arts panels. Later, an all-woman show was proposed.
This idea was rejected but five women artists were nominated to select
the '1978 Hayward Annual': Gillian Wise Ciobotaru, Rita Donagh,
Tess Jaray, Liliane Lijn and Kim Lim. These artists did not share a
common style and so they did not consider themselves a group, nor
were they ardent feminists. However, the experience of organizing the
show and the reactions to it did serve to raise their awareness of
gender issues. In total, 23 artists were selected, a minority of whom
(seven) were men. This proportion, the selectors pointed out, was
higher than male selectors had permitted women in the past.

The '1978 Hayward Annual' included artworks by four of the
selectors and by Sandra Blow, Elisabeth Frink, Susan Hiller, Alexis
Hunter, Mary Kelly, Deanna Petherbridge and Wendy Taylor. Male
exhibitors included: Stephen Cox, Adrian Morris and Michael

Sandle. Some of the female exhibitors were feminists and some were not. Frink, a successful sculptor who specialized in making heads of men, claimed she had experienced discrimination in the art world, not because of her gender, but because she preferred figuration to abstraction.

Patronizing journalists dubbed the exhibition 'ladies' night' and 'girls' annual', but most reviews turned out to be favourable because, overall, the women selectors had made safe choices. Tim Hilton, a Ruskin expert and Greenberg-influenced critic committed to abstract, formalist painting, disagreed. He found the show 'second rate . . . a dispiriting experience' and blamed the selectors for prioritizing politics over 'beauty'. Hilton's negative assessment was even-handed: he was as hard on the men's art as he was on the women's. For instance, Morris' paintings were judged 'painfully inept' and Sandle's *Twentieth Century Memorial* (1971–78) – 'a horrifying model of a flayed Mickey Mouse behind a machine gun' – did not count as sculpture as far as he was concerned.[18] Compared to most other British sculptures, Sandle's sinister, anti-war bronze was exceptional because of its ambitious theme and technical complexity and because it was representational and symbolic without being naturalistic in style.

Arguably, this work – which had its origins in Sandle's reaction to America's involvement in the Vietnam War – was the most substantial sculpture by a British artist produced in the 1970s. Sandle (b. 1936) was an artist obsessed by subjects such as ghosts, violence, war, death and the power of the mass media. He had been influenced by German art while a student at the Slade (1956–59) and, after spending three years in Canada (1970–73), he moved to West Germany because his poetic type of sculpture was more appreciated there than in Britain.

Hilton's remarks typified the two charges repeatedly made against politically committed art: either it was bad art or it was not art at all. The issue of quality was a vexed and recurring one. The enemies of socialist and feminist art played this card whenever radical political artists gained a small victory. Of course, weak but 'politically correct' art was made and shown, but there was also plenty of mediocre

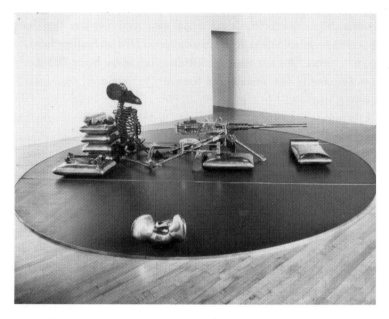

30. Michael Sandle, *A Twentieth Century Memorial* (1971–78). Bronze on painted wood base, 5.7 m in diameter, 1.4 m high. Photo D. Atkins, reproduced courtesy of the artist.

abstract and figurative painting around. Furthermore, what the form-alists were reluctant to consider was the fact that critical evaluation in respect of new art was problematic and that aesthetic quality was itself a contested concept: what criteria were being applied, by whom and in whose interests? For instance, since Hilton was not a woman, mother or feminist – Mary Kelly's intended audience – it was hardly surprising he failed to relate to the content and form of 'Post-Partum Document'.

However, even some left-wing female reviewers were critical of Kelly's art and the exhibition in general. Juliet Steyn and Deborah Cherry, for instance, felt that the selectors had presented 'a narrow range of works, all of which are in well-established modernist traditions'. Although the curators had 'succeeded in increasing the numerical quota of female exhibitors', they had 'failed to expose the versatility of women's practice'.[19] Griselda Pollock also wrote a

thorough critique of the show.[20] Rasheed Araeen chose the show's opening night to highlight another omission by distributing handouts which asked: 'Why are black artists *always* excluded from official exhibitions/surveys like the Hayward Annuals?'

Chapter 10

1979

1979 was declared International Year of the Child. A Soviet-backed coup occurred in Afganistan. Egypt and Israel signed a peace treaty in Washington DC. A popular revolution occurred in Iran – the Shah was deposed and exiled and the religious leader Ayattollah Khomeini gained power; 50 American embassy staff were then taken hostage; Islamic fundamentalism was triumphant. Sandanista rebel forces won power in Nicaragua. Saddam Hussein became President of Iraq. In Germany, the Green Party was founded. An accident occurred at the American nuclear power station at Three-Mile Island, Pennsylvania. An IRA bomb killed Earl Mountbatten in Eire and 18 British soldiers died at Warrenpoint. The INLA killed the Conservative MP Airey Neave in London. Referendums on devolution for Scotland and Wales were held but no action followed. British police hunted for the so-called Yorkshire Ripper, a serial killer of women. 2000 women marched in London's Soho to 'reclaim the night'. A Socialist Feminist National Conference was held in London. Riots in Southall occurred in response to a meeting of the National Front during which the police allegedly killed Blair Peach, an Anti-Nazi League demonstrator. The Conservatives won a general election and Margaret Thatcher became the first woman Prime Minister. Norman St John-Stevas became Minister for the Arts (a Cabinet position). In December, NATO decided 160 American cruise missiles should be based on British soil. The Vietnam War movie Apocalypse Now, directed by Francis Ford Coppola and starring Marlon Brando and Martin Sheen, was critically acclaimed, as was Rainer Werner Fassbinder's Berlin Alexanderplatz and Ridley Scott's space/horror film Alien, starring Sigourney Weaver. Woody Allen wrote, directed and starred in

Manhattan. Mel Gibson starred in *Mad Max*. Derek Jarman's film *The Tempest* was released and he made pop music promos for the singer Marianne Faithfull. The premiere of *The Alternative Miss World* took place. Julien Temple wrote and directed a film about the Sex Pistols: *The Great Rock 'n' Roll Swindle*. In New York, Sid Vicious (ex-Sex Pistols member) killed his girlfriend and later died of a drugs overdose. Compact discs were developed. Dick Hebdige's book *Subculture: The Meaning of Style* was published.

A week of performance art was organized at the University of Southampton. The first issues of *PS (Primary Sources on the International Performing Arts)*, *The Performance Magazine* and RoseLee Goldberg's book *Performance: Live Art 1909 to the Present* were published. Bruce McLean and Paul Richards performed *The Masterwork, Award Winning Fishknife* at Riverside Studios, London. Photography Workshop organized the lecture course 'Feminism and Photography'. The annual *Photography: Politics One* and the photographic magazine *Ten 8* were established. Professor T.J. Clark left Leeds University for an American University; John Tagg was his replacement. The 'Film as Film: Formal Experiment in Film, 1910–1975' was mounted at the Hayward Gallery. Peter Kennard designed posters for a revived Campaign for Nuclear Disarmament. A *History Workshop* conference was held at the City of London Polytechnic on the theme of realism. *Block* magazine was founded by a group of left-wing and feminist art and design historians teaching at Middlesex Polytechnic. Art colleges in Britain reported cuts in their budgets. The *Artscribe*-inspired exhibition 'Style in the 1970s' toured Britain. 'Narrative Painting', selected by Timothy Hyman, was held at the Arnolfini Gallery in Bristol and other venues. John Hoyland exhibited at the Serpentine Gallery and Denis Masi had a solo show at the ICA. APG organized a summer school at the Riverside Studios. The Royal Academy mounted a huge show of post-impressionist paintings while the Hayward Gallery supplied '1979 Hayward Annual', a show of 1930s art and design and 'Three Perspectives on Photography'. Derek Boshier selected works for the 'Lives' exhibition held at the

Hayward but two of his choices were rejected by the Arts Council. A community mural painted by Brian Barnes and others, known as *Morgan's Wall*, was destroyed by the company that owned the wall. A new addition to the Tate Gallery – the Llewelyn-Davies (architects) extension – was opened and the art historian Alan Bowness was appointed as the Tate's new director after Sir Norman Reid retired. David Hockney criticized the acquisition policies of the Tate Gallery on the grounds that they favoured abstract rather than figurative art. At The Hague, the exhibition 'Feministische Kunst International' was mounted. In Paris, 'Un Certain Art Anglais' was held at the Musée d'Art Moderne, while in New York 'British Artists from the Left' was presented by Artists' Space. In November, a conference on 'Art, Politics and Ideology' was held at Dartington Hall. *The Social Role of Art* by Richard Cork and *The Obstacle Race* by Germaine Greer were published. The first issue of *FAN – Feminist Art News* – appeared. The Studio Trust issued *The Politics of Art Education*, edited by Dave Rushton and Paul Wood, and the Commission for Racial Equality published *The Arts of the Ethnic Minorities*. The *London Magazine* (April/May issue) published a series of articles on 'Painting 1979: A Crisis of Function?' Sir Anthony Blunt, the art historian and Poussin expert, was unmasked as a former Soviet spy.

Several exhibitions mounted during 1979 again raised the issue of abstraction versus figuration. John Hoyland's solo show at the Serpentine Gallery was a fillip for abstract painting and the *Artscribe*-inspired touring show 'Style in the 1970s' featured mainly abstract paintings and sculptures. (This was a pre-emptive strike by the Artscribers to capture 'the spirit' of the decade.) It featured paintings and sculptures by 30 artists (28 men and two women); the best known of whom were Graham Crowley, Jennifer Durrant, Noel Foster and Gary Wragg. Ben Jones and James Faure Walker (who was later to switch from painting to computer-generated art) also exhibited works. Adrian Searle, another participant, subsequently abandoned painting and became art critic of the *Guardian*.

The catalogue contained statements by the artists and introductory

essays by Jones, Faure Walker and David Sweet. Jones explained that the work selected was

> uncompromisingly abstract [a clichéd phrase: abstract art has often attrac-
> ted the adjective 'uncompromisingly' while figurative has not] – the vehicle
> for pure plastic expression ... Painting, the language of the pictorial
> should be coloured flat surfaces that incorporated illusionism ... sculp-
> ture, the language of the physical, should be made of literal, not depicted
> form, and it should embrace gravity and be free standing. Artists would
> understand the respective disciplines' confines as a necessary and self-
> defined tradition ... the ambition of each artist [was] the attainment of
> quality through discovery.[1]

The lingering debt to American art and theory – abstract expres-
sionism and Clement Greenberg's modernist painting thesis – was
evident from these remarks.

In contrast, 'Narrative Painting: Figurative Art of Two Generations',
a touring show selected by the critic and painter Timothy Hyman,
boosted the claims of figurative pictures with 'subjects' and 'an imagina-
tive vision of life'. Among the painters featured were: Michael
Andrews, Peter de Francia, Anthony Green, Maggi Hambling,
Howard Hodgkin, Ken Kiff and R.B. Kitaj. Many of them did not
paint directly from life but depicted scenes of people interacting that
had been imagined/invented.[2]

Gen Doy, a feminist and socialist art historian, reviewed the exhibi-
tion for *Artery* and complained that Hyman's concept of 'narrative
painting' lacked theoretical rigour. Nevertheless, she did single out
the drawings and paintings of Peter Sylveire for praise because they
presented 'a forceful and materially gripping view of contemporary
life'. One 1978 interior with figures viewed from above was entitled
The Old Bill and the Bailiffs. According to Doy, Sylveire's pictures
were 'Marxist, informed by both theory and practice, exposing contra-
dictions and developing them, forcing them to the surface, literally
and materially...'[3]

'Narrative Painting' did not receive a warm welcome everywhere in the provinces. When, for example, it reached the Hanley Museum, Stoke on Trent, local councillors and some visitors complained to the press that pictures by Green and Kiff were 'awful, crude, disgusting, insulting' and 'pornographic'.[4]

David Hockney was one of those Hyman had selected and in the same year Hockney criticized the acquisition policy of the Tate Gallery in an interview with a journalist from the *Observer* (4 March 1979). He had noticed that the Tate owned only a few of his paintings and that its curators preferred to buy abstract rather than figurative works. For example, abstractions by Americans had been added to the Tate's collection – most famously Carl Andre's *Equivalent VIII* – but not realist canvases by Edward Hopper (1882–1967), a highly regarded painter of the American scene. Sir Norman Reid, the Tate's Director, had been in charge for 16 years and admitted that his taste inclined towards the abstract. Reid had decided to retire even before Hockney's complaint appeared in print. His successor, Professor Alan Bowness, placated Hockney by increasing the Tate's holdings of his figurative paintings.

From the point of view of social/political artists and critics, the squabble between the supporters of abstraction and figuration was a diversion because what really mattered to them was a new kind of art capable of transforming society.

A more original response to the dilemma was manifested by the post-conceptual paintings Art & Language generated during the late 1970s, that is, their series of portraits of Lenin in the style of Jackson Pollock. The group's intention was to achieve 'a monstrous stylistic détente' by bringing together the two styles – Soviet socialist realism and American action painting – that had distinguished the paintings of the opposing sides during the Cold War. Thus, A & L overcame the division between abstraction and figuration by means of a shotgun marriage.

At the beginning of the 1980s, figurative painting was to become fashionable again, the so-called 'new image painting', 'trans avant-

garde' and 'neo-expressionism', to which some women artists contributed. However, Rozsika Parker and Griselda Pollock argued that, for feminist artists, such decisions were strategic:

> It is not a matter of choosing between figuration or abstraction, conceptual or scripto-visual forms, only one of which can be authorized as appropriate. It is a matter of calculating what effect any particular procedure or medium will produce in relation to a given audience, a particular context and an actual historical moment.[5]

In April 1979, the National Front (NF) decided to hold an election meeting in Southall, West London. This was a deliberate provocation because the Front knew Southall was an area where many Asian immigrants and their British-born children lived. Local youths, supported by members of the Anti-Nazi League, were determined to stop the NF just as London's East Enders had halted a march by Sir Oswald Mosley and his black-shirted fascists in 1936. (The victory of the East Enders was to be celebrated in a Cable Street mural painted by David Binnington, Paul Butler, Desmond Rochfort and Ray Walker, that commenced in the late 1970s and was completed in 1983.) When the Metropolitan police tried to protect the NF, there was a clash between them and the demonstrators. Many arrests were made and the police injured demonstrators as they were dispersing. A young man called Blair Peach had his skull fractured by truncheons and died.

Peach was a dedicated teacher in East End schools, a trade unionist, anti-Nazi and a member of the Socialist Workers Party. The police's Special Patrol Group was accused of his killing, but lack of evidence prevented a prosecution from taking place. (However, in 1989, the police did make an out-of-court settlement to Peach's brother.) Posters were produced by the SWP with his portrait plus the question: 'Who killed Blair Peach?' and these were carried in mass demonstrations. A journalist writing in 1999 described them as 'icons of old-style seventies radicalism and commitment'.[6]

Dan Jones (b. 1940), a self-taught East End artist, banner designer,

book illustrator, teacher, community worker and Secretary of Tower Hamlets Trades Council, painted a bird's eye view of a march commemorating Peach.

In fact, Jones combined two events: Peach's funeral procession in the East End and a memorial march in Southall. The painting was executed in Jones' familiar neo-naïve style, somewhat resembling that of L.S. Lowry: multiple figures simply rendered, bright flat colours, with no aerial perspective. It shows two columns of marchers, flanked by ranks of police, spectators and camera crews, converging at an intersection. The dense mass of the marchers forms the shape of a dead body lying face down on the ground with blood streaming from the head across the tarmac. A coffin and pallbearers constitute the left hand of the prone figure. Asian women dressed in saris tend bouquets of flowers in the bottom, left-hand corner. Black, the conventional colour of death and funerals in the West, is abundantly present in the police's uniforms. Elsewhere there are cheerful hues that might be thought unsuitable for the subject, but arguably there was something positive and optimistic about the representation: the fact that so many people of different races cared, the fact that they came together in a common cause.

Jones' painting was not simply a visual memorial. It had a practical function too because it was reproduced as a poster, published by Tower Hamlets Trades Council and sold for £2; the proceeds went towards the Blair Peach Memorial Fund and the Southall Defence Fund. Although Jones's style of painting was criticized by some left-wing artists during the 1970s, his image *Who killed Blair Peach?* was appropriate to the occasion and a moving tribute. Peter Kennard was another left-wing artist who responded to the killing of Blair Peach.

Derek Jarman was also to reference the resurgence of fascism in Britain during a pop music promo entitled *Broken English* made in September 1979 for the singer Marianne Faithfull. The German urban guerrilla Ulrike Meinhof, who was found hanged in her prison cell in 1976, prompted the song, which posed the question: 'What are we

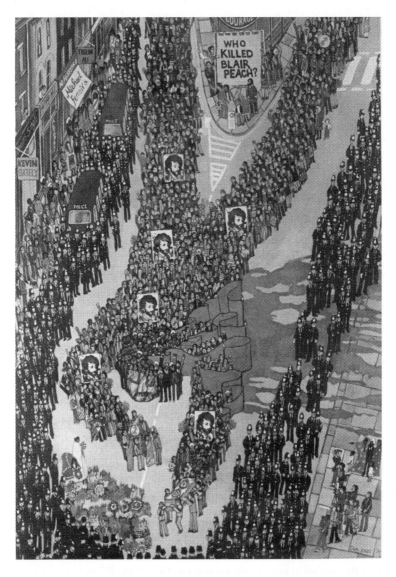

31. Dan Jones, *Who Killed Blair Peach?* (1979). Poster based on a painting, 77 x 54 cm. Published by Tower Hamlets Trades Council. Reproduced courtesy of the artist. Photo © Michael-Ann Mullen.

fighting for?' Jarman inserted historic clips of Hitler, Mussolini and Mosley, plus recent footage of NF demonstrations.

The birth of the pop or rock music video in Britain has often been ascribed to Queen's *Bohemian Rhapsody* of 1975. It was to become an extremely popular form of entertainment during the 1980s once video recorders/players became commonplace in British households and channels such as Music Television (MTV) required a constant flow of videos to fill its 24-hour schedule. Jarman was later commissioned to make several more promos for groups such as Carmel, the Pet Shop Boys and Throbbing Gristle and singers such as Marc Almond and Bryan Ferry. This kind of film or video-making was quick, well-paid and favoured directors with a flair for experiment and special or theatrical effects.

Towards the end of the decade, Derek Boshier was invited by the Arts Council to select and purchase works for its permanent collection and to exhibit them at the Serpentine Gallery in the spring of 1979. However, the venue for the exhibition was later switched to the Hayward Gallery and the exhibition then toured the country. The Council's practice of asking artists to buy work and select exhibitions rather than their own officers may be regarded as a willingness to devolve power or as a way of shielding the Council from any adverse reactions. (It was an extension of the 'arm's length principle' established by Parliament in respect of the Arts Council itself.) As we shall see, Boshier was not to enjoy complete freedom of choice.

The title 'Lives' was adopted because it featured material 'based on people's lives'. As explained earlier, Boshier had become concerned about the public's dislike of/or indifference towards elitist and self-referential contemporary art and thought that human content would enable anyone to appreciate his selection. The attendance figure of 22,094 was respectable compared to those of other shows devoted to new British art held at the Hayward throughout the 1970s.

'Lives' was not limited to the fine arts because craft, design and mass culture were also represented. In fact, the show turned out to be extremely disparate in terms of media, styles and subjects: art

therapy images, banners, caricatures, cartoons, fads, films, Margaret Harrison's painting *Rape*, performance, photography – including the genres of advertising, documentary, news, photo-booth and portraiture – postage stamp design, punk graphics and video. Famous names such as Hockney and Kitaj rubbed shoulders with virtually unknown artists. Boshier also selected several feminist and left-wing political artists. Works by two of the latter – Tony Rickaby (b. 1944) and Conrad Atkinson – disturbed Arts Council managers and the works were withdrawn, as were the personal statements the artists had written for the catalogue.

The two contentious items were: Atkinson's *Anniversary Print from the people who brought you Thalidomide* ... (1978) and Rickaby's *Fascade* (1977–78). The former criticized Distillers, a drinks and drugs corporation that enjoyed the benefit of a Royal warrant and had been involved in a 20-year drugs tragedy in which babies were born crippled. The latter consisted of a series of apparently innocuous watercolours of the frontage of London buildings, except they were all occupied by right-wing organizations. The Arts Council was unwilling to explain its act of censorship apart from saying there might have been legal consequences if the two works had been exhibited.[7] Boshier, the two artists and their supporters protested vigorously but the Arts Council refused to alter its decision despite the adverse publicity that inevitably followed.

Another act of suppression occurred in June 1979. This time the culprit was a private sector company. Brian Barnes and the Wandsworth Mural Workshop had painted a huge mural near Battersea Bridge in South London. It was entitled *Morgan's Wall, or The Good, the Bad and the Ugly.* The wall in question protected a derelict factory owned by the Morgan Crucible Company. The painting's content concerned the future development of the locality and contained imagery critical of what right-wing local councillors and big business were planning.

A Conservative administration had taken over Wandsworth in 1978 and one idea they were considering for the site was a Disneyland. This

prompted Barnes and his helpers to include the image of Mickey Mouse, which in turn caused Disney's lawyers to threaten legal action for unauthorized use of copyright material. Morgan Crucible decided to remove the mural and demolition contractors were employed to bulldoze the wall in the middle of the night. When Barnes learned what was happening, he rushed to the site and protested. He was then arrested and spent time in police cells.[8]

'ENCOUNTER/counter', a show of four three-dimensional constructions, the first dating from 1975, featuring dead, stuffed animals mounted by Denis Masi at the ICA from May to July, both disturbed and impressed those who saw it.[9] Masi, an American of Italian extraction, was born in 1942 in West Virginia and studied art in New Jersey, Milan, Paris and at the Slade in London. He first came to England in 1967 and has lived, worked and taught here ever since. A versatile artist, Masi has never limited himself to one medium: he has produced assemblages, charcoal drawings, computer-aided prints, films, live performances, metal reliefs, staged photographs, videos and mixed-media gallery installations. Furthermore, his installations have addressed several senses: hearing and smell besides sight and touch.

Two of the ICA's tableaux/constructions employed rats and the others Alsatian dogs. In *YARD (Canes Lupi)* (1978–79), two Alsatians – one snarling menacingly – were confined by absent powers in a wooden enclosure illuminated by lurid orange and red spotlights. Inside the enclosure were: a coil of barbed wire, a mirror, sand and a mysterious black felt package. A sound recording of the dogs' slow growling played and an offensive odour permeated the display. Such 'sets' were simultaneously real and unreal. Their meanings were also ambiguous and required the viewer to complete them. The 'sets' evoked the dramatic qualities of the theatre and cinema but without providing clear narratives; Masi acknowledges the influence of Brecht and filmmakers such as Bernardo Bertolucci, Robert Bresson, Stanley Kubrick and Hans-Jürgen Syberberg.[10]

Most visitors to the ICA were struck by the contrast between the extreme character of Masi's subject matter – which was similar to that

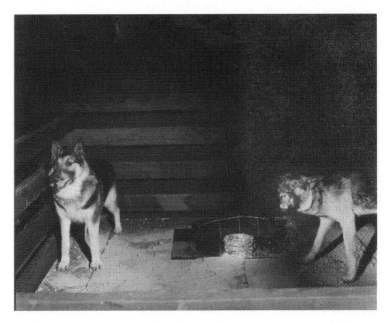

32. Denis Masi, *YARD (Canes Lupi)* (1978–79). Mixed-media construction/installation at the ICA in 1979, 4.2 x 4.2 x 1.75 m. Photo courtesy of the artist.

of the British painter Francis Bacon – and the cold precision of its presentation. (Masi prefers impersonal calculation and meticulous artisanship to expressionism.) The use of stuffed animals was clearly a precedent for the animals in vitrines Damien Hirst devised in the 1980s. In Masi's case however, their use did remind viewers of the rights of animals and the cruelty associated with experiments in scientific research laboratories but, as reviewer William Furlong explained, the artist's intention was also metaphoric:

> Masi is clearly using his animals and their predicament in a symbolic rather than a literal sense . . . these constructions suggest deprivation, confinement, fear and repression, but also institutionalisation, political manipulation and concealed social pressure. In the end, the exhibition is not about rats and dogs, it is about human beings and the world we inhabit.[11]

As a citizen, Masi is preoccupied by issues of alienation, aggression, fear, freedom, oppression, power and resistance in contemporary society, but in his art, he prefers to tackle such issues indirectly rather than via documentary or agit-prop imagery. This is because he believes critical art appearing in galleries is most effective when it mimics the appearance of what it seeks to subvert and stimulates the emotions and senses of viewers; intellectual reflection regarding causes and cures can then follow.[12]

During June and July, the Arts Council mounted an exhibition at the Hayward Gallery entitled 'Three Perspectives on Photography' that provided an opportunity to revisit the debates about the medium and its social functions that had occurred throughout the 1970s. The presence in a major public gallery of a show entirely devoted to photography signified that the arts establishment now accepted the medium was as important as painting. (However, at this time the Arts Council also downgraded the medium by disbanding its Photography Sub-committee.)

The three 'perspectives' were: 'Photographic Truth, Metaphor and Individual Expression' (selected by Paul Hill); 'Feminism and Photography' (selected by Angela Kelly); and 'A Socialist Perspective on Photographic Practice' (selected by John Tagg). Tagg's selection included Victor Burgin, Alexis Hunter and the Hackney Flashers Collective. Among those chosen by Kelly were: Yve Lomax, Sarah McCarthy, Val Wilmer and Jo Spence. In her catalogue essay, Kelly identified two main approaches: 'documentary' and 'analytical'. The reasons why Spence preferred the second approach will be made clear shortly.

Jo Spence was one of the most iconoclastic and inventive photographers of the 1970s. She was also a writer on photography, a feminist/socialist political activist, an enthusiastic teacher and tireless organizer. In addition, she made significant contributions to the promotion of a left-wing photographic culture in Britain. The number of collaborative ventures in which she was involved indicated a strong desire to overcome individualism, to substitute the value of

cooperation for the value of competition so beloved by supporters of capitalism.

Spence, born in 1934 in Essex, was first called Joan Clode. She came from a working-class family: her parents laboured in factories and were trade unionists. Her childhood was marred by the trauma of the Second World War. She left school at the age of 15 and learned about photography from 1951 to 1962 while employed as a dogsbody in the commercial environment of a photo-studio. Then, for a time, she worked as a portrait and wedding photographer in Hampstead. (Joanna Spence Associates 1967–74.) Upward social mobility made her ashamed of her class origins and she became estranged from her family.

Eventually, Spence became dissatisfied with the commodification, idealization and stereotyping associated with high street photography and so she renounced the role of professional photographer. She then photographed the lives of gypsies but experienced a personal crisis because the naturalism associated with the documentary genre seemed inadequate to the task of representing reality. This is why she later resorted to non-naturalistic techniques such as photo-theatre (performing and staging events for the camera), montage and the addition of words. Furthermore, Spence realized that subjects needed to be researched and to make sense of the facts discovered philoso-phies capable of explaining society were essential. Marxism and femin-ism provided the theoretical tools and the work of Brecht, Heartfield and Vertov precedents for a photographic practice that combined action and analysis and was by fuelled by creative anger.

With Terry Dennett, a socialist photographer and historian, she estab-lished, in 1974, Photography Workshop, an independent, educational, research and resource project. It generated touring exhibitions about labour history, taught photography to children and extra-mural courses on feminism and photography. In addition, Spence and Dennett became involved with the Half Moon Gallery (later to become Camerawork) and helped to edit the early issues of the new magazine *Camerawork* (1976–85), which was to provide a critical and

contextual study of photography.[13] Unfortunately, in 1976, Spence was locked out of the Half Moon Photography Workshop after ideological disagreements – she had been stressing the issue of social class.

In 1979, Spence, Dennett, David Evans and Sylvia Gohl edited and published the anthology *Photography: Politics One*. Its purpose was to raise the standard of writing about photography and to provide a socialist alternative to the vacuous glossy annuals so prevalent in the world of commercial photography. Another publication was the broadsheet *The Worker Photographer*, which encouraged an activity that had flourished in the 1920s and '30s: the use of photography by politically conscious workers. At the Ford car manufacturing plant at Dagenham during the 1970s, workers had protested about repeated layoffs and dangerous working conditions. (In 1976, employees became so angry they smashed up the management's canteen.) Although Ford's managers disapproved of photography within the factory, some workers began to document conditions plus their meetings, strikes and picketing. A set of 40 colour slides was produced as an organizing tool in the campaign against layoffs. Carlos Guarita, one of the Ford workers who took up the camera, later became a freelance documentary photographer.[14]

Spence was a founder member of the all-female, community photography group called the Hackney Flashers Women's Photography Collective established in 1975. Cartoonists and designers were also members. Via books, posters and exhibitions, the Collective examined such issues as women and work, motherhood and childcare. Documentary-type photographs were taken but other images were constructed using staged events and photomontage. In 1979, Hackney Flashers contributed a display entitled 'Who's Holding the Baby?' to the exhibition 'Three Perspectives on Photography'. For several years, Spence funded her photographic activities from her wages as a secretary at the British Film Institute.

Taking the feminist slogan 'the personal is political' seriously, Spence applied it to her own life, to private self-portraits and to mass media representations of women. She used her own identity and body

to explore the reciprocal relationship between 'images of women' and 'woman as image'. To gain insight into her own formation, she examined the history of her family in an exhibition project entitled 'Beyond the Family Album' (1978–79). This was displayed at the Hayward. Another group, which Spence established, was called 'Faces' because it critically examined women's self-images. Members took photographs of themselves playing out various roles and fantasies.

Spence repeatedly challenged the divisions between practice and theory, the inner and outer realms, feminism and socialism, high and low culture. Much of her work contested mass culture forms of photography in advertising, fashion and news reporting. For example, when she wrote about herself and her work for the feminist magazine *Spare Rib*, she subverted the convention of women's magazines that a glamorous young model should grace the cover by showing herself without make up looking middle-aged and tired.[15]

Unflinching honesty was the hallmark of Spence's imagery. A photograph of herself aged 43 lying naked on a sofa (taken by Dennett) juxtaposed against a snap of herself in the same pose as a baby was so striking that the two images were reproduced in London's newspaper the *Evening Standard*.[16] Here the aim was to demonstrate that it was possible for a female to be represented in the nude when older than a baby without becoming a sex object.

Taking up writing, she published articles in *Block* magazine about John Heartfield and in *Screen Education* about class and gender in images of women. In 1977, *Screen Education* also published an article by both Dennett and Spence describing their own practice.

Having never attended Art College or university, Spence felt the need to study the history and theory of photography and so, in 1979, she became a student at the Polytechnic of Central London where she was taught by Victor Burgin and Simon Watney and encountered theories of psychoanalysis and semiotics. However, a purely deconstructive approach to imagery did not satisfy Spence because she wanted to find solutions to urgent political and theoretical issues in practice, by *constructing* images that were also realist. (Wooden models of buildings

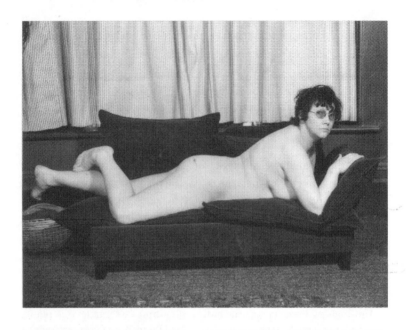

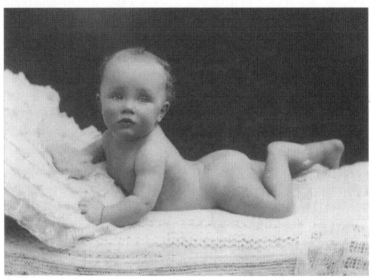

33. Jo Spence & Terry Dennett, *Jo Spence in the Nude, Middle Aged, and as a Baby* (1979). Photo courtesy of Terry Dennett and the Jo Spence Memorial Archive, London.

and ships are *constructed* but they can also be accurate representations in many, if not all, respects.) With three other women students she founded yet another group – Polysnappers – which, in 1982, used dolls and the camera to rework representations of the family.

In the same year, Spence discovered she had breast cancer. Characteristically, she employed a camera to document the progress of her illness, plus her experience of orthodox, Western medicine and later, alternative, Chinese medicine. Health issues became a central concern. With Rosy Martin, she devised 'photo-therapy' or 'psychic realism', that is, the use of photography and role-playing as an aid to healing and self-understanding. Paradoxically, masquerade became a technique to remove the masks adopted to protect the self. After a period of stability, Spence became ill again. She died from leukaemia in 1992 while still using photography to come to terms with her own mortality.

The diversity and quantity of Spence's activities makes summary and categorization difficult, but there is no doubt that she made a significant contribution to British visual culture of the 1970s and to debates about pictorial representation. Since then, her work has become internationally known and influential. Not content simply to theorize in an impersonal, academic way, she explored painful issues by experimenting with the medium of photography and succeeded in generating many accessible, instructive and vivid images – some were humorous and satirical while others were tragic. Her emphasis upon the self was not narcissistic because she always tried to connect her lived experiences to those of others and to the social forces and structures that most of us are subject to.

There are some similarities between Spence's self-images and those of the American artist-photographer Cindy Sherman, but the latter is much more obviously a fine artist. Spence did exhibit in art galleries and found being labelled 'an artist' had its uses: it increased her mobility and access to the public domain. However, the art world was not her prime audience or concern, rather it was people in adult education, the community and the Women's Movement. One reviewer of the

Hayward show thought that Spence's images had no place in an art gallery. Certainly, the word 'artist' did not do justice to Spence's role, which was why she preferred the self-descriptions 'cultural worker', 'educational photographer' and 'cultural sniper'.

Above all, Spence will be remembered for her courage in tackling taboo subjects, her quest for the truth behind appearances and her devotion the causes of education, feminism and socialism. Her frankness and 'confessional' work anticipated that of young British artists such as Tracey Emin. She acted as a role model for others and showed how dominant ideas and images could be resisted and different ones constructed. Her goal was to empower working people and class-consciousness persisted to the end of her life. Shortly before she died, she appeared in a photograph, taken for a series entitled *Class Shame*, holding a placard on which was written: 'Middle class values make me sick'.[17]

Spence and Peter Kennard both used photography and admired Heartfield's anti-Nazi montages. One difference between them was that Kennard's photomontages were more journalistic in character and function: he often had to react rapidly to recent events to supply illustrations for magazine and newspaper articles. In December, at a meeting of NATO in Brussels it was decided that 160 American cruise missiles should be based on British soil by 1983. The missiles were not to be kept in one place but dispersed around the countryside via transporters. Kennard responded to this news with a montage that was to become one of his best known: he amended a reproduction of John Constable's popular painting *The Hay Wain* (1821) by adding three missiles to the cart crossing a river. The cart's drivers were also given helmets and gas masks.

Kennard's montage disrupted the calm and harmony of a mythic landscape while at the same time giving an icon of English painting a new lease of life and purpose – he mobilized the past to serve the needs of the present. The montage dramatically illustrated the way England's countryside was being disfigured and threatened by the technology of war. It reached a wide public by appearing in an

anti-nuclear campaign, a travelling exhibition that began at the Half
Moon Gallery, London in October 1980 and by being reproduced on
postcards, in magazines – such as *Camerawork*, No 19 (July 1980) –
and booklets – such as Kennard and Sissons' *No Nuclear Weapons*
published by Pluto Press and CND in 1981. Then, in the Peace Year of
1983, it was issued free by the Greater London Council as one of a set
of 'Posters for Peace'. During the 1980s, Kennard's anti-nuclear war
images were even reproduced in colour in the pages of the decade's
'best dressed' magazine aimed at British youth: *The Face*.

In May 1979, a huge children's party was held in London's Hyde
Park to mark 'International Year of the Child'. The appalling difference
in living standards between the world's most affluent nations and
those of the poorest was (and still is) frequently exposed by photo-
graphs of children emaciated by famine appearing in news reports
and charity advertisements in the press. (So familiar were such
images that viewers were becoming emotionally numb.) At the same
time, British companies were organizing food and wine festivals as
leisure-time entertainment designed to encourage ever-higher levels
of consumption. When Jane Ginder, a Middlesex Polytechnic art
student, was invited to contribute to one such festival held at Alexan-
dra Palace in North London in the spring of 1980, she decided on a cri-
tical response. She constructed a small sculpture based on an image
of a starving child and gave it the title *It shouldn't be allowed*. The
material she used was cake and visitors to the festival were invited to
eat it – another instance of participation art. Art made from food has
also been labelled 'edible art'.

As one might expect, the sculpture grabbed the attention of a
non-art world public and prompted mixed reactions. Some visitors
were offended and thought it unsuitable for public display while
others agreed its reproach was justified. A few detached pieces of cake
and ate them. The process of consumption was a metaphor for the way
in which we 'consume' images of the starving – ingest and expel them.
As a result, the sculpture gradually deteriorated and its 'flesh' crum-
bled away. Hence, the way the bodies of real children in the Third

World diminish was visually exemplified, as was the excessive consumption of food by affluent, greedy Britons.

Ginder's work was a deliberately ephemeral, non-commodity sculpture made for a specific event in which it critically intervened. By turning a two-dimensional image into a three-dimensional figure, she made it more concrete and succeeded in reanimating a pictorial cliché. Her sculpture was direct, powerful and non-sentimental. The festival's organizers were embarrassed – they had not expected a work of art that questioned the whole premise of their event – and eventually they hid the ruined remains of the sculpture behind a screen. Business patronage of the arts, it seemed, was not always of promotional value.

In November 1979, Bruce McLean and Paul Richards, plus several assistants, presented *The Masterwork/Award Winning Fishknife* on six evenings at the Riverside Studios in Hammersmith. The two artists had been working on the project since 1975 generating numerous diagrammatic drawings and writings in pursuit of a final scenario and synopsis. Mel Gooding has described the theme of the event as follows:

> The business in *Masterwork* is that of the architect, the principal figure in the piece, whose creation gives it that part of its title. The central metaphor, the masterwork itself, is a building, the 'definitive work in mediocrity', a monstrous projection of the limited personality and institutional ideology of its architect-designer himself, whose greatest previous triumph was an award-winning Fishknife, a true indication of his petty-bourgeois consciousness. The building is an image not only of a debased and disgraced modern architecture but also of the social institutions of late capitalist civilization in general and, by extension, of any society in which the arrogance of mediocrity is encoded in bureaucratic formulae and manifested in social engineering/architecture for conformity. 'Using mediocre parts, he believes that he can (because of his personal style and wit) build "the building model", a work of great beauty that will be a dictate for civilization.'[18]

As Nena Dimitrijevic has explained, *The Masterwork*

> ... was McLean/Richards' most complex production involving two acro-
> bats, four dancers, one juggler, one actor, one real architect and a music
> ensemble led by Michael Nyman ... The performance took place on differ-
> ent levels of a large scaffolding and a fork-lift was used for lifting perfor-
> mers. The stage was dominated by a gigantic photograph showing the
> architect's shadow projected on the concrete building of the Hayward
> Gallery, and a large rock – a foundation stone of the old London Bridge, epi-
> tomizing permanence in sharp contrast to modern technology. Stage move-
> ments were structured by a computerized projection of four coloured
> lights, which divided the area in front of the seats into 80 rectangles.[19]

McLean and Richards addressed a subject that aroused the anger of
many Britons during the 1970s: recent modern architecture character-
ized by system-built housing estates, tower blocks and crude commer-
cial offices. (Of course, architects were not the only ones responsible –
builders, planners, politicians and property developers were also
involved.) To cite just one example: Richard Seifert's Centre Point,
erected in the mid-1960s, an office block with an ugly honeycomb
structure located at the Eastern end of Oxford Street was completely
out of scale with its surroundings and straddled a new road that went
nowhere. Furthermore, it was a building whose raison d'être was not
social need but the profit motive of property developers. Despite the
need of London's homeless for accommodation, Seifert's building
remained empty for over ten years!

McLean and Richard's critique also encompassed the lifestyle of the
middle class: one of their female characters represented 'The women
with three of everything'. Her dialogue included such ironic remarks
as: 'Like everything else skiing has got so much more expensive this
year. I feel at last I'm developing a real relationship with the *au pair*.
By the way, can I have my book on paralinguistics back? Quite
frankly, I have quite a lot of sympathy for the miners. Oh yes, we've
gone completely solar with our energy...'

McLean, it seems, was not entirely satisfied with the staging of *The Masterwork*. However, it was apt that the 'art and politics' decade should have culminated in an ambitious, collaborative, live performance fuelled by anger at the failures of a rival art form considered essential to human well-being.

Conclusion

Aftermath

Richard Cork, reflecting on the 1970s in 1981, remarked:

> Despite all the frustrations which art underwent during the 1970s, a range
> of valuable new liberties was established during that difficult decade.
> Artists gained the right to work in a far wider variety of ways, and their
> freedom helped dispense with the myth that painting and sculpture were
> the only 'legitimate' vehicles for 'high' art.[1]

Cork was correct in the sense that subsequent generations of artists
were able to take it for granted that they could use cameras, compu-
ters and videos, make installations and engage in performance or
paint and sculpt. However, it is the case that left-wing political art
became unfashionable because the shift to the Left in the British art
world during the 1970s was not sustained during the following two
decades. This was partly due to cyclical patterns in culture based on
reactions to what has gone before and partly because radical changes
in culture cannot persist and progress unless they are accompanied
by radical change in terms of economics and politics. In fact, what
happened next was a shift to the Right, which began when a Conserva-
tive government led by Margaret Thatcher was elected in May 1979.
Eighteen years of Tory rule followed.

The fact that Thatcher was Britain's first female prime minister
might be considered a triumph for the Women's Movement, but she
was no feminist and the number of women MPs actually fell because
of her party's victory. Nevertheless, although movements such as
Women's and Gay Liberation experienced setbacks, it was impossible
for the clock to be fully rewound. Women and homosexual artists of

today have all benefited from the efforts feminist and gay artists, critics and art historians made during the 1970s.

Under Thatcher, hard-line, right-wing policies were pursued: in economics, monetarism; competition was valued more than cooperation; privatization, the selling off of nationalized utilities; the dismantling of the mining industry and the defeat of the miners who protested led by Arthur Scargill. Workers were discouraged from militancy by anti-trade union legislation and ever-rising unemployment figures, which eventually exceeded three million. (This was after a promise in the election posters for 1978–79, designed by the advertising agency Saatchi & Saatchi, that things would be better under the Conservatives.) Trade union membership fell as manufacturing and heavy industries failed and financial and service industries flourished. Cuts in public services resulted in their decline and reductions in public housing provision (council housing was sold off to private buyers) and in benefits to young people increased the numbers of homeless people sleeping rough in the big cities. (Their presence on the street was a warning to the rest: rely on yourself and work even harder, otherwise, you could end up like them.) Meanwhile, millions of homeowners in affluent areas such as the South East benefited from massive rises in house prices.

The ideology of Thatcherism emphasized the individual and the family as against wider groupings; indeed, Thatcher once famously declared that there was 'no such thing as society'. Thatcherism promoted the free market, entrepreneurialism, deregulation, lower taxes, profits, shareholding and the pursuit of money and material possessions. The 1980s was a decade when greed and selfishness became virtually state policies. Greed, the artist Ian Breakwell thought, had emerged as a feature of British society during the 1970s. In July 1980, he wrote: 'The decade [the 1970s] ended with the democratic election of a Tory government, thus giving public endorsement of GREED as the basis of everyday life. It would be revealing to know how many artists voted for Margaret Thatcher.'[2]

Thatcher also espoused a fierce patriotism that soured Britain's

relations with her partners in Europe but enabled her to win a war against Argentina in 1982 over possession of the Falkland Islands.

Of course, there was resistance to Thatcherism. During the early 1980s, the Greater London Council (GLC) under the leadership of 'Red Ken' – Ken Livingstone – kept municipal socialism alive in London. (The affection that Livingstone aroused at that time was demonstrated in 2000 when he was elected Mayor of London despite the opposition of New Labour and Tory politicians.) The GLC's arts policy also supported local community and minority groups. Thatcher's response to the presence of an alternative power base across the Thames from Westminster was to abolish the GLC in 1986.

For the intelligentsia on the Left, the advent of Thatcherism was a serious blow. The pop artist Jann Haworth opined that '. . . because of Mrs Thatcher . . . [t]he eighties was a hideous decade for the artist, the academic, the intellectual.'[3] Some Oxford academics retaliated by refusing to grant Thatcher an honorary degree. Naturally, there were those who benefited from the changes associated with Thatcherism – business people, media tycoons, property owners, traders in the City of London, and the so-called 'yuppies' (young urban professionals).

Changes at the level of national politics were paralleled by certain developments in the fine arts. For example, some curators who had supported political art in the 1970s welcomed a resurgence of traditional art forms such as painting and sculpture; indeed, they promoted them via exhibitions such as 'New Spirit of Painting' mounted by the Royal Academy in 1981. This show was an all-male affair and so it was as though the feminist art movement of the 1970s had never happened. A new style of painting became fashionable internationally. Its name – 'neo-expressionism' – indicated a return to intuitive, personal, painterly values and 'the artist as hero' syndrome. Doris Saatchi praised the American painter Julian Schnabel in these terms in the pages of *Artscribe* at a time when she and her husband Charles owned a number of Schnabels.

Most dealers and collectors were pleased by the renewed emphasis on art objects as commodities because they were easier to exhibit and

sell than conceptual and community art, and art focusing on social and political issues. Jay Jopling, Damien Hirst's dealer, was the son of a Tory MP and he once expressed a lack of interest in 'issue-based art'.

Wealthy collectors such as Charles and Doris Saatchi influenced the exhibition policies of public galleries such as the Tate and White-chapel, and profited from buying and selling new art. In 1985, Charles Saatchi opened his own gallery in North London in order to exercise control over what was shown and how it was presented. In fact, what he established was a complete value-adding apparatus.[4] Even so, some of the British artists Saatchi collected had left-wing views and made work addressing such social problems as home-lessness, Mark Wallinger for instance.

In December 1980, the Arts Council made budget cuts and ceased funding 41 organizations. Cuts in higher education budgets made art students such as Damien Hirst of Goldsmiths' realize that their pro-spects of obtaining teaching jobs in art schools were poor and they needed to break into the commercial gallery system. To attract collec-tors, curators and dealers they marketed themselves aggressively – as Gilbert & George had done in the late 1960s – by organizing their own shows and publicity. Instead of critical and difficult content/theory, the work of the young British artists, or YBAs, named after shows held at the Saatchi Gallery, became noted for dead animals, shock, sex, photo-realism and formalist abstraction. In the main, their art proved easy to understand and hence was more popular than conceptual and feminist art.

Hard-nosed commercial attitudes also had an impact on art educa-tion. Curricular innovations of the 1960s and '70s were reversed. For example, in 1984, Jocelyn Stevens – a businessman and Thatcherite appointee – became Rector of the RCA. He was invited to open an exhi-bition by finalist Environmental Media students and was so appalled by the kind of work being produced, which he considered 'awful rubbish', that he promptly announced the course's closure.[5]

During the 1980s, it has been argued, style took precedence over substance, surface replaced depth. This was demonstrated by the

difference in appearance, content and politics of the 1970s magazine *Camerawork* and the 1980s magazine *The Face*. Nick Logan founded the latter in 1980, the former ceased publication in 1985. *The Face* stressed design/visual/tactile qualities: it was in full colour on glossy paper and featured striking advertisements, photographs and typography. Tens of thousands of youthful consumers bought it because it reported the latest trends in entertainment, rock music, fashion, films, art and design.[6] Even so, it was willing to reproduce Peter Kennard's anti-nuclear war montages.

Situated somewhere between *Camerawork* and *The Face* was the small-circulation, but highly influential, magazine *ZG* (1980–85). Its title was short for 'Zeitgeist' and so it claimed to embody the spirit of the times. Rosetta Brooks edited it and published articles about aspects of advertising, art, club culture, fashion and photography. *ZG* was symptomatic of post-modernism but it retained some of the radicalism of the 1970s in its analytical approach to its subjects. Jonathan Miles was one of its contributors.

Certain other initiatives – for example, *And* Association/magazine (1984–93), *Block* magazine (1979–89), *Third Text* (1987–) and the Pentonville Gallery, London (1980–88) – kept alive a radical, left-wing culture even during the darkest days of Thatcherism. In addition, many of the artists who came to prominence in the 1970s continued to produce and exhibit, and eventually earned a place in the history books. (Of course, some of them have died but others are still making and showing art and still teaching in art departments.) However, the British art world, as it had existed during the 1970s, was weakened by the loss of some of its brightest minds to the United States. Among those who moved across the Atlantic were: Conrad Atkinson, Derek Boshier, Rosetta Brooks, Victor Burgin, T.J. Clark, John Dugger, Dick Hebdige, Mary Kelly, Clive Phillpot and John Tagg. (Burgin and Phillpot have recently returned.) In most instances, their departure was prompted by the better prospects for employment in American art colleges and universities. To some extent, therefore, radical culture became an underground culture biding its

time until the climate of opinion had turned against Conservative rule – which finally occurred in 1997 when the Labour Party achieved a landslide election victory and Tony Blair became prime minister. (John Major led the defeated Conservatives, Thatcher's own party having dumped her in 1990.)

Labour's victory marked another change in the cultural and political ethos of Britain. Even though many voters thought the new Labour government was continuing Conservative policies, the importance of society and public services was stressed again. A Ministry of Culture was also established.

Towards the end of the 1990s, young scholars began to research the history of the art of the 1970s.[7] And while some young art critics writing in *Art Monthly* remained, in the words of Peter Kennard, 'defeatist and pessimistic' regarding art's ability to tackle socio-political issues, they started to ponder theoretical questions that had been raised during the 1970s.[8] The *Guardian* writer Jonathan Jones, in a profile of Michael Craig-Martin, the artist and professor associated with the success of the YBAs trained at Goldsmiths', claimed that 'a retro 70s scene' was emerging and complained about Marxist-influenced criticism appearing in the pages of *Art Monthly*.[9]

Renewed interest in the radical art of the 1970s and in new art with socio-political intentions became evident in the year 2000 through such shows as 'Live in your Head' (Whitechapel Art Gallery), 'Protest and Survive' (selected by Matthew Higgs and Paul Noble, Whitechapel Art Gallery) and 'Look Out: Art: Society: Politics' (selected by Peter Kennard, London: Art Circuit Touring Exhibitions). The advent of a new millennium witnessed a resurgence of grassroots politics: anti-capitalist, anti-globalization demonstrations in Seattle, London and Prague indicated that a new generation of activists had emerged. Once again, the times are propitious for an art with a social purpose.

Notes

Introduction

1. Ian Burn, [Statement in] *Conceptual Art: A Critical Anthology*, Eds Alexander Alberro & Blake Stimson (Cambridge, MA & London: MIT Press, 1999) p 392.
2. Peter Fuller, 'Where was the art of the Seventies?', *Beyond the Crisis in Art* (London: Writers and Readers, 1980) pp 16–43.
3. Stuart Bradshaw, 'It all depends . . ', *Artscribe*, No 27 (February 1981) p 35.
4. Quote from a statement given at the Theatre Writers' Union conference on censorship, London, 28 January 1979.
5. Guy Brett, 'The art of the matter', *City Limits* (27 November–3 December 1981) pp 38–40.
6. John Hilliard, 'British art in the seventies – a brief note' (1988) printed in *John Hilliard*, Ed. Uta Nusser (Heidelberg: Verlag Das Wunderhorn/Manchester: Cornerhouse, 1999) pp 12–13.
7. See: Sue Malvern, 'Women: work, politics and art: a chronology of the 1970s', *Social Process/Collaborative Action: Mary Kelly 1970–75*, Ed. Judith Mastai (Vancouver, BC: Charles H. Scott Gallery, Emily Carr Institute of Art & Design, 1997) pp 105–30.
8. John Bratby, [Letter in response to a questionnaire] 'Artist's thoughts on the seventies in words and pictures', Ed. Jasia Reichardt, *Studio International*, Vol 195, No 991/2 (1981) p 11.
9. See: Ian Breakwell, *Diary Extracts 1968–1976* (Nottingham: Midland Group, 1977) p 36.
10. Feminist art historians, such as Rozsika Parker and Griselda Pollock, prefer to speak of 'feminist artistic practices' rather than 'feminist art'. See Parker and Pollock (eds) *Framing Feminism: Art and the Women's Movement 1970–85* (London: Pandora/HarperCollins, 1987) p 80.
11. See: John A. Walker, 'A vexed trans-Atlantic relationship: Greenberg and the British' (forthcoming in the American journal *Art Criticism*).
12. For an obituary of Reise see: John McEwen, 'Barbara M. Reise, 1940–1978: a footnote', *Art Monthly*, No 15 (1978) pp 2–3. Victor Burgin, 'Socialist Formalism', *Studio International*, Vol 191 No 980 (March/April 1976) pp 148–54.
13. See: Laura Mulvey and others, 'Women and representation: a discussion with Laura Mulvey', *Wedge*, No 2 (spring 1978) pp 46–53. Incidentally, Mary Kelly appeared as a woman artist in *Riddles of the Sphinx*.

14. Norman Shrapnel, *The Seventies: Britain's Inward March* (London: Constable, 1980) p 13.

15. Conrad Atkinson, 'Statement', *Live in Your Head* (London: Whitechapel Art Gallery, 2000) p 45.

16. Christopher Booker, *The Seventies: Portrait of a Decade* (London: Allen Lane, Penguin Books, 1980).

17. Arthur Marwick, *The Sixties: Cultural Revolution in Britain, France, Italy and the United States circa 1958–1974* (Oxford: Oxford University Press, 1998). Robert Hewison, *Too Much: Art and Society in the Sixties 1960–75* (London: Methuen, 1986).

18. See: The Angry Brigade, 'Communiqué 8', *The Angry Brigade: The Cause and the Case* by Gordon Carr (London: Victor Gollancz, 1975) pp 103–104.

19. W. Januszczak, 'Making snap judgements', *Guardian* (4 July 1981).

20. For a history of political pop, see Robin Denselow, *When the Music's Over: The Story of Political Pop* (London & Boston, MA: Faber & Faber, 1989; paperback edn 1990).

21. Rozsika Parker and Griselda Pollock (eds) *Framing Feminism: Art and the Women's Movement 1970–85* (London: Pandora/HarperCollins, 1987) p 3.

22. Edward Lucie-Smith, *Art in the Seventies* (Oxford: Phaidon Press, 1970) pp 6–7.

23. See John Clarke and Tony Jefferson, *The Politics of Popular Culture: Cultures and Sub-Cultures* (Birmingham: Centre for Contemporary Cultural Studies, University of Birmingham, 1973) Stencilled Occasional Papers, p 9.

24. Norman Shrapnel, *The Seventies: Britain's Inward March* (London: Constable, 1980) p 173.

25. Frank Nelson, [Letter in response to a questionnaire] *Studio International*, Vol 195, No 991/2 (1981) p 53.

26. Tom Nairn, *The Break-up of Britain: Crisis and Neo-Nationalism* (London: New Left Books, 2nd expanded edn 1981). First edition published in 1977.

Chapter 1: 1970

1. Guy Brett, 'Internationalism among artists in the 60s and 70s', *The Other Story: Afro-Asian Artists in Post-War Britain* by Rasheed Araeen and others (London: Hayward Gallery/South Bank Centre, 1989) p 112.

2. For more detail see: John A. Walker, *John Latham – the Incidental Person – His Art and Ideas* (London: Middlesex University Press, 1995).

3. Artists Now, *Patronage of the Creative Artist* (London: Artists Now, 1974) p 2.

4. Peter Kennard and others, *Dispatches from an Unofficial War Artist* (Aldershot, Hants: Lund Humphries, 2000) p 74.

5. See: Women Artists in Revolution and others, *A Documentary Herstory of Women Artists in Revolution* (New York: Women's Interart Center, 2nd edn 1973).

6. I am grateful to the Tate Gallery Archive for a copy of a transcript of a tape recording made by Ehrenberg of his altercation with Tate guards and the police regarding his right to enter a public building wearing a mask.

7. During the 1990s, Metzger gained recognition for his critical contributions to culture when the London bookshop/gallery workfortheeyetodo gave him a show and Coracle Press published the book *Gustav Metzger: 'Damaged Nature, Auto-Destructive Art'* (1996) and Oxford's Museum of Modern Art gave him a retrospective. See: *Gustav Metzger* (Oxford: Museum of Modern Art, 1999) catalogue of an exhibition curated by Kerry Brougher and Astrid Bowron.

8. The essay is reprinted in Roland Barthes, *Image – Music – Text* (London: Fontana, 1977) pp 142–48.

9. 'Interview with John Stezaker', *The Impossible Document: Photography and Conceptual Art in Britain 1966–1976*, Ed. John Roberts (London: Camerawords, 1997) p 143.

10. John Stezaker, 'Statement', *Live in your Head: Concept and Experiment in Britain 1965–75*, curated by Clive Phillpot and Andrea Tarsia (London: Whitechapel Art Gallery, 2000) p 153.

11. See: Uta Nusser (ed.), *John Hilliard* (Heidelberg: Verlag Das Wunderhorn/Manchester: Cornerhouse, 1999) p 221.

12. Nusser (ed.), *John Hilliard*, p 223.

13. See Richard Cork, 'From sculpture to photography: John Hilliard and the issue of self-awareness in medium use', *Studio International*, Vol 190, No 976 (July/August, 1975) pp 60–68.

14. See: Walker, *John Latham* (1995).

15. Reactions to the exhibition were published in *Pages*, No 2 (winter 1970) pp 9–13. For a fuller account of Beuys' action see: Heiner Stachelhaus, *Joseph Beuys* (New York, London & Paris: Abbeville Press, 1987) p 143.

16. Janet Daley, 'Democracy as commercialization', *Studio International*, Vol 184, No 947 (September 1972) pp 99–100.

17. See: Rozsika Parker, 'Feministo', *Studio International*, Vol 193, No 987 (May/June 1977) pp 181–83, plus Margaret Harrison's chronology 'Notes on Feminist Art in Britain 1970–77' in the same issue. See also, '1977 Dossier: "Feministo" (1–4)', in *Framing Feminism: Art and the Women's Movement 1970–85*, Eds Rozsika Parker and Griselda Pollock (London: Pandora/HarperCollins, 1987) pp 207–14.

18. For an illustrated survey of Reid's graphics see: Jon Savage and Jamie Reid, *Up they Rise: The Incomplete works of Jamie Reid* (London: Faber & Faber, 1987).

Chapter 2: 1971

1. The fullest account of Medalla's life and work is Guy Brett's *Exploding Galaxies: The Art of David Medalla* (London: Kala Press, 1995).

2. For a detailed description of this incident see: Jon Bird, 'Minding the body: Robert Morris's 1971 Tate Gallery retrospective', *Rewriting Conceptual Art*, Eds Michael Newman and Jon Bird (London: Reaktion Books, 1999) pp 88–106.

3. Andrew Forge, 'Art', the *Listener* (26 August 1971) pp 283–84.

4. Ian Breakwell, 'After Spectrum' [letter] *Studio International*, Vol 182, No 939 (December 1971) p 227.

5. Edward Lucie-Smith, *Art in the Seventies* (Oxford: Phaidon Press, 1980).

6. See letters from Hunt and Tim Hilton, *Art and Artists*, Vol 6, No 4 (July 1971) p 10 and Hunt's article 'After Spectrum', *Art and Artists*, Vol 6, No 7 (November 1971) pp 12–13.

7. Margaret Harrison, 'Notes on feminist art in Britain 1970–77', *Studio International*, Vol 193, No 987 (May/June 1977) pp 212–20.

8. T. Adorno, *Aesthetic Theory* (London: Routledge & Kegan Paul, 1972) p 79.

9. Letter from Scott to the author, 18th May 2000.

10. For more details, see John A. Walker, *Art and Outrage: Provocation, Controversy and the Visual Arts* (London & Stirling, VA: Pluto Press, 1999) pp 52–57.

11. Barbara Steveni, interview with John A. Walker, July 2000.

12. Stuart Brisley, 'No, it is not on', *Studio International*, Vol 183, No 942 (March 1972) pp 95–96.

13. Gustav Metzger, 'A critical look at the Artist Placement Group', *Studio International*, Vol 183, No 940 (January 1972) pp 4–5.

14. See: Paul Tate and others, 'Hierarchies in fine art courses' [letter], *Studio International*, Vol 183, No 943 (April 1972) pp 144–45 and Anthony Everitt, 'Four Midland Polytechnic Fine Art Departments', *Studio International*, Vol 184, No 184 (November 1972) pp 176–79.

15. See: Dave Rushton and Paul Wood (eds) *Politics of Art Education* (London: The Studio Trust/Edinburgh: Scottish International Institute, 1979).

16. 'Quiz-time', *Ostrich*, No 1 (March 1976) Section EV, p 6. According to students of Trent Polytechnic, Nottingham, in 1977 Derek Carruthers, Head of the Fine Art Department, refused to allow them to use college typewriters to write articles for the magazine *Issue* (founded in 1976 and funded by the Student Union) because the Department would not 'provide support for its own criticism'. See: The Club for Studies of Socialization in and by Culture, 'Staff v. students – the war of attrition', *Issue*, No 3 (January 1979) p 35.

(Students at the RCA produced a similar magazine in the mid 1970s entitled *Ostrich*. John Dennis and Paul Wood edited it.) Naturally, the Trent students wanted their theoretical work for *Issue* to count as part of their coursework but managers would not allow them to submit it for assessment. Richard Woodfield, a cultural studies lecturer, described contributors to *Issue* as 'specialists in creating conflict ... through shop-floor agitation, meetings, posters and the publication of *Issue*'. See: R. Woodfield, 'Memorandum to Derek Carruthers' (dated 21/11/77) *Issue*, No 3 (January 1979) pp 21–23. A much larger group of students had occupied the Art and Design administration offices in March 1977 to protest about cuts and lack of consultation.

17. 'The sinking of the good ship liberalism' was the title of a pamphlet published by *Issue* in September 1977.

18. For more information on gay art see: Emmanuel Cooper, *The Sexual Perspective: Homosexuality and Art in the Last 100 Years in the West* (London & New York: Routledge & Kegan Paul, 1986).

19. See Mario Dubsky, *Tom Pilgrim's Progress among the Consequences of Christianity and Other Drawings* (London: Gay Men's Press, 1981) introduction by Edward Lucie-Smith.

20. Bacon disliked the term 'gay' and his politics were right-wing rather than left-wing.

21. For a biography of Jarman see: Tony Peake, *Derek Jarman* (London: Little, Brown & Co., 1999).

22. On the work of Logan see: Jasia Reichardt, *Andrew Logan: An Artistic Adventure* (Oxford: Museum of Modern Art, 1991).

Chapter 3: 1972

1. For more details see: John A. Walker, *Arts TV: A History of Arts Television in Britain* (London, Paris, Rome: John Libbey/Arts Council, 1993).

2. See: Frances Spalding, *The Tate: A History* (London: Tate Gallery Publishing, 1998) p 177.

3. For a summary of their discussion see: Andrew Wilson, 'Papa what did you do..', *Gustav Metzger: 'Damaged Nature, Auto-Destructive Art'* (London: Coracle @ workfortheeyetodo, 1996) pp 64–81.

4. On Gallery House, see: *Studio International*, Vol 183, No 943 (April 1972) p 145, plus advert, p ix.

5. See: Caroline Tisdall, 'Avant-garde, to all intents', *Guardian* (25 August 1972) *Arts Guardian*, p 8.

6. For a short review see: 'Three friends', *Spare Rib*, No 12 (June 1973).

7. Hilary Spurling, 'Romantic loner', *Observer Review* (24 September 1972) p 36.

8. Anon, 'Where does the artist go next . . . to represent the life of the masses?' *Time Out* (3–9 August, 1973) pp 16–17.

9. Robert Hughes, '10 years that buried the avant-garde', *Sunday Times Magazine* (30 December 1979) pp 16–21, 41–47.

10. 'John Stezaker, interviewed by Ian Kirkwood and Brandon Taylor', *Artlog*, No 3 (1979) pp 13–20.

11. Peter Wollen, the British filmmaker and theorist, continued to use the concept, indeed he wrote an article in 1975 in which he argued there was not one, but two avant-gardes. See: Peter Wollen, 'The two avant-gardes', *Studio International*, Vol 190, No 978 (November–December 1975) pp 171–75 and 'The avant-gardes of Europe and America', *Framework: A Film Journal*, No 14 (1981) pp 9–10.

12. For a detailed analysis of this show see: William Wood, 'Still you ask for more: demand, display and "The New Art"', *Rewriting Conceptual Art*, Eds Michael Newman and Jon Bird (London: Reaktion Books, 1999) pp 66–87.

13. Rosetta Brooks, 'The New Art', *Studio International*, Vol 184, No 948 (October 1972) pp 152–53. See also: R.H. Fuchs, 'More on "The New Art"', *Studio International*, Vol 184, No 949 (November 1972) pp 194–95.

14. Margaret Harrison, 'Statement', *Live in your Head* (London: Whitechapel Art Gallery, 2000) p 95.

15. See: Adrian Searle and Dan Atkinson, 'We're disturbed people . . .' *Guardian* (24 January 1997) pp 2–3, 15.

16. Daniel Farson, *Gilbert & George: A Portrait* (London: HarperCollins, 1999) p 75.

17 Brian Sewell, *The Reviews that Caused the Rumpus and other pieces* (London: Bloomsbury, 1994) p 256.

18. Judy Rumbold, 'Larger than life and twice as rude', *Guardian* (8 August 1991) p 15.

19. For a more detailed account see: John A. Walker, *Art and Outrage: Provocation, Controversy and the Visual Arts* (London & Sterling, VA: Pluto Press, 1999) pp 57–61.

20. Charles Gosford, 'Artists need a union', *Art & Politics: Proceedings of a Conference on Art and Politics held on 15th and 16th April, 1977*, Ed. Brandon Taylor (Winchester, Hants: Winchester School of Arts Press, 1980) pp 116–20.

21. See: Caroline Tisdall, 'Chinese agitscape', *Guardian* (15 December 1972) p 10.

22. Bryan Robertson, quoted in, *Groovy Bob: The Life and Times of Robert Fraser* by Harriet Vyner (London: Faber & Faber, 1999) p 110.

23. Rosetta Brooks, 'An art of refusal', *Live in your Head* (London: Whitechapel Art Gallery, 2000) pp 32–34.

24. Guy Brett, *Exploding Galaxies: The Art of David Medalla* (London: Kala Press, 1995) p 33.

Chapter 4: 1973

1. For more about The Gallery see: Nicholas Wegner, *Depart from Zero: The Development of The Gallery London 1973–1978* (London: The Gallery Trust, 1987) and John A. Walker, 'A short history of The Gallery', *And Magazine*, Nos 15/16 (1988) pp 47–9.

2. See: Tony Rickaby and others, 'Radical attitudes to the gallery', *Studio International*, Vol 195, No 990 (August 1980) pp 20–52.

3. For more on this project see: Stephen Willats, 'The externalisation of models in art practice', *Control*, No 8 (August 1974) pp 10–14; 'Edinburgh Project', *Art and Artists*, Vol 8, No 10 (January 1974) pp 6–9. The Scottish National Gallery of Modern Art, Edinburgh, also holds an archive.

4. James Faure Walker, 'The claims of social art and other complexities', *Artscribe*, No 12 (June 1978) pp 16–20.

5. An archive of Willats' printed material from 1965 to 1991 is preserved by the National Art Library at the Victoria & Albert Museum.

6. Faure Walker, 'The claims of social art and other complexities'.

7. David Mellor, *The Sixties Art Scene in London* (London: Barbican Art Gallery/Phaidon Press, 1993) p 186.

8. For a review of the Mundus show see: John A. Walker, 'John Stezaker at Nigel Greenwood . . . ', *Studio International*, Vol 186, No 961 (December, 1973) p 248.

9. Mara R. Witzling (ed.) 'Monica Sjöö', *Voicing Today's Visions: Writings by Contemporary Women Artists* (London: The Women's Press, 1994) pp 154–73. See also the interview with Sjöö by Moira Vincentelli reprinted in *Visibly Female: Feminism and Art: An Anthology*, Ed. Hilary Robinson (London: Camden Press, 1987) pp 80–90.

10. For more details about 'Womanpower' see: John A. Walker, *Art and Outrage: Provocation, Controversy and the Visual Arts* (London & Sterling, VA: Pluto Press, 1999) pp 62–68.

11. For an article comparing Clark to other women artists see: Althea Greenan, 'Domestic squalor: reclaiming an artless art', *Make*, No 81 (September/November 1998).

12. Derek Boshier, [Statement in] *Derek Boshier: Work 1971–74* (Manchester: Whitworth Art Gallery, 1975) p 4.

13. See: Derek Boshier, [Note to illustration four] *Derek Boshier: Selected Drawings 1960–1982* (Liverpool: Bluecoat Gallery, 1983).

14. See: Catherine Lampert and Derek Boshier, 'Derek Boshier on his work', *Studio International*, Vol 186, No 960 (November 1973) pp 180–81.

Chapter 5: 1974

1. Richard Cork, *Beyond Painting & Sculpture: Works Bought for the Arts Council by Richard Cork* (London: Arts Council, 1973).
2. Victor Burgin, 'Socialist Formalism', *Studio International*, Vol 191, No 980 (March/April, 1976) pp 148–54.
3. See: 'John Hilliard and Ian Breakwell', *Studio International*, Vol 180, No 925 (September 1970) pp 94–95.
4. Uta Nusser (ed.) *John Hilliard* (Heidelberg: Verlag Das Wunderhorn/Manchester: Cornerhouse, 1999) p 37.
5. Bruce McLean, 'Not even crimble crumble', *Studio International*, Vol 180, No 926 (October 1970).
6. Sarah Kent, 'Pro-Dip show', *Time Out* (4–10 October 1974) p 14.
7. Peter Fuller, 'Where was the art of the seventies?' *Beyond the Crisis in Art* (London: Writers and Readers, 1980) p 29.
8. Writing a few years later, Cork claimed that his diagnosis and prognostication had been vindicated by new developments in British sculpture during the early 1980s. See Richard Cork, 'The emancipation of modern British sculpture', *British Art in the Twentieth Century: The Modern Movement*, Ed. S. Compton (London: Royal Academy/Munich: Prestel Verlag, 1986) pp 31–52. The Lethaby Lectures were also issued on audiotape in 1975 as a supplement to *Audio Arts*.
9. Fuller, 'Where was the art of the seventies?' *Beyond the Crisis in Art*, p 29.
10. Fuller, 'Where was the art of the seventies?' *Beyond the Crisis in Art*, p 27.
11. Su Braden, 'Politics in art', *Studio International*, Vol 187, No 967 (June 1974) pp 272–73.
12. Rasheed Araeen, 'Conversation with David Medalla', *Black Phoenix*, No 3 (spring 1979) pp 10–19.
13. See: Guy Brett, 'Internationalism among artists in the '60s and '70s' in *The Other Story: Afro-Asian Artists in Post-War Britain* by Rasheed Araeen [and others] (London: Hayward Gallery/South Bank Centre, 1989) pp 111–14.
14. Michael Daley, 'Art into Society – Society into Art', *U Magazine* [International Arts Centre, London] Vol 1, No 2 (December 1974) unpaginated.
15. Gustav Metzger, [Statement in] *Art into Society – Society into Art: Seven German Artists* (London: ICA, 1974) p 79.
16. See Stewart Home and others, *Neoist Manifestos/The Art Strike Papers* (Stirling, Scotland: AK Press, 1991).
17. Rasheed Araeen, 'Conspiracy of silence', *Making Myself Visible* (London: Kala Press, 1984) p 67.
18. For more detail see: John A. Walker, *John Latham – the Incidental Person – His Art and Ideas* (London: Middlesex University Press, 1995) pp 127–29.

19. For a brief account of art about events in Northern Ireland see: Mike Catto, 'Notes from a small war: art and the troubles', *Art in Ulster 2: 1957–1977* (Belfast: The Blackstaff Press/Arts Council of Northern Ireland, 1977) pp 125–44. A new edition was published in 1991 by The Blackstaff Press.

20. Edward Lucie-Smith, *Art in the Seventies* (Oxford: Phaidon, 1980) p 97.

21. Sarat Maharaj, 'Rita Donagh: Towards a map of her artwork', *Rita Donagh: 197419841994, Paintings and Drawings* (Manchester: Cornerhouse, 1994) pp 8–16, catalogue of an exhibition that also travelled to London and Dublin.

22. I am grateful to the Gulbenkian Foundation for the supply of information, booklets and reports. Su Braden, *Artists and People* (London, Henley & Boston: Routledge & Kegan Paul, 1978).

23. See: Malcolm Miles, *Murals: A Documentary Exhibition of Mural Works in the UK* (Swindon: Jolliffe Arts Studio, 1986) catalogue of a touring exhibition. I am also grateful to the Local History Collection of Greenwich Libraries for information about the Greenwich Mural Workshop.

24. See: THAP Convenors, *Tower Hamlets Arts Project Big Show* (London: White-chapel Art Gallery, 1976) 24-page booklet.

25. Sarah Kent, 'THAP goes the Big Show', *Time Out*, No 348 (19–25 November 1976) pp 10–11.

26. Araeen, 'The art Britain *really* ignores' (1976) *Making Myself Visible*, pp 100–05.

27. See: Greater London Council, *Campaign for a Popular Culture: A Record of Struggle and Achievement, the GLC's Community Arts Programme 1981–86* (London: GLC, 1986).

Chapter 6: 1975

1. For a more detailed history, see Charles Harrison and Fred Orton, *A Provisional History of Art & Language* (Paris: Editions E. Fabre, 1982).

2. Similar problems beset The Other Cinema (1970–77) an independent film distribution and screening collective. For a history, see: Jane Clarke and Rosie Elliott, 'The Other Cinema: Screen memory', *Wedge*, No 2 (spring 1978) pp 3–11.

3. Harrison and Orton, *A Provisional History of Art & Language*, p 47.

4. Harrison and Orton, *A Provisional History of Art & Language*, p 60.

5. When the author of this book was an art student during the late 1950s he worked for several weeks in a Metal Box factory in Newcastle-upon-Tyne and can report it was a noisy, unpleasant environment. Most of the employees on the assembly lines were women.

6. Interview with Margaret Harrison conducted in Greenwich in May 2000.

7. Jane Kelly, 'Mary Kelly', *Studio International*, Vol 193, No 987 (1977) pp 186–88.

8. Rosalind Delmar, 'Woman and Work . . ', *Spare Rib*, No 40 (1975) pp 32–33.

9. LSA, *Do you really know what this exhibition is all about?* (London: LSA, 1975) 7 pages, reprinted in *Class War in the Arts!* (London: LSA, 1976) 52-page pamphlet.

10. Interview conducted with Kay Fido Hunt in South London in June 2000.

11. Dorothy Walker, author of *Modern Art in Ireland* (Dublin: The Lilliput Press, 1997), remarks: 'it is quite remarkable that, at a time when political art was widely practised in Great Britain, only three well-known British artists . . . reacted to the political problems of Northern Ireland' (pp 92–93). Furthermore, only a few pages of her history are devoted to examples of political art produced by Irish artists during the 1970s. However, for more examples, see Mike Catto, *Art in Ulster 2: 1957–1977*, cited earlier.

12. Tim Rollins, 'Art as social action: an interview with Conrad Atkinson', *Art in America*, Vol 68, No 2 (February 1980) pp 119–23.

13. For further information about Atkinson, see the book/catalogue: *Conrad Atkinson: Picturing the System*, Eds Sandy Nairne and Caroline Tisdall (London: ICA/Pluto Press, 1981).

14. See: *The Video Show: Festival of Independent Video at the Serpentine Gallery* (London: Arts Council, 1975) catalogue in the form of a folder with many loose leaves; preface by Sue Grayson and a short essay by John Howkins.

15. For more details, see: John A. Walker, *Arts TV: A History of Arts Television in Britain* (London, Paris, Rome: John Libbey/Arts Council, 1993) pp 123–24.

16. David Hall, 'British video art: towards an autonomous practice', *Studio International*, Vol 191, No 981 (May/June 1976) pp 248–52.

Chapter 7: 1976

1. The Labour politician Barbara Castle announced in 1976 that the hospital would close. Surprisingly, the Conservative politician Margaret Thatcher promised to save the hospital if her party came to power in 1979.

2. On the Poster/Film Collective see: Jonathan Miles, 'Political art', *Art and Politics: Proceedings of a Conference on Art and Politics held on 15 and 16 April 1977*, Ed. Brandon Taylor (Winchester, Hants: Winchester School of Art Press, 1980) pp 54–62.

3. For more on 'Global Routes' see Nicholas Wegner, *Depart from Zero: The Development of The Gallery, London, 1973–1978* (London: The Gallery Trust Publications, 1987).

4. The manifesto, largely written by Stezaker, was printed in: Pete Challis and

others, '8/4/76', *A Journal from the Royal College of Art*, No 2 (London: RCA, 1976) pp 3–10.

5. For example, John A. Walker, *Art in the Age of Mass Media* (London: Pluto Press, 1st edn 1983, 2nd edn 1994, 3rd edn 2001).

6. Brandon Taylor, 'The avant-garde and St Martin's', *Artscribe*, No 4 (September/ October, 1976) pp 4–7.

7. Stezaker, quoted in, John Roberts, 'Interview with John Stezaker', *Selected Errors: Writings on Art and Politics 1981–90* (London & Boulder, CO: Pluto Press, 1992) p 31.

8. Peter Fuller, 'Where was the art of the seventies?' *Beyond the Crisis in Art* (London: Writers & Readers, 1980) p 41.

9. Richard Cork, 'People in the background', *Evening Standard* (5 May 1977) p 25.

10. Monica Sjöö, 'Images of womanpower', *Towards a Revolutionary Feminist Art*, No 1 (1972) p 4.

11. See: R.B. Kitaj, 'School of London', *The Human Clay* (London: Arts Council of Great Britain, 1976).

12. John Roberts, 'Imaging history: the history painting of Terry Atkinson', *Postmodernism, Politics and Art* (Manchester & New York: Manchester University Press, 1990) p 130.

13. Roberts, 'Imaging history: the history painting of Terry Atkinson', *Postmodernism, Politics and Art*, p 133.

14. For more detailed accounts of these scandals see: John A. Walker, *Art and Outrage: Provocation, Controversy and the Visual Arts* (London & Sterling, VA: Pluto Press, 1999).

15. A detailed account of COUM can be found in Simon Ford's *Wreckers of Civilization: The Story of COUM Transmissions and Throbbing Gristle* (London: Black Dog Publishing, 1999).

16. John Tagg and Peter Fuller, 'Richard Cork and the "New Road to Wigan Pier"', *Art Monthly*, No 30 (October 1979) pp 3–7.

17. Richard Cork, 'Editorial', *Studio International*, Vol 192, No 983 (September/ October 1976) p 100–02.

18. Trevor Fawcett and Clive Phillpot (eds) *The Art Press: Two Centuries of Art Magazines* (London: The Art Book Company, 1976).

19. *Artscribe's* subsequent history and fate is worth summarizing because it is typical of what happens to many art magazines that move away from their humble, polemical origins in order to become commercial products. As the years passed, *Artscribe* became smarter in appearance, better illustrated, attracted gallery advertising, and added 'international' to its title in an effort to become a mainstream, profitable publication. During the 1980s, when it was edited by the critic and arts television presenter Matthew Collings and

bankrolled by two affluent Americans, it passed through a post-modern phase. In 1992, the publisher Alan Marcuson of Hali Publications Ltd, London acquired it (they specialized in books and periodicals about Oriental carpets and textiles) and Majorie Allthorpe-Guyton was appointed as editor. The magazine was revamped yet again: it became larger, glossier and more expensive. Presumably, the publishers did not recoup their investment from sales because, after only one issue in the new format, the magazine folded. Allthorpe-Guyton was thus made redundant but she was re-employed by the Arts Council of England where she is now Director of Visual Arts. The Scottish artist Peter Hill gives a more detailed history of the magazine on a website: http://www.artschool.utas.edu.au/moci/encyc/entries/artscribe.html

20. William Furlong, 'Collaborations', *Audio Arts: Discourse and Practice in Contemporary Art* (London: Academy Editions, 1994) p 111.

21. Marc Chaimowicz, 'Performance', *Studio International*, Vol 193, No 986 (March/April 1977) Review Section, pp 137–38.

Chapter 8: 1977

1. Linda Nochlin's essay first appeared in *Women in Sexist Society: Studies in Power and Powerlessness*, Eds V. Gornick & B. Moran (New York: Basic Books, 1971) pp 480–510.

2. Peter Fuller, 'Troubles with British Art now', *Artforum*, Vol 15, No 8 (April 1977) pp 42–47.

3. For further comments by Fuller on Buckley, see: 'Where was the art of the seventies?' *Beyond the Crisis in Art* (London: Writers & Readers, 1980) p 39.

4. Toni del Renzio, a left-wing critic and one-time member of the Independent Group of the 1950s, dubbed Fuller a 'petty pundit' and 'instant critic' (that is, one with instant opinions). See: Toni del Renzio, 'Instant critic: Peter Fuller in 1980', *Block*, No 4 (1981) pp 57–60.

5. Peter Fuller's writings on John Berger include: *Seeing Berger: A Revaluation of 'Ways of Seeing'* (London: Writers & Readers, 1980) and his revised version of the 1980 book entitled *Seeing Through Berger* (London: Claridge Press, 1989).

6. For more details about the interrelationship between the visual arts and pop music, see: John A. Walker, *Cross-Overs: Art into Pop/Pop into Art* (London & New York: Comedia/Methuen, 1987).

7. Derek Jarman, *Up in the Air: Collected Film Scripts* (London: Vintage/Random House, 1996) introduction by Michael O'Pray, p 43.

8. Jarman, quoted in *England's Dreaming: Sex Pistols and Punk Rock* by Jon Savage (London & Boston: Faber & Faber, 1991) p 377.

9. Scott Meek, 'Jubilee', *Monthly Film Bulletin*, Vol 45, No 531 (April 1978) p 66. For a more recent positive review, see: Julian Upton, 'Anarchy in the UK: Derek Jarman's *Jubilee* revisited', *Bright Lights Film Journal*, No 30 (October 2000) available on the Internet.

10. Tony Peake, *Derek Jarman* (London: Little, Brown & Co., 1999) p 246.

11. Jarman, *Up in the Air: Collected Film Scripts*, p 43.

12. I am grateful to Conrad Atkinson for information supplied.

13. Conrad Atkinson, '1984 in the light of *Guernica*', *1984: An Exhibition* (London: Camden Arts Centre, 1984) p 28.

14. Rasheed Araeen, *Making Myself Visible* (London: Kala Press, 1984) p 114.

15. See, for example: Zelda Curtis, 'No love in the gallery', *East End News* (10 July 1981) p 13, a review of a show of G & G's photo-works at the Whitechapel Art Gallery in 1981. Curtis remarked: 'These artists show arrogance and a dispassionate unconcern for people. Their pictures are cold and unfeeling ... My companion was moved to anger by their portrait *The Black Man* for he felt the racism inherent in it.'

16. Wolf Jahn, *Gilbert & George or An Aesthetic of Existence* (London: Thames & Hudson, 1989) p 205.

17. Rosetta Brooks, 'Gilbert & George: Shake hands with the Devil', *Artforum*, Vol 22, No 10 (summer 1984) pp 56–60.

18. 'Lewisham, August 13 1977', *Camerawork*, No 8 (November 1977).

19. Eirlys Tynan, 'Victor Burgin', *Studio International*, Vol 192, No 983 (September/October, 1976) Review Section, pp 225–26. See also the letter from Robert Self in the following issue.

20. Art & Language, 'Poster in Eldon Square ...' *Aspects*, No 2 (February/April, 1978) p 4.

21. Letter from Dugger to author dated 18 May 2000.

22. Derek Boshier, 'Interview with John Dugger', *Real Life Magazine*, No 15 (Winter 1985–86) pp 10–14. See also: John Dugger, 'Victory is certain, 1976', *Lives: an Exhibition of Artists whose Work is based on other People's Lives*, selected by Derek Boshier (London: Hayward Gallery/Arts Council of Great Britain, 1979).

23. James Faure Walker, 'The claims of Social art and other perplexities', *Artscribe*, No 12 (1978) pp 16–20.

24. John Gorman, *Images of Labour: Selected Memorabilia from the National Museum of Labour History, London* (London: Scorpion Publishing, 1985) p 56.

Chapter 9: 1978

1. 'The State of British Art', *Studio International*, Vol 194, No 989 (1978) pp 74–138.

2. Not everyone was impressed by the conference: for two negative reactions by art critics, see: Sarah Kent, 'ICA Star Wars', *Time Out* (24 February – 2 March 1978) p 9, and Adrian Searle, 'The State of Art debate at the ICA', *Artscribe*, No 11 (April 1978) pp 39–42.

3. Margaret Harrison, 'Art in life: a feminist model', *The Growth of Women's Art: From Manifesto to Polemic* (Sydney: Women's Forum Seminar Papers, 1982) p 10.

4. Rozsika Parker and Griselda Pollock (eds) *Framing Feminism: Art and the Women's Movement 1970–1985* (London: Pandora/HarperCollins, 1987) pp 94–95.

5. Margaret Harrison, [Response to a questionnaire about radical attitudes to the gallery] *Studio International*, Vol 195, No 990 (1980) p 37.

6. Harrison continues to work in Britain and the United States, painting watercolours about political themes. At the time of writing, she is a Research Professor at Manchester Metropolitan University. For more on Harrison's art, see: Lucy R. Lippard & others, *Margaret Harrison: Moving Pictures* (Manchester: Manchester Metropolitan University, 1998).

7. See the catalogue: *"We want the people to know the truth." Patchwork pictures from Chile* (Glasgow & London: 1978) with an essay by Brett, reprinted in *Black Phoenix*, No 1 (winter, 1978) pp 19–22.

8. Peter Kennard, 'Notes on photomontage', *Artery*, Vol 5, No 3 (1980) pp 17–20.

9. Bernard Levin, 'This poisoning of the wells of art', *The Times* (12 May 1978) p 16.

10. Sarah Kent, 'ICA Star Wars', *Time Out* (24 February–2 March 1978) p 9.

11. James Faure Walker, 'The claims of social art and other perplexities', *Artscribe*, No 12 (1978) pp 16–20.

12. Ian Walters, 'The Royal Oak murals: interview', *Artery*, No 14 (spring 1978) pp 17–23.

13. Jeff Sawtell, 'The Royal Oak murals, Harrow Rd', *Artscribe*, No 11 (April 1978) pp 61–62.

14. Faure Walker, 'The claims of social art and other perplexities', pp 16–20.

15. Art & Language, 'On the recent fashion for caring', *Art Monthly*, No 20 (October 1978) pp 22–23.

16. In 1997, two artists who had once been members of A & L – Terry Atkinson and Joseph Kosuth – challenged the holier-than-thou stance of the group by describing its social practice as an 'ethical swamp'. See: Michael Baldwin, Mel Ramsden and Charles Harrison, 'Signing off', *tate, the art magazine*, No 11 (spring, 1997) p 80, and the reply from Joseph Kosuth and Terry Atkinson, 'The ongoing saga of Art & Language', *tate, the art magazine*, No 12 (summer 1997) p 88.

17. Fuller's paper 'Fine art after modernism' was delivered at a conference held at

the University of Wales in September 1978; it was later published in *New Left Review*, No 119 (January/February 1980) and reprinted in *Beyond the Crisis in Art* (London: Writers and Readers, 1980) pp 44–67.

18. Tim Hilton, 'More argument than art', *Times Literary Supplement* (25 August 1978) p 950.

19. Juliet Steyn and Deborah Cherry, 'Putting the Hayward Annual Two together', *Art Monthly*, No 19 (September 1978) pp 10–14.

20. Griselda Pollock, 'Feminism, femininity and the Hayward Annual exhibition 1978', *Feminist Review*, No 2 (1979) pp 33–54.

Chapter 10: 1979

1. Ben Jones and others, *Style in the 70s: A Touring Survey Show of New Painting and Sculpture of the Decade, Presented by Artscribe* (London: *Artscribe*, 1979).

2. Timothy Hyman, *Narrative Painting: Figurative Art of Two Generations* (Bristol: Arnolfini, 1979).

3. Gen Doy, 'Reviews', *Artery*, Vol 5, No 2 (June 1980) pp 32–33.

4. Timothy Hyman, 'Shocking at Stoke: An episode in popular taste', *Art Monthly*, No 35 (1980) p 2.

5. Rozsika Parker and Griselda Pollock (eds) *Framing Feminism: Art and the Women's Movement 1970–85* (London: Pandora/HarperCollins, 1987) p 5.

6. Jay Rayner, 'Blair's Britain', *Observer Review* (14 March 1999) pp 1–2.

7. For a more detailed account see: John A. Walker, *Art and Outrage: Provocation, Controversy and the Visual Arts* (London & Sterling, VA: Pluto Press, 1999) pp 98–105.

8. For a fuller account see: Walker, *Art and Outrage*, pp 105–110.

9. Sarah Kent, *Denis Masi: ENCOUNTER/counter, Four Constructions 1975–1979* (London: Institute of Contemporary Arts, 1979).

10. When Masi was asked by Jasia Reichardt to write about his experiences of the 1970s, he listed the directors and films that had interested him most. See Masi's statement in 'Artists' thoughts on the seventies in words and pictures', *Studio International*, Vol 195, Nos 991/2 (1981) pp 48–49.

11. William Furlong, 'Artifact: cruelty to animals', *Time Out*, No 476 (1–7 June 1979).

12. I am grateful to the artist for information supplied.

13. For an overview of *Camerawork*'s achievements, see: Jessica Evans (ed.) *The Camerawork Essays: Context and Meaning in Photography* (London: Rivers Oram Press, 1997).

14. I am grateful to Terry Dennett for this information.

15. Jo Spence, 'Facing up to myself', *Spare Rib*, No 68 (March 1978) pp 6–9, plus front cover.

16. Edward Lucie-Smith, 'A flash from the past', *Evening Standard* (7 June 1979).

17. For more on Spence, see: Jo Spence, *Putting Myself in the Picture: A Political, Personal and Photographic Autobiography* (London: Camden Press, 1986) and *Cultural Sniping: The Art of Transgression* (London & New York: Routledge, 1995); see also obituaries by Jane Brettle, Val Williams and Rosy Martin, 'Putting us all in the picture', *Women's Art Magazine*, No 48 (September/October 1992) pp 14–15.

18. Mel Gooding, *Bruce McLean* (Oxford & New York: Phaidon, 1990) pp 89–92.

19. Nena Dimitrijevic, *Bruce McLean* (London: Whitechapel Art Gallery, 1982) pp 46–50.

Conclusion: Aftermath

1. Richard Cork, 'It all depends . . .', *Artscribe*, No 27 (February 1981) p 37–38.

2. Ian Breakwell, [Letter in response to a questionnaire] 'Artist's thoughts on the seventies in words and pictures', Ed. Jasia Reichardt, *Studio International*, Vol 195, No 991/2 (1981) p 11.

3. Jann Haworth, quoted in *Groovy Bob: The Life and Times of Robert Fraser* by Harriet Vyner (London: Faber & Faber, 1999) p 276.

4. For more details, see: Rita Hatton and John A. Walker, *Supercollector: A Critique of Charles Saatchi* (London: . . . ellipsis, 2000).

5. Lawrence Marks, 'Picked clean by the piranha', *Observer* (8 December 1991) Arts & Books section, p 53.

6. For a comparison of *The Face* and the photographic magazine *Ten 8*, see: Dick Hebdige, 'The bottom line on planet one: squaring up to *The Face*', *Ten 8*, No 19 (1985) pp 40–49.

7. See, for instance, Neil Mulholland's article 'The fall and rise of crisis criticism', *Visual Culture in Britain*, Vol 1, No 2 (November 2000) pp 57–77.

8. Peter Kennard, 'Polemic: art and politics: Blair's art', *Art Monthly*, No 235 (April 2000) p 45.

9. Jonathan Jones, 'There goes art's last hope', *Guardian* (30 November 2000) p 12–13. M. Craig-Martin retired from teaching at Goldsmiths' and was replaced by Victor Burgin.

Bibliography

(Limited to general histories of the decade and books and articles specifically about the visual culture of the 1970s in Britain.)

General Histories

Allison, Ronald, *The Country Life Book of Britain in the Seventies* (London: Book Club Associates, 1980).

Booker, Christopher, *The Seventies: Portrait of a Decade* (London: Allen Lane, 1980).

Centre for Contemporary Cultural Studies, *The Empire Strikes Back: Race and Racism in '70s Britain* (London & New York: Routledge/University of Birmingham: Centre for Contemporary Cultural Studies, 1982).

Cliff, Tony, *A World to Win: Life of a Revolutionary* (London, Chicago & Sydney: Bookmarks, 2000). Useful for a history of the Socialist Workers Party and British politics during the 1970s.

Clutterbuck, Richard, *Britain in Agony: The Growth of Political Violence* (London: Faber & Faber, 1978; Harmondsworth, Middlesex: Penguin Books, revised edn 1980). The revised, paperback edition has a chronology that covers the period 1964 to 1979.

Hill, Tim, *The Seventies* (London: Daily Mail/Chapman's, 1991).

Olson, James S. (ed.), *Historical Dictionary of the 1970s* (Westport, CT & London: Greenwood Press, 1999). Includes a chronology but is mainly about events and people in the United States.

Shrapnel, Norman, *The Seventies: Britain's Inward March* (London: Constable, 1980).

Whitehead, Phillip, *The Writing on the Wall: Britain in the Seventies* (London: Michael Joseph & Channel Four Television, 1985).

Wilson, Des '1970–79 The wasted years: a review of the '70s', *Illustrated London News*, Vol 267, No 6977 (December 1979), pp 28–63. Title used on the cover was: 'The Savage '70s.'

Yapp, Nick (ed.), *1970s* (Koln, Germany: Konemann, 1998), decades of the twentieth century series. A photographic record.

Histories of Art and Popular Culture

Arte Ingelese Oggi 1960–76 (Milan: Palazzo Reale, 1976), a British Council

exhibition. Two-volume catalogue with essays: 'Sculpture 1960–76' by David Thompson and 'Alternative Developments' by Richard Cork.

Brett, Guy, 'Internationalism among artists in the '60s and '70s', *The Other Story: Afro-Asian Artists in Post-War Britain* by Rasheed Araeen and others (London: Hayward Gallery/South Bank Centre, 1990), pp 111–18.

British Art in the Twentieth Century: The Modern Movement, Ed. Susan Compton (London: Royal Academy/Munich: Prestel Verlag, 1986), catalogue of an exhibition held at the RA from January to April 1987. Includes essays by Richard Cork, Charles Harrison and Caroline Tisdall's 'Art controversies of the seventies', pp 83–87.

British Sculpture in the Twentieth Century, Eds Sandy Nairne and Nicholas Serota (London: Whitechapel Art Gallery, 1981), catalogue with essays by Stuart Morgan, 'A rhetoric of silence: redefinitions of sculpture in the 1960s and 1970s', Brendan Prendeville, 'Constructed sculpture' and Fenella Crichton, 'Symbols, presences and poetry'.

Cork, Richard, *The Social Role of Art: 34 Essays in Criticism for a Newspaper Public* (London: Gordon Fraser, 1979).

Curtis, David, 'English avant-garde film: an early chronology', *Studio International*, Vol 190, No 978 (November/December 1976), pp 176–82. Covers the period 1966 to 1975.

Europe in the Seventies: Aspects of Recent Art, essay by Jean-Christophe Ammann (Chicago: Art Institute of Chicago, 1977).

Fuller, Peter, 'Troubles with British Art now', *Artforum*, Vol 15, No 8 (April, 1977), pp 42–47.

Fuller, Peter, 'Where was the art of the seventies?' *Beyond the Crisis in Art* (London: Writers and Readers, 1980), pp 16–43.

Gooding, Mel, 'Art in the seventies', *Art Monthly*, No 113 (February 1988), pp 3–4. Gooding introduces three articles: (1) Adrian Heath, 'Concerning conceptualism', pp 4–6; (2) Michael Craig-Martin, 'Reflections on the 1960s and early '70s', *Art Monthly*, No 114 (March 1988), pp 3–5; (3) Jasia Reichardt, 'The seventies', *Art Monthly*, No 115 (April 1988), pp 3–5.

Gravity and Grace: The Changing Condition of Sculpture 1965–75 (London: Hayward Gallery, 1993), catalogue essay by Jon Thompson.

Harrison, Margaret, 'Notes on Feminist Art in Britain 1970–77', *Studio International*, Vol 193, No 987 (May/June 1977), pp 212–20.

Herald, Jackie, *Fashions of a Decade: 1970s* (London: Batsford, 1992).

Hewison, Robert, 'The uses of subculture: Britain in the 1970s', *Culture and*

Consensus: England, Art and Politics since 1940 (London: Methuen, 1995), pp 159–208.

Hilliard, John, 'British art in the seventies – a brief note' (1988), printed in *John Hilliard*, Ed. Uta Nusser (Heidelberg: Verlag Das Wunderhorn/ Manchester: Cornerhouse, 1999), pp 12–13.

Hughes, Robert, 'Ten years that buried the avant-garde', *Sunday Times Magazine* (30 December 1979), pp 16–21, 41–47.

Hunt, Leon, *British Low Culture from Safari Suits to Sexploitation* (London & New York: Routledge, 1998).

Live in Your Head: Concept and Experiment in Britain 1965–75 (London: Whitechapel Art Gallery, 2000), an exhibition curated by Clive Phillpot and Andrea Tarsia; catalogue has a chronology plus essays by the aforementioned and by Michael Archer and Rosetta Brooks.

Lucie-Smith, Edward, *Art in the Seventies* (Oxford: Phaidon, 1980).

Lucie-Smith, Edward, 'The gay seventies?' *Art & Artists*, Vol 14, No 8 (December 1979), pp 4–11.

Mastai, Judith (ed.), *Social Process/Collaborative Action: Mary Kelly 1970–75* (Vancouver, BC: Charles H. Scott Gallery, Emily Carr Institute of Art & Design, 1997), a book/catalogue that includes essays by Mary Kelly, Griselda Pollock and Peter Wollen, plus a chronology of the 1970s by Sue Malvern.

Moore-Gilbert, Bart (ed.), *The Arts in the 1970s: Cultural Closure?* (London & New York: Routledge, 1994), a book that includes an essay by Stuart Sillars, ' "Is it possible for me to do nothing as my contribution?": visual art in the 1970s', pp 259–80.

Mulholland, Neil, 'The fall and rise of crisis criticism', *Visual Culture in Britain*, Vol 1, No 2 (November 2000), pp 57–77.

'Painting 1979: a crisis of function?' *London Magazine*, Vol 19, Nos 1 & 2 (April/May 1979), pp 9–60, a special issue based on a questionnaire with articles by Timothy Hyman, John Hoyland, Victor Pasmore, Peter Fuller, Janet Daley, James Faure Walker and others.

Parker, Rozsika and Pollock, Griselda (eds), *Framing Feminism: Art and the Women's Movement 1970–85* (London: Pandora/HarperCollins, 1987).

Peacock, John, *The 1970s* (London: Thames & Hudson, 1997), covers fashion design.

Reichardt, Jasia (ed.), 'Artist's thoughts on the seventies in words and pictures', *Studio International*, Vol 195, No 991/2 (1981), pp 2–73, artists' responses to a questionnaire.

Roberts, John (ed.), *The Impossible Document: Photography and Conceptual Art in Britain 1966–1976* (London: Camerawork/Camerwords, 1997).

Spalding, Frances, *The Tate: A History* (London: Tate Gallery Publishing, 1998).

Tisdall, Caroline, *Grist to the Mill: Selected Writings 1970–1995* (London: Red Lion House, 1995).

Twenty-five Years, Annely Juda Fine Art/Juda Rowan Gallery: Masterpieces of the Avant-Garde, Three decades of Contemporary Art: the Sixties ... the Seventies ... the Eighties (London: Annely Juda Fine Art, 1985).

Willats, Stephen, *Art and Social Function* (London: ... ellipsis, 2000), writings first published in 1976.

York, Peter, *Style Wars* (London: Sidgwick & Jackson, 1980), reprints of short articles most of which appeared in *Harpers & Queen* between 1975 and 1980.

See also: ' "Other Educated Persons": Art and Art organizations in the East End of London 1972–1999', a multimedia web resource developed by Anne Baker and archived by VADS (Visual Arts Data Service). This site features interviews with artists who lived in London during the 1970s. http://vads.adhs.ac.uk/vads.catalogue/oep.description.html

Index